The Sony a7 and a7R

Dr. Brian Matsumoto is a retired research scientist who has worked for 30 years recording experiments with a wide range of film and digital cameras. He now spends his time photographing with a variety of cameras and lenses. He enjoys exploring how a camera's potential can be expanded by pairing it with specialized optics such as microscopes and telescopes. He carries a camera on all his hikes and enjoys photographing nature. In addition to the seven books he has written for Rocky Nook, Dr. Matsumoto has published several articles and has had his photographs published in a number of periodicals. He is experienced in the technical aspects of photography and has taught courses on recording scientific experiments with digital cameras.

Carol F. Roullard has been an avid photographer since her high school years, where she first experimented with black-and-white artistic composition. Since then, she has continued photographing, mainly nature and architecture. Carol has used a variety of cameras covering a wide range of makes and models, from simple point-and-shoot cameras to complex professional-level cameras. Carol produces fine art photography and is utilizing her previous art business experience for her online gallery and art shows. As a former Project Management Quality and Compliance Engineer, Carol spent a number of years developing procedural and quality control methodology for IT projects. In addition, she has developed and conducted training sessions covering best practices for procedural and quality control, breaking down complex subjects into easy-to-use approaches to learning.

The Sony a7 and a7R

The Unofficial Quintessential Guide

Brian Matsumoto
Carol F. Roullard

rockynook

Brian Matsumoto (www.matsuimaging.com)
Carol F. Roullard (www.vistafocus.net)

Project Editor: Maggie Yates
Copyeditor: Maggie Yates
Layout: Jan Martí, Command Z
Cover Design: Helmut Kraus, www.exclam.de
Printer: Sheridan Books, Inc
Printed in the USA

ISBN 978-1-937538-49-1

1st Edition 2014
© 2014 by Brian Matsumoto, Carol F. Roullard

Rocky Nook Inc.
802 East Cota St., 3rd Floor
Santa Barbara, CA 93103
www.rockynook.com

Library of Congress Cataloging-in-Publication Data

Matsumoto, Brian.
 The Sony a7 and a7R : the unofficial quintessential guide / by Brian Matsumoto,
Carol F. Roullard. -- 1st edition.
 pages cm
 ISBN 978-1-937538-49-1 (softcover : alk. paper)
 1. Sony digital cameras. 2. Photography--Digital techniques. I. Roullard, Carol F. II. Title.
 TR263.S66M37 2014
 771.3--dc23
 2014010950

Distributed by O'Reilly Media
1005 Gravenstein Highway North
Sebastopol, CA 95472

This book is dedicated to my father, Harold Zachary Frank, who, along with my mother, gave me strong roots in tradition and moral values and broad wings to soar and accomplish my goals.

Harold Zachary Frank
January 22, 1921 - May 28, 2014

Acknowledgements

Writing this book was a collaborative effort and we are indebted to the expertise and aid of several people who helped bring this book to fruition. Thanks to Scott Dordick, owner of Acratech, Inc., for his assistance and discussions about using tripods in photography. Also, thanks to Matt Cardwell of Cognysis, Inc. for his guidance about focus stacking and the applicability of the Cognysis' ShotStack, a program for extending the depth of field in our scientific and close-up photography. Both Scott and Matt provided product shots of their accessories for this book. In addition, we thank Sony for allowing us to use their product shots of the Sony a7 and a7R.

Last but not least, thanks to the staff of Rocky Nook. We are indebted to Gerhard Rossbach for his guidance in putting together our books, and to Joan Dixon, Managing Editor, and Matthias Rossmanith, Project Manager, for overseeing our efforts and the efforts of Maggie Yates, Editorial Assistant, and Jan Marti, layout artist, for formatting our book.

It is a major benefit for us to have an opportunity to work with such a wonderful group of people.

Brian Matsumoto
www.MatsuImaging.com

Carol Roullard
www.VistaFocus.net

Preface

The Sony a7 and a7R have a breakthrough camera design. At the time of writing this book, they are the lightest, least expensive, full-frame interchangeable lens cameras available to professional and amateur photographers. The cameras' light weight and compact size makes them very portable, and convenient for the photographer to have at their side at all times. For the adventurous photographer, these cameras can be carried easily to remote locations for recording unique photographic vistas.

Sony has been refining a completely electronic viewfinder system: there is no optical finder on the a7/a7R. This electronic viewfinder provides not only a technical tool for taking photographs, but a creative tool as well. It offers a more efficient workflow to the busy photographer by providing immediate feedback on errors in white balance, focus, and exposure. For the artist, the viewfinder provides a way to pre-visualize the scene to determine if any aesthetic changes should be made. The viewfinder allows the photographer to preview the image with additional artistic elements, such as saturated vivid colors, or muted colors and subtle shades, to decide how to create the proper ambience for the scene. It also allows you to easily switch to black-and-white photography so you can visualize the scene as a monochrome image. This aids in framing the shot by allowing you to balance shadows, gray tones, and highlights for the perfect composition.

This is not to say that the camera is perfect. For those photographers who are interested in taking action shots with a rapid-fire burst capability, this camera is not as well suited as some heavier digital SLRs. However, the a7/a7R is eminently suitable for those photographers who are interested in taking pictures at a more deliberate rate, who are concerned about critical composition, and whose aim is to take landscapes, close-ups, portraits, or scientific photographs.

This book was written with the intent of helping you get the most out of these two cameras. Even if you are a neophyte photographer who is unfamiliar with photographic terms and principles, you can use this book to help you start taking pictures immediately. This book will take you from opening the camera box to becoming comfortable with manually setting your new camera's controls and taking photos and movies using your own settings. If you are an experienced photographer who needs to get the most out of your equipment, this book describes the camera settings in detail. As always, we have many recommendations on ways to set your camera to get the most out of your efforts. We also discuss camera accessories, including legacy lenses that will benefit your work with the a7/a7R, so you can explore new avenues of creativity with your camera.

Hopefully this book will help you get more enjoyment out of your experience with these two camera models and your photography overall.

Brian Matsumoto

Carol Roullard

Table of Contents

Camera Body Reference
(Product photos throughout the book courtesy of Sony)

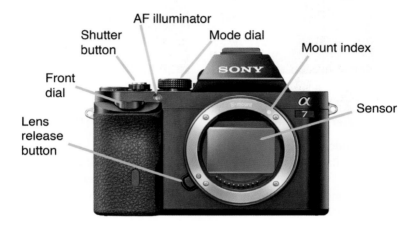

Figure A: Sony a7 and a7R camera front

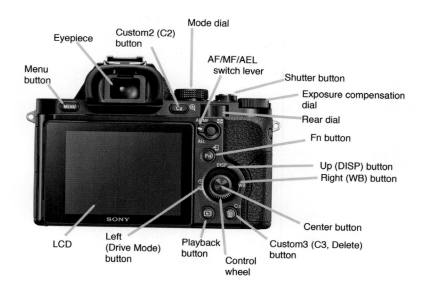

Figure B: Sony a7 and a7R camera back

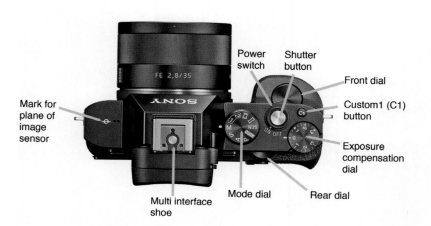

Figure B: Sony a7 and a7R camera top

Chapter 1: Getting Started

Introduction

This book covers two similar Sony camera models: the a7 and the a7R. When we use the term *camera* or *a7/a7R*, we are referring to both cameras. The differences between the two are mainly with their sensors and a few commands. When covering a specific feature belonging to just one of the cameras, we will refer to the camera as either a7 or a7R.

Using This Book

The Sony a7/a7R is a versatile camera for photographers of all levels of expertise. If you are a beginner who does not know about exposure values (EV), sensor sensitivity (ISO), or shutter speed, you can set the camera to Intelligent Auto or Superior Auto mode and use it as a point-and-shoot. As you gain experience, you can improve your images by using the camera's SCN mode and selecting the type of subject you intend to photograph. At this level, your input tells the camera how it should fine-tune its settings for recording a specific type of subject. For example, when you select the Sports Action icon, the camera will use a faster shutter speed and a higher ISO to freeze rapid motion. When you select the Landscape icon, the camera uses a slower shutter speed and a lower ISO to capture a noise-free image.

Even professionals will find the automatic modes valuable. Frequently, when the camera has been tuned for a specific photographic assignment, you might need a fast way to return to a generic setting to capture a shot. This can be accomplished effectively by turning the mode dial to the automatic modes to grab a quick shot.

The majority of expert photographers will use the mode dial to take control of the camera. They will select from the P, A, S, and M modes for still photography. For taking movies, they can set the mode dial to Movie mode and use P, A, S, and M.

In short, because of the multitude of camera commands and features, learning how to use the a7/a7R can be confusing. To help you learn, this guide has been structured so that the topics follow a natural progression. First we will introduce the most important features so you can start operating the camera with minimum effort. This will allow you to start taking pictures right away. A description of how to navigate through the camera's menus is included in this chapter. This will prepare you to use the camera to its fullest potential.

For those who are experienced photographers or who have owned a previous Sony camera model, you may decide to glance through the early portion of the book and concentrate more on the sections that deal with semi-automatic and manual exposure (Chapters 5 and 6). With that said, we still recommend reading this chapter to learn how to navigate through the menus. In addition, because menu navigation can be slow, we describe the importance of the Fn button and the Quick Navi screen. These serve as gateways into the menu and provide a

faster means to change settings. If you understand the menu system and how to use the Fn button and Quick Navi screen, you will have fast access to almost all of Sony's features.

Chapter 2 covers photographic basics and expands on the camera's basic controls. The chapter gives you an intuitive feel for what the camera does and the importance of different types of settings in pictorial composition. Chapter 3 describes how to manage your images: it covers topics from how to customize your view through the display screens to organizing your saved images. We describe in later chapters how to get the most out of your camera: we progress from the automatic modes in Chapter 4 to the semi-automatic modes in Chapter 5. Chapter 6 discusses how to take full control of the camera settings. Later chapters explore the accessories and advanced features of your camera.

The Camera

The a7/a7R is Sony's first E-mount camera to do away with the NEX designation, have a full frame sensor (36x24mm), and require a new lens line—the full frame E-mount (FE mount). This is a breakthrough design—it's the first to incorporate a full frame sensor in a compact, mirrorless camera equipped with an electronic viewfinder (EVF).

There are theoretical and practical advantages in using a larger-size array to contain the pixels. Chief among these is that larger individual photodiodes can be used to capture photons. The common APS-C sensor has an overall size of 16x24mm, and when compared to a full frame sensor (36x24mm), it is evident that for a given number of pixels, the individual photosites of the APS-C sensor must be smaller.

For a 24-megapixel sensor, simple geometry predicts that a single photodiode of the a7 will be 1.5x greater in size than that of the NEX-7, which uses the APS-C sensor. For a photographer, this means that both the a7 and NEX-7 will make the same size publication print of 20x13 inches at 300 dots per inch (dpi). However, the larger-sensor a7 camera will make a print that has lower noise in the shadows and an increased dynamic range. Having this capability in a camera that is smaller than most APS-C cameras is incredible.

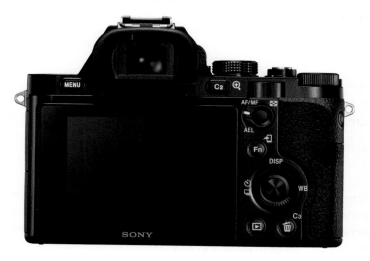

In the case of the a7R, its photosite is the same size as that used in the 16-megapixel NEX-6, which means the noise characteristic and dynamic range should be the same as with that camera. However, while retaining the same level of noise and dynamic range, the a7R has a higher overall pixel count. It is 36 megapixels to the NEX-6's 16 megapixels. If you are making a print for publication at 300 dpi, the a7R will make a print that is 24x16 inches, while the NEX-6 will make a print that is 16x11 inches.

The a7 and a7R are the smallest full frame sensor cameras with interchangeable lenses currently on the market. Table 1-1 compares their weights, prices, and pixel counts to those of the competitors. In terms of price, both of these models are economical options for a full frame sensor camera. The 36-megapixel a7R is $600 less expensive than the Nikon 800E. Both cameras lack an anti-aliasing filter, which is incorporated in most sensors to reduce moiré. However, this filter will also reduce pixel-to-pixel resolution—without it, you will achieve a higher level of sharpness. The 24-megapixel Sony a7 is a cost-effective alternative for those who do not need the higher pixel count. In comparison to its competitors, its price is also very reasonable. In addition, the light weight of both these camera bodies makes them easy to carry.

Camera Model	Megapixel Count	Anti-Aliasing Filter	Weight in Ounces	Sony
Sony a7	24	Yes	14.7	$1,698
Sony a7R	36	No	14.4	$2,298
Sony SLT a99	24	Yes	28.8	$2,798
Leica M Digital	24	No	24	$6,950
Nikon D4	16	Yes	41.6	$5,997
Nikon D3x	24	Yes	43.2	$6,999
Nikon 610	24	Yes	26.8	$1,997
Nikon 800E	36	No	32	$3,299
Nikon Df	16	Yes	25	$2,747
Canon EOS-1D Mark III	21	Yes	54.4	$6,800
Canon EOS 5D Mark III	22.3	Yes	33.5	$3,399
Canon EOS 6D	20.2	Yes	26.7	$1,899

Table 1-1: Comparison of full frame sensor cameras

Which camera should you buy? That depends on your photographic skills and needs. If you are just entering the field, the 36-megapixel higher resolution has to be matched to your photographic skills. Recording the finest details of your subject requires not just the best lenses, but also meticulous technique. We frequently used a tripod to achieve the fine definition promised by the a7R's sensor. If using a tripod for your photographic session is a major obstacle, then think carefully about whether or not you would benefit from using this model. The less-expensive a7 might be a better choice for you. Also, consider how often you make big prints. Previously, we described how large a publication print could be made at 300 dpi. This serves as a good guide for the advantages to be gained by buying the a7R. The a7's sensor can be used to make a 20x13-inch print at 300 dpi, while the a7R's sensor can easily be used to make a 24x16-inch print. So the question you have to ask yourself is whether the increase in 25% in print area is worth the $600 price differential between the a7R and the a7.

It should be noted that the a7 has features that give it advantages over the more expensive a7R. First, its shutter is designed to be virtually vibration-free, which is advantageous for imaging with extreme telephotos or microscopes. Second, the a7's sensor uses a hybrid autofocusing design that provides faster focusing when shooting continuously. Third, since it uses slightly larger pixels, its noise is lower and its dynamic range is slightly greater. Fourth, the a7 fires more frames per second in continuous shooting conditions. In other words, the a7 is the camera

for those users who feel handicapped by using a tripod with the a7R. It can adapt a bit more quickly to changing situations and is still capable of making prints that would match those taken with a Nikon 610 or a Canon EOS 5D Mark III.

The main disadvantage of both cameras is the limited number of available auto-focus, full frame lenses. At the time of writing, there are only five, which rules this camera out for many professionals. However, for those who do not need immediate access to a variety of lenses, either of these two cameras can be considered an investment for the future. The two standard zoom lenses that are currently available will cover your needs for most situations. The fixed focal length prime lenses, 35mm and 50mm, are good for low-light work. The recently released 70-200mm f/4.0 telephoto zoom is a popular and useful telephoto zoom. These five lenses will cover the needs of most photographers. However, what will be missing from this lineup are some of the more specialized lenses found in the Nikon or Canon lens line. What will be lacking are extreme wide angles with a focal length shorter than 20mm, shift tilt lens for architectural photography, and long telephoto zoom lenses for nature photography.

This deficiency can be circumvented, in part, by using lenses designed for other camera bodies . Owners of Sony's Alpha SLR or SLT cameras can use these lenses on the a7 and a7R with a Sony LA-EA3 or LA-EA4 adapter. The latter makes the camera the equivalent of the a99, Sony's full frame SLT camera. The major feature you lose by doing this is Sony's sensor stabilization feature. Note that the cost of the a7R plus the LA-EA4 adapter is less than the a99, and you gain the advantage of the 36-megapixel sensor (the a99's sensor is 24 megapixels). Also, the autofocusing speed is enhanced by using the LA-EA4 adapter. Manual focus lenses from other manufacturers can be easily used on the Sony a7 and a7R; although you sacrifice automatic focusing, this is a small disadvantage for those who do macro photography or need to use perspective control or tilt lenses.

In regard to competing camera models, a couple of points should be noted. First, the cost of the Sony a7R is significantly lower than the cost of the 36-mega-pixel Nikon D800E. Even when equipped with the LA-EA4 adapter, which provides compatibility with Sony's A series lenses, the camera's cost and weight is still less than the D800E. The a7 is also less expensive than its competitors. It can also be equipped with the same adapter. These two cameras have created tremendous excitement in the photographic community because of their utility and value. This is not to say these cameras are without imperfection—there have been complaints about slowness in focusing and shutter bounce, but this book will help you use these two cameras to the best of their capabilities by circumventing their limitations.

Description of the Camera and Its Features

Unlike a DSLR, which uses a mirror to direct light to an optical viewfinder, the Sony a7/a7R is mirrorless. Light goes directly to the sensor, which drives one of two electronic displays—either the 3-inch rear LCD screen or the electronic viewfinder (EVF), both shown in figure 1-1. Having two ways to view your subject enhances the camera's versatility. You can use the electronic viewfinder for stability or use the LCD when the camera is mounted on a tripod.

Figure 1-1: Back of camera body showing the two electronic display screens

These electronic displays provide extensive data about your scene, enabling you to work more efficiently. You can view a histogram of the overall light intensity while studying the subject. Additionally, you have an accurate gauge of the appearance of the scene before it is captured by the sensor. If exposure is set lower than the camera's recommendation, the viewfinder shows a darkened image. As you increase exposure, the scene in the viewfinder becomes progressively brighter in proportion to the opening of the aperture or the slowing of the shutter speed. This is advantageous because errors in exposure or white balance can be corrected before the shot is taken, which promotes an efficient workflow since the need to review shots is reduced.

The electronic displays provide greater precision for manual focusing. You can selectively enlarge portions of the screen to ensure that the finest details are visible for focusing. This advantage is especially critical for long telephoto work where there is little depth of field. You can also apply a colorization scheme that highlights the borders of the subject when they are in focus.

Finally, both of the electronic finders can provide a real-time preview of depth of field. When the camera is set to Aperture Priority (A) mode, it displays the image at the working aperture of the lens, so you can estimate if the background or foreground surrounding the subject is rendered sharply or if it's blurred. You can do this with a digital SLR optical viewfinder, but it requires that you press a button to physically close down the lens's aperture. This is disadvantageous because as you close the aperture, the viewfinder becomes progressively dimmer, making it difficult to see fine details. This is not the case with an electronic finder in A mode. The screen maintains a constant brightness so you can see clearly how fine details are rendered at various aperture settings.

The absence of the mirror makes the a7R less prone to blurring the image during the exposure than a DSLR, whose body vibrates as a result of the upward movement of the mirror and the mechanical movement of the shutter's first curtain. In this regard, the a7 is even more advantageous than the a7R because it replaces the mechanical first curtain shutter with an electronic one, which makes it virtually vibration free when the exposure is taken.

Because the a7R does not use an electronic first curtain shutter, some owners have claimed that when it is fired, its mechanical shutter creates enough vibration to blur even pictures taken with the aid of a tripod or a long telephoto lens. This has not been our experience. These types of shots can be accomplished with good photographic technique, such as holding the camera correctly and practicing situational awareness of the shutter speed value. We use both cameras for work that involves microscopes and telescopes and have developed techniques that provide sharp images. These techniques will be described in Chapter 7.

For capturing movies, the absence of a hinged mirror in the a7 and a7R provides several advantages. Perhaps the most obvious is the ease with which movies can be taken—simply press a button to start recording. In contrast, a DSLR must have its mirror raised before you can record.

Dual Viewing System

The Sony a7/a7R has two electronic displays: an EVF with an eyepiece and an LCD screen on the back of the camera. Most digital camera users are familiar with the latter.

The LCD screen can be viewed when the camera is held at arm's length and is convenient to use when the camera is mounted on a tripod or copy stand. For

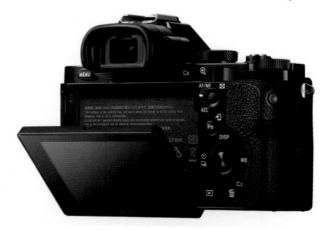

Figure 1-2: Back of Sony a7/a7R camera showing tilted LCD screen

those subjects that are difficult to access, you can take advantage of the tilting feature of Sony's rear LCD to take photographs from unusual angles (figure 1-2). For example, suppose you are in the middle of a crowd and have to photograph someone at its periphery. You can grab your shot by tilting the camera's LCD and holding the camera over your head. This way, you can look up and view the screen in order to point and aim your camera onto the subject.

The Sony a7 and a7R's electronic viewfinder is one of best of its kind—it is extremely sharp and has a good refresh rate. It uses the same screen as the Sony SLT-a99. It is invaluable when working in bright sunlight where ambient light overwhelms the view on the rear LCD. It is also convenient in a darkened auditorium when you can't disturb your surroundings with the light from the LCD screen. Also, and perhaps most importantly, having the camera pressed up against your face helps steady the camera, ensuring a sharper photograph.

The Sony a7 and a7R provide a different view of the camera settings depending on whether you use the viewfinder or the LCD screen. There are advantages and drawbacks to each of the viewing displays. For example, the view through the viewfinder appears larger, making it easier to study fine details. However, if you are using the menu to review or change settings, the advantage of using the rear LCD screen is that you can see the buttons and press them while you are reading the screen. As you use the camera and become familiar with its settings and buttons, you will develop personal choices as to which viewing system works best for you. In Chapter 3 we will cover details about the LCD screen and the viewfinder and discuss how to display information on each of them.

To conserve battery life, the EVF and the LCD screen are never on at the same time. When one is on, the other is off. The viewfinder is enabled when the camera senses that your eye is close to the eyepiece. When you move your eye away from the EVF, the LCD screen takes over and turns on when the EVF turns off.

Diopter Adjustment Dial

To effectively use the viewfinder, you need to know that it has a magnifier that must be precisely focused for your eyesight. To the right of the EVF is a small wheel called the diopter adjustment dial (figure 1-3). Rotate the dial up or down until the objects in the viewfinder appear maximally sharp. If you wear eyeglasses with either progressive or bifocal lenses, you must take care to position the corrective lenses for your eyes at the same point over this magnifier.

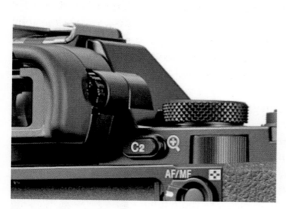

If you share your camera with others, they may need to change the viewfinder's focus to work for their eyes. If one user is nearsighted and the other user is farsighted, the diopter adjustment dial will have to be fine-tuned whenever they exchange the camera.

Figure 1-3: The diopter adjustment dial to the right of the viewfinder

Setting Up Your New Sony a7/a7R

When you take your camera out of the box, you will have the following components:

- Camera body
- E-mount 28-70mm zoom lens for the a7 kit (no lens is supplied with the a7R)
- Front and rear lens caps
- Body cap
- Accessory shoe cap
- Rechargeable InfoLithium (NP-FW50) battery
- AC adapter
- Shoulder/neck strap
- Micro USB cable

Make sure you have everything before you assemble your new camera. Attach the lens and insert the battery and a memory card on which to store your pictures and movies. We recommend attaching the shoulder/neck strap to give you added security when carrying your camera around. Before using the camera, make sure the battery is fully charged.

Battery

The supplied InfoLithium (NP-FW50) lithium ion battery should be fully charged before use. Plug the Micro USB cable into the AC charger, and then plug the charger into an outlet. Then insert the opposite side of the cable into the camera. Just above the camera's USB port is a small LED that indicates how the charging is progressing (figure 1-4):

- Steady yellow glow: the battery is charging.
- Yellow light flashing: charging is not occurring, probably because the ambient temperature is too low or too high (50°F to 86°F).
- No light: the battery is fully charged.

It is important to charge the battery completely before using it in the camera. Also note that batteries can be damaged if you allow them to drain to depletion. Rechargeable lithium batteries will last longer if you partially discharge them and then recharge them fully. This is a good reason to have more than one battery: you can replace the partially depleted battery with a fully charged battery and continue shooting without the fear of running out of power.

Figure 1-4: The charge lamp will glow yellow while the battery is charging

When you buy a spare battery, we recommend purchasing Sony batteries. Using uncertified batteries from third-party manufacturers will void your warranty if they damage your camera. For the active photographer, it's not a question of if you will need to buy a spare battery; it's a question of when. These batteries do not have an indefinite lifespan: generally, with heavy use, the battery's capacity to hold a full charge will decrease and it will have to be replaced in about three years.

Why Use a Certified Battery?

Buying third-party batteries is tempting because they are often less expensive. The risk in using them is that Sony does not guarantee their quality. If they damage your camera during its warranty period, Sony is not obligated to repair or replace your camera; so using such batteries is a gamble. Under the best conditions you may be happy with these third-party batteries, so no harm is done. But you can also end up with a battery that doesn't hold as much of a charge or drains too quickly; or, in the worse case scenario, the battery may damage your camera and the money you saved by buying the inexpensive battery will be lost because you'll have to repair or replace your camera.

Memory Card

You will need a memory card to use with this camera. Unlike some point-and-shoot consumer cameras, the a7/a7R has no internal memory for storing images. You may already have a compatible memory card from a previous camera.

The a7/a7R uses a Secure Digital (SD) memory card, which is about the size of a postage stamp. They come in many varieties with various memory capacities and data transfer speeds. They are designated as SD, SDHC, or SDXC, which refer to the card's potential maximum memory capacity (see the "Memory Cards" sidebar later in this chapter). Don't be too concerned about these designations because your camera can handle all of these memory cards. Before purchasing an SDXC type card, which has a potential capacity of 2-terabytes (TB), make sure your computer can read it. Computers using early versions of Windows will not be able to use this type of card. If in doubt, stick to the SD or SDHC category; their memory capacity is sufficient for most photographers. The class rating of the card is more important.

Memory cards are categorized into classes (2, 4, 6, 8, and 10); the higher the class, the faster the card can receive and record data. The size and class of the memory card you buy depends on how you will use the camera and how you plan to maintain the stored pictures and movies. If you plan to record a lot of movies, you will need a high-capacity memory card with a fast speed rating. Although the manual says a Class 4 rating is sufficient for recording movies, Sony's technical support recommends buying a Class 10. We advise using at least 8 gigabytes (GB) to give you plenty of storage space. If you are going to take only still photos, you can economize by using a 4 GB Class 4 card.

You can use any manufacturer's SD, SDHC, or SDXC memory card of Class 10 or faster for both still pictures and movies. Sony currently sells an SDHC Class 10 card that holds 64 GB of data for about $40. You can also opt for a 32-GB card (about $19) or a 16-GB card (about $13) instead. The SDXC cards are the most expensive and can have the highest memory rating. We do not use these because we find the 32-GB SDHC cards to be a perfect economical choice for a day of shooting or recording movies. A potential problem with high-capacity memory cards is that a failure in the card can result in a greater loss of data. For this reason, many photographers use several smaller-capacity memory cards so that if one goes bad, the loss of pictures is limited to that one card.

Instead of using an SD card, you may wish to use a Sony Memory Stick card. They are not as common, and are a bit more expensive in terms of their memory capacity. However, if you already own these cards, you may wish to use them in your new camera. Note that if you want to record both still pictures and movies on a Memory Stick PRO Duo, it must be the Mark 2 version. The Memory Stick PRO-HG Duo and the Memory Stick XC-HG Duo record both still pictures and movies.

At the end of each shooting day, get in the habit of downloading the images from your camera to your computer. After the files are downloaded, erase the images on the card by using the camera's Format command. This allows you to start fresh the next day, minimizing the risk of running out of memory.

MENU>Setup (5)>Format

Although you can connect your camera to your computer with a cable and transfer the stored files directly, we prefer to download the files with a card reader. Remove the memory card from the camera and insert it into a card reader that is connected directly to your computer with a USB cable. We recommend doing it this way because if your computer has USB 3.0 port and you have a suitable card reader your download speeds should be faster.

Memory Cards

It is difficult to predict the number of still pictures or how many minutes of movies you can store on a specific memory card. Sony provides some guidelines on the capacity of its memory cards, but these values should be taken with a grain of salt because the memory used depends on the fineness of the detail within the images and the file type.

Memory card criteria:

- SD memory card (8 MB to 2 GB)
- SDHC memory card (4 GB to 32 GB)
- SDXC memory card (32 GB to 2 TB)

Additional information:

- An SDHC memory card can be used with equipment that's compatible with the SDHC or SDXC memory cards.
- An SDXC memory card can be used only with compatible SDXC equipment.

Assembling the Camera

Make sure you have the camera turned off before you insert or remove the battery, memory card, and lens.

The battery and memory card occupy different positions in the camera. The battery chamber's door is on the bottom. When you invert the camera, you will see

the cover with a sliding switch for opening the compartment. Slide the battery in the direction of the arrow painted on its side. The battery can be fully seated only one way; a set of ridges surrounding the contacts helps you orient the battery properly. You will hear a solid click when it is properly seated. You can now close the battery cover. To remove the battery, open the compartment to expose a small blue lever that blocks the removal of the battery. Push the lever to the side, and the battery will pop up for easy removal.

The memory card compartment is on the right side of the camera and can be opened even if the camera is mounted on a tripod. You can open the hinged door with a push of your finger toward the rear of the camera to expose the slot for the memory card. Insert the memory card with the metallic reading bars going in first. It will lock into position with a click. The card can only be loaded in one direction—it should not be forced. If the memory card is defective or if its contacts are dirty, a NO CARD message will be displayed on the LCD screen when you turn on the camera. If this occurs, remove the memory card, check it, brush off dirt if there is any, and reinsert. The message should go away. If it doesn't, the card may be defective and will have to be replaced. To remove the card, gently push its top down to release the lock. The card will pop up for easy removal.

Next, attach the lens to the camera body. Remove the rear lens and camera body caps. Store

Figure 1-5a: Side of camera and lens showing white index bump on the lens

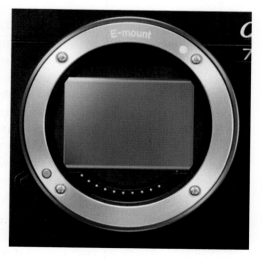

Figure 1-5b: The camera body without the lens, showing the white alignment dot

both caps in a safe place for future use. Inserting the lens is a two-step process. There is a white bump on the barrel of the lens (figure 1-5a) and a white dot on the rim of the camera body's lens mount (figure 1-5b). Align these two indicators, insert the lens, and then rotate the lens clockwise until you feel and hear a click. The lens is now locked in position and ready to use.

Last but not least, attach the camera strap. It should always be secured to the camera and placed either around your neck or over your shoulder when you're carrying or using the camera.

Protecting the Lens

There are several ways to protect your camera lens from damage. The first and most obvious is to keep the lens cap on when you are not using your camera. The second is to use a lens hood. It not only reduces glare, it recesses the lens so the front element is shielded.

The third way is to put an ultraviolet (UV) filter in front of the lens. These are threaded and can be screwed onto the lens to serve as a clear optical lens cap. Sony sells these filters, but if you know the thread diameter of your lens, you can buy the filter from Tiffen, Hoya, or B+W (Schneider). In the case of the new 28-70mm zoom lens, buy a 55 mm diameter filter. For the Carl Zeiss 24-70mm for the a7/a7R, use a 67 mm diameter filter.

Using these filters is controversial. Some claim it's a good idea, while others claim the protection is minimal and the filter degrades image quality. There is an element of truth in both viewpoints. We find inexpensive, off-brand UV filters to be problematic, and the worst examples of these cheap filters will reduce the sharpness of the image. This can be avoided by using high-quality filters made by reputable manufacturers. Filters made by Tiffen, Hoya, and B+W are of excellent quality and do not degrade lens performance. You may be surprised at their expense, but considering they are optically ground and made of polished, coated optical-grade glass, their price is reasonable. We routinely mount high-quality UV filters on our lenses. Although there is a theoretical chance of losing some image sharpness, it's so slight that we don't notice it. It is cheap insurance.

An advantage of these optical lens caps is the ease with which they can be cleaned. When working in the field, we simply wipe the dust off the filter's surface with a quick pass of a lens tissue or a microfiber cloth. Such a cavalier practice is not advisable for the front element of a lens. A piece of grit can scratch the glass or damage its coatings. If we damage the front surface of a filter, we can easily afford to replace it, which is not the case with an expensive lens.

Protecting the LCD Screen

Although the Sony a7/a7R LCD screen is made of durable material, it can still be scratched. This won't affect the camera's ability to take good pictures, but it can affect your ability to know when you need to improve focus. We recommend that you buy an LCD screen protector. Sony offers them for the a7/a7R at a nominal cost. We purchased the semi-hard plastic model. It is sticky and is applied directly to the LCD. The adhesive is not a permanent bond, so if the protector gets scratched, it can be replaced. Another nice feature of the protector is that it resists picking up smudges from fingerprints.

Turning On the Camera

After you have assembled your camera, you are ready to turn it on. The ON/OFF power switch is on the top-right side of the camera, beneath the shutter button (figure 1-6). Move the lever so the indicator matches up with the ON option.

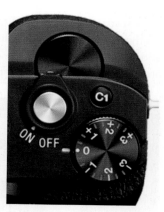

Setting the Camera Date, Time, and Area

The first time you turn on the camera, you will be asked if you want to set its internal clock. The information from the clock is recorded with each picture and movie—a valuable detail if you wish to organize your recordings later by date and time. Entering the date and time for your camera is a great way to learn about maneuvering through the menu options and using the controls. It also

Figure 1-6: ON/OFF power switch set to ON

illustrates how Sony provides plenty of prompts to help you execute a command.

The screen you will see when you first turn on the camera will be Set Area/Date/Time (figure 1-7a). Notice the prompts directing you how to maneuver through the screen. At the bottom of the screen is the Select prompt with two arrows, one up and one down, representing the control wheel's up and down buttons. The second prompt, a circle, represents the center button as the method to enter your selected value. Your cursor

Figure 1-7a: First menu screen for setting area, date, and time

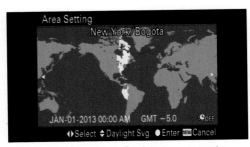

Figure 1-7b: Menu screen for showing area setting (Eastern Standard Time selected)

is a red rectangle that highlights the choice to be executed. In this case, the cursor is on Enter. Press the center button and the Area Setting screen is displayed for you to select your current time zone (figure 1-7b).

Looking at the world map screen, you will see plenty of prompts. The current time zone is highlighted in white. The horizontal arrowheads at the bottom of the screen are reminders that pressing the left and right buttons on the control wheel will move the highlighted area east or west so you can navigate it to correspond with your current location. You can set the Daylight Savings (Daylight Svg) indicator from this screen by using the up and down buttons. Once the current time zone and Daylight Savings indicator are selected, press the center button to accept your settings.

Figure 1-8a: Menu screen with the Daylight Savings option highlighted

After you select your time zone, the Date/Time Setup menu screen is displayed with the Daylight Savings option highlighted (figure 1-8a), giving you a second chance to change this value. Press the down button once to highlight the Date/Time option (figure 1-8b). Press the center button to select the Date/Time option, and you'll see a new screen where you can actually set the time (figure 1-9). Use the right and left buttons to navigate through the fields. As the prompts suggest, use the up and down buttons to change the fields' values. When you finish entering the information, press

Figure 1-8b: Menu screen with the Date/Time option selected

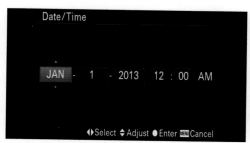

the center button to save it, thus completing the process. A half press of the shutter button returns you to Live View and you can start taking photographs.

You can use this same process if you reinitialize your camera with the Setting Reset command.

Figure 1-9: Menu screen to enter date and time information

Daylight Savings Time

Most areas in the United States observe daylight savings time in the summer months. In the spring, the time is set forward by one hour, and in the fall, the time is set backward by one hour. The Date/Time Setup command's Daylight Savings option allows you to specify if your current location is in daylight savings time. Unfortunately, as you travel in and out of daylight savings time zones or switch from daylight savings to regular time, you need to reset the Daylight Savings indicator to reflect the current situation and location.

Introducing Menu Navigation

Although most of the important camera operations can be quickly changed using the buttons and dials, you should become familiar with using the menu system because there are commands that can only be accessed by navigating through the menu.

To enter the menu, press the MENU button on the left side of the camera's back (figure 1-10). You will see a screen with six icons along the top. From left to right, they are Camera Settings (camera symbol), Custom Settings (gear symbol), Wireless (radiating radio waves), Application (matrix symbol), Playback (video play symbol), and Setup (tool box symbol). Use the left or right buttons to position the cursor over the Setup icon (figure 1-11). Note the row of numbers just below the menu icons. They indicate the screen pages within the selected

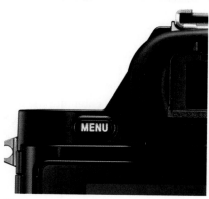

Figure 1-10: MENU button

Figure 1-11: Selecting the Setup icon

Figure 1-12: Setup menu with page numbers enabled

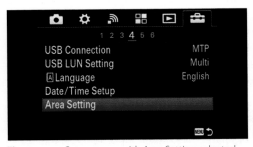

Figure 1-13: Setup menu with Area Setting selected

menu, and will be different for each icon. If the numbers are grayed out, press the down button to make them active (figure 1-12). Once the numbers are enabled, the commands on the screen become enabled too, and your cursor will be positioned on the first command. Use the right and left buttons to scroll through the screen pages. As you navigate, each page's commands will be displayed with the top option highlighted. Use the up and down buttons to navigate through the screen's commands. You may notice that some of the commands are grayed out. Those commands are not available with the camera's current settings.

Press the center button to enter a command. You will be presented with either a list of available command options or another screen to navigate through. Use the up/down buttons to navigate through the list of options. You may see horizontal arrows indicating that you should use the right and left buttons to see and set values.

Let's return to the task of changing the camera's date and time information. Press the MENU button. Use the left or right buttons to position the cursor over the Setup icon. In the case of the Setup menu, there are six screen pages. Press the down button to enter into the page bar. Note that the page number you are

on turns white and the remaining page numbers are a deep gray. In this case you are on page 1. Press the right button to navigate to page 4. At this point you will see a screen that shows the Date/Time Setup and Area Setting commands (figure 1-13). If you highlight either of these commands and push the center button, you will access their respective set-up screens.

Menu Navigation Commands

Throughout the book we reference commands and explain how to locate them within the menu. To do this, we use a shorthand command path that reflects the menu's structural flow. Using the same example of setting the camera's date and time, you will want to find and use the following command path:

MENU>Setup (4)>Date/Time Setup>Date/Time>[Month], [Day], [Year], [Hour], [Minute]

This is our shorthand for specifying the series of commands and options you would choose to find and set a command through the camera's menu. Sony engineers have provided page numbers to help you locate a pertinent command (we list those page numbers next to the main menu in parentheses). We use the ">" to indicate the level within the command structure. In the case of "Date/Time Setup>Date/Time," the ">" indicates you will need to move into the submenu "Date/Time" from "Date/Time Setup". We use square brackets to encase values you can select. In the case of Date/Time command path, all of the listed values in brackets at the end of the path are available for you to set. For most commands, the end options are [On] and [Off], which means only one can be chosen at a time.

Maintaining the Camera's Date and Time Information

In addition to the replaceable battery pack for powering the camera, there is a small internal battery for maintaining the date and time settings, registration of faces, customized buttons, stored Memory Recall information, and downloaded apps. This battery ensures that the camera will retain this information when you remove your depleted battery and replace it with a fully charged battery. Even if the main battery is depleted, the internal battery has sufficient power to maintain these personalized settings for three months as long as the camera is not turned on. If this internal battery becomes depleted, its power will be restored when a charged battery pack is inserted in the camera. However, its depletion will result in a loss of the date and time settings, and other stored data.

Error Messages

The Sony a7/a7R has a number of self-explanatory information and error messages to help guide you through setting up and using the camera.

As mentioned earlier, some of the menu commands are grayed out because they are not available with the camera's current settings. If you press the center button while one of these options is highlighted, you will receive a command-specific error message indicating that the command is unavailable. The error message will also include the menu command that is preventing the entered command from being enabled.

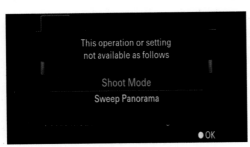

Figure 1-14: Error message screen when accessing a disabled command

For example, you cannot choose Drive Mode when the mode dial is set to Sweep Panorama. If you try, you will receive the error message screen in figure 1-14.

There are also many non-command-specific error and warning messages that are covered in Appendix B.

Getting out of Trouble by Reinitializing Commands to Their Default Values

You will set and change command values frequently as you use the camera. At times, the camera may get confused. In computer jargon, it will "hang" and not respond to commands, you may find that familiar commands do not work as you expect. If this occurs, take the following steps to get the camera operating again.

The first and easiest step is to simply turn the camera off and then back on to see if the problem disappears. If this does not work, turn off the camera and remove the battery for about 10 seconds, then reinsert the battery and check again to see if the problem is resolved. If the camera is still not responding, you can start over with the camera's default values by executing the following command:

MENU>Setup (6)>Setting Reset>[Camera Settings Reset], [Initialize]

Execute the [Camera Settings Reset] option first. This option resets all the menu items listed under the Camera icon (Camera Settings) to their default values. This includes commands such as ISO, Quality, Image Size, and DRO. None of the command settings in the other menus are affected. Check to see if the camera starts operating as expected.

The last possible way to solve the problem on your own consists of executing the Setting Reset command's [Initialize] option. The [Initialize] option is much more aggressive—it not only resets the camera to all of its default values, but also deletes stored information in the camera's internal memory. Face registration, Date/Time settings, Area location and downloaded apps are erased and have to be restored manually. Obviously, the [Initialize] option should be used only as a last resort. If losing internal memory data is unacceptable, contact Sony technical support for advice prior to executing the Initialize function. If you choose to execute the Setting Reset command's [Initialize]option, check again to see if the camera's problem has been rectified. If not, you will have to contact Sony technical support for advice.

Introduction to Buttons, Dials, and Controls

Using the a7/a7R's menu commands provides access to all the operational controls and features of the camera. However, the sheer number of options prevents the active shooter from changing settings rapidly. Fortunately, there are 16 buttons, one control wheel, and three dials for quickly selecting, initiating, and choosing menu command options. For the active photographer who needs a fast change in the camera settings, these controls are invaluable. See table 1-2 for a list of these controls and their functions. Note that this table lists the default camera settings, most of which can be customized to execute different commands.

Control	Control Label	Description
Control wheel	ISO	Adjusts the gain of the sensor
AF/MF button	AF/MF (Selected by lever)	Default: Switches from automatic focus to manual focus while holding down the button
AEL button	AEL (Selected by lever)	Default: Locks exposure while holding down the button
Custom 1 button	C1	Default: Focus Setting—Varies the overall type of focus area: whole screen, spot, etc.
Custom 2 button	C2	Default: Focus Mode—Varies overall nature of focus: single locked, continuous, and manual focus
Custom 3 button	C3	To be defined by user
Center button	None	Default: Eye AF—With facial identification, it sets focus to the subject's eye

Control	Control Label	Description
Up button	DISP	Default: DISP Button—Varies the type of display in the electronic viewfinder and rear LCD
Left button	Drive Mode icon	Default: Drive Mode—Controls how the camera fires: single shot, continuous,or bracketing
Right button	WB	Default: Adjusts the sensor output so that a gray card is rendered without a color cast under various lighting conditions
Down button	None	To be defined by user
Menu button	MENU	Entry command to access menu
Exposure compensation dial	Top of dial marked with 0 and numbers, 1, 2, and 3	Overrides the camera's recommended exposure
Front dial	None	Default: In M mode, it controls aperture
Rear dial	None	Default: In M mode, it controls shutter speed
Mode dial	None. Top of dial inscribed with the letters P, A, S, M, etc.	Determines the overall shooting characteristic of the camera: fully automatic to manual settings
Control wheel	ISO	Adjusts the gain of the sensor

Table 1-2: Default camera settings for the camera's buttons, dials, and control wheel

Spending time to learn the standard camera settings is important because of the complexity of the default button assignments. Depending on your camera settings, many of the buttons and dials perform two functions. For example, when you are taking a picture, the left button serves as a way of changing the Drive Mode. However, when you are in a menu, it serves as a navigation control to move through menu selections. This maximizes the number of commands that can be accessed by pressing the buttons without having to increase the physical number of mechanical switches. This puts you in greater control of your camera; however, before customizing the controls, we recommend you first become comfortable with the command assignments. You do not have to customize every control from the beginning. Our experience was that the customization process occurred in

stages. First, we took our time to figure out which commands we used the most and which we used the least. If we thought we would need a command not currently assigned to a button, we assigned it first to one of the two buttons without a defined value: the down button and C3 button. This was a temporary assignment. If we found this assignment helpful to our workflow we would assign the function to a permanent location. We would select a button whose commands we did not use and replace it with the more useful command. We would then restore the down and C3 button to their unassigned status. By doing this, we could assign the buttons with our most-used commands while gradually eliminating those assignments that we hardly used. Once you have developed your own shooting style, you will know which commands you need to access quickly.

This is why we recommend that you assign commands to the down button and C3 button for a "trial period" until you can decide if you want to assign the command to a customized key. If you customize more than two buttons, you will displace some of the assignments that Sony had made with their buttons. Just make sure you keep a written record of your customizations in case you need to reset some temporarily or have to execute a Setting Reset's [Initialize] option. You always have the option of reassigning customizations if you later find you need a different function more frequently. We will cover customization of these entry points in Chapter 7.

Fn Button

The Fn button is on the right side of the back of the camera. This is the button that can initiate the most commands. Pressing it accesses up to 12 commands, displayed in two rows of six commands each on the bottom of the screen. In its default mode, the first row consists of: Drive Mode, Flash Mode, Flash Comp., Focus Mode, Focus Area, and Exposure Compensation. The second row consists of ISO, Metering Mode, White Balance, DRO/Auto HDR, Creative Style, and Shoot Mode. This command menu is superimposed over the

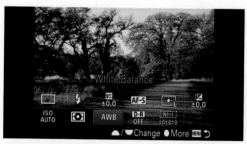

Figure 1-15: The screen after pressing the Fn button: 12 functions are available at the bottom of the screen

preview image (figure 1-15). Use the up, down, right, and left buttons to navigate though the command icons.

When a command is selected for modification, it is highlighted in orange and a description of the command appears on the screen above the top row. Different commands are selected by using the right, left, up, and down buttons. You can change the values within the highlighted commands by turning the front control dial or the control wheel. If you select a complex command that adjusts several parameters, such as WB (white balance), pressing the center button takes you into the list of the command's options. From here, press the right button to enter into the submenu to adjust the white balance's selected tint.

Not every command on the Fn screen will be enabled all the time. There are times when some of the Fn button's 12 commands are grayed out—disabled commands are unavailable in the camera's current shooting mode and settings.

Again, we recommend you use the camera for a while to see which commands you most frequently access. If you want to play with different settings, many of the commands are represented on the buttons on the back of the camera. For example, Drive Mode, ISO, and WB already have dedicated keys, so you may want to eliminate these and customize the Fn button to display other commands. Chapter 7 will describe how to customize the Fn button.

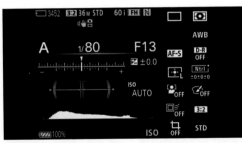

Figure 1-16a: [For viewfinder] display screen

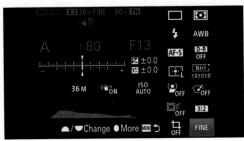

Figure 1-16b: Quick Navi screen with the Quality's [Fine] option highlighted

DISP and Quick Navi Screen

When in Live View, press the DISP button (up button) to cycle through the various data display formats for the LCD monitor and the viewfinder. Although we will describe the different display formats in more detail in Chapter 3, we need to mention one display, [For viewfinder], for entering commands. The [For viewfinder] format, which works with the Fn button, is readily recognizable because it is the only screen that does not display what your camera sensor sees (figure 1-16a). Instead, is has numbers, letters, and a graph providing an immediate readout of all your camera settings. When you see this screen,

press the Fn button and the
screen becomes the interactive
Quick Navi screen (figure 1-16b),
which provides a convenient and
fast way to select commands and
alter their settings. Press the up,
down, right, and left buttons to
navigate through the screen.
Your position is highlighted in
orange. To change a highlighted
value, turn the control wheel or

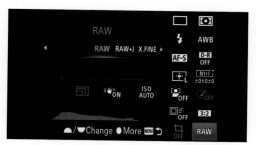

Figure 1-16c: Quick Navi screen with the Quality's [RAW] option selected

the front dial to select different options (figure 1-16c). Or, press the center button
and you will see a screen with available options for the selected command. Select
a value and press the center button to return to the [For viewfinder] display with
the accepted value.

Control Wheel (ISO)

When you're framing and composing an image, rotating the control wheel provides
ISO options for adjusting the sensor's sensitivity. A high ISO number makes the
sensor more sensitive to light, allowing you to take pictures in low-light situations.
Conversely, a low ISO number means the sensor is less sensitive, which enables
you to take detailed pictures in bright daylight. We will discuss ISO functionality
in greater detail in Chapter 2.

Left Button (Drive Mode)

Press the control wheel's left rim (left button), and the Drive Mode command's
options will appear along the left side of the screen. Rotate the control wheel to
navigate through the command options. Press the center button to select the
highlighted value. These options enable you to determine how the camera will
fire when the shutter button is depressed. We will discuss Drive Mode in greater
depth in Chapter 2. Just know that you can access the Drive Mode command by
pressing the left button in Live View.

Right Button (WB)

When the right button is pressed while in Live View, it displays the White Balance
(WB) command. The default setting is [AWB], or Auto White Balance. With this op-
tion, the camera tries to adjust its sensor output so that the colors appear natural.
Navigate through the WB options and press the center button to accept a value.

The Dials (Front, Rear, and Exposure Compensation)

You will use these three dials most frequently when you set the camera's mode dial to P, A, S, or M and take an active part in adjusting the exposure. The front and rear dials adjust either the lens opening or the shutter speed. When you wish to depart from the camera's recommended exposure, use the exposure compensation dial. When you are navigating through the menus, the front dial will move the cursor up and down the screen, and the rear dial will move the selection to the left and right. This is particularly convenient if you are using the viewfinder to change menu settings—for example, when you are shooting in sunny daylight conditions and the rear LCD screen is difficult to read.

Cleaning the Sensor

When you change the lens, dust particles can enter the camera body and land on the sensor. On the recorded image, they can be seen as blurred shadows. You can limit this problem by removing and replacing the lens quickly and in environments with no wind. You should also try to make the switch while holding the camera body with the lens opening facing downward. This will help to prevent dust from falling into the body cavity.

However, the entry of dust is inevitable. The Sony a7/a7R dislodges dirt from the sensor by shaking it off at high speed. Each time you turn the camera off, it automatically cleans the sensor with ultrasonic vibrations. There may be times when you think an extra cleaning is needed, and you can accomplish this using the following command:

MENU>Setup (3)>Cleaning Mode>[Enter]

Note that this command for cleaning the sensor will not work if the battery level is low. You will need three or more bars on the battery icon to perform this operation; Sony recommends connecting the camera to its transformer.

If foreign particles still remain, you can do a manual cleaning. First, take off the camera lens. Use a manual bulb blower to clean the sensor's surface. It is best to hold the camera with the lens opening facing down so the dust particles can fall out of the camera. Do not touch the image sensor with your fingers or the blower. Sony does not recommend "wet" cleaning, which entails using solution to wipe the surface of the sensor clean. If the dirt persists, Sony recommends using their service facility.

We do not recommend using a can of pressurized gas to blow out the camera's interior because any dirt in the nozzle can be blown into the camera body with enough force to damage the sensor. Also, if propellant is expelled, it will be difficult to remove from the sensor's surface. If you have any problems or concerns, take your camera to a professional service center.

Recommendations

It turns out that charging the camera battery by plugging your camera into your computer via the USB cable is possible, but we do not recommend it because some computer USB ports do not deliver enough power to accomplish this task. Also, the camera may not recharge if it is turned on, so make sure it is off. If you are a photographer who takes hundreds of pictures a day, we recommend that you always have at least one fully charged spare battery and an additional memory card. Use only Sony-certified batteries in order to maintain your camera's warranty. If you get a spare battery and you use it frequently, you should also buy the AC charger (BC-VW1). This allows you to use your camera while you charge your spare battery outside your camera body.

If you want to take pictures immediately, set the mode dial to Auto and select either Intelligent or Superior Auto. As you use the camera and move into other shooting modes, you will need to become familiar with additional control tools. This chapter provided some instruction on changing the camera's options to get you started. We will build on these instructions in the later chapters.

In Auto mode, the camera determines the settings and options it uses based on the situation. It is a learning experience for you to review the images you took in Auto mode and judge whether you could have done better by using different options. As you begin to choose your own settings and options rather than rely on the camera, you will find that you access some menu commands frequently. You can assign these commands to certain buttons in order to access them more easily. If you decide to customize the control tools, as described in Chapter 7, you will find that you'll hardly ever need to dive into the camera's menu. Instead, you'll be able to access the functions that are most important to you by using the external dials and buttons.

Chapter 2 : Basics of Digital Photography

Introduction

The Sony a7/a7R has scores of menu commands and options, which can discourage even the most experienced user, let alone someone attempting to move beyond a simple point-and-shoot camera. This should not prevent you from immediately taking pictures. You can start by treating the camera as a point-and-shoot. By using the Auto modes, you don't need to worry about things like aperture, shutter speed, or ISO. Even expert photographers may still find these automatic settings useful.

The best way to learn about photography is to take pictures, study your efforts, and then figure out how you can improve your images. You can experiment with the options on the camera, and then analyze your results to learn photographic tools that will allow you to override automatic settings and impart your artistic interpretation of a scene. On the other hand, if you are an expert photographer, you may enjoy delving into the automatic settings. You may find that there are automatic settings and options that can be incorporated into your photographic arsenal.

This chapter describes how the camera settings affect exposure, depth of field, shutter speed, and sensor sensitivity. Our goal is to provide an intuitive, rather than scientific, explanation of how the camera renders a sharp and detailed image so you can more thoroughly understand what the automatic settings are doing. You will learn what a technically good picture is and how you can modify the camera settings to create an artistic image that is imbued with your vision of the scene. The most important thing to realize is that there are several ways to get a sharp picture, and the options you choose will depend on your subject. The best settings for portraits are not the same as for scenic or action shots.

In both the Intelligent Auto and Superior Auto modes, the camera decides all of the settings. Your camera identifies the scene you are shooting, and then applies the appropriate settings for that subject. For example, if the camera focuses on the horizon hundreds of feet away, it assumes you are photographing a distant scene and taking a scenic shot, and will employ the best settings for that type of image.

Unfortunately, the camera's scene identification is not foolproof, and it can choose a less-than-optimal combination of settings for your subject. The resulting picture might be adequate, but it could have been improved by using more appropriate settings to bring out the subject's best features. To gain more control and improved accuracy, use the SCN mode to match your subject to a predefined scene category, such as sports activities, portraiture, or low-light conditions. Switching from the Auto modes to the SCN mode will increase your percentage of good photographs. Eventually, you may want to take over the process entirely by looking at the scene, pre-visualizing the picture, and setting the camera controls to record your subject.

Many of the topics we will cover in this chapter are handled in depth in later chapters. This chapter will cover the locations and high-level descriptions of the camera's operations.

Basic Photography Concepts

A photograph is a two-dimensional rendering of a three-dimensional object. The camera's light detector, called a sensor, is flat. A lens projects light from the subject onto the sensor. If the distance between the lens and the sensor is not adjusted precisely, the image will be blurred. Only one plane that is parallel to the sensor is rendered at maximum sharpness—in other words, the subject will be in focus only if it occupies this plane. Objects in front of or behind this plane become progressively blurred as their distance from the in-focus subject increases. When the distance is great enough, the out-of-focus portions of the image appear as a complete blur.

The diameter of the lens aperture will extend or limit the range of sharpness. By reducing the aperture's opening, you create an image in which both nearby and distant objects appear sharp (large depth of field). By opening the aperture wider, you create a shallow depth of field in which you pick the plane that will be sharp, and the objects outside that plane are blurred. This concept is illustrated in figure 2-1. The image on the left was photographed with the aperture set to f/2.8, leaving only the balcony in sharp focus. By closing the aperture to f/16, we increased the depth of field to sharply record a larger area in front of and behind the balcony, as shown in the image on the right. Not only is the intended object sharp, but the background and foreground areas are sharp, as well.

Figure 2-1: Shallow versus large depth of field

What Are Sensors and Images?

A digital camera uses a solid-state device with millions of individual photosites for converting light into an electrical signal. An individual photosite is the physical basis of a pixel, the smallest unit for sensing light. In the Sony a7R, there are more than 36 million pixels in a 7360x3264 rectangular array. For the Sony a7 there are 24 million pixels in a 6000x4000 rectangular array. Signals from these sensors are transmitted to the camera's display screen. Together they make up the mosaic of intensities and colors that become an image. The viewed image is a numerical expression that can be manipulated mathematically. This enables the camera to alter the image's appearance. Then it can be stored on a memory card.

The sensor can record only a limited intensity of light. If there is too little light, you will record a black photograph; if there is too much light, your image will be a brilliant white. In either case, little to no detail will be recorded, and you will not be able to resurrect your picture with image processing. This differs from our visual perception of the world, in which we can view a much broader range of light intensities. To record these intensities in a picture, you have to adjust the amount of light that reaches the sensor to ensure proper exposure. If you provide the correct amount of light, the camera's sensor will record a picture that is rich in detail in both the brightest and darkest regions.

Three factors control exposure. The first is lens aperture, which regulates how much light enters the camera body. The second is shutter speed, which regulates how long the sensor is receptive to light. A short shutter speed of 1/1000 second provides less light to the sensor than a long shutter speed of one second. The final control is ISO, which is essentially an electronic gain that increases or decreases the signal from the sensor. Think of it as a sensitivity control—the higher the ISO, the more sensitive the sensor is to light.

In summary, to record a technically sharp picture, you must properly focus the subject onto the sensor and ensure that the intensity of collected light lies within a prescribed range. The camera does this on its own when you set it to an automatic shooting mode, and the process is refined enough that most people are satisfied with the results. However, photography is an artistic endeavor, and there is no universal setting that always renders an image with emotional impact. To create an artistically satisfying image, you may have to set the controls differently than the optimum settings for sharpness or exposure. For example, a running athlete can be photographed with a relatively long shutter speed to blur the arms and legs, creating the impression of movement, or he can be photographed with a short shutter speed to freeze all motion. In the former, the picture you create has an impression of speed; in the latter, you sacrifice this component to record fine details.

2

Basic Photographic Terms

To capture an image that records the entirety of the subject's detail, the sensor must register all of the light levels within the scene. This requires adjusting the amount of light that falls on the sensor by regulating the shutter speed and aperture opening. If these adjustments fail to provide enough light, the signal from the sensor will be insufficient and the recorded image will be overly dark. To ameliorate this situation, raise the camera's ISO setting. Basically, this amplifies the sensor's output signal to brighten the recorded image.

The aperture controls the quantity of light passing through the lens. The degree of transmission is defined as the f-stop—the ratio between the diameter of the lens and its focal length. The important thing to realize is that a lens set at f/5.6 transmits the same intensity of light whether it is a telephoto or a wide-angle lens.

> ### What Are F-Stop Numbers?
>
> F-stop numbers represent the ratio of the lens opening to its focal length. They provide a measure of consistency for using lenses of different focal lengths or magnifications. A telephoto lens with a focal length of 400mm and a wide-angle lens with a focal length of 14mm both pass the same intensity of light when they are set to the same aperture.

One thing to be aware of is that f-stops on many zoom lenses vary depending on where you set the zoom ring. Usually the lens is more open when it is used at wide-angle settings, and less open when you use a telephoto setting. Fortunately, because your Sony a7/a7R measures light at the sensor, the camera compensates for these variations in the amount of light. Those zoom lenses, which maintain a constant aperture as you change their focal length, are premium designs and can be very expensive ($1000). Such lenses are usually heavier for a given zoom range and have better optical quality than the variable aperture lenses.

Another way to regulate the amount of light falling on the sensor is by controlling the duration of the exposure. This is the role of the shutter. The shutter speed reflects the time the sensor is exposed to light. An exposure of 1/30 second allows the sensor to receive twice as much light as a shutter speed of 1/60 second.

There are technical and artistic advantages to be gained by varying the aperture and shutter speed to control aspects of the exposure. First of all, you have control over a much broader range of light intensities. Closing the aperture and shortening the shutter speed are additive; doing both reduces the effect of the light more than doing just one or the other. The intensities you can work with range from using the longest shutter speed with the widest aperture opening to the shortest shutter speed with the narrowest aperture opening. Aperture openings are expressed in

numbers, with the smaller numerical values indicating that the lens transmits more light. Shutter speeds are typically expressed as a fraction of a second.

Several combinations of aperture and shutter speed settings can produce an equivalent exposure. Setting the aperture to f/2 and the shutter speed to 1/60 second provides the same exposure as setting the aperture to f/16 and the shutter speed to 1 second. With a shutter speed of short duration, a flying bird can be rendered tack-sharp while suspended in space. With a shutter speed of a longer duration, the same bird's flapping wings will appear blurred, giving the impression of rapid movement. To obtain an equivalent exposure with these two shutter speeds, you'll need to the use appropriate lens aperture setting for each. The faster shutter speed requires the lens aperture to be opened up to admit more light, and the slower shutter speed requires the aperture to be closed down to admit less light.

Another artistic advantage of varying the aperture is the ability to control the depth of field. Depth of field can be increased by closing down the aperture and decreased by opening it. In regards to maintaining exposure, using a small aperture requires using a slower shutter speed so enough light still reaches the sensor.

You can use depth of field to direct the viewer's attention to the subject. In the case of a portrait, you can focus on the subject's face and blur the background by opening the aperture to provide a shallow depth of field. To offset the increase in aperture, use a shorter shutter speed to reduce the amount of light falling on the sensor. Again, the dual control of shutter speed and aperture is an important concept to master so you have the most influence over the design of your image.

There are times when you may need to raise the shutter speed or narrow the aperture to reduce the intensity of the light that reaches the sensor. You can offset this by increasing the ISO. However, increasing the ISO reduces the range of light (the dynamic range) that the sensor can record, which sacrifices some image quality. The image becomes granular—that is, areas that should be rendered as smooth tones become speckled with blotches of color, and the overall definition is reduced. This is referred to as image noise, and is most easily seen in the shadowed regions of the image. Many expert photographers prefer to set the ISO manually to ensure that they use a value that best balances between high image quality and proper light sensitivity.

2

What is ISO?

ISO stands for International Organization for Standardization. Historically, this term referred to the light sensitivity of film. Today, it is associated with digital cameras and refers to the gain that can be employed to generate a brighter image. Technically, a sensor's sensitivity to light does not vary—it generates a signal that is proportional to the amount of light falling on it. However, the sensor has an amplifier that increases the strength of a weak signal when the ISO number is increased. By raising the ISO, you can capture images in dim light. To obtain the highest image quality with the Sony a7/a7R, we recommend using ISO 100. We do not hesitate to raise the ISO when working in dim light; however, we prefer not to use an ISO greater than 1600. For us, the compromise in image quality at that high of an ISO is too great.

In conclusion, you have three variables for controlling exposure: aperture, shutter speed, and ISO. These three variables allow you to impart an ambience to your pictures. Intelligent Auto and Superior Auto modes try to identify the subject, and they will set the three variables to produce a final image based on that identification. However, compared to the photographer, the Auto modes have a limited capacity to identify the scene, so the ability to manually control exposure is important.

To improve the quality of your pictures, you can take advantage of the SCN mode and select a predefined scene mode that matches your subject. In these modes, there is a bias for certain settings. For example, when you select Sports Action mode, the camera increases its ISO and uses a fast shutter speed. In contrast, if you select Landscape mode, the camera uses a lower ISO for improved image quality and a slower shutter speed to compensate for the reduced light intensity. The Intelligent Auto, Superior Auto, and SCN modes try to find the best combination of these three controls. However, as you gain experience, you will discover that you can improve on their recommended settings. This is the main reason to go beyond the automatic modes and start experimenting with the P, A, S, and M modes.

White Balance and the Appearance of Colors

We live in a world of color, in which our eyes and brain work together to ensure that we identify hues correctly in all lighting conditions, whether it be direct sunlight, indirect sunlight, shade, or artificial light. Our vision works so well that we don't expect an object's appearance to vary based on light—the human eye is able to identify color in all of these conditions.

However, when you're using a digital camera, the recorded image reflects the object's appearance based on variant lighting scenarios. If nothing is adjusted within

the camera, an object will look different when shot in different lighting conditions. For example, indoor light makes objects appear ruddy; sunny outdoor light makes them look white; and indirect sunlight from the sky makes them look blue. To match our visual impression of what the object should look like, digital cameras use automatic white balance (AWB), which adjusts the balance of colors so that when an image is saved, the object's hues look consistent with our expectations, regardless of the lighting condition (figure 2-2).

Figure 2-2: Automatic white balance setting

However, AWB is imperfect, and the photographer must know when and why to override it. There are several ways to do this and we will discuss the various techniques later in the book. The methods range from selecting a WB icon whose name indicates the type of ambient lighting (Chapter 5), to a quantitative technique where numerical values describing the color are used to calibrate the camera (Chapter 6).

ISO

You can select the camera's ISO by rotating the control wheel or selecting ISO through the Fn button, Quick Navi screen, or the menu. In the default configuration of your camera, you will see ISO AUTO in white letters at the bottom of the Live View screen (figure 2-3a). In the automatic modes and SCN modes, the camera only uses ISO AUTO. You can only change the value of the ISO in P, A, S, and M modes, which are covered in Chapters 5 and 6. In these modes, when you rotate the control wheel, the ISO setting at the bottom of the screen

Figure 2-3a: When in Live View, the ISO values are in white letters (ISO AUTO)

Figure 2-3b: Rotating the control wheel allows you to select the ISO value, in this case 1000

will turn orange and you will scroll through a series of numbers. In figure 2-3b, the number is set to 1000. After a few seconds, the orange coloring will disappear and the numbers will turn white. This color change is a visual prompt to aid you when you're altering your camera settings.

ISO AUTO sets the ISO value in a default range from 100 to 6400, with the low values providing the least sensitivity and the high values providing the greatest. ISO AUTO sets the sensitivity automatically and you will not know what value is set until you press the shutter button halfway. The highest-quality images are obtained with ISO 100. This setting provides the least amount of image noise and the greatest dynamic range. However, ISO 100 may be unsuitable for handheld photography under dim lights because the shutter speed may be so long that either camera movement or the movement of the subject blurs the photograph.

How far ISO can be increased is dependent on the photographer's acceptance for the appearance of noise. This in turn depends on the subject and how the recorded image will be displayed. If the intent is to provide images for viewing on a computer screen via email attachments or web page pictures, you can raise this value aggressively. The smaller the final picture size, the less obvious the noise, so the increased ISO value can be tolerated. We found that an ISO of 8000 will provide acceptable results if the subject occupies most of the sensor. When the photo was displayed on our computer as a full-screen image, we did not feel that the image's appearance was detracted by noise. However, when the image is destined to be printed as artwork at 24x36 inches or larger, we will invariably set the ISO to 100. Being able to set your own ISO is important so you can control your image quality. This is one of the major reasons to forego the automatic or the SCN modes. We will discuss adjusting ISO in Chapters 5 and 6.

Drive Mode Button

The Drive Mode command allows you to specify how the camera will act when you fully depress the shutter button. You will have a varying degree of control over this command depending on whether you are in the Auto or the SCN modes. You can use most of the Drive Mode settings in Intelligent and Superior Auto, but in the SCN modes, some of them

Figure 2-4: The preview screen after pressing the left button

will be inaccessible for change. When in Live View, press the left button (note the associated Drive Mode icon) and the Drive Mode command's options will appear along the left side of the screen (figure 2-4). Rotate the control wheel to navigate through the command options. Press the center button to select the highlighted value. Table 2-1 contains a summary of the commands.

Icon	Name	Description
▭	Single Shooting	One shot fires per shutter press
⊟	Cont. Shooting	Fires 1 (a7R) or 1.5 (a7) pictures per second while the shutter button is held down
ⓈⒹ	Spd Priority Cont.	Fires 4 (a7R) or 5 (a7) pictures per second while the shutter button is held down
⟳	Self-timer	Shoots an image after a 2- or 10-second delay
⟳C	Self-timer (Cont.)	Shoots either three or five pictures after a 10-second delay
BRK C	Cont. Bracket	Fires multiple shots to bracket the determined exposure
BRK S	Single Bracket	Fires multiple shots to bracket the determined exposure, but requires pressing the shutter button to capture each of the bracketed shots
BRK WB	WB bracket	Fires one shot and creates three images that bracket the determined WB
BRK DRO	DRO Bracket	Fires one shot and creates three images that bracket the determined contrast of the scene

Table 2-1: Drive Mode options

 The Drive Mode options can be broken into three types: immediate non-processed (single/continuous) shooting, delayed shooting, and image-processed (bracket) shooting. A more detailed discussion of each of the Drive Mode options will occur later in the book when we cover automatic, semi-automatic, and manual shooting modes.

Single and Continuous Shooting

The Single Shooting setting instructs the camera to fire one shot for each press of the shutter button. The Continuous Shooting setting (Cont. Shooting) instructs the camera to fire continuously when the shutter is held down. Continuous Shooting can fire at a rate of about two frames per second for the a7, or 1.5 frames per second for the a7R. The Speed Priority Continuous (Spd Priority Cont.) setting will increase the continuous shooting rate to five frames per second for the a7 and four frames per second for the a7R. In a perfect world, using a continuous shooting mode would mean the camera would keep taking pictures until it filled the memory card. Unfortunately, this is not always the case. The memory card is limited and does not have the speed to accept new pictures as fast as the Sony a7/a7R can generate them.

To alleviate this deficiency, Sony has engineered a fast memory buffer that rapidly accepts and stores pictures generated from the sensor. When this buffer is filled during a rapid-fire sequence of shots, the buffer cannot accept new pictures, and it slows the firing rate of the camera. The buffer must be cleared to maintain a fast continuous firing rate. When using Spd Priority Cont. mode, we can usually obtain 13-19 pictures before the buffer is filled. The variation in the number of pictures is due to file size. Because of their smaller size, more JPEG pictures can be stored in the fast memory buffer than the larger RAW files.

Delayed Firing of the Camera

To include yourself in a picture, you can use either of the following two Drive Mode commands. One is Self-timer and the other is Self-Timer (Cont.). There are two options under Self-timer: a 10-second or 2-second delay between pressing the shutter button and the camera firing (table 2-2). The 10-second delay affords you sufficient time to race out to the front of the camera to be included in the photograph. The 2-second delay option allows the camera to avoid the effects of the movement caused by pressing down the shutter button.

Drive Mode Self-Timer Options		
⟳ Self-timer	Delays the firing of the camera after the shutter button is pressed.	
	⟳10 (Default)	Uses a 10-second delay. Use this option when you need to get into a group shot.
	⟳2	Uses a 2-second delay. Use this option to avoid camera-shake caused by pressing the shutter button.
⟳C Self-timer (Cont.)	Delays the firing of the camera after the shutter button is pressed.	
	⟳C3 (Default)	Delays firing for 10 seconds, and then fires three shots.
	⟳C5	Delays firing for 10 seconds, and then fires five shots.

Table 2-2: Delayed Drive Mode command options

Self-timer (Cont.) instructs the camera to fire a burst of either three or five photographs after a 10-second delay. The rationale is that in a group shot, some-one frequently commits a faux pas that is captured by the camera. The miscreant may look away at the wrong time, blink just as the shutter fires, or fail to smile. Working on the assumption that these problems occur randomly, Sony uses a statistical approach to allow you to get the perfect shot. Self-timer (Cont.) gives you the option to fire three or five shots in the hope that one of these pictures will be perfect.

Both commands work better with the a7 than the a7R. In the a7, no vibration results from the movement of the electronic first curtain, so the camera only needs to recover from the vibration or movement induced by pressing the shutter button. The a7R has a mechanical first curtain, and its movement creates enough motion to blur a photograph taken through a microscope or a long telephoto.

Using remote triggering devices creates the least amount of camera vibration by preventing inadvertent jarring and avoiding the movement from pressing the shutter button. We apply additional anti-vibration measures when we shoot with the a7R by mounting the camera on a tripod. Chapter 9 covers different types of tripods and associated equipment.

2

Bracket Firing

We will defer discussing this feature in depth until we reach Chapter 6, which describes Manual Operation of the camera. These manual options are specialized for the user who needs precise settings for exposure, white balance, and contrast.

File Formats

Your digital camera records your images on a memory card, and at some point you'll transfer these files to your computer. From there, you may want to prepare the pictures for printing, e-mails, or posting to social media sites. The same is true with the movies you record. You may download them to your computer for editing, or you may compress them to send as attachments or upload them to the Internet. Either way, knowing how you are going to work with your recordings will determine your file format type.

File Formats for Still Photography

An advanced camera such as the Sony a7/a7R allows you to choose to record and save your images as either RAW or JPEG files. RAW files are the equivalent of digital negatives since you cannot use them directly on your computer—first you have to develop them with special software. This means either acquiring third-party software, such as Photoshop, or working with the Sony supplied software, Image Data Converter version 4.02. The advantage of the RAW format for those who like to process their images is that RAW files provide the greatest flexibility for post-processing. These files contain all of the information collected by the sensor, some of which cannot be seen directly when viewed on a computer monitor. RAW files are stored in a 14-bit format while JPEG files are stored in an 8-bit format. This means that for each of the three color channels in a RAW image, the intensity values are recorded within a range of 1 to16,384. In contrast, JPEG files' data is stored in a courser fashion: each of their three color channels stores intensity information within a range of only 1 to 256. RAW's increased precision in recording intensity level information allows the photographer to process their images so as to reveal subtle details in the highlights and shadows. Such details cannot be revealed when working with JPEG files. This increased precision of RAW images facilitates correcting errors in white balance and effectively adjusting contrast. Because of the high information content, these files are large.

In contrast, working with JPEG files is very straightforward. Almost all computers and image-processing packages can open and work with JPEGs. For these files, the camera processes and compresses the sensor data before storing the image. In

essence, the files are already processed and are available immediately for viewing or attaching to e-mails. Because JPEGs are compressed, you are limited in what enhancing you can do to the files. For this reason, many people feel this file format does not generate the highest quality picture from a camera.

JPEG and RAW Defined

JPEG: A JPEG image file is compressed using a method developed by the Joint Photographic Experts Group. This compression produces a loss of information from the original image file that cannot be restored. The file has the extension .jpg (commonly used on Windows computers) or .jpeg (commonly used on Macintosh computers).

RAW: A RAW file is a digital camera file that is minimally processed. It retains the highest amount of the data originally captured by the sensor. A Sony a7R/a7R image file has the extension .arw. Unlike the JPEG, the compression in the Sony file minimally processes the data in order to maintain its fidelity.

When you first use your Sony a7/a7R, your pictures will be saved as JPEG files. This is logical, since some of the most advanced camera features for capturing, processing, and manipulating the image can only be done when saving pictures as JPEGs. When using the JPEG file format, you have the option, before taking the picture, to specify the degree of sharpness, contrast, or color rendition you want applied to the image. Quality photographs can be achieved directly out of the camera, but to get the best results, the photographer has to understand how these settings will affect the final picture. There will be less flexibility in correcting mistakes in exposure or color balance when processing these files.

So, which file type should you use? The simplest answer is to use both. The Sony a7/a7R allows you to simultaneously record an image in both RAW and JPEG formats, giving you the best of both worlds—the full image processing potential of a large RAW file and the convenience of a generally accessible, small JPEG file. To record an image in both RAW and JPEG formats, press the MENU button, follow the subsequent command path, and select the [RAW & JPEG] option:

MENU>Camera Settings (1)>Quality>[RAW], [RAW & JPEG], [Extra fine], [Fine], [Standard]

However, using both formats is not always available, nor is it always desirable. The selection of Sony's file types is a tool—we recommend making a pragmatic decision that reflects what you want to accomplish with your photography. Keep in mind that Sony has several unique features, such as Sweep Panorama mode and Multi Frame NR, that are recorded only as JPEGs. Since these techniques are

valuable for shooting broad vistas or recording under low-light conditions, you may decide to use JPEG to avail yourself of these features. These special features will be disabled if you choose the RAW & JPEG option. As a rule of thumb, any operation that involves combining several different exposures into a single processed image will require the file to be saved only as a JPEG. To effectively use all of the Sony a7/a7R features, you must be prepared to switch from RAW to JPEG.

Choosing JPEG requires additional decisions, such as selecting which Quality to use. You have the options of [Extra Fine], [Fine], or [Standard], depending on how much detail you wish to retain in the image. Please avoid the assumption that JPEG images are of lesser quality than RAW images. When properly prepared, a print generated by a JPEG file is indistinguishable from one generated from a RAW file.

To record the most detail, choose [Extra Fine]. If you plan to save a large number of images on your memory card, you might decide to reduce the file size by compressing it more, thereby recording less detail. To do this, set the Quality value to [Standard]—the greatest degree of software compression is applied to Standard images. We choose the [Fine] option since these JPEG files are small enough for our purposes, and we see little value in further compressing the files. We should note that the option called [Standard] is a misnomer—it is not the default setting used in this camera. Instead, the default setting is the [Fine] file type, which is also the chosen JPEG format when the [RAW & JPEG] file type is selected.

You can also shrink the file size by reducing the number of pixels saved in the file. You can do this with the Image Size command:

MENU>Camera Settings (1)>Image Size>[L], [M], [S]

The RAW files' default image size for the a7/a7R is [L], and this cannot be altered. For JPEGs, the default size is also [L], which is 24 megapixels (6000x4000 pixels) for the a7, and 36 megapixels (7360x4912 pixels) for the a7R; however, you can downscale the JPEG image size to either an [M] or [S] (table 2-3). It is important to note that the megapixel count (M preceded by a number) will vary between the a7 and a7R. On the a7R, the [L] size will be 36M, while on the a7, the [L] size will be 24M. The abbreviations used in the camera's display are shown in the parenthesis in table 2-3. You can also change the Image Size value through the Quick Navi screen.

Image Size When Aspect Ratio = 3:2	a7	a7R
L	6000x4000 (24M)	7360x4912 (36M)
M	3936x2624 (10M)	4800x3200 (15M)
S	3008x2000 (6M)	3680x 456 (9M)
Image Size When Aspect Ratio = 16:9	**a7**	**a7R**
L	6000x3376 (20M)	7360x4144 (30M)
M	3936x2216 (8.7M)	4800x2704 (13M)
S	3008x1688 (5.1M)	3680x2072 (7.6M)

Table 2-3: Sony a7 and a7R image pixel sizes

It is unnecessary to save the files with a smaller pixel count if you post-process your images on a computer. Most independent programs, like Photoshop or Gimp, will allow you to resize your picture and reduce its file size.

Reducing Noise in JPEG Files

If you want to only work with JPEG files on your camera, it's important to understand how the camera processes these files so you can achieve the best quality. When shooting at ISOs of 1600 or greater, Sony uses NR (Noise Reduction) software to remove the appearance of punctate dots (noise) in the image. This ensures that areas such as a painted wall with a smooth surface are recorded as having an even tone. However, noise reduction can, if employed aggressively, destroy fine details. This can be seen in images of an animal's fur where the individual hairs become indistinguishable from each other and take on a smeared appearance.

Sony has designed their cameras to employ NR at high ISOs to remove the punctate artifacts resulting from sensor noise. Unfortunately, Sony's default option, [Normal], removes fine details as well. This degradation is usually acceptable if you do not enlarge the picture too much. Many viewers will not see this lack of fine detail in a scene that is composed to fill the whole frame of the sensor, and whose enlargement is kept smaller than 8x10 inches. However, if you intend to make larger prints or crop the image to enlarge only a small region of the image, areas containing fine details will appear blurred.

To avoid this problem, go to the High ISO NR command and switch it from its default value [Normal] to either the [Low] option or the [Off] option. We set it to [Off], and if the punctate appearance on the image is too annoying, we reduce it by using a third-party noise-reduction software, like Noise Ninja.

The command path for controlling in-camera noise reduction is:

MENU>Camera Settings (5)>High ISO NR>[Normal], [Low], [Off]

Before leaving the topic of JPEG files and noise reduction, there is one setting that we should briefly mention: Multi-Frame Noise Reduction. This setting provides even greater noise reduction than that which can be achieved with High ISO NR. Rather than relying on one exposure, Multi-Frame Noise Reduction takes four exposures and uses image processing to further reduce noise. It is available on the ISO selection only if Quality is set to a JPEG file format. This option is best used when you tripod-mount your camera and focus on immobile subjects. It can be used for handheld photography, although the results obtained this way can be problematic. We will discuss this option in detail later in Chapter 5.

Image Size and Digital Zoom

When composing a scene using live preview, you can magnify the image. Perform the following command to set the limits on how far you can magnify the preview image:

MENU>Custom Settings (3)>Zoom Setting>[Optical zoom only],
[On:ClearImage Zoom], [On:Digital Zoom]

The Zoom Setting command's default option is [Optical zoom only] and serves as a place marker: its selection ensures that the digital zooms are off. Any changes in the image magnification will occur only if the lens is capable of varying its focal length, meaning you can physically zoom in by turning the lens's zoom ring.

The [On:ClearImage Zoom] and [On:Digital Zoom] are software commands that set the limits on how much the image recorded by the sensor can be enlarged. Functionally, they are distinct from the [Optical zoom only] in that the enlarged image is degraded by the software when magnified.

The degradation arises because digital zooming takes the pixels from the sensor and, in effect, increases the separation between neighboring pixels. Rather than display the separation as being empty, the camera's software fills in this created space with a guess of what it thinks it should be. This is only an interpolation, and as a consequence, digitally enlarged images will appear increasingly fuzzy as the magnification is increased. In contrast, when using [Optical zoom only] the image size is enlarged by increasing the magnification optically on the sensor. This option does not change the relationship between adjacent pixels, so the enlarged image should not become fuzzy as the image size is increased.

The predominant difference between [On:ClearImage Zoom] and [On:Digital Zoom] is the extent of enlargement being allowed. This is where the options become confusing because the limit of these zoom features is not fixed, but varies depending on the JPEG file's size, if you are using an APS-C NEX lens rather than an FE lens, or if you are using the a7 or a7R. To keep things simple, we will restrict our discussion to the [L] image size for JPEG options. Using the [On:ClearImage Zoom] limits the increase in the image magnification from its original size (1x) to twice its original size (2x). Increasing the magnification beyond this requires [On:Digital Zoom]. Selecting [On:Digital Zoom] will also activate [On:ClearOptical Zoom] so you can seamlessly go from 1X to 2X and then from 2X to 4X. Sony's rationale for distinguishing these two settings is that they employ a different means to interpolate the increasing separation between the individual pixels. Basically, [On:ClearImage Zoom] is supposed to do a better job in rendering a sharp image than [On:Digital Zoom].

Once you have set the limits on the zoom settings, activate the zoom with the following command:

MENU>Camera Settings (4)>Zoom>[Desired value]

The [Desired value] can be set by pressing the left or right button, which respectively lowers or raises the zoom. If you are using an E-mount lens that has a power zoom lever, you can implement the zoom with this lever.

Before closing this section, we need to describe the Smart Zoom. This only can occur when you set the JPEG size to either [M] or [S]. This is not a Zoom Setting command option that you activate directly. As you increase the zoom, you will see a set of changing icons. First, there will be one for Smart Zoom, which will be replaced by the one for [On:ClearImage Zoom], which in turn will be replaced with the one for [On:Digital Zoom]. Keep in mind that the camera always records the data collected by the individual pixels or photosites that make up the sensor. To keep the example simple, we will use the a7 sensor, which has a maximum of 6000x4000 pixels with the Aspect Ratio set to [3:2]. When Image Size is set to [M] or [S], the sensor pixels are grouped or binned so that the 6000x4000 pixel sensor appears to generate either a 3936x2624 (if the image size is set to [M]) or a 3008x2000 pixel sensor (if the image size is set to [S]). You might think of this as binning or grouping adjacent, individual pixels to form a larger, superpixel. The 3936x2624 or 3008x2000 image is comprised of these superpixels.

When you first zoom an [M]- or [S]-sized image, you are increasing the separation between the superpixels. However, in this case, the newly formed space is being filled in with data collected by the original single pixels. In other words, there is no interpolation—real data is used to fill the new space. As a result, there is no

breakdown in the image and Sony claims that enlargements done this way do not show any degradation. Eventually, as the magnification increases, the camera can no longer fill in the space with data. This occurs when [On:ClearImage Zoom] is operating and the image quality becomes degraded.

We recommend sticking with the camera's default setting and just using [Optical zoom only]. You will obtain the same results by enlarging the image with post-processing software.

A summary of how much magnification the digital zooms provide is listed in table 2-4.

JPEG Quality	Smart Zoom Range	Clear Image Zoom Range	Digital Zoom Range
L: 24M for a7 L: 36M for a7R	Not available	1.1X-2.0X	2.1X-4.0X
M: 10M for a7 M: 15M for a7R	1.1X-1.5X	1.6X-3.0X	3.1X-6.1X
S: 6M for a7 S: 9M for a7R	1.1X-2.0X	2.1X-4.0X	4.1X-8.0X

Table 2-4: Digital Zoom magnifications as measured from the Sony a7/a7R using the 28-70mm zoom

File Formats for Movies

For recording movies, there are two different file formats: AVCHD and MP4. AVCHD stands for Advanced Video Coding High Definition and has the highest spatial and temporal resolution for recording movies (1920x1080 pixels at 60 frames per second). There are two types of AVCHD: 60i/60p or 50i/50p. The former is the standard used in North America and parts of South America, while the latter is the standard used in Europe, Africa, and the Asia-Pacific region. Where you buy your camera determines which of these two formats are used. Files stored in these formats can be used to project your movie directly from your camera onto your television. With Sony's PlayMemories Home software, you can also burn the movies onto discs for playback on a DVD player.

The advantage of the MP4 file format is that you can edit these types of files in readily available programs, such as QuickTime 7 Pro. The output of MP4 files has lower resolution (table 2-5), but, like JPEG files, they are simpler to work with on your computer. The main disadvantage is that you cannot burn MP4 files to discs for playback on a DVD player.

Movie Format	Pixel Array	Comments
AVCHD (default)	1920x1080	Files need to be transcoded before they can be processed. Additional software is needed for editing this file format. Results have the highest pixel count and temporal resolution.
MP4	1440x1080	Creates a computer file that is easily copied and read. Does not need transcoding.

Table 2-5: Movie format options

You must set the movie file format type through the camera's menu. It is not in the Quick Navi screen, nor can you customize the Fn button or other buttons to provide a gateway to this command.

MENU>Camera Settings (1)>Movie File Format>[AVCHD], [MP4]

Note: Sony uses an icon, which looks like a short length of a filmstrip, for all commands dealing with movies. We have substituted the word "Movie" for this icon.

Figure 2-5: Shutter button

The movie's record size has a long list of options to choose from. At this stage in handling your camera, we advise against altering the Movie Record Setting command. Changing its default option, 60i 17M(FH), can prevent you from being able to save your movies to a DVD. The default option provides a good-quality HD movie that can be burned to a DVD for playback. We will cover how to create higher quality movies in other formats in Chapter 11.

Shutter Button

The shutter button is located on the camera's top-right panel (figure 2-5). When you press it down halfway, you will feel an increase in resistance. Even though the camera has not fired, you can stop there and hold this position. This halfway press is a control point that initiates many of the camera's settings. It also can serve to lock focus and exposure.

Typically, pressing the shutter button halfway starts the automatic focusing process. When focus is obtained in Focus Mode's [Single-shot AF], the lens is locked and a green circle lights up in the lower-left corner of the screen (table 2-6). As long as you keep the shutter button at its halfway point, you can aim the camera to another area without the camera refocusing. To take the picture, press

the shutter button down fully. This is a useful technique to master for those times when the camera does not focus on the intended subject. This can occur when the subject has no fine details or when the scene is cluttered with material in front of and behind your desired subject.

If the camera's Focus Mode is set at [Continuous AF], the camera's automatic focusing does not lock when you push the shutter button. Instead, the focus will change if the subject moves closer to or father away from the camera. A green focus indicator surrounded by green colored brackets on the display screen tells you that the camera is maintaining focus as the subject's position changes. If the green circle is not lit, the camera has not found focus.

Focus Indicator	Condition	Status
●	Steady Green Light	Focus is locked and the camera is ready to shoot.
(●)	Green Light	Continuously focuses while the shutter button is held down halfway.
()	Green Light	Continuous autofocus is in operation and focus has yet to be achieved.
●	Flashing Green Light	The camera is unable to find focus.

Table 2-6: Display screen focus indicators

As we mentioned earlier, the camera lens focuses the scene onto the sensor. When these cameras are taken off automatic modes, i.e. they are being used in P, A, S, and M modes, the a7 differs from the a7R in that it uses the [Wide] option for specifying the focusing area. There are 25 rectangular regions distributed throughout the sensor and used for establishing focus. You won't know which focusing region will be used until you press the shutter button. Then the camera focuses, and the areas that are used to establish focus are indicated with green brackets.

In contrast, the a7R uses [Flexible Spot], which is a single focus point in a small region of the screen. This spot has to be aimed onto the target for accurate focusing, and there is no question of what will be focused on in the scene.

In Intelligent Auto or Superior Auto mode, both cameras use the [Wide] option for focusing. In these modes, the camera tends to focus on objects in the center of the field of view. This is a logical strategy because the center is the most likely place for your subject. However, this setting covers a large area and may focus on the wrong region, thereby blurring the region of interest. To get more directed focus, the camera can be set to use facial detection. When the Face Detection

command is activated, the camera identifies a face, and uses it for the focus point. In the camera's default configuration, the center button will provide even more accurate focus by targeting and focusing on the eye. Many professional photographers believe that the most critical region to record sharply in a portrait is the eye.

Working with autofocus requires understanding the cues for judging what is in focus. For the Sony a7/a7R, the final determination for focus is contrast. When an object is out of focus, its edges are blurred and the transition between light and dark is gradual. When it is brought into focus, the object's edges are sharply defined, emphasizing the transitions from dark to light. In essence, a sharp, in-focus object has a greater range of intensity values than a fuzzy, out-of-focus object. To achieve accurate focus, you have to find a subject that has some variation in light and dark. Trying to find focus on a blank wall can be impossible.

The a7 camera uses phase detection to initiate focus and contrast detection to finalize focus. Phase detectors provide faster initiation of focusing, although they are less accurate in identifying the final point of focus. The mechanism for phase detection determines the direction and extent that the focus needs to be changed to ensure a sharp image. However, focus can be off, and in some cameras, such as the Sony SLT cameras (which uses phase detectors), the camera's focus may be imperfect. Such cameras have a menu setting that allows you to calibrate the phase detectors to compensate for a lens that consistently misses hitting perfect focus. In the case of contrast detectors, there is a 50 percent chance that focusing will move in a direction that renders the image out of focus. When this occurs, the contrast drops and the sensors, having noted this, will instruct the focusing mechanism to reverse its action. In half of the cases, contrast increases and focus is achieved. The other half of the time, focusing is delayed while the focusing mechanism determines it is blurring the image and backtracks to achieve the sharpest image. Cameras equipped with this type of focusing mechanism have greater accuracy in finding focus, but achieving the point of focus is delayed. The Sony a7's advantage in achieving rapid focus is by using a hybrid focusing scheme. The a7R is a bit slower in finding focus because it relies solely on contrast detection.

Both the a7 and the a7R can be set to focus continuously:

MENU>Camera Settings (2)>Focus Mode>[Single-shot AF], [Continuous AF], [DMF], [MF]

In [Continuous AF] mode, the camera updates its focus in between shots if the object moves toward or away from you. This is a handy feature for shooting action shots since the camera will try to keep everything in focus as the subject moves about. The camera has green icons on the display screen (viewfinder and LCD screen) to tell you how automatic focusing is doing (table 2-6). If you see

2

green brackets, the camera is in [Continuous AF]. If a green circle appears within the brackets, the camera has found focus. If the green circle flashes, the camera is unable to maintain focus on the subject.

In Intelligent Auto, Superior Auto, and many of the SCN predefined scene modes, the camera determines the Focus Mode for you. Most of the time it is set to autofocus and shoot one image: [Single-shot AF]. However, if you choose the predefined [Sports Action] SCN mode, the camera will use [Continuous AF]. This makes sense for a situation in which you expect the subject to be moving about and you need the camera to maintain focus.

As well as autofocusing works, you may need to take over and focus manually. There is no button for directly switching to manual focus on this camera's body, so you can make the switch using the menu. Turn off the AF, and set the camera to the Direct Manual Focus (DMF) option or the Manual Focus (MF) option with the following command:

MENU>Camera Settings (2)>Focus Mode>[DMF], [MF]

This command can also be executed by using the Quick Navi screen. Both of these options involve manual operation, and we will cover these in more detail in Chapter 6.

Advanced Focusing Features: Face Detection and Object Tracking

Although we will discuss them in more detail in Chapter 4, this is a good place to mention advanced focusing features so you can watch out for them as you experiment with your new camera.

Face Detection identifies a human face and then focuses on it. By default, this command is [Off] in all of the shooting modes, even when you would think it should be automatically activated, such as in the SCN [Portrait] mode.

MENU>Camera Settings (5)>Smile/Face Detect.>[Off], [On (Regist. Faces)], [On], [Smile Shutter]

(Where Smile Shutter has three suboptions of its own: [On: Big Smile], [On: Normal Smile], and [On: Slight Smile])

When you select Face Detection's [On (Regist. Faces] or [On], you will see a frame surrounding each of the detected faces. The frame's color indicates the Face Detection status. A white square frame indicates that the face has been

identified and the camera can focus on it. When you lock focus by pressing the shutter button halfway, the frame turns from white to green. When several faces are in the viewfinder, they may each be surrounded with a frame. The gray frames indicate a face has been detected but will not be used for focusing. If the face has been registered but is not being used for focus, the square will be magenta. If no faces are detected, the camera will still focus on the scene; the only difference is that the faces won't be the preferred targets.

The [On (Regist. Faces)] command is for faces you have taught the camera to recognize. When this command is used, the camera focuses on and exposes for these preferred people. This command has some limitations—we will discuss those limitations and how to register faces in greater detail in Chapter 4.

The other advanced focusing mode is Lock-on AF, which will track a specific subject as it moves about within the display screen.

MENU>Camera Settings (5)>Lock-on AF>[Off], [On], [On (Start w/shutter]

When this command is activated, the camera attempts to follow an object for focusing, which can be a useful feature for photographing active children or pets.

Recommendations

If you want to take pictures immediately, set the mode dial to Auto and select either Intelligent or Superior Auto. In these modes, the camera determines the settings and options it uses, which provides you a good opportunity to review the images and decide what you could have done better or differently by using alternate options. As you use the camera and move into other shooting modes, you will need to become familiar with additional tools for controlling the appearance of your images. This chapter provided some instruction on selecting the camera's options; however, remember that the automatic settings work well.

As you explore the camera's manual settings, you will find that some menu commands are accessed frequently. You can access these commands more immediately if you assign their execution to a press of a button. If you decide to customize the control tools, as described in Chapter 7, you'll hardly ever have to dive into the camera menus. Instead, you'll be able to access the functions that are most important to you by using the external dial and buttons.

Chapter 3: Managing Your Images

Introduction

The Sony a7/a7R electronic display screens serve two purposes. The first is to compose and preview the subject before recording it to the memory card. The second is to evaluate the recorded picture or movie after it has been captured. In both cases, you can check the image's quality, ensuring that focus, exposure, and coloration are suitable. Previewing the image in the electronic finders assures that egregious errors can be avoided. Reviewing the captured image allows you to fine-tune the camera settings to ensure that your next images will have the results you want.

Only one of the display screens work at a time. The default is to have the electronic viewfinder (EVF) enabled when the camera senses an object, presumably your eye, in front of the eyepiece. When this happens, the viewfinder turns on and the LCD screen turns off. This feature prevents the battery from being drained unnecessarily.

Although they both serve the same purposes, each display has its advantages. The value of using the LCD screen is that it can be extended out from the body of the camera and tilted to face up or down so you can view your scene from above or below the level of the camera. Using the LCD screen also allows you to view both the subject and the back of the camera at the same time. This is an advantage when you are manipulating the camera's controls or navigating through its menus. When the camera is mounted on a tripod, the rear LCD screen provides a particularly convenient means of aiming and adjusting the camera.

The first benefit of using the viewfinder is that the positioning of your eye blocks the ambient light from impacting your ability to view your subject. Intense noonday sunlight can swamp the brightness of the LCD screen, making it difficult to see and therefore to frame or compose the subject. A second advantage is the added steadiness gained when the camera's viewfinder is held against your face. Be flexible and use whichever display provides the best results in a given situation.

This chapter covers how to preview and review your still pictures and movies, and offers useful tools to use when evaluating your images. As with most functions on the a7/a7R, there is often more than one way to accomplish your photographic goals. It is best to experiment. Over time, you will develop preferences that work well for you.

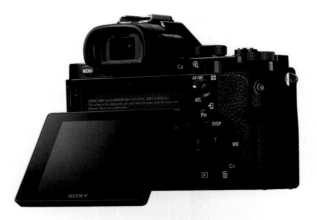

Figure 3-1: Tilting capability of the LCD screen

The LCD Screen

The Sony a7/a7R uses a large, high-quality liquid crystal display (LCD) composed of 921,600 dots, located on the back of the camera (figure 3-1). It has a diagonal measurement of 3 inches (7.5 cm), which is large enough to provide a clear view at arm's length.

The LCD screen's hinged display and ability to extend out from the camera body give you flexibility when working in cramped or awkward locations. For example, to frame a photograph over a crowd, raise the camera above your head and tilt the LCD screen down so you can look up and compose the image. To get the same shots with a DSLR that does not have a tilting LCD screen, you would need to raise the camera above your head and shoot blind.

We already mentioned that a benefit of using the LCD screen is that you can view the camera commands and buttons simultaneously with your scene, making it easier to navigate the camera's functions and set them at the same time. In addition, its more comfortable to view your framed image on the LCD screen when the camera is tripod-mounted.

You can set the LCD monitor's brightness using the Monitor Brightness command:

MENU>Setup (1)>Monitor Brightness>Brightness Setup>[Manual], [Sunny Weather]

This command is only available if you are viewing the LCD monitor. If you attempt to execute the Monitor Brightness command while looking through the viewfinder, you will see an error message instructing you to use the LCD screen.

Along with the command's options, a color grid and grayscale step wedge are displayed to give you an indication of how the selected level of brightness affects your view of all the colors and shades in the range from black to white on the screen.

Using the [Manual] option on the Brightness Setup allows you to adjust the screen from -2 to +2 units of brightness (figure 3-2). Note the color grid and grayscale will change as you press the right or left buttons. Use these color indicators to set the brightness to a level suitable for the ambient lighting.

However, this control may be insufficient for working under bright outdoor conditions. If this is the case, set the command to [Sunny Weather], which maximizes the screen brightness. This setting is useful when you

Figure 3-2: Brightness Setup command's Manual screen

are working with the camera on a tripod, since you will probably be framing the image with the LCD. Keep in mind, you will deplete the batteries quickly if you use this setting frequently. But when handholding the camera, it is simpler and faster to use the EVF, which isn't affected by bright sunlight.

The Viewfinder

The Sony a7/a7R's electronic viewfinder is a half-inch screen made up of 2,359,296 dots. A focusable magnifier enlarges the screen for your eye. Like the LCD monitor, it provides a live view, with the camera settings reflected in the image prior to taking the picture. Its function is analogous to that of a DSLR optical viewfinder. The advantage of the electronic viewfinder is that it provides an excellent, enlarged, and bright image, making composition easier. The magnifier allows you to view fine details. As described in Chapter 1, you should focus the viewfinder display to your eye by using the diopter adjustment dial. To do this, use the letters and numbers that are displayed in the viewfinder as your focus points. This will give you an easy reference object to help you decide when you have focused the viewfinder for your eyesight.

Unlike a DSLR's optical viewfinder, you can display the camera's menu commands and options in the a7/a7R viewfinder, as well as histogram information and graphical displays of intensity levels. The control wheel, dials, and custom buttons all function the same way as they do for the LCD screen. For example, when you review the available menu, rotate the control wheel or press its up or down buttons to move through the menu structure and command settings.

You can adjust the viewfinder screen's brightness by using the Viewfinder Bright. command:

MENU>Setup (1)>Viewfinder Bright.>Brightness Setup>[Auto], [Manual]

Set the Brightness Setup option to [Auto] to let the camera determine the brightness level of the viewfinder screen. If you are unhappy with this setting, set the option to [Manual] to be able to adjust the viewfinder screen from -2 to +2 units of brightness.

The Viewfinder Bright. command works only when you are looking through the viewfinder. If you are viewing the LCD monitor, an error message will display informing you to use the viewfinder.

There are situations when it is advantageous to use the EVF instead of the LCD, for example, when photographing a stage production, where the glow from the camera can distract the subject or annoy the audience. Another important advantage of using the viewfinder is the stability gained by holding the camera against your face. This is beneficial for low-light photography, and situations when you are using long shutter speeds or working with a long telephoto lens, where the slightest tremor is magnified. Steadiness is even more critical when capturing movies since all camera movement is recorded.

LCD Screen versus Viewfinder

As mentioned before, you can have only the LCD screen or the viewfinder active at one time. Which option you use in different situations depends on your personal preference. When you have determined your style, you can set the FINDER/MONITOR command to conform to your needs.

MENU>Custom Settings (3)>FINDER/MONITOR>[Auto], [Viewfinder], [Monitor]

The command's [Auto] option is the default setting. This option switches between the LCD and the viewfinder, depending on which screen you happen to be using. This switching can be disruptive when you are entering menu commands on the LCD screen. If your hand passes close to the viewfinder, it may turn off the LCD and activate the EVF. Also, if you are shooting in an environment where the onset of light could be distracting, you don't want the LCD screen to turn on when you remove your eye from the viewfinder. In these types of situations, you can avoid this by setting the FINDER/MONITOR command to either [Viewfinder] or [Monitor], depending on which screen you want to be enabled exclusively. Then, only the selected screen will be active, and the other will remain dark.

Data Display Formats

Reviewing the camera settings in Live View prior to and after recording in Playback gives you the opportunity to adjust the settings and to improve your image. However, you may find this data distracting if it clutters your preview screen when you are concentrating on composing the picture. The following sections cover data display formats prior to and after recording a still picture or movie. Become familiar with each format. You may find that certain data display formats work best for you in different shooting scenarios.

3

Previewing Data Display Formats

There are six display formats. Five of them are used for previewing or composing your subject from the LCD screen. The sixth display option, [For viewfinder], shows no image—only numerical data. This screen provides a quick summary of the camera settings. When used with the Fn button, it provides a fast and efficient way to change settings. In contrast, the display formats for the electronic viewfinder are used only for previewing your subject—the [For viewfinder] option is not available. With this many choices, deciding which to use can seem like a daunting task. The following information will simplify the selection process.

First, let's review all six of the data display formats:

- **Graphic Display:** Displays a full-size image with major shooting settings and two horizontal scales, one for shutter speed and the other for aperture, with the current setting indicated on the scale with a vertical line. These are displayed on the bottom-right side of the screen (only for still picture shooting modes). When in Movie mode, two horizontal audio recording scales, Ch1 and Ch2, are displayed on the screen's left side. Note, Graphic Display is not a default option for either LCD or EVF, and you will have to enable it if you wish to use it.
- **Display All Info.:** Displays a full-size image with camera shooting settings superimposed around three of the image's border. When the mode dial is turned to Movie, Ch1 and Ch2 horizontal recording sound scales are displayed on the screen's left side. This is a default setting for the LCD, but not for the EVF. The overlay of data and settings over the screen tends to be distracting when composing the image, but for scientific or technical work, having these settings visible is advantageous.
- **No Disp. Info.:** This format displays the image with shooting mode and battery power superimposed over the image at the top of the screen. These will disappear after a few seconds, leaving a clear screen, ideal for careful composition and framing. Additional shooting settings are displayed in the borders outside the image area. When viewing through the viewfinder, this format also displays and retains additional shooting information in the borders around the image. This is a default setting for both the LCD and the EVF.

- **Histogram:** Displays the full-size image, shooting mode, and exposure settings. A real-time histogram occupies the lower-right of the screen. When the mode dial is turned to Movie, Ch1 and Ch2 horizontal recording sound scales are displayed on the screen's left side. Additional shooting settings are displayed in the viewfinder. The shooting mode and battery power superimposed over the image at the top of the LCD screen disappear after a few seconds. This is a default setting for both the LCD and the EVF. The histogram helps the expert photographer adjust his exposure under difficult lighting conditions.
- **Level:** Displays the full-size image, shooting mode, exposure settings, and the digital level-gauge tool in the center of the screen. The gauge's indicator turns green when the camera is level, both horizontally and front to back. When the mode dial is turned to Movie, Ch1 and Ch2 horizontal recording sound scales are displayed on the screen's left side. Additional shooting settings are displayed in the viewfinder. The shooting mode and battery superimposed over the image at the top of the LCD screen disappear after a few seconds. This is a default setting for the EVF but not for the LCD. For shooting with wide-angle lenses in interiors or for architectural photographs, the level information is useful for eliminating perspective distortion that arises from tilting the camera.
- **For viewfinder (LCD only):** For still picture modes, this option only shows data and does not display the subject. There is a histogram, level, and exposure settings. This data display format has an extra feature. When used with the Fn button, the screen is referred to as the Quick Navi screen since it provides a convenient way to change camera settings. Pressing the Fn button highlights one of the settings displayed in the screen. You can now navigate using the control wheel. Pressing the center button activates the highlighted command for selecting a new value. This display format is a default for the LCD screen but is not available for the viewfinder or when the mode dial is set to Movie mode.

There are two exceptions. When in Sweep Panorama mode, the [Graphic Display] format displays without the two scales, and the Histogram data display format is replaced with the [No Disp Info.] format. Plus, when in Movie mode, the [For viewfinder] slot is replaced with the [Display All Info.] format on the LCD screen.

To summarize, each format has its benefits. When you are carefully composing a landscape or a portrait, an unobstructed preview of the image is important, so you might use [No Disp. Info.]. When keeping the camera level is important—such as when taking a panoramic picture, using extreme wide-angle lenses, or architectural photography—use [Level]. When you want to have easy access to your settings, use the [For viewfinder] to initiate the Quick Navi screen. You will probably have a favorite or two, but switching them is easy with the DISP button, so you will most likely use each of the display formats frequently enough to see the worth in having them all turned on.

Activating Data Display Formats

The data display formats on the LCD screen and in the viewfinder work independently of each other. For example, you can have three formats selected for the monitor and five for the viewfinder. Scrolling through the activated data display formats also works independently of the other display screen. You can have Graphic Display format on the monitor and No Disp. Info. on the viewfinder.

Use the DISP>Monitor command to select which data display formats to have available for previewing your images via the LCD screen.

> MENU>Custom Settings (2)>DISP Button>Monitor>[Graphic Display], [Display All Info.], [No Disp. Info.], [Histogram], [Level], [For viewfinder]

When you enter the DISP>Monitor command, each of the data display format options are preceded by a check box. As you scroll through the options, a sample display screen appears in the lower left corner (figure 3-3). This shows the appearance of the display format to help you decide if you wish to use it. Press the center button to check or uncheck an option. You can check up to six of the options for the Monitor. Navigate to [Enter] and press the center button to save the option changes. Only the checked data display formats will be available in preview mode.

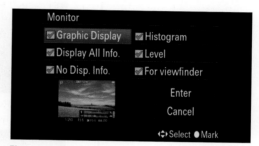

Figure 3-3: DISP>Monitor command positioned on [Graphic Display]

After you select your data display formats, go to preview mode and press the DISP button to cycle through the various views. For example, say you select DISP>Monitor>[Display All Info.], [Histogram], and [Level]. Each time you press the DISP button while previewing a framed image, you will cycle through these three display designs. Choose which screen display to use based on personal preference. For example, you may feel that the preview image is too cluttered with information, so you can select [No Disp. Info.]. Doing so, your framed image will be displayed on the LCD screen without an overlay of numbers or letters. The shooting mode and the battery level is displayed briefly, but disappears in less than 5 seconds.

A similar strategy is used to select the data display formats available on the viewfinder:

> MENU>Custom Settings (2)>DISP Button>Finder>[Graphic Display], [Display All Info.], [No Disp. Info.], [Histogram], [Level]

Framing for a Movie Recording

When you start to record a movie while the camera is set to a shooting mode other than Movie, the preview image on the screen will change from a 3:2 to a 16:9 aspect ratio. This means that the framing of your movie image may not be what you had originally seen in your LCD monitor or viewfinder. If being exact is important, we recommend you record a test movie first to determine adequate scene framing. Even better, switch to Movie on the mode dial and you can compose with precision.

Playing Back Saved Still Picture Data Display Formats

When you play back your still pictures for review, there are three data display formats available:

- Image with recording data (figure 3-4a)
- Image with histograms (figure 3-4b)
- Image only, no data (figure 3-4c)

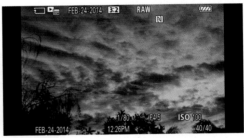

Figure 3-4a: Data display with recording data

After you press the playback button to review your saved pictures, cycle through the three display formats by pressing the DISP button.

Each playback display layout has its benefits. The recording data consists of the camera settings used to produce the image. This is invaluable when reviewing images for determining which camera settings work and which might need to be adjusted to improve the next shot.

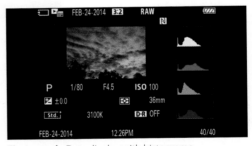

Figure 3-4b: Data display with histograms

The histogram view displays the intensity range of the luminosity and the three-color channels (red, blue, and green) of the recorded picture. Thus, you can see if the sensor failed to capture all of the light and color

Figure 3-4c: Data display of recorded image only

information of the scene. This is important because if the full range of all colors was not captured, a color shift may be introduced if you change the brightness of the image during post-processing.

You will also see any overexposed, or blown-out, areas blinking from white to black, and any underexposed, dark areas blinking from black to white. This is an excellent way to determine what areas of the image have details that were not recorded by the sensor. Highlights will be predominantly white with a few intensity transitions, and underexposed areas will display noise and no detail.

Reviewing Movie Data Initial Display Formats

Although there are three data display formats initially available when you first press the playback button to review your movie, there are really only two playback formats when the actual movie is played. After you press the playback button but prior to playing back the movie, pressing the DISP button will cycle through the following formats:

- Movie with recording data displayed within the picture's border (figure 3-5a)
- Small thumbnail image of the movies first frame, with recording data displayed outside the picture frame.
- Movie without recording data (figure 3-5b)

Figure 3-5a: Data display with recording data

All three of these will display the first frame of your recorded movie with a playback arrow in the center of the screen. When you start the movie by pressing the center button, the DISP button only has two formats to cycle through: one with the recording-data display and one without.

Figure 3-5b: Data display of recorded image only

Preview Image Overlays for Composition

In addition to data, the camera can project lines and grids onto the screen to aid you with composition. These overlays help you align and frame your pictures and movies. They are not recorded on the image file and are not visible when you review the image in playback.

Use the following command to set these lines and grids:

MENU>Custom Settings (1)>Grid Line>[Rule of 3rds Grid], [Square Grid], [Diag. + Square Grid], [Off]

The three Grid Line options each have specific patterns and benefits. The [Rule of 3rds Grid] pattern consists of a 3x3 array of rectangles (figure 3-6). This pattern allows you to position the main subject one-third or two-thirds of the way from any side of the screen. Many artists feel this helps in providing a balanced composition. The next two patterns are more useful for our scientific photography. [Square Grid] pattern divides the screen into an array of 6x4 squares to help you make sure the picture is well balanced and not tilted. The final pattern, [Diag. + Square Grid], divides the screen into an array of 4x4 rectangles with diagonal lines from the center to each corner, which helps you center the image in the frame. No grid lines are shown when the command is set to [Off].

Figure 3-6: Rule of 3rds Grid

3

Using a Tilt Shift Lens for Architectural Photography

All three grid patterns are useful in architectural photography and in scenic shots with a horizon. They help you avoid perspective distortion by providing an alignment guide to ensure the vertical lines of buildings are rendered as being parallel rather than converging to a point (this occurs when the photographer frames a tall building by tilting the camera). This creates the illusion that the building appears to be falling over. To avoid this appearance, the photographer must keep the sensor vertical and use a shift lens to frame the top of the building. Sony does not sell such a lens for architectural photography, but you can easily use third-party shift lenses made by Bower, Rokinon, Samyang, or Schneider with the aid of an adapter. Although this type of photography is best done with a tripod, we have taken successful handheld shots with the help of the grid lines and the level. The a7/a7R's high pixel count provides the potential for dramatic shots of tall buildings, without generating the appearance that they are falling over.

Review Recorded Images

Displaying Recorded Images

You should review the results after you have recorded a still picture or a movie. This will give you the opportunity to improve your shot by adjusting composition or exposure and reshooting. There are a couple of tools to help you do this. Keep in mind that when we refer to still pictures, we include panorama shots.

Auto Review or No Auto Review

The Auto Review command allows you to view a picture immediately after it has been taken. You can choose to have the camera display the picture for 2, 5, or 10 seconds, or you can eliminate the review by using the [Off] option.

MENU>Custom Settings (1)>Auto Review>[10 Sec], [5 Sec], [2 Sec], [Off]

You will be automatically returned to Live View when the display time has elapsed or when the shutter button is pressed at least halfway.

We always turn this command to [Off] so the camera will return to Live View immediately after taking a picture. This eliminates any interruption to picture taking and enables you to continue viewing your object on the display screen. This is very important when shooting action or sports photographs where you need to follow a subject. For example, you might be photographing a your child's soccer game, and he's passed the ball and is advancing on the goal. An interruption to Live View

could cause you to miss your next great picture. Since reviewing pictures is easily accomplished by simply pressing the playback button, we feel that keeping Auto Review on just slows down our photography.

Reviewing Files with the Playback Button

You can review your still pictures using either the Slide Show command, discussed later in this chapter, or the playback button, which puts the camera in Playback mode. Beware: some of the camera applications create files that are not recognized through Playback. For example, when we created a time-lapse movie using the Time-lapse app, the only way to review this movie on our camera is to use the Time-lapse app. If you have exited this app, pressing the playback button will not display the time-lapse movie in Playback mode.

The type of file displayed when you press the playback button—still pictures or movies—is dictated by the type of image you dealt with last, either the last type of recorded image, the last played-back image when you ended the Playback function, or the last selected View Mode command option. For example, if your last action was to take a picture, you will be presented with that image when you press the playback button. Likewise, if you were in Playback mode, exited, and then re-entered, the image displayed will be the last one presented to you.

The View Mode command makes you first define what type of files to display, and then decide the order you wish to view your images.

MENU>Playback (1)>View Mode>[Date View], [Folder View(Still)], [Folder View(MP4)], [AVCHD View]

The advantage of using this command is that it allows you to specify whether you want to view images from a given date, still pictures, HD movies (AVCHD files), or computer movies (MP4 files). If you want to playback images recorded on a specific date, for example your child's birthday, select View Mode command's [Date View] option, navigate to the specific date on the calendar, and press the center button to select.

Regardless of which of the four View Mode options you select, you will be presented with a screen consisting of three parts. On the left is the File Type Select bar, which contains the icons for each of the four View Mode options. This allows you to change your file type selection without having to go back to the beginning of the menu (figure 3-7a).

What you see in the second and third portions of the screen depends on whether you selected a View Mode option that is date specific or folder specific. The [Date View] and [AVCHD View] are date specific and the [Folder View(Still)] and [Folder View(MP4)] are folder specific. The second portion of the screen contains

either a month bar or a folder icon depending on the file type selected. The third portion of the screen contains either a calendar for you to select a specific date or a grayed-out preview of the files to be displayed in the highlighted folder (figure 3-7a).

Figure 3-7a: View Mode – select folder name

Use the right button to move from the File Type Select bar to the next portion of the select screen. Use the up or down buttons to navigate through the list of months or folders, depending on the selected View Mode option. As you move through the months or folders, the calendar to the right changes to match the month, or the grayed-out image preview changes to match the highlighted folder. Once you select a folder, you will be presented with the folder's images for you to view. If you selected a month, you'll have one additional step to select the specific date within the month. Use the right button to enter the calendar and navigate to the specific date (figure 3-7b). Press

Figure 3-7b: View Mode – select specific date

Figure 3-7c: View Mode – displayed files by date

the center button and you will see your images presented to you by date with the selected date first (figure 3-7c).

If you are already in Playbook mode, a faster way to enter View Mode and change between folders is to press the index image button, which will also act as the AF/ MF and AEL buttons when outside of Playback mode (figure 3-8). This function will take you directly into the activated View Mode display file option and will operate in the same way as if you had entered the command through the camera's menu.

Once you have activated the Image Index function, rotate or press the control wheel's rims to navigate through the images. The vertical bar on the right side of the screen changes as you move through the images, indicating the relative

position of the displayed images within the total number of images for the selected file type saved on the memory card. Use the vertical File Type Select bar on the left to change the file type.

Sometimes when you enter Playback mode, you don't see the images you expect. This is because the View Mode command is set to a different file type. To correct this problem, enter the View Mode command and select the desired file type. An easy way to have Playback return to a specific file type is the brute force strategy of snapping a quick image. If you snap a still picture, you will reset the folder type back to still pictures. Similarly, quickly starting and stopping a movie will reset the playback button's folder type to the type of movie file that you just recorded. The problem with this strategy is its lack of precision. Although selecting still pictures this way is straightforward, it does not allow you to specify which type of movie file (MP4 or AVCHD) you wish to view, and therefore you may open the wrong file folder. In the case of movies, it is best to switch file types by executing the View Mode command through the menu or image index button directly.

Playing Back Still Pictures

When you are positioned to display still images, press the playback button. Either the last recorded or the last played-back still picture will be displayed first. Rotate the control wheel clockwise or counterclockwise to display the next or previous saved picture, respectively. You can also press the right or left buttons or rotate the front dial to navigate through saved pictures. Note that the displayed images wrap around as you continue to rotate the wheel.

Figure 3-8: Image Index button

Remember to use the DISP button to view the recorded image data through the different data display formats.

Playing Back Panoramic Pictures

Sweep Panorama images play back differently than regular still pictures. When you first see it, the image appears small since the entire panorama is displayed (figure 3-9a) with dark borders filling the rest of the screen. When you press the center button, the image enlarges to fill the screen, and starts to pan through the panoramic in the direction it was recorded (figure 3-9b). After the camera has played to the end of the sweep, the image is zoomed out so that its entirety is displayed again as seen in figure 3-9a. This gives you both the overall view of the panorama as well as a closer view of the image.

Figure 3-9a: Sweep Panorama playback; initial and final display

Figure 3-9b: During the playback sweep portion of a Sweep Panorama image

Playing Back MP4 or AVCHD Movies

As you cycle through the memory card files in Playback mode, you will only see the first frame of each movie. Press the center button to play the movie. Pressing the DISP button toggles between playing back the movie with operational information displayed and playing back the movie (figure 3-10a) by itself, without overlays.

The operational data displayed prior to initiating the playback includes the date and time the movie was taken, the movie file type, and the prompts to adjust the volume (down button) and to start movie playback (center button). Once the movie starts playing, you will see the prompts for Fast Rewind (left button), Fast Forward (right button), and Pause (center button). The

Figure 3-10a: Movie played back with no data displayed

Figure 3-10b: Movie played back with operational data and Control Panel option displayed

Figure 3-10c: Volume control horizontal scale displayed

down button icon is present and labeled "Control Panel" (figure 3-10b). You can set the movie's audio volume either before you start the playback of the movie (center button) or during playback via the Control Panel. Both methods display the same screen (figure 3-10c). Use the right and left buttons to raise or decrease the volume respectively.

You do not have to completely play the first movie to see the next recorded movies. While the first movie is playing, press Pause (center button). Press the right button to advance to the first frame of the next movie. You can move to subsequent recorded movies by simply continuing to press the right button. If you wish to back track and view a previous movie, press the left button. When you are ready to play back a movie, press the center button.

When you play the movie without any data, pressing the down button brings up the Control Panel for controlling the movie. It should be noted that Fast Forward and Rapid Rewind are still available even though there is no visible icon. Just press the right and left button respectively.

Movie Playback Navigation	
Operation	**Process**
Play/pause	Press the center button to initiate movie playback. While the movie is playing, press the center button to pause it.
Stop	Press the shutter button to terminate movie playback and return to Live View.
Fast forward	While a movie is playing, press the right button or turn the control wheel clockwise. The movie plays forward by skipping several frames at once, giving it a jerky look. Once the movie has reached its end, playback stops and the initial image is displayed.
Fast rewind	While a movie is playing, press the left button or turn the control wheel counter-clockwise. The movie plays backwards by skipping several frames at once, giving it a jerky look. Once the movie has reached its beginning, playback stops and the initial image is displayed.

Movie Playback Navigation	
Operation	**Process**
Slow forward	While playing a movie, press the center button to pause the movie. Rotate the control wheel clockwise by one click. The movie moves forward with each click and stops when you have reached the end of the movie.
Slow rewind	While playing a movie, press the center button to pause the movie. Rotate the control wheel counter-clockwise by one click. The movie moves backwards with each click and stops when you have reached the beginning of the movie.
Move to Next Movie	When viewing the preview of a movie's first frame, press the right button to view the beginning of the next movie. When playing back the movie, pause and press the right button to display the next movie.
Move to Previous Movie	When viewing the preview of a movie's first frame, press the left button to view the beginning of the previous movie. When playing back a movie, pause and press the left button to display the previous movie.
Reduce or increase volume level	Press the down button to display the Control Panel menu. Use the right or left buttons to navigate to the Volume Control icon. Press the center button to display the Volume Control scale. Press the right or left button to raise or lower the volume control respectively. Press the center button to accept the change. Volume setting is retained even if camera is turned off. You can also set the volume control when the first frame is displayed. Press the center button to display the volume control scale.
Display operational information	During playback, press the up button to cycle through the two display formats until you see the following information displayed: playback status, playback bar, time played, date and time recorded, the movie file number that is currently playing (out of the total number of movie files), and available operational controls.

Table 3-1: MP4 and AVCHD movie playback navigation controls

You can also use the Control Panel menu to navigate and execute the movie playback operations. While a movie is playing, press the down button. The Control Panel menu will be displayed on the bottom of the display screen (figure 3-11). Depending on what you wish to do, you may find that you have to go back and forth to the pause

Figure 3-11: Movie Playback Control Panel menu

icon in order to execute one of the other icons. Other than using this menu for setting the volume control, we found that executing the operations without the icons was actually easier for us. Use table 3-1 to become familiar with available movie operational controls.

Reviewing Several Pictures and Movies

Use the Image Index command to select between displaying 9 or 25 thumbnail images (still pictures and/or movies) within a folder at one time:

MENU>Playback (1)>Image Index>[9 Images], [25 Images]

The selected Image Index value is applied regardless of the displayed file type, although there is the difference between displaying the files by date or by folder. In the case of displaying files by a specific folder, up to 9 or 25 images are displayed at one time. When you display files by date, the number of images displayed might be less because some of the screen will be taken up by displaying the date. The main thing to keep in mind is more images are displayed if you select [25 Images] instead of [9 Images] The assigned option also applies to the number of thumbnail

images that are displayed when you push the Image Index button while in Playback mode.

As before, use the control wheel to navigate through the displayed thumbnail images (figure 3-12). To view a specific image, navigate to the image you'd like to see, and press the center button when that image is highlighted. The highlighted image will be displayed at the

Figure 3-12: Image Index screen with thumbnail images

full-screen size. You can continue to scroll through the images one by one, or return to the multiple-image view by pressing the image index button again.

You may see fewer than 9 or 25 images displayed when you first enter the Image Index screen. This is because there are fewer than 9 or 25 images saved, you are seeing the last few saved images that can be displayed, or you have chosen to view the images by date. If this is the case, you can determine the total number of images by scrolling or looking at the bottom-right corner of the screen where the image number (out of the total number of images) is displayed.

Reviewing Still Pictures with the Slide Show Command

The slide show function can be a fun tool to test out. You can play the slide show on either your camera's display screen or on a compatible TV by connecting it to your camera with an HDMI Type D (Micro) connector.

The Slide Show command is heavily dependent on the View Mode command's setting. First, the Slide Show command is enabled or disabled based on the selected

View Mode value. The command is enabled when View Mode is set to [Date View] or [Folder View(Still)], but it is disabled when View Mode is set to [Folder View(MP4)] or [AVCHD View]. Second, the Slide Show command plays back only the images on the camera's inserted memory card in sequence, starting with either the last played back or last recorded image based on the selected View Mode. Although Slide Show does not let you specify creating a show of movies, since [Date View] also includes AVCHD and MP4 movies, they are included in the slide show when View Mode is set to [Date View].

To build and initiate a slide show, navigate to the following command:

MENU>Playback (1)>Slide Show>[Repeat], [Interval]

After you enter the Slide Show command, you will see two options: Repeat and Interval along with [Enter] and [Cancel] operations (figure 3-13).

The Repeat [On] option enables the slide show to loop back through the pictures continuously. The [Off] value executes the slide show only once and then exits to Live View.

Figure 3-13: Slide Show command screen

MENU>Playback (1)>Slide Show>Repeat>[On], [Off]

The Interval option allows you to set the length of time each picture is displayed (from 1 to 30 seconds).

MENU>Playback (1)>Slide Show>Interval>[1 Sec], [3 Sec], [5 Sec], [10 Sec], [30 Sec]

To initiate the slide show, navigate to [Enter] and press the center button or select [Cancel] to exit the Slide Show command.

After a slide show begins, you have a couple of navigational options. Press the right or left buttons to navigate forward or backward through the slide show. You can also rotate the control wheel clockwise or counter-clockwise. The front or rear dials on the top of the camera will give you the same results.

Since movies also play in the slide show when View Mode is set to [Date View], there is a volume control option to raise or lower the sound. You must first pause the movie, then press the down button. Press the right or left buttons to raise or lower the volume. The volume change is retained even after the slide show finishes.

To terminate the slide show, press the MENU button or the shutter button halfway to return to Live View, or press the center button to enter Playback mode. There is no way to pause the slide show when still pictures are playing.

The disadvantage of creating a slide show with your camera is it is inflexible and temporary. The command plays back all of the saved images—the good and the bad. Primarily, in-camera slide shows are a quick way to view each image without having to manually scroll through them. Keep in mind that the Slide Show command only uses images and movies on the memory card within the camera. For a more permanent and flexible solution, download your images to your computer and use software to create slide shows. This way you can combine images from multiple memory cards, order the images to your liking, add image transitions, and maybe even music, depending on the software you are using.

There is one major benefit in using the in-camera slide show function: being able to see your still images on a big television screen. This requires that you have an HDMI cable (not supplied with the camera) to connect to your HD television. Use the following steps to connect the camera to the television:

1. Turn off both the camera and TV
2. Connect an HDMI cable to your Sony a7/a7R; then connect the other end of the cable to your HD television.
3. Turn on the TV and make sure the HDMI input selection is set appropriately.
4. Turn your camera on. If the TV input is set properly (input matched to the port being used by the camera's output), you will see an image of what the camera is displaying.
5. When you press the MENU button on the camera, you will see the menu commands appear on the television.
6. Note: If you have a suitable 4K television, you can see your still images at 3840x2160 pixels. This is twice the pixel count of a true HD television, so you will see finer detail than you would on an HD television. To activate this feature, use the following menu command:

MENU>Playback (2)>4K Still Image PB>[OK]

If the command is grayed out, the television is not compatible with 4K operation. If the command is accessible, select OK.

Zooming In on Recorded Still Images

Sometimes you need extra magnification to see if the fine details in a recorded picture are clear. Although you cannot enlarge movie files, you can enlarge all types of still pictures, including panoramas. To do so, press the C2 button while in Playback mode (figure 3-14). This initial press of the button will enlarge the image

significantly. You can continue to enlarge the image in smaller increments by pressing the C2 button multiple times, depending on the recorded file's Image Size. Regardless of the Aspect Ratio, if you have recorded a small image, you will be able to enlarge the image up to nine times during playback. Large and medium image-size pictures can be enlarged up to eight times.

Figure 3-14: C2 button with the Enlarge Image icon

After the image is enlarged, a white box containing a picture of the original image is superimposed in the lower quadrant of the screen. It shows the entire image with a small orange box on it indicating the portion of the image that is enlarged (figure 3-15).

Remember that each subsequent press of the C2 button increases the magnification of

Figure 3-15: Enlarged image with original image box superimposed

the image in small increments. To decrease the magnification, press the AF/MF (or AEL) button. Unlike the initial press of the C2 button, there is no initial large decrease in magnification. Instead, each press of the AF/MF button decreases the magnification by a small amount. The orange box enlarges as the magnification decreases, reflecting the viewable area on the LCD screen.

Four arrows surrounding the enlarged image indicate the directions you can move the displayed portion (by pressing the corresponding right, left, up, or down buttons). Note that the small box within the full image display moves in tandem with the button's direction, indicating what portion of the image you are viewing on the display screen. You can also enlarge the last viewed image without entering the playback mode by initiating the Enlarge Image command:

MENU>Playback (2)>Enlarge Image

This command works in the same way as entering Playback mode and pressing the C2 button to enlarge the image. Either method yields the same results. We prefer using the C2 button instead of the Enlarge Image command because we don't have to go through the camera's menu.

Evaluating Exposure with Histograms

A histogram is a tool that helps you evaluate exposure. It's a graphical representation of the range and distribution of light-intensity values recorded by the sensor. Intensity values are represented on the horizontal axis (black to white), and the numbers of pixels are represented on the vertical axis.

Theoretically, a histogram has the shape of a classic bell curve, with the maximum values near the center, indicating that the brightness level of most pixels is in the middle—not too bright, not too dark. However, in practice, a histogram's shape may be distorted and irregular. Figure 3-16 shows three histogram plots taken from the Sony a7/a7R LCD screen.

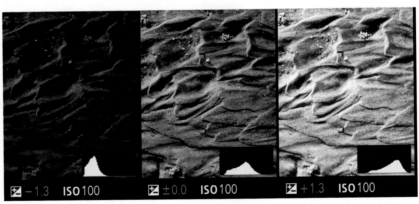

Figure 3-16: Histogram examples of an image that is underexposed, properly exposed, and overexposed

The left histogram indicates that the image is underexposed, meaning that not enough light is hitting the sensor; the middle histogram shows a properly exposed image; and the right histogram indicates that the image is overexposed, meaning that too much light is hitting the sensor.

As you do more photography, you'll realize that you should watch for large numbers of pixels appearing at the extreme ends of the graph. If the histogram is skewed with the curve piling up on the right side of the horizontal axis, then the some of the pixels are receiving too much light and the sensor cannot record all the intensities in the brightest region of the scene. If these areas are large, they will appear as a white mass. However, if there were only a few pixels that are over exposed and they are widely separated, the picture would still be acceptable.

Conversely, if the histogram is piled up against the left side of the horizontal axis, it indicates underexposure. Many pixels are not receiving sufficient light to generate an electrical signal. Again, if there are many underexposed pixels grouped together, that means dark regions of the scene are not being recorded. Such an area will not reveal fine details and will exhibit increased noise. Either way, you will have problems—at the extreme right, the image will have burned-out highlights; at the extreme left, the image will have impenetrable black shadows that lack detail.

Histograms in Preview Mode

The Sony a7/a7R displays a histogram when you preview your shot so you can adjust the camera settings prior to taking the picture. This histogram is a rough guide. To display the histogram during preview, make sure the Histogram data display format box (figure 3-17) is checked in the DISP Button>Monitor or Finder command covered earlier in this chapter. You can even see a histogram while taking a movie or just before taking a panorama. In the case of a panorama, the DISP's Histogram data display format does not work, but you can review the histogram prior to starting a panorama shot via the [For viewfinder] data display format on the LCD screen.

Figure 3-17: Histogram box checked in DISP Button>Monitor command

Keep in mind that a histogram is a real-time measurement of light at the moment you take the photograph. It will change to match changes in the lighting or when you change the camera's settings. Different scenes will usually show varying histograms. Since panoramas involve shooting multiple locations, you can first pan the intended area to view for excessive exposure issues through the preview histograms and make any adjustments prior to shooting the scene.

The live histogram is an approximation—it only displays luminosity. Also, the live histogram cannot show the results of a flash exposure.

A more accurate way to evaluate the exposure is to study the histogram that is displayed when you use the playback button. This displays four histograms: one for luminosity, a second for the green color channel, a third for the red color channel, and the fourth for the blue color channel.

Histograms in Playback Mode

You can obtain more information by studying histograms in playback. For example, you can see how the color channels responded to your exposure. Here, along with the overall intensity histogram, you will have additional color-channel histograms (red, green, and blue) to help you further evaluate the image (figure 3-18). Each color channel has a different sensitivity to light. When you view individual color-

channel histograms, you can see how intensity values "pile up" at the ends of the intensity axis. An imbalance in the color-channels' histograms indicates that there will be a color shift in either the image's highlights or shadows.

Figure 3-18: Histograms available when reviewing a picture

If one channel is over- or underexposed, as evidenced by its histogram, your picture may take on a color cast in either the highlights or shadows. The luminosity (white) histogram may miss this detail. Luminosity is, at best, an average of the light intensities from the red, green, and blue photosites. For example, underexposed images show intensity values accumulating and spiking on the left border of the graph. This can be corrected by reshooting with an increased exposure. The reverse is true for overexposure.

Protecting Saved Pictures and Movies

Have you ever intended to save a picture and inadvertently deleted it? It's frustrating when this occurs. The Protect command guarantees this won't happen when you tag the images that you do not want to accidently erase with the Delete command.

MENU>Playback (2)>Protect>[Multiple Img.], [All with this date], [All in this Folder], [Cancel All with this date], [Cancel All in this Folder]

This command can easily cause confusion. The Protect command's menu has five different options, but only three will be available in the menu at any one time. This is because the displayed Protect command's options are dictated by the View Mode command's value. If you are not seeing what you expected, go back to the View Mode command and set it to the date or folder in which you wish to protect images.

Protect command's [Multiple Img.] option always displays, but the rest will vary:

- When View Mode is set to [Date View] or [AVCHD View], the Protect command displays the following:

 MENU>Playback (2)>Protect>[Multiple Img.], [All with this date], [Cancel All with this date]

3

- When View Mode is set to [Folder View(Still)] or [Folder View(MP4)], the Protect command displays the following:

 MENU>Playback (2)>Protect>[Multiple Img.], [All in this Folder], [Cancel All in this Folder]

The [Multiple Img.] option displays all of the saved files on the memory card regardless of their file type, starting with the last one recorded or played back. To protect specific images, do the following:

1. Select Protect's [Multiple Img.] option. The recorded images are displayed with a check box in the middle-left side of the display screen.
2. Scroll through the images to find an image you wish to protect.
3. Press the center button when the image you would like to protect is highlighted. An orange check is entered into the check box to indicate the image should be protected. To unprotect, uncheck the image by pressing the center button again.
4. Once you have indicated all of the images you wish to protect, press the MENU button to enter the checked images.
5. Select [OK] to protect the files and then press the center button.
6. Once the process is completed, press the center button to exit.

When you select the [All with this date] option, a message displays informing you of the date it will use to determine what images to protect. If you agree, select [Enter]. Otherwise select [Cancel] to exit the command. The displayed date is selected based on the View Mode's last date value.

The [All in this Folder] option works the same way, but protects files in a specific folder. In both cases, if you aren't seeing the images you expected when you select [All with this date] or [All in this Folder], exit the Protect command, go to the View Mode command, and modify it to your desired value.

There are two ways to unprotect images:

- Reenter the Protect command, select the [Multiple Img.] option, and uncheck the checked boxes one at a time.
- Execute the available cancel option: [Cancel All with this date] or [Cancel All in this Folder], depending on the camera's View Mode value.

All image and movie files, protected or otherwise, will be erased when you reformat the memory card using the Format command. In addition, the Protect command is enabled only if there is at least one image stored on the memory card for the selected View Mode.

Deleting Saved Pictures and Movies

Not every picture or movie will be a keeper. As you view the saved images on the camera, you may want to delete one or more.

There are multiple ways to delete files. One way is to use the Delete button to delete one image at a time while in Playback mode. The Delete function screen will be displayed with the Delete and Cancel options. Navigate to the option you want and press the center button to execute. The Delete option deletes the image and displays the next image within Playback mode. The Cancel option exits out of the Delete function and continues to display the image.

Another way to delete images is to use the Delete command in the Playback menu. This method allows you to delete multiple images at the same time. But, like the Protect command, the Delete command's options are at the mercy of the View Mode command's value.

MENU>Playback (1)>Delete>[Multiple Img.], [All with this date], [All in this Folder]

This command's [Multiple Img.] option is always displayed, but the [All with this date] or [All in this Folder] options are dependent on which View Mode is set:
- When View Mode is set to [Date View] or [AVCHD View], the Delete command displays the following:

MENU>Playback (1)>Delete>[Multiple Img.], [All with this date]

- When View Mode is set to [Folder View(Still)] or [Folder View(MP4)], the Delete command displays the following:

MENU>Playback (1)>Delete>[Multiple Img.], [All in this Folder]

To delete specific images, do the following:

1. Select Delete's [Multiple Img.] option. The recorded images are displayed with a check box in the middle-left side of the display screen.
2. Scroll through the images to find an image you wish to delete.
3. Press the center button. An orange check is entered into the check box to indicate the image should be deleted (figure 3-19). You can uncheck the delete indicator by pressing the center button again.
4. Once you have indicated all of the images you wish delete, press the MENU button to enter the checked images.
5. Select [OK] to delete the files and press the center button.
6. Once the process is completed, press the center button to exit.

Figure 3-19: Image selected for deletion. Note the checked box on the left.

When you select the [All with this date] option, a message will be displayed informing you of the date it will use to determine which images to delete. If you agree, select [Enter]. Otherwise select [Cancel] to exit the command. The displayed date is selected based on the View Mode's last date value.

The [All in this Folder] option works the same way, except it deletes files in a specific folder.

In both cases, if you aren't seeing the images you expected when you selected [All with this date] or [All in this Folder], exit the Delete command, go to the View Mode command, and modify it to your desired value.

A third method is to reformat the memory card to delete all saved files regardless of file type:

MENU>Setup (5)>Format>[Enter], [Cancel]

Executing this command will delete all stored files (even protected files) on the memory card.

The most important thing to remember is when you delete a saved file, it is permanently gone from the memory card. The Format command erases everything on the memory card regardless of whether it is protected or not. The Delete function does not erase files that are protected. In addition, the Delete command is enabled only if there is at least one image stored in the appropriate folder or date on the memory card. For example, if you have stored still picture images but there are none in the MP4 folder, you will find the Delete command grayed out if you select the MP4 View Mode, but enabled when you select the still images folder.

Recommendations

We recommend leaving the FINDER/MONITOR setting to [Auto] so the automatic switching between the LCD screen and the viewfinder is operational. This way, you can quickly switch between the two display screens without making a change through the menu structure.

We usually turn off the Auto Review command. Having the Auto Review command only slows up the operation of the camera and disrupts the flow of capturing pictures. Also, we shoot a series of pictures and then review them as a group. Some of the pictures take only a second to review; some take longer. Setting Auto Review to [Off] puts the review process in our hands.

The need to retake pictures is reduced because the display screen allows us to evaluate our image for exposure, white balance, and focus before taking the picture. Unlike a DSLR's optical viewfinder, the more egregious errors of incorrect WB or exposure can be identified immediately and corrected before taking the picture. This makes picture-taking very efficient, and allows us to have a good success rate in the field.

It might seem like overkill, but we have concluded that it is best to select all of the data display formats for previewing the images. Although we have our preferences, we find that we use each of the display formats at least occasionally. Therefore, checking them all gives us the flexibility to use what we want at the time we need it without having to change any settings. If we decide we need the Level gauge, it's already available. We just have to press the DISP button to get the desired format.

We recommend that you review your histograms frequently. A histogram is an excellent tool for reviewing an exposure, both before and after recording. We use them often, especially in the camera's semiautomatic and manual modes.

We set the grid line command to the [Rule of 3rds Grid] option. This helps us balance the image composition with a minimal number of lines. The grid lines are prominent enough that you can see them when you want them, but faint enough to overlook when you don't need them.

Be aware that by itself, the LCD or EVF does not provide sufficient magnification to evaluate image sharpness critically. We frequently enlarge the image before and after taking a picture. It allows us to confirm that the image detail is in focus. Rather than spending money to print out the image only to find that important parts of it are not actually in focus, get in the habit of enlarging the image on the LCD screen. If it isn't in focus, you will most likely have time to make some adjustments and recapture the image.

Don't forget about the View Mode select bar in the Image Index screen. Several camera functions work based on the current View Mode file type. It is easy to get confused about why your movies aren't showing up on the Image Index screen. It may be that the camera is not set to your expected file type. Also remember that if you have created files via a camera application, that file might not show up in the View Mode.

On occasion, we will take time to protect our images. You may need to do the same, especially if you share your camera with someone else.

We are judicious about deleting files while photographing in the field. We occasionally weed out unacceptable images directly from the camera, but we find it much easier to do this cleanup process later when we view the images on our computer.

3

Chapter 4: Automatic Settings

Introduction

How you use the Sony a7/a7R depends on your expertise, your desire to control aspects of picture taking, and your creativity. Even if you do not know such photographic terms as f-stop, shutter speed, ISO, or EV, you can still take technically excellent pictures and movies using the automatic modes. As mentioned in Chapter 2, automated camera settings can take excellent pictures; however, the settings you use depend on the type of subject (i.e. landscape, person) in your image. With the Intelligent and Superior Auto modes, the camera software automatically tries to identify the subject and match it to one of the scene types, thereby ensuring that the most efficient combination of settings are used to create the image. However, you can improve upon these results by choosing a specific scene identification option—turn the mode dial to SCN and choose the predefined automatic mode that is most appropriate for your subject.

The difference between Superior and Intelligent Auto is subtle. Intelligent Auto uses simpler software and restricts itself to working within a single shot. It adjusts the lens opening, the shutter speed, ISO, and white balance to provide an optimum exposure for the scene it identifies. In contrast, Superior Auto uses complex image-processing software that can expose several shots of the same scene and combine them so that the final image is superior to any of the single shots. For example, the camera may fire four shots under low light conditions at high ISO and use them to reduce the appearance of sensor noise in the final picture. This is a major advantage when photographing dimly lit scenes requiring high sensor sensitivity. For example, using multiple shots and combining them mathematically is commonly used in astrophotography.

In many respects, Superior Auto can employ techniques similar to those used by an experienced photographer who is making adjustments to an image in Photoshop. For example, to adjust for extremes in lighting, the camera will employ Auto HDR, firing three shots—one exposure for the highlights, another for the mid-tones, and a final for the shadows. The three exposures are combined within the camera, resulting in an image showing details in all three regions: a feat that cannot be accomplished with a single exposure.

So why does the a7/a7R have two separate auto modes, rather than a single intelligent mode? Sony does not clearly answer this question. From our perspective as users, there's a pragmatic reason for having two such modes: the available speed with which you can capture a follow-up shot. When the camera decides to use the multi-shot strategy in Superior Auto, the camera can spend several seconds processing the images and saving them to the memory card. This can take as long as 10 seconds, and the camera is inoperable for this time. This makes using Superior Auto problematic when you are in a situation where you need to take several shots in quick succession. When you need to grab the next photograph quickly, set your camera to Intelligent Auto.

We start this chapter by discussing the automatic modes, and then cover several menu functions that are available for both Auto and SCN modes to help you plan which automatic mode will suit your workflow.

Shooting Modes

The shooting mode dial (figure 4-1) is the starting point for exerting control over how you shoot your pictures and movies. It provides you with a mixture of automatic and semiautomatic settings and additional artistic features.

The mode dial has ten shooting mode options. Table 4-1 lists these along with a brief description. Rotate the mode dial to activate each shooting mode. If you are new to many of these shooting modes, you can activate the Mode Dial Guide command so a brief description will be displayed for the selected mode (figure 4-2). By default, this option is set to [Off].

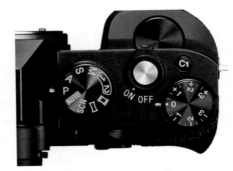

Figure 4-1: Shooting mode set to P

MENU>Setup (2)>Mode Dial Guide>[On], [Off]

To exit out of the description screen, press the center button or shutter button halfway. The selected shooting mode's icon will be displayed in the upper-left corner of the display screen.

The Scene Selection (SCN) shooting mode has a submenu. To select a predefined SCN shooting mode, rotate the front dial (next to the mode dial). Note that the shooting mode icon changes each time the option changes. Stop rotating the dial when it is positioned on the desired SCN shooting mode.

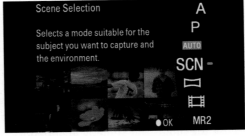

Figure 4-2: Mode Dial Guide description screen

Shoot Mode Option	Description
M Manual Exposure	The camera requires you to set both the shutter speed and aperture manually.
S Shutter Priority	The camera automatically sets the aperture in response to the setting you choose for the shutter speed.
A Aperture Priority	The camera automatically sets the shutter speed in response to the setting you choose for the aperture.
P Program Auto	The camera automatically sets both the shutter speed and aperture, and allows you change the two, in synchrony, so you can use either the aperture or the shutter speed you desire without having to set the other value.
AUTO	The camera evaluates the framed image, attempts to identify the scene type, and sets the controls according to its evaluation. Intelligent Auto only takes one shot, but Superior Auto mode has the additional capability to use multi-frame image processing to improve the quality of the recorded image.
SCN	The camera allows you to select a specific predefined scene mode with settings appropriate to the corresponding scene or subject.
▭ Sweep Panorama	With this option, the camera builds a horizontal or vertical composite panoramic image.
🎬 Movie	This option enables and disables the menu commands that are appropriate for recording movies.
1 Memory Recall 1	This option enables you to recall and shoot with a set of previously saved menu command values.
2 Memory Recall 2	This option enables you to recall and shoot with a set of previously saved menu command values.

Table 4-1: Shooting mode options

Intelligent and Superior Auto Modes

A single mode dial icon, AUTO, controls both the Intelligent and Superior Auto modes. Once the mode dial has been turned to the Intelligent/Superior Auto icon, you are able to use the camera's menu to select the Auto mode you wish to use.

MENU>Camera Settings (6)>Auto Mode>[Intelligent Auto], [Superior Auto]

We recommend retaining the Shoot Mode command as one of the Fn button options so you can avoid having to navigate through the menu to select an Auto mode. You can also access the Shoot Mode on the Quick Navi screen. Both of these options are easier and more straightforward than using the menu. We will cover more about the Fn button in Chapter 7.

Both the Intelligent and Superior Auto modes evaluate the framed image, assign a scene type, and then determine the proper exposure, ISO setting, WB, aperture, and focus for the image based on that assigned scene (table 4-2). When the scene type is determined, the camera displays a corresponding green (Intelligent Auto) or yellow (Superior Auto) icon in the upper-left corner of the display screen.

Intelligent and Superior Auto Scenes		
Icon	**Name**	**Description**
☽	Night Scene	The camera determines that the image is a night scene with artificial lights illuminating a dim scene. The saved image will show predominant dark tones.
🌃	Night Scene using a Tripod	The camera determines that the subject is in a low-light situation that requires a tripod. SteadyShot is disabled.
🌙	Night Portrait	Requires face detection to be turned on manually. Camera identifies at least one face in front of dimly lit background.
🖼	Backlight	The camera determines that the light is behind the focus area, causing a silhouette effect. The camera will adjust the ISO, aperture, and shutter speed to reduce the silhouette effect and obtain a picture. Superior Auto may set to Auto HDR.
👤	Backlight Portrait	Face Detection must be turned on manually. The camera detects a face with strong background light. The camera adjusts the ISO, aperture, and shutter speed to reduce the silhouette effect and obtain a picture.
👤	Portrait	Face Detection must be turned on manually. The camera detects a face and attempts to establish focus and exposure for the face. Face identification must be set to On.

Intelligent and Superior Auto Scenes		
Icon	**Name**	**Description**
⛰	Landscape	The camera determines that the subject is a great distance away and increases the depth of field.
🌷	Macro	The camera determines that it is close to the subject. The aperture is narrowed to increase the depth of field.
⊙	Spotlight	The camera determines that the subject is illuminated by a spotlight and records the subject, leaving the background dim.
🕯	Low Light	The camera determines that the environment has low lighting. The camera will adjust its ISO, aperture, and shutter speed to obtain a picture. Low light is distinct from Night Scene, which is typically used for outdoor shots.
👶	Infant	The camera detects an infant's face by interpreting its facial features/proportions. Face Detection needs to be turned on.
🌙✋	Hand-held Twilight	This scene is only available for identification in Superior Auto. The camera has determined that it is being hand-held in a low light situation. The camera's stabilizer is activated. A series of four shots are taken and combined into one image to reduce noise. This option is not available when Quality is set to [RAW] or [RAW & JPEG].
i⊡	General (Default)	When the camera cannot identify the scene, it chooses generic settings based on lighting and focal point.

Table 4-2: Intelligent/Superior Auto scenes, icons, and descriptions

So how does the camera select the scene mode? Sony engineers and their technical staff do not describe how this is accomplished, but its criteria for choosing a scene can be inferred by using the camera and noting the conditions that are associated with the selected scene. For example, say the camera determines that the framed image's subject is very close (that is, within about a foot to the lens). The camera's software will set the scene type to Macro and sets the camera controls to the best values for a close-up picture. Alternately, if the camera focuses on a subject but detects a lot of light in the background, it would assign Backlight (or Backlight Portrait if the camera perceives the subject to be a person). This brings us to Face Detection and some of the inconsistencies in the design of the [Intelligent Auto] and [Superior Auto] modes. There are four different portrait modes: Portrait, Night Portrait, Backlight Portrait, and Infant. You would think that the camera would be designed to automatically have Face Detection function to [On], but this is not the case. None of these portrait modes can be automatically assigned by the camera's software unless you first set the Smile/Face Detect. command to [On] (figure 4-3).

There are times when the camera's software is unable to determine a specific scene type. In this case, the General Auto icon is displayed on the screen and the camera chooses generic settings (figure 4-4). You will get a good exposure, but the shutter speed, aperture, and ISO may not be optimal for the subject that you are recording.

There are several camera functions that are unavailable in both the Intelligent and Superior Auto modes:

- None of the brightness/color related menu commands, such as White Balance, Creative Style, or Picture Effect, are available.
- Exposure compensation is not available.
- Commands to establish the focus area is unavailable.
- Light metering commands are unavailable.
- The bracket-related Drive Mode options are disabled.
- The Slow Sync., Rear Sync., and Wireless Flash Mode options are disabled.

Figure 4-3: Intelligent Auto with Smile/Face Detect. Off, so Macro scene was selected Instead of a Portrait scene

Figure 4-4: Intelligent Auto with General scene selected

Superior Auto Mode Added Features

Although Intelligent Auto mode can produce great results, Superior Auto mode has an added feature that is able to fine-tune the camera settings to create a better-quality image. Superior Auto determines the same scene modes as Intelligent Auto (table 4-2), but it can also determine if the image would benefit from applying one of the following six shooting functions: Auto HDR, Slow Sync., Daylight Sync., Slow Shutter, Cont. Shooting, or Hand-held Twilight. Some of these shooting functions involve multiple images and/or additional image processing, which means the camera will need more time to take and record the shot. How Superior Auto determines which features to use seems to be proprietary information—after speaking with Sony Technical Support and shooting an immense amount of different shots in different scenarios, we still find it to be a well-kept secret. With that said, don't be surprised if, while in Superior Auto mode, one of the additional shooting functions is displayed briefly along the top of the display screen for a few seconds before you press the shutter button (figure 4-5).

There is a useful command you might want to deploy to get a glimpse of the behind-the-scenes workings of what Superior Auto's multiple-shot shooting functions do to the combined images:

MENU>Custom Settings (4)>S. Auto Img. Extract.>[Auto], [Off]

When the S. Auto Img. Extract. command is set to [Auto], all of the shots taken in a multiple-shot burst are saved, including the resulting combined shot. When the S. Auto Img. Extract. command is set to [Off], only the resulting combined shot is saved on your memory card. We set S. Auto Img. Extract to [Auto] because the allure of seeing all

Figure 4-5: Superior Auto's shooting function, displayed on the screen

the shots that were used to create the combined shot is just too great to pass up. Keep in mind that if you turn this command on, you will see the multiple shots along with the combined picture when you playback your images.

Intelligent/Superior Auto Mode Summary

Scene identification in both Intelligent and Superior Auto modes is imperfect. It should be used as an aid to help you to quickly capture images without having to consider camera settings. Many aspects of these Auto modes prompt the camera to extrapolate the necessary settings for a particular image, and then reset the command settings for your convenience. One exception is the Smile/Face Detection command; you will have to inform the Auto modes to look for faces by manually turning the Smile/Face Detection command on. We can only presume this is a design error in version 1.02 that will be corrected in later bios upgrades for the a7/a7R.

As you become more comfortable with using the camera, you can categorize the subject and select the appropriate predefined scene mode using the SCN mode option without aid of the Auto modes. For more creative photography, you will want to learn how to use the P, A, S, and M modes.

SCN Predefined Scene Modes

When you turn the mode dial to SCN, you will have access to nine predefined scene modes to choose from (table 4-3). Using the SCN's predefined scene modes gives you more control than using the Auto modes because the camera will make setting decisions, such as ISO, exposure, shutter speed, and aperture, based on your selected predefined scene mode and how it interprets the image when you obtain focus. This is an excellent way to help increase your percentage of satisfactory images.

SCN Icon and Name	Description
Portrait	Use this mode to focus on people within the image. Smile/Face Detect. is activated automatically to detect faces. The detected face(s) acquire focus, and the background is blurred.
Sports Action	Use this mode when taking pictures of a moving subject. Drive Mode is automatically set to [Cont. Shooting], Focus Mode to [Continuous AF] focus, and Lock-on AF to [Start w/shutter]. In this mode, the camera is biased to high ISO and fast shutter speed.
Macro	Use this when the subject is close to the camera. The object in view is projected 0.1X or larger on the sensor. The camera is biased to selecting narrower apertures for greater depth of field and low ISO.
Landscape	Use this when photographing distant objects outdoors. The camera uses a lower ISO.
Sunset	Use this when taking pictures of sunrises or sunsets. This mode enhances the red and orange tones in the image. The camera is biased to a lower ISO. You can set this mode even if you are not taking a picture of a sunrise or a sunset.
Night Scene	Use when taking pictures in a nighttime environment. The shutter speed is reduced to capture more light on the sensor. Use a tripod for the best results. The camera is biased to high ISOs.
Hand-held Twilight	Use this mode when shooting a relatively stationary subject at night without a tripod. The camera sets the shutter speed to 1/60 second and raises the ISO. The camera takes four shots and utilizes internal image-processing software to combine them into a single image to reduce image noise and blur (due to low light and camera shake, respectively). Your results can be unsatisfactory if the subject has too little contrast, which makes it difficult for the software to merge multiple images; if the subject moves significantly during the capture sequence; or if the image has repeating patterns that create a moiré effect.

SCN Icon and Name	Description
![Night Portrait icon] Night Portrait	Use this mode when shooting a portrait in a nighttime environment. Face Detection must be manually enabled. The shutter speed is reduced to capture more light on the sensor. Use a tripod for the best results.
((▲)) Anti Motion Blur	Use this mode when shooting indoors without a flash. In this mode, the camera adjusts both the shutter speed and the aperture as necessary. It takes four shots and utilizes internal image processing software to combine them into a single image to reduce image noise and blur (due to low light and camera shake, respectively). In comparison to Hand-held Twilight, it tends to select higher shutter speeds and higher ISO values.

Table 4-3: SCN predefined scene modes

You must always have the mode dial turned to SCN in order to view and select a predefined scene mode. When you select SCN mode, the last selected predefined scene icon will be displayed in the upper-left corner of the display screen. Rotate the front dial (next to the mode dial) to move through the available predefined scenes. As you scroll through the scene options, the scene mode's icon changes. The camera will automatically apply the camera settings for the selected scene option when you focus and take the picture.

Another way to access the SCN options is through the Shoot Mode command. This is one of the Fn button's default options. If you select the Shoot Mode through this method and the mode dial is set to SCN, the predefined scene modes will be displayed in a vertical list along the left side of the display screen. Rotate the control wheel to move through the list. If you have the Mode Dial Guide command set to [On], each highlighted, predefined scene mode will include a brief description to help you decide if it best suits your image (figure 4-6). Press the center button to select a scene mode. Again, we recommend retaining the Shoot Mode command as one of the Fn button options rather than navigating through the menu using the front dial. We will cover more about the Fn button in Chapter 7.

Most of the predefined scene modes are straightforward. Two of the options, Hand-held Twilight and Anti Motion Blur, are not so easily distinguished. Both modes fire multiple shots and average them into a single image to reduce noise and blurring caused by slight camera movements. The other predefined scene modes allows

Figure 4-6: Description of Macro predefined scene mode

you to record the images in RAW format, but these two modes only allow [Extra Fine], [Fine], or [Standard] JPEG, thus limiting your ability to do post-processing outside of the camera. If you had the Quality command set to [RAW] or [RAW & JPEG], the camera temporarily changes the Quality value to [Fine]. The original Quality value will be restored when you move out of this SCN option.

Generally, low light causes noise to be recorded within the image. Use the Hand-held Twilight mode when you are photographing an outdoor scene in dim light without a tripod. When this mode is activated, the camera takes four shots at high sensitivity and merges them to form a single image with reduced noise.

Use Anti Motion Blur mode when you are shooting indoors in low-light environments or when there is slight camera movement, usually caused by holding your camera in your hand while shooting. As with Hand-held Twilight, the Anti Motion Blur mode takes four shots and averages the results into one image, thus reducing the slight blurring due to camera movement.

Both of these commands prompt the camera to adjust the shutter speed and aperture as necessary for the framed image. The difference between the two commands is that Anti Motion Blur is far more aggressive in raising the ISO than Hand-held Twilight. It is our belief that the former must contend with subject motion (hence, Anti Motion) and small degrees of motion are more easily corrected with a shorter shutter duration. In contrast, Hand-held Twilight makes the assumption that the scene is mostly static and is therefore less concerned about freezing movement.

Neither Hand-held Twilight nor Anti Motion Blur is effective in all situations. In order to align the multiple exposures into one, the image has to have sufficient color contrast so the camera can match up the objects in each image and merge them together to build a final photograph. This will be difficult if the subject moves or if the light source flickers, such as with fluorescent lights. In addition, problems can occur when the color scheme in the image is monotone or has repeating patterns; this will confuse the camera when it is trying to align the subject to merge the multiple images.

Figures 4-7a and 4-7b are a comparison between Anti Motion Blur and a single shot image taken in a low-light environment. Both images have been enlarged to show the amount of noise.

Functions Available for Automatic Modes

The automatic modes do not provide the full range of controls that you have available when shooting in P, A, S, or M mode. Fortunately, they do allow you to adjust the Drive Mode, Flash Mode, Lock-on AF, and Smile/Face Detect. We will cover these options in this section since you can change them in the automatic modes, but we will discuss them in greater detail in Chapters 5 and 6 when we discuss P, A, S, and M modes.

Drive Mode Command

The Drive Mode command allows you to specify how the camera will act when you fully depress the shutter button. The Drive Mode has a total of nine options, but not all are available within the automatic modes. In this section we will cover

Figure 4-7a: Low-light Anti Motion Blur mode results

Figure 4-7b: Low-light P mode results

the options that are available for modification within the automatic modes. The remaining, unavailable options will be discussed in Chapter 6.

MENU>Camera Settings>Drive Mode (1)>[Single Shooting], [Cont. Shooting], [Spd Priority Cont.], [Self-timer], [Self-timer(Cont.)], [Cont. Bracket], [Single Bracket], [White Balance Bracket], [DRO Bracket]

Table 4-4 shows which Drive Mode options and sub-options are available in the Intelligent Auto, Superior Auto, and SCN modes. Keep in mind that the Drive Mode setting has no effect when recording a movie.

Drive Mode Option Availability									
Automatic Modes	Single Shooting	Cont. Shooting	Spd Priority Cont.	Self-timer	Self-timer (Cont.)	Cont. Bracket	Single Bracket	White Balance Bracket	DRO Bracket
Intelligent Auto	E	E	E	E	E	D	D	D	D
Superior Auto	E	E	E	E	E	D	D	D	D
SCN									
Portrait	E	D	D	E	D	D	D	D	D
Sports Action	E	E	E	D	D	D	D	D	D
Macro	E	D	D	E	D	D	D	D	D
Landscape	E	D	D	E	D	D	D	D	D
Sunset	E	D	D	E	D	D	D	D	D
Night Scene	E	D	D	E	D	D	D	D	D
Hand-held Twilight	Drive Mode command is disabled								
Night Scene	E	D	D	E	D	D	D	D	D
Anti Motion Blur	Drive Mode command is disabled								
E = Option is enabled; D = Option is disabled									

Table 4-4: Drive Mode options available in automatic modes

The following icons represent the available options:

⬜ Single Shooting—The camera fires one shot per press of the shutter button.

🔲 Cont. Shooting—The camera shoots continuously as long as the shutter button is held down and the memory card has room to store images. The camera maintains this firing rate until the memory buffer is filled. If the flash is operational, the firing rate slows down to allow the flash to recharge in between shots.

⬚ Spd Priority Cont.—The camera shoots continuously at a higher speed than [Cont. Shooting] as long as the shutter button is held down and the memory card has room to store the images. The camera maintains this firing rate until the memory buffer is filled. After that, the rate of firing drops. When using the flash, the continuous shooting rate is slowed to allow the flash to recharge before firing.

↻ Self-timer—When operational, this option delays firing the camera either two or ten seconds after the shutter button is pressed, at which time it fires a single shot.

↻C Self-timer (Cont.)—This option delays firing the camera until ten seconds after the shutter button is pressed, at which time the camera fires a continuous set of three or five shots.

Why Does the Self-timer (Cont.) Drive Mode Take More Than One Shot?

When you take a photograph of a group of people, it always seems like one person is blinking or looking away just when the shutter is released. This can ruin the photograph, so Sony gives you the option of firing three or five shots after the self-timer has ticked off ten seconds. Hopefully, at least one of the pictures will show everyone perfectly posed, and you will have an excellent group shot of your family and friends.

Flash Mode Command

The Sony a7/a7R does not have an internal flash unit of its own. Instead it has a multi interface shoe on the top of the camera to hold an external flash. How it fires will be controlled by the Flash Mode command:

MENU>Camera Settings (2)>Flash Mode>[Flash Off], [Autoflash], [Fill-flash], [Slow Sync.], [Rear Sync.], [Wireless]

Because the Sony a7/a7R lacks a built-in flash unit, these options all pertain to a compatible, attached accessory flash. Even though the Flash Mode allows you to specify how and when this attached flash will fire, not all of the command's options are available in the automatic modes. See table 4-5 for a list of the available options.

Flash Mode Option Availability in Automatic Modes						
	Flash Mode Options					
Modes	Flash Off	Auto-flash	Fill-flash	Slow Sync.	Rear Sync.	Wireless
Intelligent Auto	E	E	E	D	D	D
Superior Auto	E	E	E	D	D	D
SCN						
Portrait	E	E	E	D	D	D
Sports Action	E	D	E	D	D	D
Macro	E	E	E	D	D	D
Landscape	E	D	E	D	D	D
Sunset	E	D	E	D	D	D
Night Scene	Flash Mode command is disabled					
Hand-held Twilight	Flash Mode command is disabled					
Night Portrait	Flash Mode command is disabled					
Anti Motion Blur	Flash Mode command is disabled					
E = Option is enabled; D = Option is disabled						

Table 4-5: Flash Mode options available in automatic modes

The following icons represent the available command's options. They are accompanied by a high-level description. Chapter 10 will cover the flash functionality in more detail.

- Flash Off—This option prevents the attached flash unit from firing.
- Autoflash—With Autoflash, the camera decides when the level of light is low enough to fire the attached flash.
- Fill-flash—When this option is selected, the attached flash always fires.

Face Detection and Registration Functionality

Cameras equipped with Live View frequently have Face Detection software, which can be quite elaborate, with many options for memorizing a face and prioritizing its value for focusing. Sony Face Detection and registration is straightforward and easy to use.

There are two aspects of the Face Detection process. The first is to simply identify a face within the frame by turning on the Face Detection feature. The second is to ensure that the camera recognizes a specific face. This requires that you register faces into a library stored within the camera's internal memory. Once this is done, the camera will remember a person's face, and when it is recognized, that face becomes the focus point of the image. When there are multiple faces within the image, the camera will focus on a registered face before a nonregistered face. Then,

the camera prioritizes focus of registered faces based on how you rank those faces in the library, making the highest-prioritized face the focus point.

The value of this feature is that it prevents the camera's software from choosing a random stranger as the focal point of your picture. For example, if you are taking a picture of your child at a park, you want the camera to focus on your child's face, not on the strangers standing around him. You can be assured that this will occur if his face is registered in the camera's memory.

In order to be recognized, the person must be facing the camera so that their facial features are clearly presented. The software bases its determination of a face on detecting two eyes, a nose, and a mouth. Facial recognition will fail if all the camera sees is a person's profile. Also, certain conditions, such as the face being too small in the frame or harsh shadows falling on the person's face, may interfere with face recognition.

Face Registration requires that you to assemble a library of portraits for the camera. You can register up to eight faces and order them by their importance. This way, if you have a group picture, the camera will focus on the person most important to you (based on your rankings within the registration library). To increase the probability of focusing on the right person, you can register multiple images of the same person.

Important points:
- Up to eight faces can be detected within one framed image.
- Face Detection functionality is enabled for single still picture shooting modes. It is disabled when the image is magnified by any Digital Zoom option; or when the camera is in Sweep Panorama mode; or when either SCN's Hand-held Twilight or Anti Motion Blur predefined shooting modes are activated.
- Face Detection can be activated when taking movies but registered faces are not prioritized.
- Animal faces cannot be detected.
- Face Detection and/or registration may fail if facial features are obscured—such as when the person is wearing sunglasses or a hat. Poor or bright lighting that casts unusual shadows can prevent the successful recognition of a face.
- Face Registration information is not deleted when you execute the Setting Reset command's [Camera Setting Reset] option, but will be deleted if you execute the [Initialize] option.

Why Doesn't Face Detection Recognize My Cat?

Even with two eyes, a nose, and a mouth, your cat's facial proportions are uniquely feline. Face Detection and recognition software looks for proportions and ratios between the two eyes, the noise, and the mouth that characterize the human face.

Registering Faces

To register faces within the registration library, first access the Face Registration command through the MENU button:

MENU>Custom Settings (5)>Face Registration>[New Registration], [Order Exchanging], [Delete], [Delete All]

Make sure your subject is brightly and evenly illuminated without pronounced shadows. They should be looking into the camera and should not be wearing sunglasses or hats. Then execute the following steps:

1. Enter the following command:

MENU>Custom Settings (5)>Face Registration>[New Registration]

2. Frame the person's face you wish to register (figure 4-8a). Make sure the person is facing the camera so you can capture the entire face. A white box will display in the center of the screen. Position the camera so that the person's face is within the white box.

3. Press the shutter button halfway to establish focus. Adjust the framed face to ensure the person's eyes, nose, and mouth are centered within the cornered brackets.

Figure 4-8a: Face framed for registration

Figure 4-8b: Face registered

Figure 4-8c: Confirmation face is registered

Figure 4-8d: Face could not be registered

4. Press the shutter button to take the image.
5. The camera will determine if there are sufficient facial characteristics to register the face. If there are, you will be asked if you want to register the face (figure 4-8b). To accept, press the center button to select Enter. If there is sufficient information to register the face, the camera will indicate it is registered (figure 4-8c). If there is insufficient information, the camera will inform you that it cannot register the face and ask you to start again (figure 4-8d).

You can register up to eight faces. The [New Registration] option is enabled only when there is at least one empty slot available. If all eight slots are filled, you must remove at least one registered face (using the [Delete] option) in order to register another face.

Assigning Priorities to Registered Faces

Each time you register a face, the image is stored in the next available slot. You can see the order when the [Order Exchanging] option is selected. Each slot is numbered with its priority, starting with first priority in the top-left slot and so on down to the bottom-right slot, which is ranked eighth priority. To change the order of the faces in the slots, follow these steps:

1. Enter the following command:

 MENU> Custom Settings (5)>Face Registration>[Order Exchanging]

2. Highlight the face you wish to reorder (figure 4-9a). The face will be enclosed in an orange box. Press the center button to select the face. The face will be underlined with an orange

Figure 4-9a: Highlighted face

Figure 4-9b: Pending location for selected face

Figure 4-9c: New location for selected face

line. An orange double-arrow vertical bar will be displayed to the left of the selected face.

3. Using the right or left button, navigate the double-arrowed bar to the left of the slot where you wish to move the image (figure 4-9b).

4. Press the center button and the selected image will be moved to its new location (figure 4-9c).

The [Order Exchanging] option is enabled after at least one face is registered.

Deleting Registered Faces

As your children get older, you will need to update your library register by replacing their registered image with a more recent image. Remember, you can register only eight faces— you'll probably need to delete out-of-date faces at some point.

To delete a registered face, follow these steps:

1. Enter the following command:

 MENU>Custom Settings (5)>Face Registration>[Delete]

2. Eight boxes are displayed on the screen. The first box is enclosed in an orange frame. Each box contains an image of a person you have registered, or the box is empty. Navigate to the image you wish to delete. The orange box moves to each selected slot. Press the center button to select the image for deletion.

3. A confirmation menu will be displayed.

4. Select the [Enter] option to delete the selected face, or the [Cancel] option to cancel the deletion. Press the center button to complete the process.

To delete all of the registered faces at one time, follow these steps:

1. Enter the following command:

 MENU>Custom Settings (5)>Face Registration>[Delete All]

2. A confirmation menu will be displayed.

3. Select the [Delete] option to delete all of the registered faces or the [Cancel] option to cancel the deletion. Press the center button to complete the process. The [Delete] and [Delete All] options are enabled after at least one face is registered.

Activating Face Detection

As mentioned earlier in the chapter, Face Detection defaults to [Off] in most modes, even in situations when you'd assume it to be automatically activated. Fortunately it's easy to activate Face Detection by selecting the following command:

MENU>Camera Settings (5)>Smile/Face Detect.>[Off], [On (Regist. Faces)], [On], [Smile Shutter]

The Face Detect. command portion has three options (table 4-6). Select the [On] or [On (Regist. Faces)] option and press the center button to activate Face Detection.

Face Detection Icon/Name	Description
[●] On (Regist. Faces)	Activates Face Detection and prioritizes focus for registered faces based on the order of importance specified in the register library. Face Detection is automatically set to this value when Smile Shutter is activated.
[●]ON On	Activates Face Detection but does not prioritize registered faces to establish focus.
[●]OFF Off	Deactivates Face Detection. The camera is oblivious to faces in the framed image unless you select them as objects for tracking.

Table 4-6: Face Detection command options

Using Face Detection and Registration

When Face Detection is set to [Off], no faces will be detected and focusing will be managed by the Focus Mode and Focus Area command settings. When Face Detection is set to [On], and the camera detects one or more faces, it will surround each face with either a white or gray box. A white box indicates that the face will be used to establish focus; gray means that the face is detected, but is not being used for focusing.

If Face Detection is set to [On (Regist. Faces)], focus will be established based on the focus priority in the registry. If a single face is detected, a white box encases the face. When you press the shutter button halfway and the camera locks focus on the face, the white box turns green. If several faces are detected within the frame, boxes surround each of the faces. Each box is colored white, gray, or magenta. A white box indicates the face that the camera intends to focus on. A gray box indicates the face is detected, but will not be used for focusing, and magenta indicates a registered face that will not be given focus priority. We've found the Sony a7/a7R to be inconsistent—the identified-face boxes sometimes changed colors while we were framing the image.

The Face Detection function is available in Manual Focus Mode, but although faces are detected, they cannot be used to automatically establish focus.

Smile Shutter Functionality

How many times have you said, "Say cheese," and still found that your subject failed to smile when the picture was taken? The Sony a7/a7R has a function to help prevent this. After focus is obtained, the Smile Shutter command instructs the camera to automatically take a picture when it detects that a person is smiling. Furthermore, you can set the degree of smile sensitivity the camera will use to trigger the shutter (table 4-7).

Smile Shutter Icon/Name	Description
☺OFF Off	The shutter is not triggered when a detected face smiles.
☺ On: Slight Smile	The shutter is triggered when a slight smile is detected.
☺ On: Normal Smile	The shutter is triggered when a normal smile is detected.
☺ On: Big Smile	The shutter is triggered when a big, full smile is detected.

Table 4-7: Smile Shutter command options

Enter the following command to access the Smile Shutter options:

MENU>Camera Settings (5)>Smile/Face Detect>Smile Shutter>[On: Big Smile], [On: Normal Smile], [On: Slight Smile]

Activating Smile Shutter can be a bit confusing. The command's Smile Shutter On option activates the function, but there is no Off option. When the On value is selected, use the left or right buttons to move through the smile sensitivity submenu. Regardless of which Face Detection option you select, once you select the Smile Shutter option, Face Detection is set to [On (Regist. Faces)] and a smile sensitivity bar will be displayed vertically on the left side of the screen. To turn off the Smile Shutter functionality, press the MENU button, use the mode dial to change the shooting mode, or press the playback button. Entering and exiting any of these three functions will be enough to turn the Smile Shutter functionality off.

Figure 4-10 shows the resulting display screen after [On: Slight Smile] is selected. Note the vertical smile sensitivity meter on the left side, with the arrow indicating the level of smile sensitivity that needs to be reached to trigger the camera to take the picture.

Figure 4-10: Smile Shutter display screen with Slight Smile selected

The next time the camera detects a face and obtains focus (indicated by the box around the face turning orange), it will try to interpret the person's level of smile. If the smile meets or exceeds the selected sensitivity level, the camera will automatically take the picture and will continue to take pictures until the person's smile no longer meets the selected level.

You can still manually take a picture even if the smile does not meet the chosen sensitivity criteria. Maybe you have Smile Shutter turned on, but your subject starts frowning. You may feel that this serious expression will make a great portrait. To capture this moment, press the shutter button and take the picture. After this, the camera will resume taking pictures automatically when it detects a smiling face that meets or exceeds your chosen smile sensitivity level, regardless of whether the face had been registered or not. If you find that the subject's smiles are not meeting the sensitivity level, select a lower sensitivity option.

How Does Smile Shutter Work with Multiple Faces?

Say you have multiple people in your picture, and not all of them are smiling. You have Smile Shutter turned on, with Face Detection automatically set to [On (Regist. Faces)]. Unfortunately, this function doesn't wait for everyone to smile. After the camera detects faces and obtains focus, all it takes is for one detected person to smile at or above the smile sensitivity level to trigger the shutter button.

Important points:
- When Smile Shutter is active, the camera does not go into sleep mode. You can run down the battery very quickly while the camera looks for qualified smiles for a prolonged amount of time.
- Smile Shutter functionality does not work in Manual Focus Mode or when Face Detection is turned off or is unavailable, such as when the Zoom feature is being used, or when the camera is in Sweep Panorama or SCN's Hand-held Twilight or Anti Motion Blur predefined shooting modes.

- Once activated, the Smile Shutter command remains active until the shooting mode is changed, you have entered the menu, or you press the playback button.
- Turning on Smile Shutter automatically turns on Face Detection and Registration recognition. Turning Smile Shutter off will cause Face Detection to revert to its previous value.
- Smile Shutter is inconsistent. Sometimes your subject gives a big smile, and it does not trigger a shot.
- When Smile Shutter function is activated, the Drive Mode option is automatically set to [Single Shooting] and will change back to its previous setting once Smile Shutter function is deactivated.
- If the DRO/Auto HDR command is set to [Auto HDR], Smile Shutter will take three shots and create an HDR image.

Tracking Objects with Lock-on AF Command

The Lock-on AF command allows the user to select a subject for the camera to track. If the subject moves within the frame, the camera maintains focus on it and retains the set exposure values. This command is not available when the Focus Mode command is set to Manual Focus [MF], when in Sweep Panorama shooting mode, or in SCN's Anti Motion Blur or Hand-held Twilight predefined shooting modes.

Select the command through the menu:

MENU>Camera Settings (5)>Lock-on AF>[OFF], [ON], [On (Start w/shutter)]

When the Lock-on AF function is initiated, a small white box with a larger gray box surrounding it is displayed in the center of the screen (figure 4-11a). Frame the image with the subject you wish to track in the center of the white box. Press the center button to initiate tracking the object. A white double box (a box within a box) will frame the selected object, and it will follow the subject as it moves within the screen (figure 4-11b). Press

Figure 4-11a: Lock-on AF Object Tracking selection screen

Figure 4-11b: Object selected for tracking

the shutter button halfway to focus. If focus is obtained, the double box will turn green, and you can take the shot.

The camera should continue to track the subject, allowing you to take shot after shot until the camera no longer has sight of the subject, the Lock-on AF command has been turned off through the menu or by pressing the center button, or the camera is turned off. If you wish to start tracking another subject, return to the Lock-on AF command, select [ON], position the white and gray boxes over your subject, and press the center button.

The [On (Start w/shutter)] option gives you a faster way to establish tracking. This Lock-on AF option is enabled only when the Focus Mode command is set to [Continuous AF]. In this case, frame the object you wish to track in the center of your screen and press the shutter button halfway. When focus is established (double green box surrounding your subject), tracking is initiated. Since you have continuous autofocusing turned on, the camera will continue to track your subject and try to maintain focus as long as you hold the shutter button down halfway. When you are ready to take the shot, fully depress the shutter button.

If you want to start tracking another subject, frame it in the center of your screen and press the shutter button halfway to establish focus. Now the camera will track this new subject.

Successful object tracking requires the camera to be able to distinguish the selected object's colors and details from the background. You will most likely select only a portion of the subject you want to track. Make sure the part you select is detailed and can be easily differentiated from other objects within the scene; otherwise the camera may lose its target.

Lock-on AF command's [On (Start w/shutter)] option is automatically enabled when shooting in SCN's Sports Action predefined shooting mode, but is disabled in Sweep Panorama and SCN's Anti Motion Blur and Hand-held Twilight predefined shooting modes, and unusable if the Focus Mode command is set to Manual Focus [MF].

We had great hopes of using the Lock-on AF functionality, especially due to the ease of initiating it with the shutter button. Theoretically, this could be a great feature to utilize. Unfortunately, we had difficulty making this command work consistently, and therefore rarely use it. This command frequently lost tracking of the object—even slow-moving subjects could not be followed consistently.

Recommendations

If you want to take technically good images without having to choose any of the settings, we recommend that you try the Intelligent Auto, Superior Auto, and SCN predefined scene modes. Although it's likely that eventually you will want to take

control of the camera settings yourself, these automatic modes are excellent for capturing a picture on the spur of the moment when you don't have time to evaluate the camera settings and lighting.

It's not always obvious how the camera software determines its automatic settings. As you take pictures, instead of just accepting the results, review your work and think about how the image could be changed and whether the changes improve or weaken the picture. For example, is it better to show action shots as frozen images, with all their details rendered sharply, or is it better to use a longer shutter speed to blur portions of the image to suggest speed? Check out the nuances of camera command settings for specific predefined scene modes. You can always view the settings for an image in the data display screen format described in Chapter 3. Keep in mind that the camera software makes its best guess about the settings to be used for a particular scene, and implements decisions based on what is considered typical for that situation.

We have used the Hand-held Twilight and Anti Motion Blur predefined scene modes to reduce image noise in dim lighting while doing handheld photography. Our concern about using these modes is that they both capture only JPEG files. We recommend that you try both and see which suits you best in various scenarios. Although these modes are valuable features for those who shoot handheld, keep in mind that a tripod is a great way to stabilize the camera for shooting with long exposures in dim light. If you're in a situation in which you must rely on a single exposure of your subject, we think the better course of action is to capture a RAW image rather than a JPEG. RAW images have more image data, which gives you the option of using third-party software to reduce noise and ultimately get better resolution than the combined JPEGs processed by Sony's in-camera noise reduction software.

Both the Smile Shutter and Face Detection/Registration functionality clearly have value and can help you capture great pictures. We've found that Face Detection/ Registration sometimes misidentifies which face to focus on first. Several times we've seen a nonregistered face gain focus over one that was registered. This may be due to the nonregistered face being closer to the camera.

If you find that the results are satisfactory, you may remain an avid user of the automatic modes. However, remember that the image-processing algorithms used in these modes can also be applied to your images outside of the camera. By using image-processing software with your RAW-format files, you can bring out the finest nuances, details, and contrast in your images. To accomplish this, you'll have to use the semiautomatic and manual modes described in Chapters 5 and 6, respectively. These modes afford you more control over your photographic results. Granted, there is a learning curve, but everything you are learning now provides the groundwork for later lessons on how to have more manual control of your photography.

Chapter 5: Taking Control of the Camera

Introduction

This chapter is about taking greater control of your camera's operations. Intelligent Auto, Superior Auto, and the SCN modes automatically set the camera's Focus Mode, shutter speed, and aperture; although this yields a sharp and properly exposed image, it prevents you from adjusting the camera settings and improving the image based on your artistic designs.

You can gain this control by using the Program Auto (P), Aperture Priority (A), and Shutter Priority (S) shooting modes. Essentially, these allow you to control the aperture, shutter speed, or ISO independently while still having automatic exposure provided by the camera. Hence, we consider these shooting modes to be semiautomatic. If used improperly, these controls will result in blurred or out-of-focus pictures, which are inferior to what can be achieved by relying on the camera's fully automatic settings.

However, when used with care, these semiautomatic modes can create pictures that would be unattainable in any other way, such as recording the night sky or other scenes set in difficult lighting conditions. Unlike the fully Manual Exposure (M) shooting mode, P, A, and S have a degree of automation which speeds up the process of setting exposure. In fact, we tend to use these semiautomatic modes more frequently than the fully manual mode described in the next chapter.

The camera's ISO value is selected by the automatic modes. When you switch to semiautomatic you can control the ISO setting. The Sony a7/a7R's ISO command has two option icons, which can be easily confused: [ISO AUTO] and [AUTO]. The Sony's supplied user guide manual refers to these icons by their descriptive names: [Multi Frame NR] and [ISO AUTO], respectively. In order to prevent confusion, we will reference these options by these descriptive names.

P mode allows the camera to set both its aperture and its shutter speed for proper exposure. Unlike the automatic modes, in P mode you can set the ISO and WB. To use this mode and all the other semiautomatic modes effectively, we recommend taking the camera off of [ISO AUTO] and setting it to a specific value. You will need to monitor your shutter speed to make sure it does not become so prolonged that camera movement softens the image. Although the camera sets both aperture and shutter speed automatically, you have a degree of control because you can choose different combinations of the two with the camera providing a commensurate balance to your setting. For example, the camera may initially set the aperture to f/4.0 and the shutter sped to 1/125 second. You don't have to use these values. You can change the combination of aperture and shutter speed to another value, such as f/2.8 and 1/250 second or to f/5.6 and 1/60 second. Sony calls these changes Program Shift, and it is accomplished by rotating the front or rear dial.

If you want to take more direct control of the lens opening, turn the mode dial to A. Here, you select the aperture and the camera sets its shutter speed for the recommended exposure. This is called Aperture Priority. In contrast, turning the mode dial to S allows you to select the shutter speed while the camera sets its aperture to obtain the recommended exposure. This is called Shutter Priority. In all three cases, you can override the camera's recommendations with the exposure compensation dial and apply more or less exposure.

The advantages of using A and S modes is that they allow you to control the depth of field or the appearance of moving objects, respectively. Certain types of subjects require the aperture to be set at a constant value. This is done frequently for macro photography, portraiture, and landscapes. In contrast, to properly render an active subject, you have to have control of the shutter speed. You can attain this control by using S mode. This level of control is not attainable when using either the Intelligent or Superior Auto.

When you carefully evaluate your pictures and decide to exert greater control over the settings, you gain awareness of what you should focus on in the scene. In automatic modes, the camera selects where to establish focus. For example, the factory default for the a7 uses a wide field for focusing. This is suitable for a moving subject when the photographer does not have time to carefully select where focus should be. However, in more leisurely photography, such as capturing a landscape, there is time to identify what region should be in focus. It should be noted that the a7R's factory default uses a flexible spot for focusing. This allows the photographer to aim the camera at the subject of interest, lock focus on it, and then align the camera to frame the subject properly. The difference between the two default focusing areas reflects Sony's belief that the a7 is more suited to action photography, and the higher resolution a7R is more suited to landscape photography. In this chapter, we will discuss how to target the automatic focus and how to override it so you can focus manually.

Included in this chapter are detailed descriptions of white balance, ISO, and Focus Area. These functions are now yours to control, and you will have to decide when to choose predefined values for them if you wish to alter their automatic behavior.

Three Semiautomatic Modes: Shutter Priority (S), Aperture Priority (A), and Program Auto (P)

As mentioned earlier, using the P, A, or S shooting modes gives you greater control over your photography. You select these modes with the mode dial.

Program Auto (P)

Program Auto (P) mode sets both the shutter speed and the aperture, and keeps the two in balance. As you turn the front or rear dial, you will see the shutter speed values changing in parallel to the aperture. If you don't like the aperture or the shutter speed that is set, turn the front or rear dial again to see if you like the results better with a different set of control values.

Turn the mode dial to P; you will see the letter P in the upper-left region of the screen along with the camera's selected aperture and shutter speed combination settings along the bottom of the screen (figure 5-1a). The letter may disappear in certain display options on the LCD screen. If the camera is set to [ISO AUTO], it will allow you a greater range to vary your settings; unfortunately you won't know what ISO value will be used until you press the shutter button down halfway. At this point, the ISO value will be displayed just prior to taking the picture.

If you depart from the camera's recommendation by rotating the front or rear dial, the P is replaced with a P* (figure 5-1b). This is Sony's symbol for Program Shift. When you apply exposure

Figure 5-1a: P mode in Live View with an aperture of f/5.0 and shutter speed of 1/100 second

Figure 5-1b: Program Shift by changing the shutter speed or aperture

1/125　F5.6　**⊠** – 1 0　ISO AUTO

Figure 5-1c: Exposure compensation changed to -1 EV in P mode

compensation, two things will occur. The aperture opening and/or the shutter speed value will be altered from the values that the camera had set initially. In either case, turning the exposure compensation dial is shown by a change in the exposure compensation value's color from white to orange on the display screen (figure 5-1c). This color will turn back to white after a few seconds.

The exposure compensation will display differently depending on where you view it. When viewing it on the LCD screen, the exposure compensation is a single ± number on the bottom on the screen. Through the viewfinder, the exposure compensation value is represented by a triangle moving across a scale. Although the scale spans ±5 EV, the exposure compensation dial only lets you adjust by ±3 EV. The larger compensation range can only be set in software. In any case, when you attempt to go beyond the limits of the lens's maximum and minimum aperture, the f-stop, shutter speed, and the exposure compensation values start flashing.

If you use [ISO AUTO] with P mode, you have the working photographer's equivalent of Intelligent Auto or Superior Auto. With experience, you can duplicate and improve on the automatic settings with little cost in convenience or speed of operation.

Aperture Priority (A)

Aperture Priority (A) mode allows you to select the aperture, and the shutter speed will be adjusted by the camera for the recommended exposure. This enables you to control the depth of field, which is critical for Extended Depth of Field and HDR (High Dynamic Range) photography. Both of these techniques require that several shots be taken that will be combined in post processing to provide either an increase in depth of field or an increase in the dynamic range of the sensor. For Extended Depth of Field, the focus is changed slightly with each shot, but the depth of focus is kept constant to ensure that sharpness between two adjacent focus settings overlap. Otherwise, there would be blurred regions in the final processed image. In the case of the HDR, you expose the same scene at multiple exposures without changing focus or aperture. The depth of field must be held constant to prevent variations in sharpness between adjacent exposures, causing blurring in those areas.

Additionally, aperture control is important for taking single photographs. By restricting the depth of field, you can force the viewer to concentrate on the subject. In the case of portraiture work, you want the viewer to focus on the model's face. This is accomplished by focusing sharply on the model's eyes and using an aperture with a narrow depth of field that blurs the background and foreground.

Turn the mode dial to A to use Aperture Priority. You will see an A in the upper-left corner of the preview screens. Again, the letter may disappear in some display modes. The f-stop value turns orange when you turn the front or rear dial. As its value changes, so does that of the shutter speed. When exposure compensation is applied, the shutter speed varies and the EV numbers for exposure compensation temporarily turn orange.

Two Types of Depth-of-Field Preview

A mode provides a real-time depth of field because it closes the aperture down as you turn the front or rear dial. In essence, the camera measures the decrease of light and uses this value for calculating exposure. This is unlike S and P modes. In these modes, the lens normally stays at its most open aperture, and as you turn the dial, the camera calculates what the exposure should be for the aperture you set. During this change of aperture, the intensity of light does not change and depth of field remains at this narrowest level. When you press the shutter button, the lens closes to set its aperture just before the picture is taken. What this means is that you do not get a real-time depth-of-field preview when composing your subject. To see depth of field, you need to manually close down the lens to its set aperture.

Sony allows you to customize a button (the C1, C2, C3, and center button), and assign it as either the [Aperture Preview] or [Shot. Result Preview] option. Both of these options will narrow the lens aperture when the customized button is pressed. Both show you what the depth of field will be when you take the picture. The one difference between the two commands deals with the appearance of moving objects. Remember that a slow shutter speed will blur a moving object. The [Shot. Result Preview] option provides you an indication of how much blurring will take place when you use the slower shutter speeds. Its effect is imperfect—it will not show the blurring that would result from using a one second or longer exposure, but you may still find it helpful.

Previewing depth of field is an important benefit for the landscape or portrait photographer who uses the lens aperture to focus the person's interest on the subject. It is critical for macro photography. However, photographers who shoot action shots will eschew this feature.

Shutter Priority (S)

To select Shutter Priority (S), set the mode dial to S. This mode allows you to select the camera's shutter speed, and the camera will select the aperture for proper exposure. This is advantageous for action shots since a fast shutter speed prevents a moving subject from being rendered as a fuzzy blur. Conversely, for artistic effect, if you want to show a moving subject as a soft blur (a streak across the frame), you can use a slow shutter speed.

Once you select S mode on your mode dial, you will see the letter S prominently displayed on the upper-left corner of your preview screen. Depending on the viewing screen you are using, the letter may disappear after a few seconds. As you turn

Figure 5-2: S mode with shutter speed changed to 1/4000 of a second

the front or rear dial, the shutter speed value at the bottom of the display screen turns orange and its number changes (figure 5-2). You will also see the aperture value change in concert, but remain white. When you exceed the maximum or minimum lens aperture, the aperture value will blink to warn you that you're over (or under) the limit. To override

Figure 5-3a: A fast (or short) shutter speed freezes the appearance of moving water

Figure 5-3b: A slow (or long) shutter speed gives moving water a flowing appearance

the recommended exposure, rotate the exposure compensation dial and you will see the aperture change from the camera's set value.

Setting the shutter speed gives you artistic control over recording a moving subject. You may wish to use a fast shutter speed to freeze the motion (figure 5-3a) or use a slow shutter speed to blur anything that is moving (figure 5-3b).

Aside from creating artistic effects, you may need to use a fast shutter speed to ensure that you get a sharp image. This will prevent blurring when handholding the camera, especially when using a telephoto lens, which magnifies camera movement.

Keep in mind that when you need a faster shutter speed, you must increase the light that falls onto the sensor. This can be accomplished by using a flash or by opening the lens's aperture. If this is impossible, you may need to increase the ISO. For exposures that require the shutter to be open longer than 1/30 of a second, you should mount your camera on a tripod. This requires that you turn off SteadyShot. Once you are done using a tripod, be sure to set SteadyShot back to [On].

MENU>Camera Settings (6)>SteadyShot>[On], [Off]

Exposure Compensation: Fine-Tuning Automatic Exposure

You can depart from the camera's recommended exposure only when you use P, A, S, or M mode. If you think the image needs to be brightened or darkened you can rotate the exposure compensation dial at the top of the camera (figure 5-4). This dial provides an exposure range of plus and minus 3 f-stops, in 1/3 f-stop increments. Your electronic viewfinder and LCD monitor will brighten or darken as you depart from the camera's recommended exposure. The one exception to this rule is if the camera is set using the following command:

MENU>Custom Setting (2)>Live View Display>[Setting Effect ON], [Setting Effect OFF]

In this case, [Setting Effect ON] varies the electronic displays to reflect the change in exposure and the application of color changes. In contrast, [Setting Effect OFF] causes the electronic displays to remain at a constant intensity without variation in brightness.

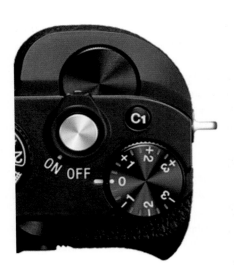

Figure 5-4: Exposure compensation dial

In our opinion, using [Setting Effect OFF] is counterproductive when you use ambient lighting. The advantages of previewing the effects of light and exposure are lost when you use this option. For example, the color tints that occur when the white balance is set incorrectly are not shown. For us, keeping the default [Setting Effect ON] is most advantageous for our black and white photography. We compose the scene in monochrome, which we can only see if we have set the command to [Setting Effect ON]—viewing it in color is distracting. In short, we find it easier to compose a scene for black and white photography if we can preview the subject in black and white by setting the Creative Style to [Black & White].

You can monitor your exposure whether you are using [Setting Effect ON] or [Setting Effect OFF]. There are quantitative displays with both that show how far you've deviated from the camera's light meter. In the viewfinder, this is done with an EV scale. The 0 position corresponds to the camera's recommended exposure and the triangle above the bar shows the extent of exposure compensation being applied. In the case of the LCD monitor when using [Setting Effect OFF], any screen that shows the subject also has an exposure compensation value at the bottom of the screen—a numerical value preceded by a plus or minus sign. The one quantitative feature unavailable for evaluating exposure on the LCD monitor is the histogram. The shape and position of this graphical display does not change as you vary the f-stop or shutter speed because the histogram is collecting the intensity informa-tion that will be displayed on the LCD. Since [Setting Effect OFF] keeps the display at a constant brightness, the histogram does not change with varying exposure. This can be regarded as a flaw in the camera design. If the histogram were actually measuring the light intensity directly from the sensor, it would show a change in position and shape as the f-stop and shutter speed varied.

You can also change the exposure without touching the exposure compensation dial. This is accomplished by using either the Fn button or the Quick Navi screen. If the Fn button has been set with [Exposure Comp.] as one of its options, you can select it and vary the exposure by turning either the front dial or the control wheel. You have to exercise a bit more care in the Quick Navi screen. Here, you will find two exposure compensation scales. The top scale is for overriding overall

exposure and the bottom scale is for overriding the flash exposure. When adjusting exposure, both scales are highlighted on an orange background. The selected scale to be adjusted turns white while the other scale remains dark (figure 5-5). As with the Fn button, once you highlight the exposure compensation icon, apply your EV offset by turning the front dial or the control wheel. The primary advantage to using these software controls is that you have a greater range to override your exposure with a scale of +5 EV rather than the +3 provided by the exposure compensation dial.

You might be concerned that the camera will become confused when using these controls simultaneously—it won't. There are only two ways to override exposure: one is the exposure compensation dial, and the other is via the camera's menu. As mentioned earlier, the Fn button and the Quick Navi screen are gateways to enter the menu quickly through the following command:

Figure 5-5: Exposure compensation scale in the Quick Navi screen

MENU>Camera Settings (3)>Exposure Comp.>[Exposure EV]

This results in the same exposure compensation screen as would have been obtained by using the Quick Navi screen or simply pressing the Fn button.

It turns out that the exposure compensation is the most important control, and its settings are paramount. If the exposure compensation dial is set to a value other than 0, you will find that the menu-based command is disabled and you cannot override the dial setting. Also, if you have set the menu command to alter exposure, the exposure compensation dial, when turned, will reset the menu-based command to a value that is selected by the exposure compensation dial. Basically, the exposure compensation dial trumps the camera-exposure setting.

Consequently, when compensating within ±3 EV, we do not use the Fn button or Quick Navi screen to alter exposure. Using either of these methods is the equivalent of using the menu command to adjust exposure. Moreover, using the Fn button or Quick Navi screen does not allow you to study the changing shape and distribution of the histogram in the live preview mode. This is undesirable because these tools, when used together, are useful for determining the optimum exposure. When using the live preview with the histogram, you can see the extent that you are losing detail in either the shadows or the highlights.

Autofocus

Autofocus Area: Identifying Where to Focus

Most photographers feel the Sony a7 has the more advanced focusing system because it uses a mixture of phase and contrast detection sensors. Phase detectors determine how far and in what direction the subject is out of focus. If the object is far from the camera, phase detectors will direct the motor to bring distant objects into focus. In addition, it can direct the speed with which the motor drives the lens. The further out of focus the subject, the greater the speed the motor will use to obtain focus. Unfortunately, phase detectors can be unreliable with certain lenses. Cameras that rely exclusively on phase detectors, such as the Nikon D800 or the Canon EOS 5D Mark III, have controls that allow the user to fine-tune those phase detectors in case they fail to hit perfect focus. These controls are unnecessary in the a7 because it also uses contrast detection to ensure that the lens achieves perfect focus. In contrast, the Sony a7R has the accuracy of contrast detection, but lacks the speed provided by the phase detectors, which is to say that the a7 should be the superior camera for action photography; especially, for those situations that require keeping the subject focused when firing continuously.

For this reason, many photographers believe the a7 is better suited for shooting sports, while the a7R, with its higher-resolution sensor, is best suited for stationary subjects, such as landscapes. Sony designers appear to feel the same way—they chose the default for the a7's Focus Area command option to be [Wide]. In other words, it selects its focusing point by using 25 AF focus regions distributed across its viewing screen. When one of these regions is identified as being in focus, its borders turn green. In the case of figure 5-6, six focusing areas were used to establish focus. It is unnecessary to carefully aim your camera to lock focus; instead, you can quickly frame a shot, and the camera will find focus on something within the finder. This is an advantage for quick-grab shots, but there is a chance that the point of focus will not be on the subject of interest.

In contrast, the a7R comes configured to use a single focus area, which is placed centrally on the screen. This is marked by a set of black brackets that are aimed at the subject of interest (figure 5-7). The demarked region is precise enough to ensure that the area enclosed by the brackets will be in focus. When focus is

Figure 5-6: Area used to establish focus (in green brackets)

achieved, the brackets turn green. This system works well for stationary objects and objects that are moving slowly. To put this in perspective, if we shoot an active child in play, we would use the a7 default style of focusing. If we were taking the child's portrait, the a7R's default style of focus would be preferred.

Figure 5-7: Flexible spot focuses in the area of the brackets

Fortunately, you are not locked into any one style of focusing. You have the option to choose what regions to used. This versatility ensures that you do not have to relegate your camera to just one specialized task. To choose your focusing area you can use the menu's Focus Area command:

MENU>Camera Settings (3)>Focus Area>[Wide], [Zone], [Center], [Flexible Spot]

You can avoid the menu by using the Quick Navi screen, which displays the menu command icons. Select the Focus Area icon to display the menu command. When setting this command, you will see your options on the left side of the screen (figure 5-8, table 5-1). Rotate the control wheel or the front dial to scroll through the options, and press the center button to make your selection.

Figure 5-8: Selecting Focus Area command's [Wide] option

Focus Area	
Option /Name	**Description**
Wide (a7 default)	The camera determines which of the 25 focus areas will be used for focusing. When you frame a still image, press the shutter button halfway. A grid of green brackets is displayed around the areas that are in focus.
Zone	Tells the camera which of the nine zones to use to establish focus. Each zone consists of a unit of nine focus areas. Use the up, down, right, and left buttons to position the nine focus areas. Press the center button to accept the location. The camera will use the specified zone and determine which of the zone's focus areas will be used. Note that the green brackets show you what areas within the zone are being used as the focus areas. This will allow you to bring a portion of your image in focus while the rest is out of focus.
Center	Only the center of the framed image is used to determine focus. A faint set of four brackets will be displayed on the screen to indicate the area the camera will use for focusing. They will turn green once focus is obtained.
Flexible Spot (a7R default)	You can select a specific spot and size of focus area for the camera to use to establish focus. Rotate the control wheel to cycle through the spots (S, M, and L). Use the up, down, right, and left buttons to navigate horizontally and vertically through the available focus area spots on the screen. Each sized spot has a different number of total spots available to select from. For example, the following counts are for the a7: Small Spot: 323 spots (19 horizontal x 17 vertical) Medium Spot: 289 spots (17 horizontal x 17 vertical) Large Spot: 255 spots (17 horizontal x 15 vertical)

Table 5-1: Focus Area command options. Note that Flexible Spot will have the selected spot size superimposed on the icon's lower-right corner.

The options [Zone] and [Flexible Spot] are more complicated because they control not only the size of the focusing area, but the position. To select these commands from the Quick Navi screen, highlight the Focus Area icon (figure 5-9a) and press the center button. Once the Focus Area command's options are displayed, highlight the icon for Zone focusing (figure 5-9b) and press the center button. When selected, you will see the

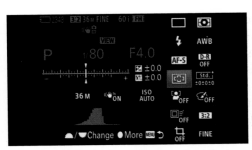

Figure 5-9a: Selecting Focus Area from Quick Navi

focusing brackets. Note that [Zone] uses nine focus rectangles rather than the 25 used in [Wide] (figure 5-9c). The arrows indicate the directions you can position the Zone focus on your screen. After positioning the zone using the directional buttons, press the center button to select the focusing location. When you go to Live View, you will see a set of four brackets when framing your scene. These indicate the zone that will be used for focusing (figure 5-9d).

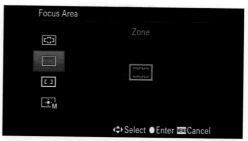

Figure 5-9b: Selecting Zone Focus Area

A more direct way to control the zone focus area is to press the FN button. You will see the selected regions overlaid on your live preview screen. You can decide where you want to position this area while studying its location over the scene. The nine focusing sites display orange borders and can be shifted up, down, to the left, or to the right with the directional buttons. When you select them by either a half press of the shutter button or with the press of the center button, they disappear and are replaced by four brackets that

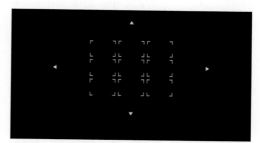

Figure 5-9c: Positioning Zone Focus Area

Figure 5-9d: Focus area marked on Live View

mark the focusing zone (figure 5-9d). When one of the activated areas finds focus, it will show up with green borders.

Remember that the Focus Area's icon appearance varies when the Fn button is pressed, reflecting the option that was last selected. When the proper box in the Fn row is highlighted, the words "Focus Area" appear on the screen just above the top row of the Fn command. Press the center button to display the list of options: [Wide], [Zone], [Center], and [Flexible Spot]. When you highlight Flexible Spot (figure 5-10a), you will see an orange letter (S, M, or L) designating the size of the spot

on the screen. At this point, the right and left buttons can change the size of the spot. When you are happy with this selection, press the center button and you will see the orange brackets that you can position within the screen (5-10b) using the directional buttons: up, down, left, and right.

Figure 5-10a: Focus Area command with Flexible Spot M highlighted

The orange color of the brackets indicates you still control the size of the spot. If you turn the control wheel, you can vary the focus bracket from [S]mall, [M]edium to [L]arge and match it for your subject. Once satisfied, press the center button. The orange brackets turn black, become fixed, and cannot be changed. In figure 5-11a, you can see how small this focusing area can become. When in Live View, a half press of the shutter button will start focus. When focus is achieved, the brackets turn green (figure 5-11b). Essentially, you can use the Fn button to quickly activate the Focus Area command without having to use the camera's menu. An additional advantage is that the selected focusing areas are visible as overlays on your subject, enabling you to select the one that will best identify the subject of interest.

Figure 5-10b: Orange brackets indicate available positioning and sizing

One important point to consider is Face Detection. If you have Face Detection turned on, the camera will detect the face, but it will not focus on it unless it is within the selected focus area. The a7/a7R has, in its default configuration, a feature that selects the eye and uses it as the focus point when you press the center button (Face Detection must be enabled).

Figure 5-11a: Orange small flexible spot positioned in the center of the screen

Choosing a Focus Area

The Focus Area command's [Wide] option tells the camera to use any of the 25 areas to determine focus. When the shutter is pressed halfway, green brackets mark the area that the camera has used to establish sharp focus.

Figure 5-11b: Green medium flexible spot that has obtained focus

If your subject does not have green brackets around it, it may be out of focus.

To increase your precision for focusing, you can specify a more limited region to be used for that task. The [Zone] option narrows down the available focusing areas from 25 to 9. The [Flexible Spot] option narrows it down even further by letting you choose only one focusing area that can be varied in size from [L] down to [S].

Normally we set the focus area to the default option for the a7R: the medium-sized [Flexible Spot]. Although it is not the default for the a7, we use it on this camera as well since it ensures that the camera focuses on what we deem is important. This selection is a good choice for either stationary or slow-moving subjects. We seldom use [Center]. We feel this command is redundant because [Flexible Spot] has the advantage of changeable size and position. Also, if you have positioned the point of focus in [Flexible Spot] or [Zone] in the periphery of the screen, you can bring it back to center by pressing the C3 button.

When the subject is active, we use the [Zone] option. This option rapidly acquires focus without the need to aim the camera precisely, and provides a narrower field of selection than [Wide]. Unfortunately, it doesn't always record the best picture. You may want only your subject to be in focus and the rest of the image to be deemphasized by being blurred. When the subject is stationary, we prefer to use a single focus point by selecting either [Center] (the center focus point) or [Flexible Spot], and choosing a focus point that lies outside the center of the screen.

In the case of photographing an animal from a distance, we like the animal's eyes to be recorded sharply with a reflective glint. We accomplish this by setting the Focus Mode (described next) to [Single-shot AF], and selecting Focus Area's [Flexible Spot]. By aiming the focusing target at the animal's eyes, we can lock focus with a half press on the shutter button. While holding the shutter button halfway, we can adjust our framing, knowing that the eyes will stay in focus. When we are satisfied with our composition, we capture the image by fully depressing the shutter button. Sometimes we choose to use the smallest [Flexible Spot] size to accomplish this goal.

Focus Mode

The Focus Mode command specifies to the camera how it will focus: either focus once and shoot or focus continuously and shoot.

> MENU>Camera Settings (2)>Focus Mode>[Single-shot AF], [Continuous AF], [DMF], [MF]

By using the Focus Mode command's [Single-shot AF] option, the camera will identify focus, lock focus, and then shoot. Partially depressing the shutter button will keep the focus locked. In contrast, when you use [Continuous AF], the camera's focusing motor is kept active so that it will continually refocus. This constant updating of the focus helps maintain a sharp recording of the subjects that are moving away from or toward the camera.

Note: [Single-shot AF] and [Continuous AF] are usually displayed as AF-S and AF-C, respectively.

A faster way to select these commands is to press the Fn button and select the Focus Mode icon at the bottom of the screen. The default option is [Single-shot AF] (figure 5-12a), and you can switch it quickly to [Continuous AF] (figure 5-12b) by rotating the control wheel or front dial. Focus Mode command is also on the Quick Navi screen (figure 5-12c).

There are two additional options: [DMF] and [MF]. The first is a rapid means to transition to manual focus after autofocus is achieved. The second option, [MF], switches you directly to manual focus. Both of these manual focusing options will be discussed in the next chapter when we cover M mode.

Autofocus in Dim Light

You may find that in a dimly lit scene the camera projects a beam of red light from the front of the camera to illuminate the

Figure 5-12a: Focus Mode command's Fn [Single-shot AF] option highlighted

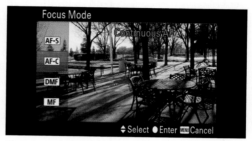

Figure 5-12b: Focus Mode command's [Continuous AF] option selected

Figure 5-12c: Focus Mode [Single-shot AF] command highlighted in Quick Navi screen

subject. At short distances, this is enough to aid automatic focusing; however, in some dimly lit environments, like shooting images of performers on stage, a red light can be annoying to the subject. In this case, you may want to disable the AF Illuminator so the red light will not be used. To do so, use the following command:

MENU>Camera Setting (3)>AF Illuminator>[Auto], [Off]

[Auto] is the default value enabling the camera to turn on the AF Illuminator in low-light situations, whereas the [Off] value means the light never turns on. If you turn this option off, you will notice that focusing becomes slower and more hesitant before locking. To counter this effect, you can try a couple of strategies. First, make sure the camera is using the widest aperture lens available. You will have better luck using the prime lenses: the 35mm f/2.8 and the 55mm f/1.8 lens. Both of these will provide more light to the sensor than the zoom lenses and this additional light can make a difference in automatic focusing. Second, regardless of which lens you use, make sure the camera is using its widest (most open aperture). This is especially important if you use M or A mode. In these two modes, the camera is metering and focusing at the set aperture of the lens. If the aperture is slightly closed, this will rob the sensor of light. This is not a factor if you are using the P or S mode because the lens is always maintained at its widest aperture in these modes.

As an informal test, we experimented with autofocusing with our a7R camera with the 24-70mm f/4.0 Zeiss lens under low light conditions. When in Zone focusing mode, we obtained reliable autofocus at an ISO of 6400 at f/4.0 at 1/80 second. At this light level, we found the Flexible Spot Focus Mode functionality to be less reliable than the Zone mode, so we made the Zone mode our standard choice when the light is low.

ISO

The default ISO for the camera is [ISO AUTO], in which the camera sets the sensitivity of its sensor in a default value range from (minimum) 100 to (maximum) 6400. Many photographers, ourselves included, do not care for the maximum limit. We prefer to set the ISO to 3200. If we need a higher ISO, we like to be able to specifically select the ISO value ourselves.

There are three options for adjusting the maximum limit. The first option is to input the following menu command:

MENU>Camera Settings (3)>ISO>[Multi Frame NR], [ISO AUTO], [n]

(Where [n] represents an ISO number from 50 to 25600.)

As mentioned at the beginning of the chapter, rather than referring to the first two ISO command options by option icon, ISO AUTO and AUTO, as we do with other commands, we will refer to them by their descriptive names, Multi Frame NR and ISO AUTO, to remain consistent with the Sony user guide manual.

When you highlight the ISO command icons via the menu and press the center button, you will see a screen like the one in figure 5-13a, which has a series of numbers or letters on its left side. This plate shows that the setting of this command is [ISO AUTO]. The [ISO AUTO] option allows you to set the minimum and maximum limit (range) from which the camera can select an ISO to use. The screen prompts indicate that you can press the right button to reach a screen that gives you the option to select either ISO 100 (AUTO Minimum) or ISO 6400 (AUTO Maximum). In either of these two cases, the up and down buttons allow you to change values. Once you complete your settings, confirm them by pressing the center button.

Figure 5-13a: ISO command's [ISO AUTO] in Quick Navi

Figure 5-13b: ISO command's [AUTO Minimum] [AUTO Maximum] options displayed

The second way to set the ISO value is to use the Quick Navi screen. This is a quick entry into the menu system. Highlight the region labeled ISO (figure 5-13b) and press the center button. Once in the menu system, you will see the screen shown in figure 5-13a.

Another method of changing the ISO is to use the Fn button. This option avoids navigation through the menu. Highlight the ISO icon and press the center button

to see the available ISO values (figure 5-14a). Again, when [ISO AUTO] is selected, pressing the right button will display screens for setting the maximum and minimum [ISO AUTO] limits (figure 5-14b).

As mentioned earlier, when you set your own ISO value, you need to keep an eye on the shutter speed. If your shutter speed is too slow (becomes too long), it is more likely that your camera will move during the exposure and blur the image. When shooting handheld, a rule of thumb when using 35mm film is to use a shutter speed that is the reciprocal of the lens's focal length. If you set the lens to 100mm, then you should set a minimum exposure of 1/100 second. For digital photography, this guideline does not take into account Sony's SteadyShot feature. This is normally set to [On], and can allow users to use longer shutter speeds.

Figure 5-14a: ISO command's [AUTO Minimum] and [AUTO Maximum]

Figure 5-14b: ISO command's [AUTO Minimum] high-lighted

However, SteadyShot is no guarantee for sharp pictures with handheld photography. If you jerk or move slightly during the point of exposure, SteadyShot may not counteract this, resulting in a blurred photograph. Also, under certain conditions the blur may be the result of the movement of your subject. Keep in mind that when you shoot at the outer limits stated in review articles, or in this book, you will always get some technically unacceptable shots. So do not hesitate to take multiple shots of the same scene and review them afterwards to make sure you have images you are happy with.

Obviously, there are many variables that affect how slow a shutter speed can be before the images will blur. One of the simplest ways to work with longer shutter speeds is to brace the camera while you take the picture. An advantage in using the viewfinder is that you can press the camera body against your face for increased stability. We hold the camera with two hands (one underneath the lens), and make a point to press our elbows against our body. In contrast, when you use the

LCD screen, you are holding the camera out away from you and cannot brace the camera against your body. Using these techniques is especially important when working with the a7R, whose mechanical shutter curtain generates more vibration within the camera body. Although [ISO AUTO] is a convenient feature, we limit its range to ensure we get the quality of pictures we prefer. Since ISO is so critical in determining your working shutter speed, we tend to use the control wheel to manually set the ISO when doing critical work with a telephoto lens, or when we need to follow fast action. Having this control allows us to use an ISO that has the right balance between image quality and sensor sensitivity.

Multi Frame Noise Reduction

This is a special ISO setting for reducing the appearance of noise for stationary subjects. Its icon can be confusing since it uses the words "ISO AUTO." However, the icon is distinguished from [ISO AUTO] by highlighting ISO with a white flag (figure 5–15a) whose appearance resembles the icon used for Cont. Shooting. The icon, as well as the name "Multi Frame Noise Reduction," refers to its process of taking four photographs, combining them, and taking an average of the intensity values of each pixel. Because noise is random, treating it as a statistical problem can reduce its appearance within the scene. This is the only ISO setting that restricts you to shooting JPEG files: you cannot use either [RAW] or [RAW & JPEG] with this command.

If you have used either of the SCN modes, [Hand-held Twilight] or [Anti Motion Blur], you may have already used this function. The factory default is for Multi Frame Noise Reduction to set its ISO automatically, so you will not know what value will be used prior to taking the photograph. In P, A, S, or M mode we prefer using this command by setting its ISO manually. With Multi Frame Noise Reduction, you will find that you can set the EV to 51200.

To make this adjustment using the Quick Navi screen, select the ISO icon on the screen and press the center button. (Note that our screen shots are based on using Sony's default settings.) You will see the ISO settings on the left side of the screen. Select the icon at the top of this list that has ISO on a white flag with AUTO underneath it (figure 5-15a).

Figure 5-15a: Multi Frame Noise Reduction's ISO AUTO option selected

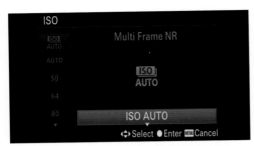

Figure 5-15b: In the Multi Frame Noise Reduction's submenu to select an ISO value for the function

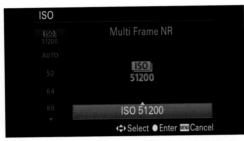

Figure 5-15c: Multi Frame Noise Reduction's ISO value of 51,200 selected

The [Multi Frame NR] option also has a submenu. You can let the camera decide the ISO value by selecting ISO AUTO or you can choose a specific value. If you press the right button, you will see ISO AUTO in a red bar (figure 5-15b). Pressing the down button brings up a series of numbers ranging from 100 to 51,200. Choose which of these ISO values you wish to use with Multi Frame Noise Reduction (figure 5-15c) and press the center button to accept your selection. With experience, you can judge how high an ISO you can use in extremely low-light conditions with this feature. We have used an ISO as high as 51,200 with this setting. We generally do not use an ISO higher than ISO 12800; if the subject is motionless, the image will be clean and exhibit little noise.

Unexpected Changes In ISO

Some users have complained that the ISO values can change unexpectedly on the Sony a7/a7R. Apparently while handling or carrying the camera, the control wheel is inadvertently rotated, thus changing its setting. To avoid this problem, use the following command:

MENU>Custom Settings (6)>Dial/Wheel Lock>[Lock], [Unlock]

Once you have selected [Lock], you will find that your camera will operate as it did before, but with one important modification. If you press the Fn button and hold it down for at least three seconds, you will see a "Locked" message displayed on the camera's screen. This indicates whether your dials and wheel will be operational. To unlock the dials and wheel, press the Fn button again for three seconds and the

"Unlocked" message will be displayed. You can also change the Dial/Wheel Lock command to [Unlock], and the control wheel and dials will be active for changes whenever the camera is turned on. When the camera is locked, a Locked icon will be displayed in the lower-right corner of the screen.

White Balance

The Sony a7/a7R has to be calibrated so that it can record colors accurately. In effect, the camera must be told what type of light is illuminating the subject. This task used to be performed manually; however, the method was inconvenient, and if a mistake in identifying the light source was made, an image with erroneous colors would be created.

To get around this problem, camera designers developed automatic white balance (AWB), which enables the camera to calibrate itself to the light source. In essence, this feature takes a statistical sampling of the light in the image and makes a best guess about what type of light is illuminating the scene. AWB is automatically chosen when using Intelligent or Superior Auto, or when in the SCN modes.

For the most part, it does a good job; many photographers are happy with the results and will only use this setting. But, like all statistical sampling techniques, it is not foolproof. This is most evident when working with indoor lighting, which can give your images a ruddy color cast. Fortunately, you can compensate for this in the Sony a7/a7R by selecting preset white balance (WB) values. To do this, you must use P, A, S, or M shooting modes.

To better control the appearance of your photograph, we recommend that you become accustomed to setting your own WB. Your results will be more consistent and reproducible if you get into this habit. To do so, use the following command:

MENU>Camera Settings (4)>White Balance>multiple options

There is a long list of WB options. Rather than list all the values on the command line, we prepared table 5-2, which contains the available options. For many users, the preset options are sufficient. The remaining WB settings, which require direct user input, such as a customized WB or assigning a color temperature value, will be discussed in Chapter 6 on Manual Exposure.

Option Icon and Name	Description
AWB Auto (Default)	WB is set automatically by the camera.
Daylight	WB is set for a subject in direct sunlight.
Shade	WB is set for a subject in the shade—not illuminated by direct sunlight.
Cloudy	WB is set for a subject on a cloudy, overcast day.
Incandescent	WB is set for a subject illuminated by indoor light (assumes the light is tungsten filament).
Fluor.: Warm White	WB is set for a subject illuminated by warm fluorescent light (3000 K).
Fluor.: Cool White	WB is set for a subject illuminated by cool fluorescent light (4100 K).
Fluor.: Day White	WB is set for a subject illuminated by day white fluorescent light (5000 K).
Fluor.: Daylight	WB is set for a subject illuminated by daylight fluorescent light (6500 K).
Flash	WB is set for a subject illuminated by an electronic flash unit. Some tints are added to enrich and warm up the picture
Underwater Auto	WB is set to compensate for scenarios when the quality of the light becomes progressively bluer as you dive deeper underwater. Water absorbs the red portion of the spectrum and this option compensates for this loss.

Table 5-2: WB icons and light sources

You can set the WB through the menu, Fn button, Quick Navi screen, or by simply pressing the button labeled WB. When using the Fn button, find and press the WB command among the 12 icons (figure 5-16a). The WB screen displays the WB icons on the left, and the highlighted option's name will be at the top center (figure 5-16b). As you can see, the list of WB preset options is long. Rotate the control wheel to scroll through the options. You will see the affect of the highlighted WB option applied to the Live View image as you cycle through the different WB presets (figure 5-16b). This gives you a quick appreciation of the effects of different light sources. Highlight the WB preset you want to use and press the center button.

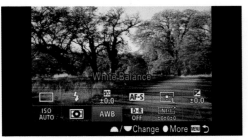

Figure 5-16a: Fn button screen showing WB icon set to AWB

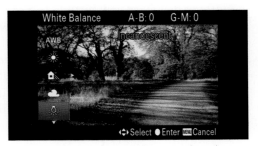

Figure 5-16b: Incandescent WB preset selected

An interesting feature is Underwater Auto. This is for those who have an underwater housing and will be taking pictures while snorkeling or scuba diving. As you submerge into the depths, water absorbs the red light wavelengths, giving a blue tinge to the scene. This tinting is sufficiently enough that the AWB cannot provide a neutral coloration to brightly colored sea creatures. Their natural colors can be recorded by setting the camera to Underwater Auto, which balances out the increased blue coloration.

Remember that WB presets are only an approximation of the illuminant's color. For example, the [Incandescent] option assumes an ideal bulb emitting a specific color of light. In fact, general-use bulbs for indoor lighting can have a wide range of color values, and only specialized technical bulbs are rated for a specific color. In many homes, the brightness of an incandescent light can be dimmed, which shifts the color from a brilliant white to a ruddy red. Inaccurate WB occurs frequently under fluorescent bulbs. They vary so widely in their color output that the a7/a7R has four presets for them. The easiest way to determine which setting to use is to cycle through them to see which one provides the most neutral color in the display screen. Although Sony characterizes these presets as warm white, cool white, day

white, and daylight color, you will find that these settings frequently do not match the manufacturer's description of the bulb. To deal with such conditions, Chapter 6 offers some techniques for manually adjusting the WB.

Working Outside the Camera

Introduction

There are many ways to view and manage your pictures and movies outside the camera. At the most basic, you can treat your camera as an output device. Its pictures and movies can be played directly from the camera to the TV. Alternately, you can make adjustments to your picture within the camera using applications, and upload the images and movies to social media sites. Eventually, though, you will want to download your pictures to a computer and work with them. While this does add an extra degree of work, it allows you to get the most out of your photography.

The technology you use depends on your equipment and software, as well as your level of knowledge. Rather than go into the details of how to use various technologies, we recommend that you consult your equipment and software manuals, along with their corresponding websites, for specific information on how to accomplish your goals.

Downloading Pictures and Movies to Your Computer

Eventually you will want to download your pictures and movies from your camera's memory card to another device, most likely your computer, and then delete them from your memory card. Sony supplies Image Data Converter and PlayMemories Home software to help you manage your files on your computer and create lasting files for you to share and view. Of course, you can use third-party software instead, such as Adobe Photoshop Elements or Apple iPhoto for still photographs, or iMovie for movies. Sony does not supply the software on a disc. Instead you have to go to their website and download it.

First, a caveat on Sony software. It has the benefit of being free and you can avoid having to buy a program to work on your RAW files. Having said that, we feel that third-party software, such as Adobe Lightroom and Apple's Aperture, are easier and faster to work with.

There are two ways to download your files to your computer. The first is to use the supplied USB cable and connect your camera to your computer's USB port. Typically, if you have installed an image-processing program on your computer, a prompt will pop up on your monitor to direct you in copying the file to the computer. For example, PlayMemories Home program appears automatically and shows the

RAW, JPEG, MP4, and MT5 files stored on the camera's memory card. Select and import your files to your computer's hard drive. This is a straightforward process, but it does consume camera battery power to move the files. If you deplete your battery during the download, your files may be corrupted and lost. If you use this download method, make sure you have a fully charged battery.

The second way is to download the files directly from the memory card. Remove the card from your camera and insert it into a card reader that is connected to your computer's USB port. Card readers are devices that have a slot for one or more types of memory cards. In many cases, laptop computers have an SD card-reader built into their chassis. You simply insert the card into the slot and start your download. In essence, you treat your SD card as an external hard drive and transfer files like you would data files for a computer. Again, if you have a PC with Image Data Converter and PlayMemories Home software, you will see prompts to save your files onto your computer. After the files are downloaded, you can organize, edit, and display them.

In the case of Macs, which update the RAW conversion files of new cameras with updates in their OS, you will be able to see the RAW files in preview.

You can treat the card as if it is an external hard drive and use your computer's OS to physically transfer the files to your hard drive. This strategy works well with still photographs or MP4 files. However, it does not work as well for AVCHD files because they are stored on the memory card in a bewildering array of subdirectories, making it unclear what to download and where to save the associated files. This is especially true if you intend to burn the movies onto a DVD so you can play them on your digital player. In this case, relying on a program such as PlayMemories Home or iMovie facilitates the correct, logical downloading of AVCHD movies to your computer.

Please keep in mind that PlayMemories Home for the Mac is different from that for the PC. In the case of the former (at the time of writing of this book), there was no command for burning AVCHD files to disc for playback. In the case of the latter, there is a prompt for making such discs.

If you want to process your files and use more advanced software than the supplied Sony programs, you can use proprietary software. Apple Aperture ($80) and Adobe Lightroom ($79 upgrade) are two programs that provide a way to organize and manipulate images on your computer. More advanced users might want to try Adobe Photoshop ($9.99 monthly subscription). Other options are Adobe Photoshop Elements ($99.99 MSRP) and Apple iPhoto '11 ($15). There are even two free choices for either Windows or Macintosh computers: Picasa (picasa.google.com) and GIMP (gimp.org).

Sony a7/a7R Software

Your Sony a7/a7R camera does not come with software on a CD. If you want to use Image Data Converter 4.0 and PlayMemories Home, you will have to download them from the Internet, using the following Sony's a7/a7R's url:

http://esupport.sony.com/US/p/model-home.pl?mdl=ILCE7&LOC=3#/manualsTab

We've provided the url, but the risk of mistyping the address is fairly high. We noticed in our earlier books that typographical errors can defeat our good intentions, so we have provided url links to the software download, camera manuals, and online user guides on our websites:

VistaFocus.net
MatsuImaging.com

If you are not already using third-party image processing programs, try Sony's free, supplied software. We suspect that you will soon outgrow this software (and most expert photographers will simply ignore it). Apple computers provide updates to their OS that provide RAW translation so that you can view your files in your directory and Preview program. However, we recommend that you download Image Data Converter 4.02—this version can open and process both RAW and JPEG files. Its advantage is that you can mimic some of the effects that you would initiate in your camera. Of particular interest is Sony's DRO feature. This is the Dynamic Range Optimization, and when used in the camera, it lightens shadows. If you use Image Data Converter 4.02, you will see that it allows you to apply DRO to your images. The effects are not identical to what can be done by using the camera settings for this option; however, it provides a useful learning tool. By opening your RAW files with this program, you can experiment with applying different DRO settings to get a feel for what this option does to your images.

We prefer using Apple's Aperture or Adobe's Lightroom for working with still images, since these programs execute image-processing faster than Image Data Converter. However, if you're shooting in RAW format, Image Data Converter allows you to get the best quality images from your Sony a7/a7R as soon as you receive the camera. With third-party software, you first need to make sure your software is current and capable of translating your Sony RAW files. The latest versions of Aperture and Lightroom will read and work with a7/a7R RAW files.

Image Data Converter

Although Image Data Converter can view JPEG files, its ability to process these files is limited. It is designed for processing Sony RAW files to adjust brightness and WB, and to optimize the dynamic range. You can also apply Creative Style options, experiment with DRO (Dynamic Range Optimization), add shading compensation, sharpness, and noise reduction, along with some other image-processing functions. Figure 5-17 shows a screen shot of an image opened in Image Data Converter. The software also lets you do some minor image processing to JPEG files, such as rotating an image and adjusting its tone curve. Files can be saved as Sony RAW, 16-bit Tiff, or JPEG.

If you do not have an image-processing program, Image Data Converter is definitely worth using. When we obtained the a7/a7R, third-party software RAW converters were unavailable and Image Data Converter was the only way to work

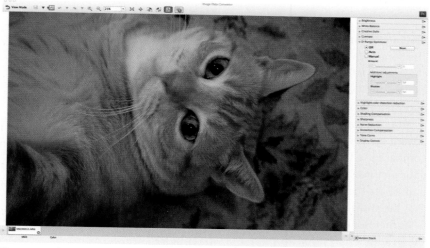

Figure 5-17: RAW image open in Image Data Converter

with these files. For editing, we would take the Sony ARW file and convert it to a 16-bit tiff. A wide variety of image-processing software packages will handle this file type.

We used Image Data Converter until the RAW converters came out for Photoshop and Aperture. Now we use these programs because they need less time to process a RAW file. Aperture and Photoshop are not free, but Image Data Converter is included with your camera. We have worked with the software on a Dell computer with a quad-core processor (i7) and a MacBook Pro with a quad-core processor. In both instances, the program was workable, but it took a second or two to execute a function or open a pull-down menu.

PlayMemories Home

You can download your images (pictures and movies) onto your computer using PlayMemories Home. The program lets you organize and maintain files in folders. Not only can you view your files by name, file type, or as thumbnails, but you can also add date information and organize them in a calendar structure. For AVCHD movies, with their complicated file-storing system on the camera's memory card, this is the most convenient way to transfer files to your computer. If you use a Windows machine, we feel PlayMemories Home is a worthwhile program. You can convert your AVCHD files to playable discs. However, we were unenthusiastic about this program for the Apple computers, and prefer to use iMovies, which can download and transcode AVCHD files to our computer. It provides us with more movie-editing capability than the Sony software package. For professional work with the Apple computer, we would recommend using Final Cut Pro for working with still and movie files.

Playing Pictures and Movies on Your TV Screen

The Sony a7/a7R can be connected directly to your TV, but you will need to purchase an HDMI cable to connect them. We recommend that you consult both the camera and TV manual, as well as the manufacturers' websites, to get up-to-date information.

After the camera is connected, you can play your slide shows on your TV. One advantage of viewing your slide show on a wide-screen HDTV is its size. It is huge compared to the camera's LCD screen, making it possible to comfortably show your pictures and movies to several friends at once. You will be able to better appreciate the definition, color, and contrast of your pictures and movies when they are shown on a large screen.

As mentioned in Chapter 3's Slide Show section, if you have a 4K-compatible TV, an additional Playback option will be displayed:

MENU>Playback (2)>4K Still Image PB>[OK]

This command will allow you to play back your still images in 4K on the attached, compatible TV.

Printing Your Pictures

You can print your images with third-party software or the supplied PlayMemories Home software, or you can utilize Sony a7/a7R's Specify Printing command and then take your memory card to a print shop that supports digital print order format

(DPOF). Make sure the print shop can handle your images properly. Discuss any restraints the shop might have to make sure you can get the desired print results.

There are three controls within the Specify Printing command:

MENU>Playback (2)>Specify Printing>[Multiple Img.], [Cancel All], [Print Setting]

The [Multiple Img.] option displays all of the saved files on the memory card, regardless of their file type, starting with the last one recorded or played back. To select specific images for printing, do the following:

1. Select the [Multiple Img.] option. The recorded images are displayed with a check box in the middle-left side of the display screen.
2. Scroll through the images to find an image you wish to print.
3. Press the center button. An orange check is entered into the check box to indicate the image should be printed. To unselect for printing, uncheck the image by pressing the center button again. Note: even through your movie files will be displayed, they will not be displayed with a print check box.
4. Once you have indicated all of the images you wish print, press the MENU button to enter the checked images.
5. Select [OK] to save the print indicators and press the center button.
6. Once the process is completed, press the center button to exit.

The [Cancel All] option erases all of the existing check marks so no images are selected for print. You will be asked to validate your request by entering [OK] twice via pressing the center button.

The [Print Setting] option allows you to specify if you want to have the recorded date and time stamped on the printed copy.

MENU>Playback (2)>Specify Printing>Print Setting>Date Imprint>[On], [Off]

The Specify Printing command formats your selected images with the common DPOF protocol. Using DPOF is advantageous if you do not have a printer connected to your computer. You can take your memory card to a printing service, and they can use the information directly from the card to generate your selected prints. Some printers can use the DPOF data to generate your selected prints directly from the memory card. They usually have a card slot that does not need to be attached to a computer.

Important points:
- Like with anything important, back up the contents of your memory card prior to handing it to a printing service.
- The Specify Printing command is available only for JPEG still pictures. You cannot select RAW files. This is another good reason to save your files both in JPEG and RAW formats.
- The Specify Printing command is enabled only if the View Mode is set to [Date View] or [Folder View(Still)], and there is at least one image stored on the memory card. Note the image might be a movie, which cannot be selected for printing.
- Although you can check the boxes for panoramic images, you may not be able to print them. It depends on the capabilities of the printer.
- Images shot in widescreen [16:9] format may have both of the sides cut off when they are printed.

Recommendations

When you use your a7/a7R camera's P, A, or S modes, you start taking greater control of your camera's settings. Many controls that were unavailable in the automatic modes are now accessible, and you can develop your own artistic style. You can now adjust the exposure, select the ISO, and lock in the WB.

When we want to use the camera for point-and-shoot work, we set it to P mode and set the ISO to [ISO AUTO]. The camera sets the aperture, shutter speed, and ISO. If we don't care for the shutter speed, we can rotate the control dial to select a new combination of shutter speed and aperture. If the exposure is not to our liking, we can alter the exposure with exposure compensation. We can also select our WB to fit the scene. This takes some thought: for example, if you photograph a sunset and set the WB preset to [Daylight], the red hues will be recorded with greater saturation than if you set the camera to [AWB], where it will attempt to neutralize the predominant red scene and capture a neutral shade.

When we are concerned about depth of field, we use the A mode because we can select the aperture, and the camera adjusts the shutter speed to provide the proper exposure. A narrow aperture increases the depth of field. A wide aperture reduces it. Most DSLRs, and Sony SLT (Single Lens Translucent) cameras, require the lens to be stopped down manually by pressing a depth of field preview button. This is unnecessary when the a7/a7R is set to A mode. With this setting, the camera

provides a real-time depth of field preview. As you close or open the aperture, the display screen shows the depth of field as it is seen by the sensor.

When we deal with moving subjects or a long telephoto lens, we set the camera to S mode and set the shutter speed ourselves. As expected, the camera adjusts the aperture to set the recommended exposure.

In regards to ISO, we like to adjust the sensitivity of the sensor. We use ISO 100 for the highest quality work. We use higher ISOs, such as ISO 400–1600, for rapidly moving subjects in daylight. For dim light work, we use ISO 3200, and on rare occasion, ISO 6400. At this high of an ISO, we will process our saved RAW files with a third-party noise-reduction software, such as Noise Ninja.

Again, we recommend saving files in a RAW format. Virtually all programs that read RAW files have a straightforward command for adjusting WB if it is set incorrectly in the camera.

Most likely you will rely on your computer to manage your photos and movies. This may sound obvious, but get in the habit of downloading your pictures and movies to your computer soon after they are recorded, so you can reformat the memory card and have space to shoot again. Since we download the contents of our memory cards to our computers, we don't use the DPOF print capabilities. We prefer to do our own printing. But this takes time, and you need to have your own equipment, so an easy solution is to utilize the Specify Printing command and send your files out to be printed by a third party.

Last, but not least, try out the a7/a7R's Slide Show command. It's fun and quick, but not lasting. For something more permanent, use your computer to build slide shows with Sony's Image Data Converter and PlayMemories Home software or with a third-party software. Then store the results on a DVD so you can play back your saved memories on your computer or TV. An added benefit is that you can make copies of your DVDs to share with friends and family.

Chapter 6: Manual Control

Introduction

Whereas Chapter 5 dealt with taking partial control of the camera settings, this chapter is about taking complete control of the settings and learning to manually fine-tune them to reflect your artistic, photographic vision. Although we use the semiautomatic settings described in the previous chapter the most, we use manual controls when we are concerned about being able to absolutely reproduce the results.

There are times when you want the exposure and focus to be fixed at a constant value. For example, suppose you want to take a panoramic shot the old-fashioned way, without using the a7/a7R's Sweep Panorama feature. To do this, mount the camera on a tripod, set the exposure manually, and take a series of overlapping pictures by panning the camera with the tripod head. The focus and aperture must be fixed; they should not change as you pan. After you take all of the pictures, download them to your computer and join them together with third-party software to create your panoramic image.

While more laborious than the automated Sweep Panorama mode, using manual settings provides much higher image resolution. By working with the full area of the a7R sensor, you can, by positioning the sensor for portrait-type framing, collect a series of images that have a vertical height of 7360 pixels rather than the 1856 pixels generated with Sweep Panorama. A knowledgeable photographer can go further and create an even larger panorama by doing multiple sets of sweeps and building one on top of the other. Knowing how to set the camera to manual exposure and manual focus enables you to pursue such strategies for improving your images.

In this chapter we will describe how the manual control extends beyond exposure and focusing. Rather than using incandescent or daylight preset WB settings, you will learn how to set the white balance for any light source. This requires you to set an illuminant's color temperature value based on the specifications of the bulb's manufacturer. We will also describe how to calibrate your camera directly to the ambient light if you are dealing with a variety of light sources.

We will also cover the DRO/Auto HDR function. Both DRO and HDR allow you to record an image under difficult lighting conditions. Under bright daylight, it's difficult to record enough detail in both the highlights and the shadows. When you expose for the highlights, then the shadow areas become impenetrable black masses. When you expose for the shadows, the highlighted areas can be blinding white with little or no detail. When you use DRO/Auto HDR, you obtain an image that shows details in the both the shadows and highlights.

Taking control of your camera enables you to extend your photographic abilities and create artistic, one-of-a-kind shots.

Manual Exposure Mode Controls

Turn the mode dial to Manual Exposure (M). You will see a display screen (figure 6-1a) with the shutter speed and aperture values displayed at the bottom as white numbers. You can change them by rotating either the rear dial (shutter speed) or the front dial (aperture). In this figure (6-1b), the rear dial is being rotated, changing the shutter speed from 1/160 to 1/60 second. To determine how many EVs you are departing from the recommended exposure, glance at the numbers at the bottom of the LCD screen, to the right of the letters M.M, which stands for "Metered Manual." In this case, the camera has been set to -0.7 EV. You can see that the shape

Figure 6-1a: Live View in M mode with aperture and shutter speed set to the meter's recommendation

Figure 6-1b: Exposure set to -0.7 EV from the meter's recommended exposure

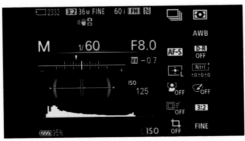

Figure 6-1c: Viewfinder screen showing -0.7 EV offset on the exposure bar

and position of the histogram has been shifted to the left. There is an exposure bar to the left of -0.7M.M in the [For viewfinder] display (figure 6-1c). The triangle on that bar (to the left of the central tic mark) indicates where the exposure value is set. This exposure bar, which can also be seen in the viewfinder, is a graphical indicator of how far you have departed from the recommended exposure.

When the camera settings are at ±0.0 M.M., they are set at the recommended exposure. As you deviate from this value, you will see the EV change in increments of one-third of an EV. These numbers help provide an offset value to the recommended exposure. When framing a snow scene, we have determined that applying a +1 EV offset renders the snow as a brilliant white. The camera's standard ±0.0 M.M. exposure estimate is based on

the assumption that the overall scene consists of midtone values, which results in the snow having a dingy gray color.

You can check the effects of offsetting the exposure by studying the LCD screen. The beauty of having a Live View camera is that you can preview the subject before you actually take the picture. In M mode, the brightness of the a7/a7R display screen is an indicator of the appearance of the recorded image. If the sensor receives too little light, you will see a dark screen with muddy colors; if it receives too much light, you will see a bright screen with washed-out colors.

The camera's exposure can be adjusted by modifying the aperture, shutter speed, and ISO values. The exposure compensation dial is disabled when you set your ISO to a numerical value. In contrast, it becomes active if you use [ISO AUTO]. In this case, when you turn the exposure compensation dial, you change the sensitivity of the sensor.

Extremely Long Exposure "B" Shutter Speed

The longest shutter speed for P, A, and S modes is 30 seconds. M mode gives you more flexibility when shooting in dim light by allowing you to set exposures to at least five minutes. Turn the rear dial to lengthen the value of the shutter speed numbers until you reach "B" (Bulb). This occurs just beyond a 30-second exposure. At this setting, the shutter opens when you depress the shutter button and remains open as long as the button remains depressed. Releasing the shutter button terminates the exposure by closing the shutter. While testing the camera, we successfully captured an image with a shutter speed of five minutes.

If you find that [Bulb] is unavailable, you've probably set a command that disables this setting. This includes commands that take multiple exposures, i.e., Multi Frame NR, Auto HDR, Cont. Shooting, and Spd Priority Cont.

For multi-second exposures, the camera should be mounted on a tripod and fired with a remote shutter control. Any camera movement will blur the image, and it is difficult to hold the shutter button down for such a long period without jarring the camera. Also, physically touching the camera may shift its position. If you do this type of work, we recommend getting the Sony cable trigger (RM-VPR1 Remote Commander). When you set the shutter speed to [Bulb], a single press of the remote's shutter button will open the a7/a7R shutter and keep it open. The RM-VPR1 Remote Commander has a lock so you do not have to continuously press down on the release. You can select this lock and release it when the time is up.

Bulb

Historically, mechanical cameras had pneumatically driven shutters. To open the shutter, the photographer squeezed an air bulb and the shutter would stay open until he released the bulb. In modern cameras, the analogous operation is to press the shutter button to open the shutter and maintain pressure on the button to keep the shutter open. Releasing the shutter button closes the shutter.

If you intend to do much work with a tripod, we recommend you get Sony's RM-VPR1 Remote Commander. Not only will it provide you with a slider for locking the shutter open in [Bulb], you also get a dedicated button for starting a movie recording and a rocker switch for adjusting the focal length of the motorized zoom lenses. In addition, this unit can be used on the Sony SLT series cameras. If you own the previous model of the Remote Commander for the SLT series cameras, you will find that it cannot be used on the a7/a7R. Sony's full-frame mirrorless cameras use a different receptacle for connecting to the previous Remote Commander model.

The Appearance of Numbers

Normally the Sony a7/a7R shutter speed is measured in fractions of a second. You will typically see the number presented as a fraction so that "1/4" represents a quarter of a second. However, when you set a shutter speed longer than 1/3 of a second, the display switches from fractions to decimals, so the next longest shutter speed is 0.4. From one second on, the (") symbol follows the shutter speed number. For example, 1" indicates one second, and 30" indicates 30 seconds.

When the Exposure Set. Guide command is activated, a ribbon is displayed on the screen that shows the f-stop or shutter speed numbers in a larger format. Essentially, this shows what settings are being changed as you rotate the front or rear dial. This strip portrays numbers directly, without the reciprocal sign. The bar will disappear after a short time of inactivity.

MENU>Custom Settings (2)>Exposure Set Guide>[On], [Off]

One drawback is that the exposure setting guide obscures the histogram while adjusting the aperture or the shutter speed. For this reason, we prefer to keep this guide turned off.

Noise Reduction with Long Exposure

Images taken with long exposures may suffer from a special kind of noise. This noise appears as bright (hot) pixels that stand out against the black background. The Long Exposure NR command reduces this effect by using a procedure known as dark frame subtraction whenever the shutter speed exceeds one second. The Long Exposure NR command is set as follows:

MENU>Camera Settings (5)>Long Exposure NR>[On], [Off]

This process requires taking two images to create a single image and will operate only in shooting and drive modes where only a single image is being recorded. It will not work if the camera is recording a continuous series of images, such as when in Sweep Panorama or SCN's Hand-held Twilight or Anti Motion Blur modes. Also, this command is not available in any of the Continuous and Bracket Drive Mode options. It does, however, work on both RAW and JPEG files.

When the Long Exposure NR command is turned [On] and the exposure is one second or longer, the following steps occur:

1. When the shutter button is pressed, the camera records the image, including the noise generated by the sensor.
2. The camera takes a second exposure but does not record an image. This is the so-called dark frame, which creates a reference map for the previous image's noise pattern.
3. The camera subtracts the hot pixels recorded in the dark frame image from the first image to reduce the appearance of noise in the final image. The Long Exposure NR command doubles the time it takes to record an image.

The Long Exposure NR command doubles the time it takes to record an image. For example, you take a photograph with a 10-second exposure, the camera will automatically take a subsequent exposure of 10 seconds to create the dark frame. Then the camera processes the subtraction to remove the noise from the first image. For exposures that run more than several seconds, this can create a tedious wait, so some people turn this command off.

Most of our exposures are less than one second in duration, so having this command turned on makes no difference. For the few pictures we have taken with exposures of several seconds or more, we have been pleased with this command's results. It is only when exposures are 30 seconds or longer that we think about turning the command off. Again, when using long exposure times, make sure you mount the camera on a tripod, trigger the shutter with a remote control, and turn off the SteadyShot option.

Noise Reduction at High ISO

As we mentioned previously, using a higher ISO results in increased noise, so we tend to photograph at an ISO of 1600 or lower. If you are forced to work at a higher ISO, you might want to try this in-camera noise reduction option. It only works on JPEG files, and is used with ISO 1600 and higher. The High ISO NR command does not require a second exposure to capture a dark frame; instead, it works on just one image. You can set noise reduction to [Normal], [Low], or [Off] with the following menu command:

MENU>Camera Settings (5)>High ISO NR>[Normal], [Low], [Off]

This command essentially blurs the image and smoothens the appearance of noise, at the expense of image sharpness. It can be used when you fire continuously. Be aware that the command can take some time to execute, so the noise reduction feature may slow down the frame rate when you use continuous firing. We set High ISO NR to [Low] when shooting JPEG files. When we shoot RAW and JPEG files together, we set the command [Off]. We do not use the default setting of [Normal] because it destroys fine detail. Instead, when we shoot RAW and JPEG files together, we set it to [Off]. The command only acts on the JPEG files; not on RAW files. When shooting in low-light conditions, we prefer saving the picture as a RAW file and removing the noise later with third-party noise-reduction software. We use Noise Ninja, which seems to reduce noise with less detail loss than the Sony a7/a7R High ISO NR option.

Metering Modes

Controlling your exposure is critical, so it is important when using the manual settings to know where and how your camera's light meter measures intensity. The Sony a7/a7R's built-in light meter uses three metering modes (table 6-1). You can access the options with the following command:

MENU>Camera Settings (4)>Metering Mode>[Multi], [Center], [Spot]

The above command can be set quickly using the Quick Navi screen or the Fn button (figure 6-2).

Metering Mode	
Icon/Name	**Description**
![Multi icon] Multi	The camera divides the framed image into multiple areas, measures the lighting in each, and determines an overall exposure.
![Center icon] Center	The camera biases its exposure on the central area and provides less emphasis on the periphery.
![Spot icon] Spot	The camera uses only the center of the framed image to determine exposure. A faint circle displays on the screen indicating the area the camera will use.

Table 6-1: Metering Mode command options

The default and most commonly used method is [Multi], where light over the entire area of the framed image is used to calculate the exposure. This is more than a simple average—it is a complex computation that ensures a balanced exposure for a wide variety of subjects. Camera manufacturers originally developed these calculations for film cameras, and later refined them for digital cameras.

Although early versions of this option were unreliable, they have improved over time, and have enabled [Multi] to serve as a workable exposure method for the Sony a7/a7R's automatic exposure modes. For manual

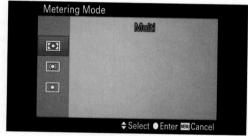

Figure 6-2: Metering Mode's three options, with [Multi] selected

exposure, it serves as a good starting place since you can override the recommended exposure easily. As you take over the camera's operation, it will, at the very least, do a good job of putting your exposure in the ballpark. The results are quite good, and you can refine them by studying the live histogram and adjusting the exposure slightly. Again, the advantage of having a Live View camera is the ability to ascertain if you need to modify the exposure before you take the photograph.

The second metering method is [Center], which uses an easily understood algorithm for evaluating exposure. It is based on the assumption that the most important part of the picture is in the center; therefore, the meter biases the exposure toward that region of the display to assure that the subject in the center is well exposed. The peripheral areas are also measured, and contribute to the

overall exposure, but they are given less priority. Historically, this was a popular way to measure light in an SLR camera. Although this older technology has the virtue of simplicity, it is not as reliable as [Multi] area metering. We rarely use this type of metering since, in comparison to [Multi], it results in a higher percentage of unacceptable exposures.

The third and most direct way to meter is [Spot]. This is for the careful photographer who is knowledgeable about the camera and the desired results. It requires great care to use properly because it converts your camera into a light meter; you will have to mentally calculate how to use exposure data to create your picture.

When selected, you see a small circle in the center of the screen that marks the area being measured for light (figure 6-3). This is a target site, and it is sighted to measure the intensity of the light within its circumference. It requires finesse and thought to interpret the reading. For example, we will use spot metering when photographing people on stage, for instance a piano recital, where the performer is lit with a spotlight and the remainder of the stage is black. Under these conditions, you determine the exposure for the shot by using [Spot] to measure the light reflected off of the performer's face. We find that giving the facial tones about +0.7 EV (for a fair complexion) records bright, clean skin tones. For people with darker complexions, we provide less exposure, maybe -0.7 EV, so as not to wash out the subject's rich complexion. As you can see, using the [Spot] meter is not a point-and-shoot operation. It requires experience. However, when using this metering option, you obtain the most accurate data for determining exposure. In the above recital example, the black background behind the spotlight does not influence the exposure reading. We have found that spot metering and photographing in M mode yields superior results to using the camera in [Multi].

For technical work, we take advantage of spot metering when photographing manuscripts. We find that putting the spot meter on the white page and overexposing by 1 2/3 f-stops records an excellent image with black text against a white background. If we do not apply exposure compensation, the white paper will appear dingy and will be a darker shade than it should.

Figure 6-3: Display screen showing the spot meter's target circle for measuring light

Manual Focusing: Overriding Automatic Focusing

In Chapter 5 we described how to use the menu to reset focus using the Focus Mode command. We discussed using the two options, [Single-shot AF] and [Continuous AF], for semiautomatic shooting modes. In this chapter, we will discuss the remaining two options, [MF] and [DMF], so you can manually focus the camera.

MENU>Camera Settings (2)>Focus Mode>[MF] or [DMF]

While the command can be selected within the camera's menu, you may find this to be too inconvenient for fast operation in the field. We have found it more convenient and faster to use either the Fn button and select the Focus Mode or to use the Quick Navi screen.

[DMF] stands for Direct Manual Focus and is supposed to provide a quick means of touching up automatic focusing. When this option is selected, pressing the shutter button halfway initiates the autofocus. When focus is established maintaining pressure on the shutter button allows you to adjust focus with the lens-focusing ring. The picture is taken by fully pressing the shutter button down. Our main complaint about using [DMF] is its quirky behavior and occasional unreliability. It first requires the camera to acquire focus automatically. Once it does so, you must maintain a light pressure on the shutter button to activate the lens-focusing ring. If you relax pressure prematurely, the ring's function is disabled. Then, because you failed, the process has to be repeated. Aside from wasting time, this option can be extremely aggravating. Failure to find focus will make manual focus unavailable and you will have to change your Focus Mode. We much prefer using the [MF] option, which allows us the surety of having the focus ring active at all times.

When you try your hand at focusing manually, you will discover that Sony has provided options for making this task easier. If the goal is to switch strictly to manual focus, you will find the AF/MF button can be even faster and more convenient, given that you have some additional command settings. In order to experiment with these features, put your camera in MF mode. Be aware that the camera's factory default requires you to press the AF/MF button in to maintain manual focusing. Once you release the button, the camera reverts to automatic focus. To use this button in a way that one press puts the camera in MF mode and then another press puts it back into AF, set the AF/MF button with the following value:

MENU>Custom Settings (6)>Custom Key Settings>AF/MF Button>[AF/MF Ctrl Toggle]

We find the above option convenient because you don't have to maintain continuous pressure on the AF/MF button for manual focusing. If your viewfinder

6

and LCD display are set to [Display All Info.], there is an icon on the left side of the screen that lets you know if the button had been set for MF or AF.

MF Assist

You may find that your view of the subject does not provide enough magnification to see fine enough details for accurate focusing. The most direct piece of assistance is [MF Assist], which magnifies the center of the screen so you can see those fine details. This ensures your focus is precisely spot-on. When using the camera in the field, we found the display screen's base magnification to be insufficient to find precise focus (figure 6-4a). If you have to focus by judging the sharpness of the image, we recommend using the viewfinder—its higher resolution shows finer details.

We use MF Assist extensively, especially when we photograph with a long telephoto lens, where increasing the magnification of the display screen makes finding focus much easier. This is accomplished by activating the MF Assist command:

MENU>Custom Settings (1)>MF Assist>[On], [Off]

When this command is set to [On], the camera provides two levels of magnification: 5.9X and 11.7X for the a7, and 7.2X and 14.4X for a7R. When in Manual Focus mode, turn the Sony lens's ring to focus and the camera magnifies the image by the

Figure 6-4a: Screen at 1X magnification, MF Assist [Off]

Figure 6-4b: Screen at 7.2 magnification, MF Assist [On]

lower magnification. Typically we find this magnification sufficient (figure 6-4b), but if you find this is not the case, you can jump from the lowest power to the highest power by pressing the center button (figure 6-4c).

A second tool to help you determine if your subject is adequately focused is to use the following command:

MENU>Custom Settings (1)>Focus Magnif. Time>[No Limit], [5 Sec], [2 Sec]

Basically, this command determines how long the magnified view is maintained. Once you stop turning the lens-focusing

ring, you can retain the enlarged image indefinitely or for either two or five seconds before the magnification drops down to 1X. Remember that in this command, the magnified view shows only a partial field of view, and you will need to drop down to 1X to frame the scene properly.

Figure 6-4c: Screen at 14.4X magnification, MF Assist [On]

When using the Sony AF lenses, you will find that when [MF] is selected with MF Assist, turning the focusing ring automatically raises the magnification of the screen to 7.7X. Remember that the timer starts only after you stop turning the lens-focusing ring, which can be accomplished in less than a second. Under these conditions, we find that two seconds (the default value) is long enough to find focus. If you need to drop down to the screen's base magnification, you can do so immediately by applying slight pressure on the shutter button.

When using the camera with macro focusing lenses, microscopes, telescopes, extreme telephoto, or legacy lenses, we set the option to [No Limit] because these conditions takes more time to operate. We find that the automatic reduction of magnification disrupts our workflow. The long duration is not a handicap since you can return to base magnification by lightly pressing the shutter button.

MF Assist function has one limitation. When you use it, you only get a partial field of view so you may end up viewing an unimportant part of the image. This can be confusing when it occurs unexpectedly. To get a preview of where the MF Assist will be more beneficial, execute the Focus Mode command. Unless you have already changed the button's assigned command, the C1 button's factory default is Focus Settings. If you have set your camera to manual focus, C1 turns on the MF Assist. In this operation, pressing the C1 button shows an orange rectangle of where you will magnify your scene. A second press of that button results in the magnification setting of 5.9X for the a7 and 7.2X for the a7R. A third press gives you 11.7X for the a7 and 14.4X for the a7R. A fourth press drops you down to 1X.

When you initiate your first C1 press, you'll see an orange rectangle, which you can aim at your target. A second press of C1 enlarges the image, and if you need to you can move the magnified region with the directional (right, left, up, and down) buttons. Press the C3 button to return to the center of the screen. You can also use the rear dial and move the rectangle horizontally. The front dial and control wheel move the rectangle vertically. When using the viewfinder, we prefer using the rim of the control wheel for positioning the rectangle. It may be just us, but we found using the dials and wheels to be awkward and inconvenient.

Peaking and Focusing

Peaking is a colorization strategy that highlights the borders of in-focus areas. You can determine the size and color of the fringes (figures 6-5a and 6-5b). They appear only when you use manual focus and are not recorded with your picture or movie.

There are two commands involved with the peaking function. The first allows you to set the level of peaking. The second command allows you to set the color of the highlights.

MENU>Custom Settings (2)>Peaking Level>[High], [Mid], [Low], [Off]
MENU>Custom Settings (2)>Peaking Color>[Red], [Yellow], [White]

Figure 6-5a: Peaking activated at [Low] setting

Figure 6-5b: Peaking activated at [High] setting

Peaking has two advantages. First, you see the full image; it does not limit the field of view through the finder. You will see all of what the sensor is seeing, which will help with overall composition. Second, it is active while you are taking movies. By comparison, MF Assist can only be used just prior to the start of recording a movie. Once you are actually recording, it becomes unavailable. Since the Peaking color fringes are not recorded, your movie will appear in its natural format.

With these advantages, you would think everyone would embrace this technology; however, Peaking does have flaws. First, and most important to the still photographer, is the distracting nature of the fringes. When its level is set to [High], its appearance at the borders interferes with careful composition. Second, there is a question of whether Peaking is as precise as MF Assist when you need critical focusing. Our feeling is that for precision macro or scientific work, Peaking is less accurate. While we find Peaking eminently useful for movie taking, we prefer using MF Assist for our still photography. The good news is if you like this function and want to use it off and on, it is an available option for several of the customizable keys.

The setting of the Peaking Color and Level depends on the scene and its over-all color scheme and contrast. We are split on our preferences—one of us prefers yellow for their work and the other prefers red. The Peaking Level option depends on the intrinsic contrast of the scene. With high contrast, it is better to use [Low] because the fringes can be large and distracting when focus is reached. In a low contrast scene, [Low] produces such small fringes that they do not aid in focusing. Under these conditions it is better to use [High] to make them visible.

Aperture and Zoom Lenses With Manual Focusing

To achieve the most accurate focus, you should have your lens set at is widest (maximum) aperture. This is attained easily in P and S modes and is Sony's normal operating strategy when using autofocus lenses. These lenses are always set to the maximum aperture while viewing a subject in Live View. When the aperture is changed via the control dials in these modes, the physical lens aperture actually stays fully open while the camera is calculating what the exposure should be with the new setting. When you press the shutter button, the lens aperture will close down to the chosen setting as the camera takes the picture.

This is not the case if you use A or M mode. As you preview the scene and decide to use a narrower aperture, the lens diaphragm closes down immediately and is set to the working aperture at which the picture will be taken. This provides the benefit of seeing the increased depth of field in real time. However, this is not ideal for accurate focusing because the increased depth of field makes it difficult to judge the precise point of focus. You can see this for yourself if you attempt to focus in A mode and compare the ease of focusing between a lens used at f/4 to one set to f/22. In the former case, as you turn the focusing ring, the image appearance changes with alacrity from tack sharp to blurry. If you set the aperture to f/22, the transition from sharp to blurriness occurs gradually, making it difficult to judge where the precise focus point is. If you use P or S mode, the focus always appears to change quickly, regardless of the lens's aperture setting.

The important message in this section is that accurate manual focus is obtained most easily when the lens is at its minimum depth of field. This rule can be extended to zoom lenses. A zoom lens will show a narrower depth of field when it is set to its maximum focal length. To accurately focus this lens, you would do so at this focal length. If you zoom back to get a wider field of view, focus will be maintained. In contrast, if you attempt to focus at the minimum focal length of this lens, you will find that as you zoom in, the focus point will change. In summary, to get the most accuracy in manual focusing, use the longest focal length of your zoom lens.

6

Manual Adjustments of Color Temperature

In Chapter 5 we described how to use preset WB values by matching a light source to an icon. However, there are two other ways to set WB: by selecting a specific color temperature and by saving a customized white balance. Table 6-2 contains icons pertaining to these two methods. Both will require some effort.

Icon/Name	Description
White Balance Customizable Options	
⮔ C.Temp./ Filter	This option allows you to set the WB based on a specific color temperature value represented in K units (Kelvin).
⮔1 Custom 1	This option stores a custom color temperature WB preset setting created using the Custom Setup WB option.
⮔2 Custom 2	This option stores a custom color temperature WB preset setting created by using the Custom Setup WB option.
⮔3 Custom 3	This option stores a custom color temperature WB preset setting created by using the Custom Setup WB option.
⮔SET Custom Setup	Use this option to set up a custom WB preset to be stored and used by one of the Custom WB options.

Table 6-2: A listing of color temperature icons

First, you can get to the WB screen through the menu:

MENU>Camera Settings (4)>White Balance>[C.Temp./Filter], [Custom 1], [Custom 2], [Custom 3], [Custom Setup]

Rather than setting the WB through the menu, we take advantage of the control wheel's right button (with the WB label) to provide quick access to White Balance (figure 6-6a).

Once you press this button, you will see various option icons on the right side of the screen, along with the description of the highlighted option at the top. Scroll through the options until you reach [C.Temp./Filter] (figure 6-6a). If you press the right button, you will enter the Color Temp. screen, which has an orange bar containing a 4-digit number preceding the letter "K" (the abbreviation for Kelvin). The up and down arrows indicate how to move through the available temperatures (figure 6-6b). The 4-digit number ranges from 2500K to 9900K. Use the up

or down button, or rotate the control wheel or front and rear dial, to navigate through the range. The numbers change in increments of 100.

Figure 6-6a: WB command's C. Temp./Filter option

These numbers represent temperatures or light-source colors, and allow you to set your camera's white balance to a specific color temperature. Artificial light sources, especially tungsten lamps, are rated by their manufacturer in degrees Kelvin. You can calibrate your camera's sensor to the lamp's specifications. Rather than discuss the scientific and physical basis for this scale, it is sufficient to say that when you dial in the appropriate numeric value for a light source, your camera should be calibrated to that light.

Figure 6-6b: Setting the color temperature to 5500K

To perform this operation, you need to know the color temperature of the light source— information the manufacturer supplies with their bulbs. For example, the tungsten bulb on our microscope is rated at 3200 K, a value provided by the manufacturer, Osram. So, we can set [C.Temp./Filter] to this number when taking pictures through our microscope. Most technicians realize this value is approximate. The bulbs age with time, and as the glass envelope becomes coated with tungsten from the filament, the light is filtered and becomes cooler in color temperature. Also, with an incandescent light source, the color temperature depends on the operating voltage. Bulbs emit a warmer color with a decline in voltage. For the most critical work, a color temperature meter is used to measure the light's output to ensure consistent color recording. These are expensive instruments and can cost more than your camera and lens combined. Fortunately, your Sony a7/a7R has this capability built into its software.

Custom White Balance

Only rarely do we use the color temperature scale. Instead, we use the Custom WB feature, which works effectively with any light source. It sets the camera's white balance by calibrating it directly to the light. This value is saved and can be used

Figure 6-7a: WB set for Custom Setup WB

Figure 6-7b: Gray circle indicating where to place a piece of white paper in the frame

Figure 6-7c: Custom Setup Register screen

as if it is a preset WB value. To do this, all you need is a blank sheet of white paper. The following steps outline the process:

1. Press the WB button and scroll through the options with the control wheel. Highlight the option [Custom Setup] (figure 6-7a).

2. Press the center button. A new screen appears with a finely inscribed circle in its center and the message: "Press center button to capture data of central area of screen." Figure 6-7b shows a white sheet of paper occupying the whole field of view. Note the color of the paper. In this case the white balance is not set correctly, causing the white paper to have an orange cast.

3. Place the white paper so the circle is filled, and then press the center button (figure 6-7c). The white paper serves as a reflector and provides a screen for displaying the illuminant's color.

4. You will hear the camera take a picture. A new screen appears with a gray rectangle stating: "Select register" along with the color temperature in K and two numbers, one following A-B and one following G-M (figure 6-7c). The gray color reflects that the white balance has been set correctly.

5. Use the left and right buttons to select a register number, 1, 2, or 3, to store the color temperature value and press the center button.

You can store up to three custom values, one value in each register. These become preset WB values that are available to you when you press the WB button and select the appropriate register number. These numbers are retained even if the camera is turned off.

Custom WB is easy to use. In fact, we use it routinely for our technical photography. For example, when working with a microscope, we remove the specimen from the field of view and calibrate the WB setting against an unobstructed region. The camera is directly calibrated to the light. This is more accurate than using a color temperature scale because it compensates for color cast imparted by the optics of the microscope. We described earlier how the color temperature of an incandescent bulb changes with age. Using Custom WB just before a photo session compensates for this.

Fine-Tuning WB: Fine Adjustment of Amber-Blue and Green-Magenta

On every WB preset selection, you can fine-tune the color further by providing hues to the image. These change the ratio of amber to blue (A-B) and the ratio of green to magenta (G-M). This can counteract an undesirable tone resulting from unusual lighting conditions. Your subject may be under several different types of lights. For example, an interior scene might be lit by daylight streaming through the window, an incandescent light sitting on the table, and fluorescent lights hanging from the ceiling. These extreme conditions can cause an undesirable color cast in the image. Fortunately, this can be corrected by adding a slight tint to the image. The slight hue addition will be recorded in both JPEG and RAW files.

When you select a WB preset, press the right button and a screen with a large square consisting of smaller, multicolored squares will be displayed. The only exception to this is the Color Temperature/Filter option. In this case, press the right button twice. The first press calls up the color temperature values, and the second press calls up the multicolored square.

At the center of this multicolored square is an orange circle (figure 6-8a). Press the control wheel's rim to move the circle within the color square. Move the orange circle horizontally to apply either blue or amber. Move

Figure 6-8a: WB color fine adjustment screen

Figure 6-8b: WB fine adjustment being applied

the orange circle vertically to apply green or magenta (figure 6-8b). You can see the effects of these color changes in your Live View screen.

As noted earlier, these hue adjustments are needed for correcting color tints when several different light sources are used. This need can also arise if you use a single light source that emits a discontinuous spectrum, such as fluorescent or LED light. When this type of lighting illuminates your subject, you may find that your images has a color cast that cannot be removed by simply selecting a preset WB value. You can use this fine adjustment process within the camera to deal with undesired coloration.

Earlier, we recommended that you save your images as both RAW and JPEG files. Each file format has its advantages. A major benefit of saving in RAW format is the ease of correcting WB errors outside the camera. We use either Sony's Image Data Converter software or third-party software, such as Photoshop or Aperture, for touching up RAW images. Figure 6-9 shows the Image Data Converter software's slider and a color temperature scale. The slider allows you to rapidly evaluate different color temperature settings. Additionally, the selection marked "Preset" displays a variety of light sources, enabling you to find your illumination type.

If you record an image of an 18% gray card, you have a quick means to calibrate the Image Data Converter software to the card's color temperature. Use the card as a target for the software's Specify gray point command. Since the card serves as a neutral reference, the software attempts to render it as gray without tinting. Notice the icons under Specify gray point; you can select either an eyedropper or a selection box and target part of the 18% gray card.

Figure 6-9: Image Data Converter controls for adjusting a RAW file's color temperature

The eyedropper is basically a pointer. When you select it, you can guide it to the precise point in the gray image that you wish to use to set your white balance. Keep in mind that it should be used with images that have little chroma noise. If your picture is taken in poor light and you see colored speckles in the gray card, you will get more consistent adjustments by using a rectangle for selecting the card. Using the larger area averages the chroma noise and provides a truer measurement of the gray card's surface.

Lens Compensation

To obtain the ultimate picture quality, the a7/a7R has software that corrects imperfections introduced by the lens. These imperfections include vignetting (peripheral shading), distortion (geometric distortion), and chromatic aberration (color fringing). Vignetting is a common lens defect in wide-angle lenses. It generates an image where the periphery is darker than its center. Distortion indicates that parallel straight lines bow in (pincushion distortion) or bow out (barrel distortion). Finally, chromatic aberration is when the subject's borders have red or blue fringes due to the inability of the lens to bring all wavelengths of light to the same focus.

Correcting these problems with software requires an in-camera database to catalog the lens defects and a processing algorithm to correct the image. Sony periodically provides updates to the camera's firmware, expanding the database as new lenses are introduced into its lineup. Remember, this correction is a software alteration of the image that provides a modified image file. For scientists requiring unaltered images, these corrections should be turned off even if the recorded image shows all of the lens defects.

The chromatic aberration and shading correction default setting is [Auto], so if the attached lens is in the database, its optical faults will be corrected in JPEG files. RAW files are not corrected and will show the image defects. Curiously, at the time of writing, when the 28-70mm Sony FE and the Carl Zeiss 24-70mm zoom lens are mounted, the Distortion Comp is grayed out and unavailable for adjustment. Normally, when available, you would select it and make sure it is set to [Auto].

Here are the three lens compensation commands and their individual options:

MENU>Custom Settings (5)>Lens Comp.>Shading Comp.>[Auto], [Off]
MENU>Custom Settings (5)>Lens Comp.>Chro.Aber. Comp.>[Auto], [Off]
MENU>Custom Settings (5)>Lens Comp.>Distortion Comp.>[Auto], [Off]

DRO/Auto HDR Function

When photographing, you sometimes encounter a scene with overly bright regions that show little to no detail. Or you might encounter a subject with deep shadows that appear as a featureless black mass. Many of these problems can be corrected or ameliorated by downloading the image to a computer and post-processing it with programs like Photoshop or iPhoto. But Sony has designed the a7/a7R so you can reduce these deficiencies in the camera with two processes: Dynamic Range Optimization (DRO) (figures 6-10a and 6-10b) and Auto High Dynamic Range (Auto HDR) (figure 6-11a). When you select either of these operations, the camera will process the image automatically and save it to your memory card. Figure 6-11b is the result of taking three shots of varying exposures and combining them into

one image using Photomatix software. You can see the extent of how Auto DRO, Auto HDR, and Photomatix bring out the shadow details.

Choose DRO when one exposure can record all of the intensity values for the scene. If the scene has too great a variation in intensity values and the extreme light levels overwhelm the sensor, use Auto HDR. This setting employs three exposures

Figure 6-10a: Image without DRO Auto **Figure 6-10b**: Image with DRO Auto

Figure 6-11a: Image made with Auto HDR **Figure 6-11b**: Image from Photomatix

taken in rapid succession: one for recording highlights, one for recording midtones, and one for recording shadows. By using multiple exposures, you can record a greater range of intensities than can be recorded in a single photograph. By combining these three images, it is possible to create a composite where shadows can be lightened, highlights can be darkened, and midtones can be maintained.

The DRO and Auto HDR functions are accessed through the menu, where you can turn both functions off or select one of them:

MENU>Camera Settings (4)>DRO/Auto HDR>[D-R Off], [DRO], [HDR]

DRO Function

Access the DRO function with the following command. Note that DRO has a list of suboptions to choose from.

MENU>Camera Settings (4)>DRO/Auto HDR>DRO>[AUTO], [Lv1], [Lv2], [Lv3], [Lv4], [Lv5]

The DRO function submenu options are shown in table 6-3. The DRO level options determine the extent to which shadows are lightened in an image—the maximum effect occurs at [Lv5], and the minimum effect occurs at [Lv1]. To select a specific Lv value, highlight the DRO activated [AUTO] option and press the right or left button to navigate through the options. Use the center button to apply the selected value to the DRO function.

DRO Icon	DRO Name	Description
DRO	OFF	Camera does not implement DRO and does not attempt to lighten the shadows.
	AUTO	Executes DRO automatically when the image has deep shadows and bright highlights. The camera chooses what level to use to adjust the shadows and highlights.
	Lv1	Level 1: Applies the least amount of change to shadows and highlights in the image.
	Lv2	Level 2: Applies the second least amount of change to shadows and highlights in the image.
	Lv3	Level 3: Applies the middle amount of change to shadows and highlights in the image.
	Lv4	Level 4: Applies the second most amount of change to shadows and highlights in the image.
	Lv5	Level 5: Applies the most amount of change to shadows and highlights in the image.

Table 6-3: DRO options of the DRO/Auto HDR command

It is difficult to estimate what level you need for a given scene. We recommend trying each of the levels until you get to know how the results look. With practice, you should be able to implement this function to your liking. Although the camera makes the level decision for you when set to [AUTO], this does not guarantee that you will like the image that is recorded.

When you select a specific level, the DRO icon will appear on the display screen along with the level you selected for both [Display All Info.] and [For viewfinder] data display formats.

The DRO command is available in P, A, S, M and Movie modes only. For still pictures, you can shoot in RAW or JPEG or both. RAW files, when opened with most image-processing software programs, do not show the effects of DRO. So when you photograph in [RAW&JPEG], you will find that the RAW files look unchanged, while the JPEG files show the effects of DRO. One program where you can see a RAW file emulating the contrast changes with DRO is Sony's Image Data Converter 4.0.

You can use DRO with a Creative Style to affect your picture's results, but not a Picture Effect. When you have DRO active and select a Picture Effect option, the DRO value will change to [D-R Off]. It will be changed back to its previous value when you set the Picture Effect command to [Off].

HDR Function

Traditionally, HDR photography involves downloading pictures taken with different exposures and combining them together on a computer to form a composite image with all the intensity levels from the scene digitized. Then tone mapping, a program for manipulating contrast, brightness, and color, is used to create an image that displays details in the brightest and darkest areas of the scene. With scenes that have a wide range of intensities, HDR photography frequently produces an image with oversaturated colors, which gives it a surreal appearance. For example, when you merge three different exposures with third-party software like Photomatix, the final composite image can have dramatically different colors than the original scene (figure 6-12). You can be aggressive with this approach and bring up the dark tones and bring down the bright tones to create an image, which shows more detail than that achieved in figure 6-11a.

Figure 6-12: Image created by merging three exposures in Photomatix

When you use the Auto HDR function, you might be surprised to find that the final image does not have the supersaturated colors that it did when the same images were processed with Photomatix. Instead, the color balance and saturation of Auto HDR are similar to a DRO image. It appears that Sony engineers have adjusted the Auto HDR output so that the resulting image retains the color balance and tonality associated with a typical photograph. To mimic the surreal appearance characteristic of HDR images, you might want to try the Picture Effect [HDR

Painting] option. Unfortunately, this effect does not work with the Auto DRO/HDR command because it can only be applied to photographs taken with a single shot. Unlike when you create this effect with third-party HDR software (which uses three exposures—one underexposed, one normally exposed, and one overexposed), images taken using the [HDR Painting] effect are limited to the dynamic range of the single exposure. Its surrealistic appearance cannot match what can be obtained by post-processing with software such as Photomatix.

Even though Auto HDR and DRO address the same problem of intensity extremes in a picture, there are important operational differences. First, DRO images can be captured in RAW format and Auto HDR function cannot. Second, DRO works on the information obtained from one image while Auto HDR works on three. DRO images will therefore have higher noise levels in the deep shadows than the images generated from Auto HDR. Remember: one of the three exposures in Auto HDR is used for capturing shadow detail and will reduce noise in this area of the image. In contrast, DRO uses image processing to increase the brightness in the shadow areas, which amplifies the appearance of sensor noise. Third, DRO has the advantage of working on a scene where the subject is moving, and for taking movies. The three exposures used in Auto HDR preclude its use for moving subjects or movies. Curiously, of the three pictures Auto HDR takes, only two are saved on the memory card: one with the normal settings and one of the merged image.

The following command enables the Auto HDR process, and the options are described in table 6-4. Again, like DRO, the HDR command has a list of suboptions to select from.

MENU>Camera Settings (4)>DRO/Auto HDR>HDR>[AUTO], [1.0EV], [2.0EV], [3.0EV], [4.0EV], [5.0EV], [6.0EV]

After the Auto HDR command is selected, you have the choice of letting the camera determine the best EV by setting [AUTO]. Alternatively, you can take control and select a specific EV value ranging from 1.0 to 6.0. The selected value becomes the ± range over which the three shots are distributed. Use a low EV value when the scene has a moderate range of light intensities; use a high EV value when the range of intensities is more extreme. To select a specific EV value, press the right button to enter the submenu. Use the right and left buttons to navigate through the options. Press the center button to apply the selected option to the HDR function.

HDR Icon	HDR Name	Description
	Auto HDR: Exposure Diff.	The camera shoots three images and combines them to bring out detail, especially in the shadows and bright, washed-out areas. The process closely retains the subject's coloring.
	AUTO	The camera determines the best EV value to use to bracket the three shots.
	1.0EV	The camera brackets the three shots within a total of +/-1.0EV.
	2.0EV	The camera brackets the three shots within a total of +/-2.0EV.
	3.0EV	The camera brackets the three shots within a total of +/-3.0EV.
	4.0EV	The camera brackets the three shots within a total of +/-4.0EV.
	5.0EV	The camera brackets the three shots within a total of +/-5.0EV.
	6.0EV	The camera brackets the three shots within a total of +/-6.0EV.

Table 6-4: HDR options of the DRO/Auto HDR command

The Auto HDR function is available in P, A, S, and M modes only, and it can only save JPEG files (Quality = [Extra Fine], [Fine] or [Standard]). If the camera is set to HDR on, and then you to set the Quality value to include RAW, the DRO/Auto HDR command's value will be changed automatically to DRO's on option but does not automatically change back if you reset the Quality command to a JPEG-only value.

As with DRO, you can use Auto HDR with a Creative Style to affect your results but not a Picture Effect. When you have Auto HDR active and select a Picture Effect option, the Auto HDR value will change to [D-R Off]. It will be changed back to its previous value when you set the Picture Effect command to [Off].

When you select a specific EV, the HDR icon will appear on the display screen along with the level you selected for both [Display All Info.] and [For viewfinder] data display formats.

Using DRO and Auto HDR

We encourage you to try these imaging techniques and see if they help your photography. They can be a benefit. As you gain more experience, you may decide to forego using these processes within the camera and start using them as post-processing procedures.

If you wish to mimic the effect of using a DRO Lv level, you can use Sony's Image Data Converter for working on your RAW files. We prefer it to the camera's internal processor. Even though Image Data Converter's effects are not identical, it is similar enough to improve the image. Its greatest advantage is that you can try several levels of DRO on one image, and also specify adjustments to the highlights and shadows. Our problem with using DRO in the camera is that it requires considerable expertise to pre-visualize its effects before taking the picture. We find it simpler to take RAW images with DRO off and then improve the images on our computer using either Image Data Converter or the "Curves" tool in Photoshop.

We have found DRO to be a powerful benefit when recording movies. The ability to post-process these files may be limited, and DRO provides a simple means of taming contrast extremes to make a pleasing movie.

Like DRO, Auto HDR can improve an image, but also like DRO, it is difficult to anticipate the recorded image's appearance. We prefer shooting in RAW, which is not available with Auto HDR. We can take multiple images, bracketing the exposure, and then post-process the RAW images on our computer with Photomatix, which allows us to experiment with different interpretations of the composite image.

Bracketing and Dynamic Range

The a7/a7R has a special feature for dealing with unusual lighting conditions. It can be set to capture three images, each recorded with a slightly different setting. The process is done as bracketing and it can be considered a shotgun attempt to find the ideal setting. These features are available as Drive Mode command options that control variations in the light level, WB, or contrast.

To vary the light level on the sensor, press the Drive Mode button. Scroll through its options with the control wheel until you highlight a rectangle containing the letters BRK. Outside the rectangle is the letter C. This is the icon for [Cont. Bracket]. Press the right button to scroll through the following options: [0.3EV 3 Image], [0.3EV 5 Image], [0.5EV 3 Image] [0.5EV 5 Image], [0.7EV 3 Image], [0.7EV 5 Image], [1.0EV 3 Image], [2.0EV 3 Image], and [1.0EV 3 Image]. You will see your selection displayed along the top of the screen.

The EV values refer to the +/- variation in exposure that will be applied, and the number preceding "Image" indicates the number of pictures that will be taken. So in the case of [1.0EV 3 Image], three pictures will be taken, one at 1.0 EV beneath the camera-recommended exposure, one at the recommended exposure, and at 1.0 EV over the recommended exposure.

Bracketing with M Mode

Typically when using HDR software, you use A mode for Bracketing. The a7/a7R allows you to use Auto HDR or exposure bracketing in manual. The camera's software uses the following strategy for varying exposure: if you have ISO set to [ISO AUTO], the camera will vary its ISO setting to alter its exposure, and the aperture and shutter speed will stay constant. If you select an ISO to be set at a constant value, the camera will vary its shutter speed to provide the variance in exposure. Your LCD and viewfinder will show the exposure ranges that will be used in these modes when you use bracketing. It will not do so if you decide to use Auto HDR.

When you find the exposure variation that suits your needs, press the center button. To take the picture, press the shutter button and keep it depressed until all the shots are fired. If you raise your shutter finger too soon, you will not complete the series.

You can specify the order of pictures that will be saved to your card with the menu commands listed below. The default option is to first save the camera-recommended exposure, then save the shortest exposure, then save the longest exposure. This is also the order in which the camera takes the pictures: a normal exposure, an underexposed image, then an overexposed image. However, you can use a different sequence where it starts from the lowest exposure and then sequentially takes the higher exposures. To do so, use the following command:

MENU>Custom Settings (4)>Bracket order>[0⇨—⇨+], [—⇨0⇨+]

Although the captured EV bracketed images can be used to fine-tune exposure, we prefer using them for HDR photography. To do this, we download the three or five bracketed exposures to our computer and use HDR software to combine them into a composite image. With tone-mapping software, we can alter the color and contrast to produce images with surreal colors. This differs from the camera's built-in Auto HDR function, which renders a more realistic image without extreme coloration.

The bracket shooting technique overcomes the sensor's limitations through image processing. A single exposure concentrates on the midtones in a scene; therefore, a bright sky may be overexposed and deep shadows may be underexposed. In the case of the Bracket order command set to [0⇨—⇨+], the first shot records the camera's optimum exposure (figure 6-13a); the second shot records detail in the highlights (figure 6-13b); and the third shot records detail in the shadows (figure 6-13c). The final composite HDR image shows detail in both the highlights and the shadows (figure 6-13d).

6

Figure 6-13a: Optimum exposure

Figure 6-13b: Underexposed by 2 f-stops

Figure 6-13c: Overexposed by 2 f-stops

Figure 6-13d: Combined image using HDR software

Another option when bracketing exposures is the icon BRK followed by S: Single Bracket. This is the same as the Cont. Bracket except instead of having the camera firing all the shots automatically with one press of the shutter button,

you will have to press the button repeatedly to take the sequenced shots. This is the difference between a semi-automatic rifle, which fires one bullet with each squeeze of a trigger, and a machine gun, which spews out a series of bullets while the trigger is depressed once.

Bracket WB and DRO

The Drive Mode bracket commands, WB Bracket and DRO Bracket, are unusual in that they work from a single shot and create three images with adjustments that are below normal, normal, and above normal. Both Bracket commands have two options: [Lo] and [Hi]. [Lo] applies a small degree of bracket adjustment and [Hi] applies a large degree of bracket adjustment.

These commands are not disabled when you save files as RAW and JPEG file types, but when using Image Data Converter, we saw DRO and WB effects applied to only the JPEG images. If you use these commands and save in [RAW&JPEG], you will save six files: 3 RAW and 3 JPEG. This may be a bug in the camera software. It may be corrected in later versions of Sony's firmware, or it may not be a problem if you use a different RAW converter. Theoretically the effects of DRO and WB could be applied to the RAW files, but we did not find this to be the case while testing the functions of this camera.

Recommendations

Manual operation of the camera is for those who want to obtain the best possible exposure and focus. When compared to using the automatic modes, manual operation is admittedly slower, but it provides advantages that are otherwise unattainable. For example, if you need exposures longer than 30 seconds, you will have to use M mode.

If you use a tripod, M mode is a natural match. You might think that modern cameras have made tripods obsolete, but this is not the case. If you are a nature photographer working with long telephoto or macro lenses, tripods are invaluable. The weight and magnification of a 400mm telephoto lens makes handholding the camera difficult. The stability and precise controls that a tripod provides help you to focus and frame your pictures precisely. At the other end of the spectrum, close-up or macro photography also benefits from using a tripod. You will find the stability of a tripod essential for precise framing and focusing. Even if you are a scenic photographer, a tripod can help you work with your kit lens. It will give you the availability to spend more time composing your image and concentrating on ensuring that the subject is in sharp focus.

For our work with telephoto and close-up lenses, we rely on MF mode. We've found that when the depth of field is small, AF mode often fails to lock onto the subject, and instead has the tendency to focus on intervening objects, such as twigs or branches.

When we are shooting an assignment, we do not like using the menu commands. It simply takes too much time to scroll through all the commands before you find the one you need to change. To speed up the process, we use the Fn button and Quick Navi screen. To use the latter, make sure the [For viewfinder] data display format is checked in the DISP Button>Monitor command. This format displays all of the camera settings instead of showing a live view of the subject. When you press the Fn button, the screen gives you a portal to alter most of the camera's displayed settings.

When shooting outdoor scenes, we turn off AWB and set WB to one of the preset values. For example, when photographing sunsets, we find the reds to be more saturated when we set the WB to daylight rather than AWB. When working indoors with incandescent lighting, we use Custom WB. We do not use the fine adjustment of colors in the camera; instead we work with the saved RAW file on our computer.

When taking movies, we leave DRO set to [DRO Auto] in order to lighten dark shadows. If you decide to use one of the Lv options instead, we recommend you experiment with different degrees of DRO and find the one that suits your photography best. For our still photography, we felt DRO Auto's effect was insufficient by itself and we dialed in an Lv of [4] or [5]. Our feeling is that DRO is difficult to use within the camera because you have to estimate its effects prior to taking the picture. We prefer lightening shadows in a picture by post processing with Image Data Converter. It is easier to obtain the effect we want by post processing the saved image. Image Data Converter provides a convenient means to create DRO-like effects on our still photographs. Similarly, we prefer using Photoshop for altering the contrast in our image. Although it does not have a DRO option selection, we find that by selecting areas of the image and using layers, we can generate an image with a satisfactory appearance.

We have tested Sony a7/a7R's Auto HDR function and achieved very good results. However, we are old-school camera users and still prefer generating HDR images by bracketing and combining the multiple RAW images in our computer with third-party software. RAW format gives us the most recorded data for maximum post-processing capability. We load the images in third-party software, such as Photomatix. After the photographs are merged, we use this software for tone rendering. We recommend that you run two tests to see which you prefer: (1) generate an HDR image with the camera's Auto HDR function, and (2) generate an HDR image of the same subject with third-party software.

Using the Auto HDR function is simple and quick, but it is not the same as capturing the images and generating the HDR image yourself. We again recommend that you play with the exposure compensation when working with this tool. We take the extra step of using exposure bracketing and third-party software. In part, this is for obtaining better control in the final picture. Not only can you vary your effect with tone-mapping software, but also, you have a greater range of settings to work with if you save in RAW. Auto HDR can only be saved as a JPEG.

6

Chapter 7: Additional Features

Introduction

The Sony a7/a7R has a wide range of additional features that enable you to set your camera quickly and to add style and uniqueness to your images. In this chapter we will cover both camera customization and additional features that will allow you to enhance your pictures.

Customizing you camera provides you quick access to the settings you need most frequently, making your photography session more efficient and enjoyable. Sony has included numerous customization capabilities in the a7/a7R cameras. Not only can you store three sets of camera commands in the memory, you can also assign a function to one of the many customizable buttons instead of searching through the menu structure to find a specific command. You will realize your needs as you use your camera, and set up your preferences to accommodate your shooting style.

As a new user, you can control whether help information is available for display as you navigate through the structure. In addition, the Sony a7/a7R has many exciting features that give you the opportunity to capture unique pictures. Normally, applying these techniques requires downloading the images to a computer and using post-processing software. Now you can carry out these techniques within the camera. You can use a compositional effect to enhance your final photograph. This can be a simple intensification of the colors or removing the colors entirely and converting the photograph to a black-and-white picture.

All of these features will allow you to tailor your camera's operations to suit your needs and save you time. How you customize your camera will depend on how you use the camera's features, your flexibility in learning shortcuts, and your patience in navigating through the menu structure. If you are just starting to use the a7/a7R, we recommend that you limit your modification of its controls. Change your button assignments gradually as you develop a photographic style and a preference for the subjects you photograph. As you gain experience and enjoyment from using your camera, the customization of your camera will happen organically.

In this chapter, we will also cover the remaining still picture shooting modes on the mode dial, Sweep Panorama, Memory Recall 1 and 2, plus two features that affect the image's color and style: Picture Effect and Creative Style. These two features offer you an opportunity to capture a special image that would have been difficult and time-consuming to create with more conventional photographic methods. We will also cover the a7/a7R's Auto Obj. Framing. When the camera detects a face or a tracked object, the Auto Obj. Framing function will automatically resize the captured image so that the subject is centered and enlarged to fill the frame when the shutter button is pressed.

Customizing Buttons

There are eleven buttons that can be customized for executing menu commands. How they are customized is controlled by two commands in the Setup menu: Function Menu Set. and Custom Key Settings. Combined, these two commands control 22 menu command customization opportunities that can be assigned to the eleven buttons. Without some customizing, you may find yourself constantly returning to the menu and navigating through its structure to find a specific command for setting a new value.

Fn (Function) Button

The Fn button (figure 7-1) is right above the control wheel on the back of the camera. Its collection of commands is controlled by the Function Menu Set. command. In its default configuration, pressing the Fn button shows twelve command icons, which appear as two rows of six commands each, displayed along the bottom of the screen. When their icons are highlighted, a descriptive text appears in the view screen. There are two ways to navigate through the displayed commands. If you only want to change one command value, navigate to the specific command icon and press the control wheel's center button. The rest of the Fn button commands will disappear, and only the selected command's options will be displayed. Make your changes and accept them, and you will be returned to Live View.

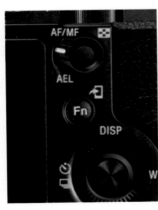

If you wish to make more than one command change, select your icon with the right, left, up, and down buttons. When you rotate the control wheel, you will see a set of changing options appear in the screen. If one or more of the options have a submenu, such as DRO/Auto HDR, you will see icons at the bottom of the screen indicating that you should use the front or rear dial to enter into the submenu and select an option. Once you have found your option, return to the Fn row by pressing the MENU button. Repeat selecting new icons with the directional buttons, and then press the control wheel's center button to save your changes. Several of the commands, such as WB, Creative Styles, and Focus Area, have submenus that cannot be entered via this method. It is best to make changes to those commands either through the menu or the Fn button by entering the command via the center button.

Figure 7-1: Fn button

We have two suggestions for modifying the Fn screen. First, if the control wheel's rim already accesses commands, such as WB, there is no reason to customize the Fn button to access the same command. Second, keep in mind that each time the camera is reset to the factory defaults through Setting Reset's [Initialize] function, the Fn button commands return to their default assignments. Because of this, when you customize the Fn button, you should write down your custom settings in case you need to reinitialize the camera.

Setting the Fn Button

To change the Fn button values, use the following command (figure 7-2a-and 7-2b):

MENU>Custom Settings (6)>Function Menu Set.>[Function Upper1], [Function Upper2], [Function Upper3], [Function Upper4], [Function Upper5], [Function Upper6],[Function Lower1], [Function Lower2], [Function Lower3], [Function Lower4], [Function Lower5], [Function Lower6]

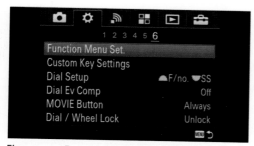

Figure 7-2a: Function Menu Set. command

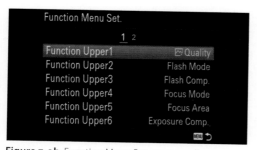

Figure 7-2b: Function Menu Set. command's page 1 options

Below is a list of the available options. Each of the Function Menu Set. commands have the same available options.

Drive Mode

Flash Mode

Flash Comp.

Focus Mode

Focus Area

Exposure Comp.

ISO

Metering Mode

White Balance

DRO/Auto HDR

Creative Style

Shoot Mode

Picture Effect

Lock-on AF

Smile/Face Detect.

🖾 Soft Skin Effect

🖾 Auto Obj. Framing

🖾 Image Size

🖾 Aspect Ratio

🖾 Quality

SteadyShot

Audio Rec Level

Zebra

Grid Line

Audio Level Display

Peaking Level

Peaking Color

Not Set

Table 7-1 contains the camera's defaults and our personal Fn button's settings. Remember, our way of customizing the Fn button may not work for the type of pictures you take. You may find that you need to change one or more of the settings because you utilize a different command more frequently for one shooting style, such as shooting portraits indoors, than you do when you are shooting outdoor daytime landscapes.

Fn button Customizable Slot	a7/a7R Defaults	Our Fn Customization
Function Upper1	Drive Mode	Quality
Function Upper2	Flash Mode	Unchanged
Function Upper3	Flash Comp.	Unchanged
Function Upper4	Focus Mode	Unchanged
Function Upper5	Focus Area	Unchanged
Function Upper6	Exposure Comp.	Unchanged
Function Lower1	ISO	Zebra
Function Lower2	Metering Mode	Peaking Level
Function Lower3	White Balance	SteadyShot
Function Lower4	DRO/Auto HDR	Unchanged
Function Lower5	Creative Style	Unchanged
Function Lower6	Shoot Mode	Unchanged

Table 7-1: Default Fn button settings and our typical customization settings

Setting one of the Function Menu Set commands to the [Not set] value voids the slot and no command icon will display in that position along the bottom of the display screen (figure 7-3). Keep in mind that not all commands will be enabled depending on the camera's shooting mode and other camera menu settings. For example, if Picture Effect command is assigned to one of the Fn button fields, the command icon will be disabled (grayed out) if Quality command is set to [RAW] or [RAW & JPEG]. As you navigate the Fn icons, you will automatically skip over any disabled icons and slots set to the [Not set] option.

When you assign either Exposure Comp. or Shoot Mode to the Fn button, these options work a bit differently than they do when you navigate to their correspond-ing commands in the camera's menu. When the Shoot Mode option is assigned to the Fn button, it covers three menu functions: Auto mode, where you can select either Intelligent Auto or Superior Auto; SCN selection, where you can select one of the 9 predefined scene option; and Movie mode, where you can select P, A, S or M mode. The Fn button's Shoot Mode icon is enabled only when the mode dial is set to AUTO, SCN, or Movie mode. In these cases, the mode dial's selection will be reflected in the assigned Fn box. Highlight the Fn box, press the center button, and the associated mode dial options will be displayed for you to select a value. Otherwise, the Shoot Mode Fn button's assigned box is disabled (the mode dial's selection will be superimposed in the box).

When the Exposure Comp. command is assigned to an Fn button option, the associated Fn box is enabled only when the exposure compensation dial on the top of the camera is set to zero. Otherwise the dial's non-zero exposure compensation value will be grayed out in the associated Fn box. Keep in mind that the exposure

compensation dial has a smaller range, +/- 3 EV, than the Exposure Comp. menu option which is +/- 5 EV. The Fn button option will use the menu's Exposure Comp. command, therefore allowing you to vary the exposure up to +/- 2 EV more than the corre-sponding dial.

Figure 7-3: Function menu with disabled and not set options

Customization of Other Buttons and the Control Wheel

In addition to customizing the Fn button, you can further modify your camera by assigning functions to ten additional buttons and wheels (figures 7-4a, b, and c).

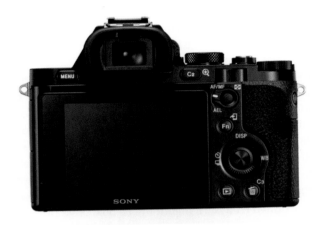

Figure 7-4a: Back of camera body with customizable C2 and C3 buttons, AEL and AF/MF buttons, the center, up, down, right, and left buttons, the control wheel, and the rear dial

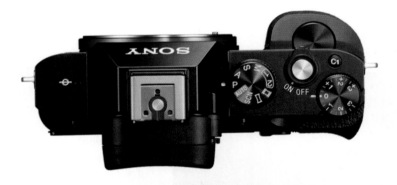

Figure 7-4b: Top of camera body with customizable C1 button and front dial

These customization buttons and wheels are set through the Custom Key Settings command (figure 7-5a and b):

MENU>Custom Settings (6)>Custom Key Setting>[Control Wheel], [AEL Button], [AF/MF Button], [Custom Button1], [Custom Button2], [Custom Button3], [Center Button], [Left Button], [Right Button], [Down Button]

Some of the customization commands have only a few choices, and others have a large variety of choices to select from. The Control Wheel command has five options to choose from:

MENU>Custom Settings (6)>Custom Key Setting>Control Wheel>[ISO], [White Balance], [Creative Style], [Picture Effect], [Not set]

Most of the command's settings will have their associated command activated when you rotate the control wheel in Live View. The last option, "Not set," deactivates the control wheel when it is rotated in Live View.

Technically the AEL and AF/MF buttons are the same button. A lever is used to determine if the button activates the AEL or AF/MF function. When the lever is switched to AEL, the AEL Button command's setting will be in effect; when the lever is switched to AF/MF, the AF/MF Button command's setting will be in effect. By default, the AEL button controls how the camera's recommended exposure will be retained when the button is pressed. The AF/MF button, by default, facilitates switching from automatic focus to manual focus.

If you don't utilize either the AF/MF or the AEL functionality often, you may wish to customize these two buttons to access more frequently used camera commands. We prefer setting the AF/MF button from [AF/MF Control Hold] to [AF/MF Ctrl Toggle]. We find it cumbersome

Figure 7-4c: Front of camera body with customizable front wheel

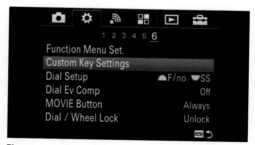

Figure 7-5a: Custom Key Settings command

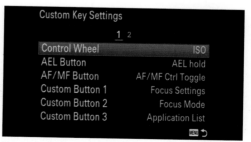

Figure 7-5b: Custom Key Settings command's page 1 options

to continually press the button to maintain the lens in manual Focus Mode. We found that it was too easy to relax our finger pressure while turning the focusing ring and unintentionally turn to automatic focus. By making this button a toggle switch, one press puts you in manual focus. Another press returns you to automatic focus.

You can also customize the three custom buttons (Custom Button1, Custom Button2, and Custom Button3), the Center Button, and the buttons on the rim of the Control Wheel (Left, Right, and Down Button). In addition the rotation of the Control Wheel can be customized to change the White Balance, Creative Style, or Picture Effect. The following list shows the options you have to choose from.

Standard	⊠ Auto Obj. Framing	AF On
Drive Mode	SteadyShot	Aperture Preview
Flash Mode	Audio Rec Level	Shot. Result Preview
Flash Comp.	⊠ Image size	Zoom
Focus Mode	⊠ Aspect Ratio	Focus Magnifier
Focus Area	⊠ Quality	Deactivate Monitor
Focus Settings	In-Camera Guide	Zebra
Exposure Comp.	Memory	Grid Line
ISO	AEL hold	Audio Level Display
Metering Mode	AEL toggle	Peaking Level
White Balance	⊡ AEL hold	Peaking Color
DRO/Auto HDR	⊡ AEL toggle	Send to Smartphone
Creative Style	AF/MF Control Hold	Download Appli.
Picture Effect	AF/MF Ctrl Toggle	Application List
Smile/Face Detect.	Lock-on AF	Monitor Brightness
⊠ Soft Skin Effect	Eye AF	Not set

There are a few exceptions. The Standard option is only available for the Center Button command, and the following options are not available for assignment to the Right, Left, and Down Button commands.

AEL hold
⊡ AEL hold
AF/MF Control Hold
Eye AF
AF On
Aperture Preview
Shot. Result Preview

Customizable Entity	a7/a7R Defaults	Our Personal Customization Settings
Control Wheel	ISO	Unchanged
AEL Button	AEL hold	Unchanged
AF/MF Button	AF/MF Control Hold	AF/MF Toggle
Custom Button 1	Focus Settings	Unchanged
Custom Button 2	Focus Mode	Unchanged
Custom Button 3	Not set	Application List
Center Button	Eye AF	Shot. Result Preview
Left Button	Drive Mode	Unchanged
Right Button	White Balance	Unchanged
Down Button	Not set	Unchanged

Table 7-2: Additional customization default settings and our typical customization settings

Once set, pressing the customized button or wheel will activate the command exactly the same way it would if you had approached it through the menu structure with some exceptions.

Several of the commands do not exist in the camera's menu: [Standard], [In-Camera Guide], [Deactivate Monitor], [Shot. Result Preview], [Aperture Preview], and [Download Appli.].

Standard Command:

When the center button is set to the [Standard] option, pressing it acts as an Enter button.

In-Camera Guide Command:

If you're new to Sony cameras, you might want to use the help information that can be displayed about a selected command and its associated options. You can set up the availability to see these descriptions with the [In-Camera Guide] option in the Custom Key Settings command. If you assign this function to one of the customizable buttons or the wheel, every time you view a command or one of its options in the menu, you can press that customized key to view a short informational description about the highlighted command or menu option on the monitor (figure 7-6). It isn't much information, but it may be sufficient to remind you of the command or the option's function and how best to use it. Press the customized key again or the MENU button to return to the menu.

Deactivate Monitor Command:

There may be times when the light from the LCD monitor will affect your photograph. Customizing one of your camera's buttons to function as the Deactivate Monitor option allows you to toggle the LCD monitor on and off. Note that even when the LCD monitor is toggled off using this command, the bottom row of minimal camera settings (shutter speed, aperture, exposure compensation, and ISO) continues to be displayed. The only data display format that does not contain this row is [For viewfinder]. In that case, the Deactivate Monitor displays a completely blank screen.

Figure 7-6: In-Camera Guide's short description

Aperture Preview Command:

The Aperture Preview command allows you to preview the image with the camera's aperture physically closed down. When the camera is in P or S mode, the lens aperture is maximally open during live preview. Without this command activated, you would not be able to preview the image's depth of field, and therefore would not be able to realize how much of the image is in focus until playing back the captured picture. This command is superfluous when shooting in M or A mode, since the lens is stopped down to its working aperture and you have a real-time depth-of-field preview in your viewfinder or on your LCD monitor.

Shot. Result Preview Command:

The Shot. Result Preview is a very useful command. Like the Aperture Preview command, it serves as a depth-of-field preview button when the camera is in P or S mode. When activated, this command shows the effect of the shutter speed and aperture while you are framing the image. For example, when framing a moving object, such as flowing water, Shot. Result Preview will allow you to see the effect of the selected shutter speed while the customized button is depressed. The slower the shutter speed, the more blurred the moving object will look on the display screen. If you want less blurring, you can increase the shutter speed, preview the effect, and take the picture when you are happy with the projected results. The benefit is for you to have an idea of how a moving subject will be captured with the set shutter speed.

Download Appli. Command:

Although you can execute an application through the menu, the Download Appli. command allows you to select a specific application and assign it to a customized key for faster execution. When you set the Download Appli. option to a customized button or wheel, you will be required at that time to select an application to be assigned to the customized key. In our experience, we did not execute downloaded applications frequently enough to make it worthwhile to dedicate a key to this function.

Customizing Front and Rear Dials

You can control which function the front and rear dial executes in Live View by setting the following command:

MENU>Custom Settings (6)>Dial Setup>[🐜 SS 🐜 F/no.], [🐜 F/no. 🐜 SS]

(Where "SS" represents the shutter speed and "F/no." represents the aperture or lens opening.)

Customizing Summary

One way of accessing the camera's commands is by navigating through the menu structure. This is tedious and impractical for the photographer in the field. For example, to turn on the Creative Style function, you must press the MENU button, navigate to page 4 in the Camera menu, scroll down to Creative Style, and press the center button to enter into the function's submenu. A faster and more convenient way to get to this command is by assigning it to one of the many customization buttons so you enter the Creative Style's menu with a press of a button.

Keep in mind that you are not setting an actual value to the specific command; you are only obtaining access to the command options for the purpose of setting a value. Another thing to keep in mind is that the customized buttons and wheels only work when in Live View. For example, the Lock-in AF command uses the center button to assign an object to be tracked. You are not considered to be in Live View at this point since you are actually in the menu activating a command. Once the object has been selected, you are back in Live View and all of the customized button and wheel command assignments will be active.

Should you need to re-initialize your camera back to the factory default values, your customized settings will be lost. We recommend that you keep notes on your customization settings so that if you need to execute the Reset Setting command's [Initialize] option, you can easily go through the steps to reenter your customization.

Sweep Panorama Mode

The Sony a7/a7R uses the Sweep Panorama mode (figure 7-7) to build a wide view of a scene.

A panoramic picture is created by slowly and smoothly panning (sweeping) a large area horizontally or vertically. The camera takes a series of shots as you sweep. After this is completed, the camera stitches them together to form a panoramic image. There are some conditions to creating a good panorama: the camera needs to be panned at a fairly constant rate—neither too fast nor too slow; you must also sweep on a level horizontal or vertical plane. If there is any substantial variation in the speed or level, the camera will stop shooting and display an error message. This is an excellent opportunity to utilize the Level data display format discussed in Chapter 3.

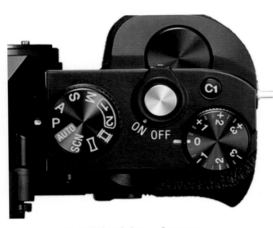

Figure 7-7: Mode dial with Sweep Panorama

The camera automatically sets its shutter speed, ISO, and aperture at the beginning of the sweep. These settings remain fixed throughout the recording, so if the lighting conditions change as you sweep the panorama, there may be areas that are under- or overexposed. The variations can cause the results to be unacceptable. Also keep in mind that the camera will not use a shutter speed slower than 1/60 second, so movement of any subject within the image may be captured.

The camera does an excellent job of stitching the individual shots to form a wide-frame picture. The software is tolerant of small variations in the sweep rate and the level. Sometimes you can get some intriguing images of moving objects when you sweep in the direction of their travel. For example, if you photograph cars speeding along a road, you may capture them in different areas of the pan so they appear multiple times in the final picture. It's certainly worth experimenting with this mode.

The camera automatically determines the ISO and the exposure, but you can select a WB and Creative Style option. You cannot use the following commands in the Sweep Panorama mode: Flash Mode, any of the Drive Mode options other than Single Shooting, Picture Effect, Lock-on AF, Smile/Face Detect., Auto Obj. Framing, and DRO/Auto HDR.

As mentioned in Chapter 3, during playback, panorama pictures are displayed in their entirety first. Press the center button to enlarge the image and view the picture sweeping across the screen. There are two ways to enlarge the picture further. First, once Playback mode has been initiated, press the center button to pause, and then press the C2 button with the magnifying icon to enter Magnification mode. You also have the option of enlarging the image after you enter Playback mode (but before you start playing back the picture) by executing the Enlarge Image command:

MENU>Playback (2)>Enlarge Image

With both methods, once you have initially enlarged the image, you can continue to press the C2 button to further magnify. You can also press the right or left buttons of the control wheel to move through the image. In both cases, press the Image Index button to decrease the size of the image or press the center button to exit the magnification view and return to Playback mode.

Sweep Panorama Mode Commands

There are two menu commands associated with panorama shots: Panorama: Size and Panorama: Direction. Both are enabled when the mode dial is set to Sweep Panorama. These commands control the width of the panorama and the direction in which you sweep the camera. To access both of these menu commands, turn the mode dial to Sweep Panorama, press the MENU button, and find the following commands (figure 7-8):

MENU>Camera Settings (1)>Panorama: Size>[Standard], [Wide]
MENU>Camera Settings (1)>Panorama: Direction>[Right], [Left], [Up], [Down]

Sweep Panorama has two sizes: [Standard] and [Wide]. The [Wide] option increases the width of the panorama and increases the pixel count over [Standard] (table 7-3). With [Wide], you can pan farther and get much wider coverage in the resulting picture.

Figure 7-8: Sweep Panorama commands

Sweep Panorama Size		
Panorama Direction	**Standard** Equivalent Pixels	**Wide** Equivalent Pixels
[Right]/[Left]	8192x1856	12416x1856
[Up]/[Down]	3872x2160	5536x2160

Table 7-3: Sweep Panorama size

Note that the [Standard] and [Wide] options produce pictures at the same height. Although the [Wide] playback version's height appears shorter in the LCD screen, it isn't. Instead, the whole picture is displayed at a lower magnification so you can see more of it on the display screen.

The Panorama: Direction command allows you to set the direction to sweep the camera: [Right], [Left], [Up], or [Down]. Once set, an arrow is displayed on the screen to show the direction to pan. An easier way to set the Panorama: Direction command is to rotate the front dial to cycle through the options while in Live View. Remember to set the mode dial to Sweep Panorama first. You can see the sweep directional arrow on the display screen change with each turn of the front dial. The Sweep Panorama mode works whether you hold the camera in landscape or portrait orientation. Just remember to pan the camera in the direction of the displayed sweep arrow.

Figures 7-9 a-d show Sweep Panorama results for several different combinations of sizes and directions.

Figure 7-9a: Size/Direction = Standard/Right

Figure 7-9b: Size/Direction = Wide/Right

Figure 7-9c: Size/Direction = Standard/Up

Figure 7-9d: Size/Direction = Wide/Up

You can take a panorama picture with either a wide angle or a telephoto lens. Interestingly, you can even zoom the lens in and out during the shooting of a panoramic shot, although it might not be easy to coordinate both sweeping and turning the zoom at the same time while maintaining a smooth, even sweep. If you want to try this and see the effect, we recommend mounting the camera on a tripod to minimize the problem of keeping the camera level.

More Than One Way to Sweep

Most people will take a panorama picture by holding the camera in the landscape (horizontal) orientation and then panning the camera in the direction of the displayed arrow. But you can also record a panoramic with the camera rotated into the portrait (vertical) orientation. Set the Panorama: Direction command to [Up] or [Down], rotate the camera 90 degrees so the directional arrow is horizontal, and then sweep the camera right or left according to the direction of the sweep panorama's arrow. The resulting picture will be taller and narrower than if you had held the camera horizontally and panned. You might also find the resultant aspect ratio more pleasing than the wider view taken when the camera is held horizontally.

Shooting a Panoramic Picture

After you select a panorama size and choose the sweep direction, the camera will display three things in Live View:

- An arrow that corresponds with the selected direction
- A message informing you to sweep according to the arrow
- A two-tone screen, in which one side is dull gray over the Live View display and the other side is unaffected (figure 7-10). The line where the two sides meet is the point where the panorama will start.

Figure 7-10: Sweep Panorama starting point, to the right of the grayed section. This picture of a piece of paper clearly shows the starting point.

Frame the image so that the point where you wish to start the sweep is positioned just inside the non-grayed side of the display screen. The side that is grayed depends on the panorama direction you select. If you select [Right], the grayed side is on the left in the display screen. If you select [Up], the grayed side is on the bottom of the screen.

This is the time to add a Creative Style and make any needed adjustments to the WB and exposure. Make the changes through the menu, Quick Navi screen, or by pressing the right or the Fn button (if you've assigned it to those functions). You can also use the top exposure compensation dial to change the EV value. Make sure you evaluate your adjustments on the non-grayed side since this is where the sweep will start recording. After you complete your adjustments, press the shutter button halfway again to make sure your focus is still intact.

There is one more step to complete before you can take your panoramic shot. Getting a realistic shot depends on a smooth, level, constant sweep. It also depends on creating a very tight radius when you do the sweep. As you pan the camera, hold it as close to the center of the sweep as possible. The best way to accomplish this is to either hold the camera up to your eye and use the viewfinder as your sweeping guide, or mount your camera on a tripod and pan in a vertical or horizontal direction. These two methods are best because they keep the pan in a tight, short radius. Holding the camera away from your body and using the LCD screen as your sweeping guide can create distortion because the shooting radius is larger.

Now you are ready to record. While holding your camera steady, hold the shutter button down and start panning. As you pan, you will notice that the arrow moves across the screen along a simulated bar called the Guidance bar. The bar represents the full amount of time you need to hold the shutter button down and pan the camera. Continue to pan the camera until the arrow has traveled the full distance. If you take your finger off the shutter button while the camera is firing, the process will stop and generate an error message.

Panorama Results

Each panorama has an element of mystery as to what exactly you will capture. Yes, you can end up with a flawless panorama where everything is a true representation of the scene. Most of these are pictures of stationary landscapes. Experiment with taking panoramic pictures of moving subjects. Depending on the subject's speed, panning in the direction the subject is moving may shorten or truncate it, and panning in the opposite direction may lengthen or elongate it. You can even get results in which a moving object appears multiple times in the photograph. Even taking panoramic pictures of stationary objects can give you some interesting results. When panning, the camera takes images that overlap. Most of the time, the camera's stitching software eliminates the overlap and creates a smooth panned image, but there will be times when the resulting panoramic picture will contain multiple images of the same object.

Panning Problems

Taking a panoramic image can require some trial and error before you are successful. If the camera detects inconsistent panning—that is, too fast, too slow, or not level—or if you don't start the panning after the shutter button is pressed, the camera will stop recording and display an error message.

The camera displays the following message if you pan the camera too slow or not in a straight line:

Could not shoot panorama. Move straight in the direction of the arrow.

The camera displays the following message if you pan the camera too fast or in the wrong direction:

Could not shoot panorama. Move camera slowly.

It can be difficult to pan at a consistent speed each time you record. Most likely you will obtain some pictures with a section of gray at the end of the panorama (figure 7-11). This means you panned too quickly, and the remaining portion of the allotted size did not have anything recorded to fill that space. Try retaking the picture while panning a bit slower.

Your results can also be affected by insufficient or extreme lighting, close or moving objects, complex patterns or monotone colors; all of which cause difficulties for the camera's stitching program to effectively process the captured data. Keep in mind that the closer the object is, the more likely it is to be distorted, especially if the object consists of straight lines or if you have handheld the camera out away from you while recording the panorama image. Although you might face some frustration, we are sure that, with practice, you will ultimately enjoy the results of the Sweep Panorama function.

Figure 7-11: Panorama results with unrecorded space grayed out

Memory Recall Shooting Modes

The mode dial has two additional options, [1] and [2], both representing a set of camera command settings saved in the camera's internal memory that can be recalled and applied when selected. Making this happen is a multi-step process. First you must establish a set of command values you would like to be able to recall and apply with a turn of the mode dial. Once you have set your camera to those values, save them in the camera's internal memory using the following command:

MENU>Camera Settings (7)>Memory

Two tabs, 1 and 2, correspond with the two numbers on the mode dial. These will be displayed at the top of the screen, with the camera positioned on the first tab (figure 7-12a). You can also view a list of the commands and their settings for the highlighted memory tab by pressing the up or down button (figure 7-12b).

Press the center button to save the group of settings in the Memory Recall mode corresponding to the tab you are positioned on. To save the other Memory Recall mode, change the command settings to another set of values and re-enter the Memory command. Move to the other tab and press the center button to save the group of values.

Figure 7-12a: Memory command's full screen with icons and values

To recall and use a group of command settings, rotate the mode dial to the Memory Recall number that contains the settings you want to apply to the camera. That's all you need to do. You can make adjustments to the applied memory recall settings, but unless you go back and re-enter the Memory command and save the settings, the changes will only be temporary.

Figure 7-12b: Memory command's list screen with command names and values

7

Automatic Object Framing

A common beginner's error is having too much extraneous background in your image that surrounds and detracts from the subject. To improve your picture's composition, Sony has provided a cropping and resizing function so you can create a more pleasing image. To have the camera automatically create a closer image of your subject, use the following command:

> MENU>Camera Settings (6)>Auto Obj. Framing>[Off], [Auto]

For this command to work, the shooting mode and several other command settings must be set properly. If your subject is a person, the Face Detection command must be either set to [On] or [On (Regist. Faces)]. If your intended subject is not a person, you will need to execute the Lock-on AF command and track the object. Regardless of whether your subject is a person or not, there are a few other conditions for Auto Obj. Framing to work. The Quality command must be set to a JPEG value ([Extra Fine], [Fine] or [Standard]), and the Focus Mode must be set to [Continuous AF]. In addition, the Auto Obj. Framing command is enabled only in P, A, S, M, Intelligent and Superior Auto, and all SCN predefined modes except Sports Action, Anti Motion Blur, and Hand-held Twilight. One final condition is that you cannot have the camera set to a multi-shot mode, such as Auto HDR. If these conditions are not met, the Auto Obj. Framing command will be disabled even if it is set to [Auto].

When the Auto Obj. Framing command is enabled and the camera detects and focuses on a face or the tracked object, press the shutter button. The camera will take the picture, enlarge the face or tracked object, and crop and resize the image into either a landscape or a portrait orientation. How the camera orients the cropped and resized image is dependent on the orientation of the double tracking box. If the box is longer vertically, the resulting image is cropped in portrait format; otherwise it is cropped in landscape format.

Auto Obj. Framing functionality records two images; first, the original image as seen on the display screen; and second, the enlarged, cropped image. Keep in mind that if the detected subject is far away, the enlarged image may still be unsatisfactory. If this is the case, it is best to move closer to the subject so you have a better result.

Although you may find that this is a useful tool for taking better pictures, there are several drawbacks. You cannot record the image in RAW file format and therefore will not have full access to your recorded data for future digital enhancements. Using this feature means you will have to accept how much of the original image is enlarged and saved, as well as the exact position. As you become more familiar

with the camera, you will be able to frame and take your own portraits without relying on the camera's automatic feature. Framing the subject, using a zoom lens, controlling the aperture (and thus the depth of field), and saving the image in RAW will let you control many more aspects of your portraits than you can using the Auto Obj. Framing command. While this may be a handy feature for quick snap-shots, we suspect most a7/a7R users will prefer to do these same manipulations by downloading the pictures to their computers and using third-party software.

Utilizing Predefined Color Schemes

Although you can post-process your images, the Sony a7/a7R gives you the op-tion to apply a predefined color scheme to your pictures and movies by using the Creative Style or Picture Effect options. This is advantageous because you can see how the altered effect or color scheme will enhance your images before you start recording.

Creative Style Function

Recording a picture or movie can be all about creating a mood or expressing an emotion. An easy way to add expression to your work is to apply a Creative Style to your images. In essence, these styles apply a change in colors and strength to add an emotion into your pictures and movies.

The Creative Style command has 13 different styles or options to choose from (table 7-4a). Each option applies a different mood or style to your movies and pictures, including panoramas. Each Creative Style option has the ability to add fine adjustment values to its applied contrast, saturation, and sharpness, with some exceptions. In addition, six of the Creative Styles options have a way for you to save a second set of customized fine adjustment settings that you can recall later for use (table 7-4b).

Each of these second Creative Style sets are denoted with a number in front of the style's icon. The icons are so similar that it is easy to get confused and not real-ize which of the two settings you have selected. With that said, if you like apply-ing Creative Styles to your images and movies, you will appreciate the additional six opportunities to save a different unique setting for the limited Creative Style options. We don't know why Sony only allows you to save a second set of fine adjustments for those specific six Creative Styles, but it could be that those are the options most commonly used, so being able to save another set of adjustments is more convenient than constantly changing the settings each time you want to apply the Creative Style.

7

Creative Style Icon	Creative Style Name	Description
Std.	Standard (Default)	Captures image with natural coloration. Note: if you wish to use a Picture Effect, Creative Style command must be assigned this setting.
Vivid	Vivid	Accentuates colors, making them more saturated and vibrant.
Ntrl	Neutral	Images are shot with subdued tones, saturation, and sharpness.
Clear	Clear	Color tones are more distinctive and differentiated from each other.
Deep	Deep	Colors appear darker.
Light	Light	Colors appear lighter.
Port.	Portrait	Softens skin tones to hide blemishes and wrinkles for a more pleasing effect.
Land.	Landscape	Heightens saturation, contrast, and sharpness to produce more vivid and crisp results.
Sunset	Sunset	Accentuates existing tones and adds warm tones to mimic or enhance sunset/sunrise appearance.
Night	Night Scene	Records the image with less color contrast.
Autm	Autumn leaves	Reds and yellows are enhanced.
B/W	Black & White	Transforms the image into black-and-white with gradations of gray.
Sepia	Sepia	Transforms the image into sepia colors.

Table 7-4a: Creative Style options and descriptions

7

Creative Style Icon	Creative Style Name	Description
1Std.	Standard Style Box	Allows you to apply a saved, modified Standard Creative Style setting.
2Vivid	Vivid Style Box	Allows you to apply a saved, modified Vivid Creative Style setting.
3Ntrl	Neutral Style Box	Allows you to apply a saved, modified Neutral Creative Style setting.
4Port.	Portrait Style Box	Allows you to apply a saved, modified Portrait Creative Style setting.
5Land.	Landscape Style Box	Allows you to apply a saved, modified Landscape Creative Style setting.
6B/W	Black & White Style Box	Allows you to apply a saved, modified Black & White Creative Style setting.

Table 7-4b: Second set of customizable Creative Style options and descriptions. Note the preceding number in the icon.

To select a Creative Style, enter the following command:

MENU>Camera Settings (4)>Creative Style

When you select the Creative Style command, the list of options is positioned at the command's current setting (figure 7-13). Rotate the control wheel or press the up or down button to navigate through the command's 19 total options. You can also use the front dial.

Although each style's name gives a hint on how the image will be affected, the only way to be sure is to preview its appearance on the display screen. As you navigate through the Creative Style options, the camera applies the color scheme in Live View so you can evaluate the potential results. For example, applying [Vivid] to a multicolored floral

Figure 7-13: Creative Style menu

image will have a much different effect than applying it to an image with only one or two colors. In the latter case, you may find a different Creative Style more appealing.

The command goes a step further and allows you to fine-tune the contrast, saturation, and sharpness (figure 7-14) for all the Creative Style options except [Black & White] and [Sepia], where only the contrast and sharpness can be adjusted.

To enter the fine adjustments menu, highlight the Creative Style option you wish to adjust and press the right or left button or rotate the rear dial to enter into the fine adjustment submenu. Continue to use the right and left buttons or rear dial to move through the fine adjustment options and the up and down buttons to change a specific fine

Figure 7-14: Creative Style fine adjustment options each set to +3.

adjustment option's value. When completed with your settings, press the center button to accept the values. The Creative Style icon along with its fine adjustments will be displayed on the [Display All Info.] and [For viewfinder] data display formats in Live View (figure 7-15).

Each fine adjustment has a range from −3 to +3 that changes in increments of 1, which means you can increase or decrease the option by a factor of 1, 2, or 3. Your fine adjustments are retained until you change them or execute the Setting Reset command to return the camera to its Camera Settings default values.

Figure 7-15: Creative Style icon with fine adjustment settings in Live View

The effects of your selected color scheme and fine adjustments are best evaluated on the LCD display screen. Table 7-5 describes each of the available adjustments and their effects on the image.

Icon	Description
◑ Contrast	Controls the intensity of highlights and shadows. A plus value makes the highlights brighter and the shadows darker and gives the image a bolder, stronger look. A minus value reduces highlights and shadows and gives the image a smoother overall look.
❀ Saturation	Controls the richness of the colors. A plus value accentuates the colors, making them bolder. A minus value mutes and softens the colors, giving the image a more homogenous look. This adjustment option is not available for [Black & White] and [Sepia] Creative Styles.
⊞ Sharpness	Controls edge definition. A plus value heightens the edges, accentuating fine details and noise. A minus value softens the edges, creating a more blended look that helps hide noise.

Table 7-5: Creative Style fine adjustment options

This is where the six customizable Creative Styles options come in. For example, if you typically switch back and forth between two variations of Creative Style [Vivid], you can save both, one in the customizable [Vivid] option and one in the regular [Vivid] option. Both are saved in the camera's internal memory unless you execute the Setting Reset command. You can even switch to using a Picture Effect or turn off the camera and then come back to Creative Style and still find both of your [Vivid] fine adjustment settings.

Here are some important points to remember:

- The Creative Style command is not available in Intelligent Auto, Superior Auto, or the SCN modes.
- You can set a Creative Style when Quality is set to [RAW] or [RAW & JPEG]. However, you will be constrained by your ability to see these effects depending on the file type you choose and the programs you use to view your images. Image Data Converter shows the Creative Style effects in both RAW and JPEG files. If you use third-party software such as Photoshop or Aperture, the RAW files may not show the effects of the applied Creative Style, but the JPEG files will.
- Creative Styles are available for all movie files.
- While using a Creative Style, you can adjust the exposure compensation, ISO, shutter speed, white balance, and aperture.
- The Creative Style command is automatically set to [Standard] and disabled when a Picture Effect option other than [Off] is selected. The Creative Style command will be enabled and restored to its previous value when Picture Effect is set to [Off].
- Saturation adjustment is not available for the [Black & White] and [Sepia] options.
- Both the regular and customizable Creative Style settings and their adjustments are retained if you switch to another shooting mode, or if the camera is turned off and back on.
- The Creative Style command is reset to [Standard] and all Creative Style adjustments are returned to zero when the MENU>Setup (6)>Setting Reset command is executed.

7

Picture Effect Function

The Picture Effect function lets you apply a predefined effect filter to be used when recording movies and JPEG picture files. This command is disabled when shooting panorama and when Quality is set to [RAW] or [RAW & JPEG]. There are 14 Picture Effect options (table 7-6). Several of the Picture Effect options have suboptions so you can further alter how you want the camera to record the image. For example, the Toy Camera option has the suboptions [Normal], [Cool], [Warm], [Green], and [Magenta], so you can apply a color tint.

Picture Effect Option	Description
Off Off (Default)	Turns off Picture Effect.
Toy Toy Camera	Creates an image as if it was taken with a toy camera. Colors and shadowing are more pronounced with less smoothness and gradation. Suboptions set the applied tint.
	Suboptions: [Normal] (Default), [Cool], [Warm], [Green], [Magenta]
Pop Pop Color	Emphasizes color tones and makes them more vivid.
Pos Posterization	Emphasizes primary colors; or, in the case of the Black and White suboption, makes the image black and white with the two colors more pronounced. Creates a more contrasting, abstract look.
	Suboptions: [Color] (Default), [B&W]
Rtro Retro Photo	Creates the image in an old-fashioned photo style using sepia and reduced contrast.
Sfth key Soft High-key	Creates a softer and more ethereal image.
Part Partial Color	Creates an image that retains one color and turns the rest to black-and-white. Suboptions determine retained color.
	Suboptions: [Red] (Default), [Green], [Blue], [Yellow]

Picture Effect Option	Description
(HC BW) High Contrast Mono.	Creates a high-contrast black-and-white image.
(Soft) Soft Focus	Creates a soft lighting effect. Suboptions set the effect intensity.
	Suboptions: [Low], [Mid] (Default), [High]
(Pntg) HDR Painting	Takes three images and merges them to create one HDR image. The image colors and details are heightened. This is unlike Auto HDR, where two images are created. Suboptions set the effect intensity
	Suboptions: [Low], [Mid] (Default), [High]
(Rich BW) Rich-tone Mono.	Takes three images and merges them to create an HDR image in black-and-white.
(Mini) Miniature	Creates an image with the main subject in focus and the background out of focus. Often used for miniature-model images where the model is in focus and the background is not. Suboptions set focus area.
	Suboptions: [Auto] (Default), [Top], [Middle(Horizontal)], [Bottom], [Right], [Middle(Vertical)], [Left]
(WtrC) Watercolor	Creates images with blurred effects, like watercolor paint spreading across the paper and bleeding into adjoining colors.
(Ilus) Illustration	Creates an illustration-like image with crisp color demarcations. Suboptions set the degree of demarcation.
	Suboptions: [Low], [Mid] (Default), [High

Table 7-6: Picture Effect options

7

Here are some important points to remember:

- Picture Effects can be applied only when Quality is set to JPEG only files. If Quality is set to [RAW] or [RAW & JPEG] setting, the Picture Effect command is disabled.
- Picture Effect is automatically disabled when the shooting mode is set to Intelligent Auto, Superior Auto, SCN, or Sweep Panorama. It will be returned to its previous value when you switch back to P, S, A, M, or Movie mode.
- The selected Picture Effect and its suboptions are retained when you switch to another supported shooting mode (P, S, A, or M), or if the camera is turned off and back on.
- Picture Effect is reset to [Off] and suboptions are returned to their default values when the MENU>Setup (6)>Setting Reset command is executed.
- While using a Picture Effect, you can adjust the exposure compensation, ISO, shutter speed, white balance, and aperture.

Selecting a Picture Effect is easy. Enter the following command:
MENU>Camera Settings (4)>Picture Effect

Use the control wheel's rim or the front dial to navigate through the available Picture Effect options (figure 7-16). When you want to apply a suboption, press the right or left button, or rotate the rear dial to navigate through the highlighted Picture Effect suboptions. Press the center button to apply the style's suboption, and you will be returned to Live View.

An icon is displayed on the [Display All Info.] and [For viewfinder] data display formats in Live View (figure 7-17), indicating the selected Picture Effect and suboption.

Figure 7-16: Picture Effect function's Soft Focus and suboption icon

Creative Styles and Picture Effects Differences

At first, applying a Picture Effect option might seem like a duplication of Creative Style. However, many of the Picture Effect options allow you to pinpoint areas to apply an effect within the image, such as [Miniature], where you identify an area to keep in focus while blurring the rest of the image. You can use Creative Style options with all Quality settings, but you cannot use Picture Effect options when the Quality is set to capture RAW files. Creative Style and Picture Effect options are not available in automatic modes (Intelligent Auto, Superior Auto, and SCN); however, unlike Picture Effect options, you can use Creative Style options in Sweep Panorama mode.

Figure 7-17: Live View with Soft Focus Picture Effect icon and Low suboption

Both the Creative Style and Picture Effect functions colorize images, but the commands cannot be operational at the same time. The Creative Style command is automatically turned to [Standard] when any Picture Effect option is used on the image, and will automatically be turned back to its previous Creative Style setting when Picture Effect is turned [Off]. In other words, each function defaults to a noncompeting value when you set the other to a nonstandard option.

Recommendations

How you customize your camera depends on your personal preferences. We recommend you become familiar with the camera and learn which commands you use frequently before you do any extensive customization. Fortunately, you can always change, add, or subtract your settings later. Once you have selected customizations, the camera will be a more responsive tool, capable of adapting quickly to a variety of photographic requirements.

After we became more comfortable with the camera and what settings we liked, we came up with a set of functions and commands that we use often and want to access easily. Table 7-7 contains the combined list of our settings for each of the customization commands. This may not be how you will want to set things up, and we might change our minds six months from now, but for the types of shots we are currently taking, these settings are working well.

7

Customizable Slot	Our Customization
Function Upper1	Quality
Function Upper2	Flash Mode
Function Upper3	Flash Comp.
Function Upper4	Focus Mode
Function Upper5	Focus Area
Function Upper6	Exposure Comp.
Function Lower1	Zebra
Function Lower2	Peaking level
Function Lower3	SteadyShot
Function Lower4	DRO/Auto HDR
Function Lower5	Creative Style
Function Lower6	Shoot Mode
Control Wheel	ISO
AEL Button	AEL hold
AF/MF Button	AF/MF Toggle
Custom Button 1	Focus Settings
Custom Button 2	Focus Mode
Custom Button 3	Application List
Center Button	Aperture Preview
Left Button	Drive Mode
Right Button	White Balance
Down Button	Not set

Table 7-7: Our current customization settings

Creative Style and Picture Effect options provide interesting color effects, with some limitations. Although you can modify a Creative Style's color contrast, saturation, and sharpness through the camera, the allowable range is less than what can be done with post-processing software. When selecting a Picture Effect with a high, mid, and low option setting, start with the high setting first. Quite often the low option setting is too subtle to judge its impact in the camera.

Creative Style allows you to capture the image in both RAW and JPEG formats, which allows you more opportunity to process your pictures outside the camera. Picture Effect allows you to apply expressive filters to your pictures, but only to JPEG files. We recommend that you play with both functions to see if any of the special styles and effects give you results you like. One note of caution: many Creative

Style options are subtle. The Picture Effect command has an [Off] option, but the nearest equivalent option for Creative Style is [Standard]; however, be aware that the [Standard] option has adjustments for contrast, saturation, and sharpness. If you don't want a Creative Style to affect your images, make sure these adjustments are set to zero. Although we enjoy having the opportunity to save two different fine adjustment settings for six of the Creative Styles, we found that the icons are so similar that we sometimes end up choosing the wrong one.

We love panoramic shots. They are fun to shoot, and the results are impressive. We have experimented with many different shots, varied the level and panning speed, and taken shots of moving and stationary subjects, which gives us a variety of results. We've taken panoramic shots with the lens fully zoomed, with the lens set to wide-angle, and a variety of settings in between. We have also applied Creative Styles to the panoramic pictures to add some punch to the results.

Using the Auto Obj. Framing command is a quick and easy way to create a closer image of a specific object, but we've found that we frequently had to shoot the image multiple times before we were satisfied with the results. We prefer to control the camera settings and frame our shots ourselves in RAW.

7

Chapter 8: Working With the Camera's Wireless Functions

Introduction

Your Sony a7/a7R has Wi-Fi capabilities and can communicate with your wireless server, smartphone, and tablet computer. The communication to the wireless server is used for directly downloading apps from the Sony website, or it can be used to share your photographs on the Internet. You can, for example, upload the pictures stored on your camera to Flickr or Facebook.

We will not cover all the available Sony apps since it is an area that has the potential to change daily. At the time of the latest Sony firmware update, version 1.02, which came out March 2014, many of the apps were updated. Rather than cover each of the available apps, we will discuss a few that we've found to be the most useful.

Using the Camera Wirelessly

We rarely use our camera to directly upload pictures to our social media sites. We find the operation to be inconvenient. For one thing, it requires us to be near a Wi-Fi network. While this isn't an issue when we are at home, it is inconvenient to seek out a Wi-Fi Hotspot when we are out and about, and stay there while we upload the images. If we need to share a photo on our social media site, we will use our phone, which will accomplish this task wherever there is a cell signal.

One of the reasons we don't use our camera to directly upload to social media sites is that it's difficult to type characters and numbers on the a7/a7R's virtual keypad (figure 8-1). Typing with this function requires you to navigate to a key by moving a selection box with the directional buttons. Once the key is highlighted, you press the center button to enter it. Each key input requires several presses of the camera buttons. If you count the clicks required to move the selection box to the correct character, you may

Figure 8-1: Sony's virtual keyboard as displayed on the a7/a7R's LCD

have to do six or more clicks just to select and enter one letter! As a consequence, we do not use Sony's app Direct Upload to upload to Flickr or Facebook account.

You can avoid this tedious task by using a device that has a better keyboard layout, such as your computer or cell phone. In a similar fashion, we find it easier to download apps from Sony's website to our computer. This allowed us to avoid having to enter in our Sony passwords to their website when using our camera. Once the app is downloaded to our computer, it is transferred to the camera by using the Sony supplied USB cable.

We mainly use our camera's Wi-Fi to communicate with our iPad and iPhone for remote firing of the camera. This is an excellent feature for studio, scenic, or close-up work. You can mount the camera on a tripod and view the scene with your tablet computer or smartphone. This allows you to move about, stage the scene, and arrange the lighting so it creates the proper mood and enhances the subject's features. If you work with flash illumination, you can take the picture, quickly review the results on the tablet's larger screen, and re-stage the scene without having to go back to the camera. When working in our laboratory, we use our tablet as a preview monitor when doing macro photography or photomicrography. We can judge focus, evaluate depth of field, and control lighting while studying the subject on the tablet's screen. While these tasks can be done on the camera, the LCD's small size makes it unsuitable for critically evaluating the image.

Using Sony's Wi-Fi for this task will require you to download Sony's Smart Remote App.

Downloading Apps

The first step to getting the Smart Remote Control App is to go to the following website via your computer:

https://www.playmemoriescameraapps.com/portal/

You will need to create an account with Sony, which requires you to give them your credit card number. As long as you download apps that are free, your card will not be billed. Fortunately, the Smart Remote Control App is free and we urge you to get it—we believe you will find it exceedingly useful.

The web instructions for creating an account are clear, and once completed, you can start the process for downloading. To do so, make sure your camera has a fully charged battery. If you own an Apple computer, navigate to the following camera menu command:

Menu>Setup (4)>USB Connection>[Auto], [Mass Storage], [MTP], [PC Remote]

The default setting for this command is [Auto], in which the camera is supposed to automatically shift to either [Mass Storage] or [MTP]. When using our Apple computers, this switch did not occur and our computer would not communicate with the camera. To load our app, we had to set the option on our

Figure 8-2: Computer screenshot of Sony app page

camera to [MTP] manually. Next, connect your camera to your computer's USB port with the cable included with your Sony camera.

Look through the selection of apps on Sony's website (figure 8-2), and find Smart Remote Control. warning message (figure 8-3) will be displayed stating that the operation is not guaranteed. We noted that Apple's latest OS and the latest version of Safari had not been tested by Sony—hence this message. You will see a list of OS

Figure 8-3: Computer screen warning that the operation is not guaranteed

versions and browsers that Sony has tested for compatibility. Although the latest versions of the Apple OS and Safari were not on this list, we ignored this warning, downloaded the app, and installed it on the camera. This task was accomplished successfully with no ill effect to our camera or computer.

Working with Tablets and Smartphones

Once you have the Smart Remote Control installed in your camera, you need to prepare your tablet or smartphone to communicate with this app. This requires you to get the free PlayMemories Mobile software and download it to your smartphone or tablet. For Android phones and tablets, download it from https://play. google.com. For the iPhones and iPads, download it from Apple's App Store. Once you have it installed on your device, you can use it to communicate with your

Figure 8-4a: Camera LCD: Menu command's Application List option

Figure 8-4b: Smart Remote Control app selected

8

camera and phone. Set up this capability on your camera with the following menu command (figures 8-4a and 8-4b):

> Menu>Application>Application List>Smart Remote Control

Assuming this is the first time you've connected your smart device to your camera, you will see a screen like the one shown in figure 8-5. This indicates that the camera is working as a transceiver. Next, you need to check your smart device's Wi-Fi settings. Locate and select the a7/a7R's SSID (figure 8-6). On your smart

Figure 8-5: Camera LCD showing its SSID, password, and Device Name

device, you will need to enter the camera's password, which is displayed at the back of the camera on its LCD screen. Once your smart device indicates you have a link, validate that the smart devices' PlayMemories Mobile app is active. We use this app frequently and will comment on its behavior during subsequent pairings of the iPad to the camera. Now your smart device should display your camera in Live View.

On subsequent uses of the Smart Remote Control app, you will not have to enter the camera's password again. It will be remembered and inserted when the smart device connects to the camera's Wi-Fi signal. However, this connection may

Figure 8-6: iPad screen showing that it's communicating with the a7R

not occur automatically. When our iPad is connected to our home wireless system, it does not relinquish this connection voluntarily when it detects the signal from the camera. You will have to go to the iPad's Settings screen and manually select the Wi-Fi signal from your camera. Once it is selected and activated, you will then have to turn on the PlayMemories Mobile program. To avoid this problem, we find it easier to simply tell our iPad to "forget" our home Wi-Fi signal. When this is done, the iPad will automatically sign onto the camera's Wi-Fi broadcast.

Smart Remote Control

We highly recommend downloading this app. First, as the title implies, it provides a way to fire your camera remotely. It is a very worthwhile app if, for no other reason, it will save you the $29.95 you would have had to spend on Sony's Remote Commander for firing your camera from a distance.

This app lets you override the camera's recommended exposure when using P, A, or S mode to see the results of your changes on your smartphone's screen. As you can see in figure 8-7, the shutter speed, f-stop, exposure compensation, ISO, and the shooting mode are displayed on your smart device. In this app's early versions, you could not control the zoom. With the newest 1.02 firmware version, you will see two buttons with the letters W and T. These buttons control the motorized zoom of three NEX series lenses. Currently there are no FE lenses with a motorized zoom for sale,

Figure 8-7: iPad screen showing the icons and the shutter icon

but Sony has shown a prototype of a 28-135mm FE lens with a motorized zoom. Sony indicates that this lens is being developed, but there is no price or release date. You will also see a silver circle containing a symbol for a camera. This is your smart device's shutter release icon. Since your tablet or smartphone has a touch screen, touching this icon fires the camera. There is an icon of a thumb with the word "FOCUS" on the lower-left corner of the screen. This is Sony's Touch Screen Focus control. When you press this icon, you can touch a region of your smart device's screen and it will become the point of focus for the camera. When focus is achieved, you will see a green focus confirmation bracket on the spot that you just touched. Press the smart device's shutter button to take a picture. Notice the word "FOCUS" will be replaced by an "x". This is the prompt that lets you know you can turn off this feature.

The symbols displayed on the screen are touch sensitive; when pressed lightly, they allow you to change the ISO, aperture, shutter speed, and the extent of exposure compensation. For example, if you press the exposure compensation icon, you can change its value. In Figure 8-8, the camera is being set to + 1.0 EV.

Figure 8-8: Screen after EV button is pressed—EV adjusted +1.0 EV

Not all of your options are visible in the preview screen. If you look at the lower-right corner of the screen, you will see a symbol of a crossed wrench and screwdriver. This is the tools icon. Touching it will bring up a new screen with additional settings for adjusting the white balance, the self-timer, how you review and how you save the captured image, as well as the quality of the Live View (figure 8-9).

If you select white balance, you will see its preset options at the bottom of the screen (figure 8-10).

Figure 8-9: Smart Device: Additional commands for Smart Remote Control

The Self-timer command allows you to delay firing the camera by two seconds after pressing the shutter button icon on your mobile device. We leave this option [Off] because we do not notice any improvement in image quality when using it. When the a7 camera model exposes the sensor, the electronic first-curtain shutter does not vibrate and there is little reason to delay firing the camera. In the case of the a7R, whose mechanical shutter does impart some movement, we did not observe any improvement in image quality when we fired the camera with a 2-second delay.

We leave the Review Image option [Off] when shooting with ambient lighting. Live View provides a good indication of what will be captured and we see little

Figure 8-10: Smart device: WB adjustment from Smart Remote Control screen

value in reviewing pictures taken under these conditions. However, we will turn it [On] if we shoot with flash. Since you cannot preview the results with this type of lighting, being able to review the shot is the only way to evaluate the effects of your lights. This will help you determine if you need to reposition the lighting for your next shot.

The Save Options allows you to save your image to your smart device. We generally do not do this for two reasons: first, the image is already saved to the camera's SD card; second, it takes a few seconds to transfer the image to the tablet or smartphone, which slows our workflow.

In order to maintain a fast workflow, we keep the size of the Review Image to 2M. Although the Live View Quality can be changed from [Standard] to [Image Quality Priority], we generally keep it at [Standard], the default option. While selecting [Image Quality Priority] provides a slight improvement in resolution, it tends to slow the response of the smart device's ability to execute commands.

Although it might appear that you can make all your adjustments from the smart device, this is not the case. There are some options that require you to push buttons on your camera. For example, you will need to press the menu button on the camera to implement commands for controlling the app. For instance, you can only exit the app from the camera screen (figure 8-11a). Furthermore, there are additional pages (figure 8-11b) for adjusting the file format, image size, aspect ratio, Flash, Focus Area, DRO/Auto HDR, Drive, Metering Mode, Creative Style, Picture Effect, and Face Detection. Having to work with both the camera controls and the smart device is an inconvenience. We hope that future upgrades of the app will have all the operational controls being placed on the smart device.

Keep in mind that Sony updates their apps independently of the camera firmware. We recently found that the current version of Smart Remote Control has been upgraded substantially. The original firmware version released for the NEX-6 did not allow us to record RAW files to

Figure 8-11a: First page of Smart Remote Control menu

Figure 8-11b: Second page of menu for Smart Remote Control menu

the SD card. The newer version for both the NEX-6 and a7/a7R cameras does. Since the upgrade is free, you should visit Sony's site periodically to check for their availability (the company does not provide email notifications of these updates to its customers).

Additional PlayMemories Camera Apps

Downloading apps to your camera can be an addictive experience. Once you have an account, you can download apps to take time-lapse videos, make multiple exposure images, or correct optical errors with lens compensation. The most expensive apps cost $9.99, others cost $4.99, and the remaining are free.

Before downloading the apps, you should be familiar with your camera and its controls and how they interact with the app. Fortunately, you do not have to buy the app to do this. You can read its specifications and its instructional manual before buying it. The only difficulty in accomplishing this task is finding the instructions. Here is some help. You will see an app listing when you are at:

https://www.playmemoriescameraapps.com

Most of the apps are shown as an icon. When you see one that interests you, double click on its icon. For example, let's investigate the free app, Smart Remote Control. A new screen appears with its version number (figure 8-12), a list of compatible cameras, and a dark rectangle with white letters that say "Install." Above this rectangle is the text: "Specifications" and "Instruction Manual." Click on these to see the app's specifications and manual. This should be sufficient to determine if the app will serve your needs. If it does, download it and install it on your camera, and it will be available on your Application List.

There are three benefits to downloading apps. First, you are guaranteed the availability of all the apps you've downloaded, even if they are lost from your camera. For example, taking the battery out of the camera before turning it off can erase the apps. If you reboot the camera using the Setting Reset command's [Initialize] option, the apps will be erased. Fortunately, Sony keeps a record of your downloads and

Smart Remote Control

Ver. 2.20

Free

Space required:
7.1MB

Compatible Cameras
NEX-5R NEX-6 NEX-5T ILCE-7 ILCE-7R ILCE-5000 DSC-HX400V DSC-HX60V ILCE-6000

Specifications
Instruction Manual

Install

Like 153

Verify whether the application is compatible with your camera.

Figure 8-12: Screen for reading specifications and instructions for Smart Remote Control

you can reload all of your purchased apps at no additional expense. Second, you can use your apps on several different cameras. If you had downloaded apps for a NEX camera, you will be allowed to download those apps (provided they are compatible) to your a7/a7R at no charge. You can load the same app onto ten individual cameras. For example, the Time-lapse app is the same for the a7/a7R and the NEX-6, and we discovered it could be downloaded on all three cameras for the one initial cost.

Third, there is no charge for upgrades. For example, the Time-lapse app has been upgraded twice since we initially purchased it for our NEX-6. Originally this app could not vary its exposure for changing light conditions. This was satisfactory for general subjects taken in constant lighting, such as clouds moving across the sky, but it was limited for sunrises and sunsets when the goal was to have a daylight and night view of these transitions. The sun's appearance or disappearance changed light values so much that parts of the movie were either severely overexposed or underexposed. The second version of the app allowed the camera to alter its exposure to prevent this from happening. However, while the camera could alter its exposure, there was no control on how rapidly the camera would adjust its exposure between adjacent shoots. The third and most recent version (released March 19, 2014) allows the photographer to provide this control. Considering the purchase of the app has the benefits of being able to be downloaded onto up to ten cameras, unlimited access, and continual upgrades, its price of $9.95 is very reasonable.

Time-lapse

Time-lapse cinematography records images over an extended period so that when they are played back at video rates, the movies show an accelerated passage of time. It is a technique to view those events whose movements are too slow to be appreciated in real time. With this technique, you can follow the opening of flower petals, the sun sinking beneath the horizon at sunset, or clouds moving across the sky.

This is a challenging app to work with because you need to anticipate how the image will change with time. It is designed to fire the camera at predefined intervals. The shortest interval is one second, which means that when you view the movie, things will be moving at least 24 times faster than they moved in real

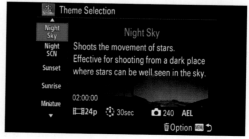

Figure 8-13: Time-lapse app showing its theme options

time. An event that requires four minutes to transpire will create a movie that can be viewed in 10 seconds. If you want to speed up the playback even more, you use longer intervals between shots. Setting the interval to 10 seconds for the same four-minute event will provide a movie that lasts only a second.

Sony tries to make creating these movies easy. The process begins with selecting a theme (figure 8-13) to be used under specific conditions. For example, there are themes entitled Cloudy Sky, Night Scene, Night Sky, Sunrise, Sunset, and Standard. For the neophyte, you match your subject to the theme to provide the settings most suitable for recording the event. There are brief descriptions of each theme to help you decide

Figure 8-14: Live View of Time-lapse app

which one to use. In addition, there is a wealth of information on the settings each theme employs. Using figure 8-13 as an example, the camera will be in operation for two hours, fire 240 shots at 30-second intervals, and the video will be saved as a 24p (24 frames per second progressive). The exposure will be locked and not altered after the initial shot. If the recommended settings are acceptable, press the center button to select them and go to Live View for framing and composing your subject (figure 8-14).

You do not have to accept the theme's initial setting. Instead of pressing the center button, you can alter these settings by pressing the Option menu (delete or C3 button). This screen allows you to alter the settings of the time-lapse. You can change the file format for the movie, the total number of shots to be taken, and the interval between the shots (figure 8-15a). A very useful feature of this app is that it calculates the viewing time of the video that will be recorded. The "10 sec" shown at the bottom of the screen is the calculated

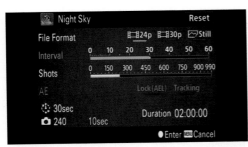

Figure 8-15a: Option menu in Time-lapse, 240 photos to be taken

length of the resulting movie. If you are taking 240 pictures and showing them at 24 fps, then the length of the movie will be 10 seconds. The up and down buttons are used to select the file format, interval, and shots. Once you highlight

one of these categories, you can change their values with the left and right buttons. Figure 8-15b shows one alteration: instead of taking 240 shots, the value has been changed to take the maximum number of 990 shots. The camera takes the entered changes and calculates how this will effect the duration of the shoot and the length of the

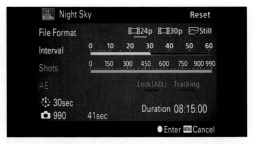

Figure 8-15b: Option menu in Time-lapse, 990 photos to be taken

movie. In this case, the camera will be in operation for 8 hours and 15 minutes and will produce a video of 41 seconds in length.

The movie files you create with this app will be AVI files and they will occupy a different directory than other image files (figure 8-16).

To playback these stored movies on your camera for review, you will have to be in the Time-lapse app. Once in the app, press the playback button to see thumbnails of each time-lapse sequence. These are the first frame of each Time-lapse movie (figure 8-17). Press the center button to watch your recorded movie. If you leave the Time-lapse app, you can replay only those movies that you had taken in regular time.

To download the Time-lapse movies to your computer, use either PlayMemories Home or iMovie. These files are not like AVCHD files. You can use a card reader and treat your SD card like an external drive. If you go to the directory shown in

Figure 8-16: File directory of SD card showing two AVI Time-lapse files

figure 8-17 and select the AVI files, you can copy the Time-lapse movies to your computer's hard drive.

An interesting feature in Time-lapse is an option that allows you to save your files as individual JPEG still frames. These will be stored in the same directory as your still photographs. With this option, we downloaded the JPEG files and by using a freeware program, ImageJ, created a movie file whose individual frames were 4800x3200 pixels. This is a huge amount of data and exceeds the frame size of HD videos (1920x1080 pixels) by three times. Indeed, the pixel array in this mode is larger than that achievable by a 4K video camera.

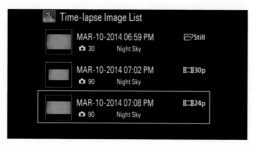

Figure 8-17: Playback screen of Time-lapse showing movie's first frame

Before moving on from the Time-lapse app, we will discuss one of its newest settings. First, keep in mind that the majority of themes used in this app set the exposure on the first image taken and then lock it to that value (AE Lock). This is to avoid the problem of flickering, which is a condition that occurs if the camera adjusts its exposure in response to changing light intensity. When playing back the movie, this is evidenced by either a sudden increase or decrease in the scene's lighting. To avoid this problem, the first release of the Time-lapse app locked the exposure on the first shot and kept the subsequent exposures at that value—unfortunately, that design limited the ability to record sunsets and sunrises. For example, if the exposure is unable to change, you won't be able to record a sunset that spans from daylight to twilight to night because the change in light will reflect a well-exposed daylight scene that gradually gets darker and finally fades to black.

If, however, the exposure could be increased to compensate for reduced levels of light, it would be possible to record both the daylight and the night scene. One way of accomplishing this is to use automatic exposure throughout the time-lapse sequence—a feature that Sony describes as AE tracking. This is an additional feature on the upgraded Sony Time-lapse app. Moreover, this feature also enables the user to control the rapidity at which the camera adjusts its exposure. It can be set to low, medium, or high. This provides a smoother transition of the scene as the light level drops. This is a finicky control and its successful application can only be achieved through experience, but it's a handy control for those who want to improve their time-lapse movies.

Lens Compensation App

The Lens Compensation app seems redundant because there is a series of commands in the camera's Custom Settings menu called Lens Comp. These are to be used with Sony's FE lenses, and they provide automatic correction for vignetting, distortion, and lateral chromatic aberration. These adjustments are part of the a7/a7R's software, and the extent of the correction is not under your control. The command is normally turned on so that the saved image file will not show these optical aberrations. If the Lens Comp. command option is turned off, the image files will have vignetting, distortion, and lateral chromatic aberration.

The downloadable app is different. It requires you to mount the lens and manually correct its deficiencies by altering the settings within the app. These adjustments are saved and can be used to improve the performance of the lens. It will also work for non-Sony lenses. This can be a handy application for users of legacy lenses because it may improve the captured image for those lenses exhibiting optical deficiencies. Moreover, this app can override the correction applied by the menu command so you can change the degree of automatic compensation provided by Lens Comp. for the FE lenses.

To avoid confusion, we will refer to the downloadable program as the Lens Compensation App. It must be downloaded from Sony's website (www.playmemoriescameraapps.com) and will cost $9.99. Once downloaded to your camera, select the Lens Compensation App from your Application list:

MENU>Application (1)>Application List

Once you start the app, you will enter a screen with the Lens Profile List on the top line. When you first use this application, the list will be empty. Highlight the Create/New selection (figure 8-18). The next screen will require you to input a lens name, its focal length, and its f-stop (figure 8-19). You will have to use Sony's virtual keyboard for this task. Keep in mind that the app's lens compensations only apply to a single focal length, so it is best used for prime lenses. It is less suitable for zoom lenses because they may exhibit a change in aberrations as you change their focal length. Since you will probably change focal lengths when using such a lens in the field, you will have to make a decision on what focal length you will apply the adjustment to. Although it is theoretically possible to select several different zoom focal lengths, this strategy will prove cumbersome.

To use the program, highlight an optical characteristic you wish to change—in this case (figure 8-19), we have highlighted Peripheral Shading (Vignetting). Before you undertake any correction, you should know ahead of time how and where

Figure 8-18: Creating a new lens profile

you will take your photograph. Using this app effectively requires some planning. For example, if you plan to correct for peripheral shading, you should find an evenly lit white surface, mount the camera on a tripod, and do a custom white balance.

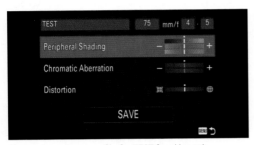

Figure 8-19: Lens profile for TEST focal length

Once completed, press the center button to activate the Peripheral Shading correction process. As soon as you do this, you will see a new screen that provides a live view through the lens. To the right of the screen is an orange dot, which can be raised or lowered with the up and down buttons. There are three rectangles at the bottom of the screen, each with a square icon in the middle. Use the right or left button to navigate. The three

squares represent the types of shading you might see. The first one on the left is a neutral darkening of the corners with no color cast; the next is a shading with a magenta color cast; the last one on the right is shading with a blue color cast. Figure 8-20a has neutral (no color cast) peripheral shading selected. By raising the orange dot with the up button, you can progressively lighten the periphery of the image. Figure 8-20b has a correction of +13 applied. This is too much correction, so that the periphery of the image is lighter than its center.

If you wish to correct for distortion, press the right button until you get to the distortion icon. When that icon is highlighted, mount the camera on a tripod and find a subject with straight, parallel lines running horizontally and vertically. You should align your sensor so its horizontal and vertical frames are parallel to those lines. On the right side of the screen is a vertical bar that shows a barrel distortion icon at the top, and a pincushion icon at the bottom. By moving the orange dot with the up and down buttons, you can correct these distortion errors. Once you have corrected it, press the MENU button. This will return you to the screen seen in figure 8-19. Move the red bar down to highlight SAVE and press the center

button. You have now performed and saved the corrections for peripheral shading and distortion.

We recommend using this app for correcting these two optical defects. We do not, however, recommend using it to correct for chromatic aberration. It should be noted that the color fringes arising from chromatic aberration are not apparent when using the camera's monitor or electronic viewfinder. Evaluating its extent or the degree you corrected it requires viewing a saved image on your computer screen. In other words, unlike the correction for peripheral shading or for geometric distortion, you do not have immediate feedback when you adjust the settings on the app. Instead, you have to apply a correction and hope you corrected for color fringing. Basically, you apply a correction, take a photograph, and load it onto your computer to see if the problem is solved. In essence, you are doing this "blind," and it's likely that too much or too little correction will have been applied. This will require you to return to the camera, try another setting, take another photograph, and check the results again. Needless to say, this can be time-consuming, so you

have to decide if it is worthwhile to implement the correction using the camera's app or just apply it in post-processing. Both Adobe's Photoshop and Apple's Aperture have the ability to remove the color fringes introduced by chromatic aberration and therefore we choose to use these programs to correct this type of defect.

Figure 8-20a: Lens displaying vignetting with no correction being applied

This brings up the question of whether you should utilize the Lens Compensation app to correct geometric distortion or peripheral shading. We do employ this app for correcting these two optical problems because it's easy to make the adjustments on the rear LCD and there is no trouble to establish the correct settings.

Figure 8-20b: Overcorrecting for vignetting

Recommendations

When Sony first came out with downloadable apps for the camera, we debated their utility and value. We have found that the apps are useful and are fun to play with. With so many apps to choose from, we covered the few that we found to be the most useful. For our working style, we use apps when they simplify our workflow. We ignore apps that are used to process images on the camera's small LCD; we prefer to use our computers with their large monitors for image processing.

We described the most useful three apps in our workflow: Smart Remote Control, Time-lapse, and Lens Compensation. Smart Remote Control facilitates our scientific photography because we can mount our camera on a tripod, a focusing rail, or a microscope, and have a large preview screen for framing and composing our image. The app provided just enough photographic controls that we felt it was indispensible for this type of work. If you like the live preview advantage, the tablet is the ideal choice. However, your smartphone is useful as a controller. We often find ourselves needing a remote triggering device, and while we might forget our cable or infrared remote release accessories, we never forget our phones. This feature is always available, even if you don't have cell phone coverage, because the communication is between the camera's and the phone's Wi-Fi transceivers.

We were surprised how often we used the Time-lapse app. This one is fun to use and makes taking this type of movie easy. The availability of themes provides the newcomer an easy introduction to this type of recording. If there is one limitation to the program it is that you will be limited to preparing a movie whose maximum length is 40 seconds. However, those 40 seconds can record a whole day's activities.

The Lens Compensation app is used with our legacy lenses. However, while we take advantage of its correction for shading and distortion, we found it too laborious to use for compensating chromatic aberration.

We strongly recommend trying these apps and checking out the others. Keep in mind, apps can be added to the Sony website anytime, so you might want to put a reminder on your calendar to check for updates and new apps. We are sure you will enjoy the results.

Chapter 9: Accessory Lenses

Introduction

To get the most out of the Sony a7/a7R cameras, you have to use the highest quality lenses. Sony currently sells five lenses for full frame coverage and promises to release 10 more lenses by the end of 2014. Although they use the NEX E-mount, this is a new line of lenses. Their optics can fully illuminate a 24mm x 36mm sensor, which is 1.5X larger than the sensor traditionally used in the NEX camera bodies. As a consequence, the new lenses are classified as belonging to the FE series. The 24-70mm and the 70-200mm zooms cost more than $1200 and are designed for high-resolution imaging. We assume that the other, not-yet-released lenses will also be expensive. While this can be daunting for those building a complete system, keep in mind how expensive it is to produce excellent optical lenses. This high quality is necessary if you want to fully exploit the capabilities of the a7 and a7R sensor.

The 28-70mm Sony zoom is the lowest-priced lens of the FE series. It is a good performer but it is not built to the same standard as the 35mm and 50mm lenses, and the 24-70mm zoom. The Zeiss 24-70mm f/4.0 lens has a wider zoom range and a fixed aperture as you vary its focal length. The 35mm and 55mm lenses have high-resolution and a large maximum aperture for work under low light conditions.

Although the lens line is limited, the a7/a7R can use a full frame lens that is not designed specifically for the camera. With the appropriate adapter, you can use virtually any manufacturer's lenses; however, this practice involves some sacrifice in convenience, such as autofocus, automatic exposure, or image stabilization.

There is one adapter that allows the retention of autofocus and autoexposure: Sony's LA-EA4, which costs $349. This adapter has a focusing motor, phase detectors, and electrical contacts that allow the use of the full frame lenses Sony makes for their SLT and DSLR cameras. This adapter will also provide automatic focus and exposure with the AF lenses made by Minolta and Konica Minolta. There is a less expensive adapter, the LA-EA3, for $200, but it cannot autofocus any lens that does not have its own internal focus motor, which means that Minolta and Konica Minolta lenses will have to be focused manually. When the LA-EA3 can provide autofocus, its focusing speed is slow. For this reason, we feel it worthwhile to spend an additional $150 to buy the LA-EA4. There are 22 full-frame lenses that can be used with the LA-EA4, ranging from a 16mm wide angle zoom to a 500mm f/4.0 super telephoto.

9

Using E-mount Lenses for the APS-C Sensor

Sony has officially announced that they will abandon using the term "NEX" for describing their new cameras using the E-mount. The replacement for the NEX-3, NEX-5, NEX-6, and NEX-7 will be designated as being Alpha-series. Historically, these cameras and their lenses were designed to work on an APS-C-sized sensor (24x16mm). With the advent of the a7/a7R, you have a camera whose sensor is 36x24mm. As a consequence, the NEX lenses would not fully illuminate the sensor (figure 9-1). Instead, its central portion would be illuminated while the periphery would be dark. However, Sony engineers designed the a7/a7R to be able to use the NEX lenses. Basically, the camera detects when the NEX lens is mounted and then records the central part of its sensor (figure 9-2). The image appears larger in the viewfinder because the camera magnifies the image by 1.5X. By using only the central 24x16mm rectangle, the camera functions like the NEX-series cameras. There is, of course, an associated reduction in the number of pixels recording the image. In the case of the a7R, the cropped image is 15 megapixels, while in the case of the a7, it is 10 megapixels.

Figure 9-1: A lens designed for an APS-C sensor vignettes when its image is projected onto a full-frame sensor

Figure 9-2: When the [Auto] option is used on the command APS-C Size Capture, it crops out the periphery of the full-frame sensor to hide the vignetting

Commands for Using Lenses Designed for APS-C Sensors

When using zoom lenses on the a7/a7R that were originally designed for the NEX cameras, the potential of vignetting is reduced as you increase the lens focal length and the imaging circle is enlarged. As the imaging circle's size becomes greater, it is possible to collect light from areas that had previously been darkened by the shorter focal length. Sony's engineers had not taken advantage of this characteristic. You, however, can gain more pixels for imaging by overriding Sony's software and setting the option for the command APS-Size Capture to [Off]. Doing so enables

you to record more than the a7R's 15 megapixels or the a7's 10 megapixels when using a zoom lens. In the case of the a7, we were able to record a picture of about 15 megapixels with our NEX kit lens (16-50mm) at its maximum zoom (figure 9-3). Admittedly there is some vignetting at the corners of the image; however, you seldom print at a 3:2 aspect ratio and these corners can easily be cropped out. You can attain a similar increase in usable pixels if you have an a7R. If recording the maximum number of pixels is important to you, be aware that you can turn the APS-C Size capture to [Off]. The increase in recordable pixel count will vary with the design of the lens, so be prepared to experiment with this option.

To take advantage of this, the a7/a7R has a very useful command to vary the size of the area recorded by the sensor:

MENU>Custom Settings (5)>APS-C Size Capture>[On], [Auto], [Off]

Normally this command is set to [Auto], which is the default option. If you mount a NEX lens onto the camera body, it will crop down the image to avoid vignetting. The [On] option, regardless of the lens type, forces the camera to reduce the area of the sensor that will be used.

If you mount a full-frame Sony lens on the camera, the APS-C Size Capture command can be useful for shooting movies if you need additional magnification in your telephoto shot. If you set this command to [On], it will crop the image down to the center of the sensor. It is a useful means of getting a 1.5X increase in magnification with little sacrifice in the quality of

Figure 9-3: An APS-C zoom lens will show less vignetting when using its maximum focal length

the video recording. There is no loss of resolution for an HD recording. However, it makes no sense to use this option when taking still pictures with a lens designed to work with a full-frame sensor, because this will result in a loss of resolution.

The [Auto] command also works when a Sony APS-C lens is mounted, it detects and records only the center of the sensor to avoid recording the massive vignetting that results from using a non-full-frame lens. Not only does this work with the series of E-mount lenses, it also works with the A-mount lenses that can be attached with the LA-EA3 or the LA-EA4 adapter.

The [Off] option allows the camera to use the sensor's entire area for recording an image. This is advantageous when using zoom lenses designed to cover an APS-C sensor because it gives you the option to crop the image and have access to more pixels than if you had selected [On] or [Auto]. However, there is no advantage to using the [Off] option with a NEX lens with a fixed focal length.

Adapters for Sony's SLT and SLR Camera Lens

Sony makes and sells two adapters for attaching A-mount lenses to the a7/a7R. The least expensive adapter is the LA-EA3 model ($200), which allows automatic exposure, diaphragm control, and limited autofocus capability where the auto-focus either will be slowed to an unacceptably low rate or it will be lost if the lens lacks a built-in focusing motor.

The second Sony adapter model is the LA-EA4 ($349). In our opinion, this more expensive adapter is superior and worth the increased price over the LA-EA3. First, it can focus all Sony lenses, including those that do not have a built-in focus-ing motor. The adaptor has its own motor, so it can drive the focus mechanism of older lenses such as Minolta and Konica Minolta AF. This also includes those Sigma and Tamron lenses that require the focusing motor to be contained in the camera body. Second, the focusing speed is very fast. Subjectively, it focuses as rapidly as a Sony a77; in essence, it converts the mirrorless design to that of an SLT camera (figure 9-4). A semitransparent mirror directs one third of the light to a set of phase detectors for focusing and the remainder goes to the imaging sensor.

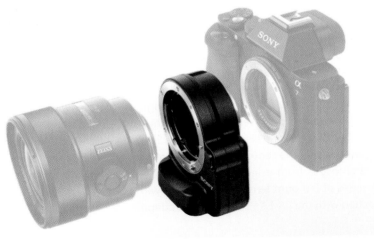

Figure 9-4: A diagram showing how the LA-EA4 fits between body and A series lens

The LA-EA4 adapter's design allows the use of the older Minolta or Konica Minolta lenses. These can be extremely good optically. For example, we bought an outstanding 100–300mm Minolta APO lens, and we use it on our Sony a7/a7R for still photography. It is very compact, very sharp, and can autofocus with the LA-EA4 adapter but not with the less expensive LA-EA3 adapter.

The following list is of some of the Sony descriptions for their A-mount lenses:

- **G**: Premium optics and superior mechanical design.
- **D**: Distance Encoder. This allows the camera to modify the flash output based on the distance of the subject from the camera.
- **DT**: Digital Technology. These lenses were designed to be used on cameras with APS-C sized sensors. They were not designed to fully illuminate a 24x36mm area.
- **HS**: High Speed. HS is found on lenses that rely on a motor in the camera body. The gears for moving the lens are optimized for speed. This is relevant only when using the LA-EA4 adapter.
- **SSM**: Super Sonic-wave Motor. This motor resides in the lens body and provides quiet operation. The lack of noise is important for taking movies since its presence would corrupt the audio files recorded with the movie. The LA-EA3 can autofocus this lens.
- **SAM**: Smooth Autofocus Motor. This motor resides in the lens body. It tends to be noisier than lenses with SSM and is associated with lower-priced lenses. The LA-EA3 will enable autofocus for this lens.

Most Sony interchangeable lens camera aficionados know that Sony's DSLR and SLT cameras can use the autofocus lenses made by Minolta or Konica Minolta. During the days of film photography, Minolta made many excellent lenses for the single lens reflex cameras. Many of these are optically excellent and designed to give full frame coverage. As a result, these lenses can be used with the LA-EA4 or LA-EA3 adapters on the Sony a7/a7R. We have successfully used a 100-300mm APO telephoto zoom and have been impressed with its performance when used with the LA-EA4 adapter. The lens autofocuses quickly and its optical quality is excellent. Similarly, we have used a 90mm f/2.8 Tamron macro lens and can vouch for its performance. The main disadvantage of using lenses designed for the SLT/SLR cameras is that image stabilization is unavailable.

Legacy and Used Lenses

A major advantage of the a7/a7R is the ability to use any lens that has a manual focusing ring and an external control for adjusting the diaphragm size. All that is required is an adapter. This can be as simple as an extension tube: one side having the mount to accept the legacy lens, the other side having a mount for the E-mount. These adapters take advantage of the short distance between the body flange and the sensor. The adapter's length ensures that the lenses' normal focusing range is maintained; specifically, it ensures that when the infinity focus mark is set, the image is in focus on the sensor. These adapters range in price from $20 to $250.

Focal Length and Aperture	Manufacturer	Lens Type
20mm f/2.8	Nikon	Fixed focal length wide angle
28mm f/2.8	Nikon	Fixed focal length wide angle
28-70mm f/2.8	Nikon	AF Nikon zoom
50mm f/1.8	Olympus	Fixed focal length
55mm f/2.8	Nikon	Macro fixed focal length
55mm f/3.5	Nikon	Macro fixed focal length
80–200mm f/2.8	Nikon	Telephoto zoom
90mm f/2.8	Tamron	Macro fixed focal length
90–180mm f/4.5	Vivitar Series 1	Macro zoom
105mm f/2.8	Nikon	Macro fixed focal length: MF version
105mm f/2.8	Nikon	Macro fixed focal length: AF version
180mm f/2.8	Nikon	Telephoto fixed focal length: MF version
180mm f/2.8	Nikon	Telephoto fixed focal length: AF version
300mm f/2.8	Nikon	Telephoto fixed focal length
300mm f/4.0	Nikon	Telephoto fixed focal length
400mm f/5.6	Tokina	Telephoto fixed focal length
400mm f/5.6	Sigma	Telephoto fixed focal length

Table 9-1: Legacy lenses that can be used with the Sony a7 and a7R

9

A glance at an online auction site reveals an abundance of used manual focus lenses, which can be fitted to the Sony body with the aid of an adapter. Such lenses can be very inexpensive since they are regarded as being obsolete. Many of the camera bodies these lenses were designed for used film instead of digital sensors. As such, these camera bodies have been out of production and their owners have sold these lenses. We tested several legacy lenses on our a7/a7R. Table 9-1 lists the lenses we found satisfactory. This list is not comprehensive—it only represents the lenses we had easy access to. Nikon, Minolta, Canon, Leica (M & S mounts), Leicaflex, and Pentax K or Pentax screw mounts are among the manual focus lenses that can be used on the a7/a7R.

You should approach adopting legacy lenses with caution. The most satisfactory lenses were the ones that were expensive when purchased new. This was especially noticeable for zoom lenses. An expensive 80-200mm f/2.8 Nikon zoom was satisfactory, but we were disappointed by the less expensive 70-210mm from an independent lens manufacturer. Be careful when selecting lenses with a wide range of focal lengths; we found that these lenses provided lower resolution than those with a more limited range. Nikon's 80-200mm f/2.8 zoom was satisfactory, but the older the 80-400mm f/4.5-5.6 zoom version was not, even though the latter was more expensive than the former. The important thing we noted is that our best performing lenses were not zooms—they were fixed focal length lenses.

We recommend you search the online forums for user evaluations to learn about other users' experiences. For example, many of the 500mm f/8.0 mirror lenses were found to be of poor quality. Also, many users dislike this lens's bokeh. Bokeh is the appearance of out-of-focus regions of the picture. Good bokeh is evidenced by a gradual loss of sharpness at the edges. For example, specular highlights appear as enlarged circles with soft edges. In contrast, a mirror lens renders out-of-focus specular highlights as bright donuts with sharp edges. In general, the images from mirror lenses were soft, and the contrast was lower than the contrast on images taken with refractor-type lenses.

The manual focus macro lens provides excellent performance. Olympus, Pentax, Canon, Minolta, and Nikon consistently made excellent lenses of this type. While they were designed to give the best results for close-up photography, their performance in distance photography is also excellent.

9

Manual Focusing Legacy lenses

There are several strategies to make the task of manual focusing easier. First, make sure the diopter adjustment control on the viewfinder's eyepiece is set properly. Since you will need to evaluate image sharpness from the screen, you cannot afford to have the finder's magnifier generate a fuzzy image to your eye. It should be noted that the viewfinder provides a sharper image than the LCD screen so the former is more reliable for obtaining accurate focus. Second, turn the lens's aperture ring to its smallest value, ensuring that its iris diaphragm is fully opened. This narrows the depth of field so that the image will blur rapidly when you turn the focusing ring. If you have the lens stopped down, the depth of field will be large and the image will not snap in and out of focus as obviously. If possible, focus with the widest aperture and then stop down the iris just before pressing the shutter button. A slight error in focus may not be as apparent due to the larger depth of field of the smaller aperture.

In addition to using these physical controls, take advantage of the two software features of your camera: Peaking function and the MF Assist. Both were described in Chapter 5. Peaking is good for rapidly identifying focus; however, it is less precise than using MF Assist, which provides an increase in the preview magnification, revealing the subject's finest details.

If you have not altered the Custom Key Settings, you will find an advantageous feature when using the C1 button. This is normally set for the Focus Settings command. When you mount a legacy lens, pressing the C1 button will put you immediately in MF Assist. Two presses on the C1 button will provide you a magnified view of your preview image, which is sufficient for obtaining critical focus.

Exposure Adjustment on Legacy Lenses

Aperture Priority is the most efficient mode to use. When using a fixed ISO value, this mode provides automatic exposure by altering the shutter speed to capture sufficient light for the sensor. Since the lens diaphragm's opening controls light throughput, the shutter speed changes in response to changes in the aperture. Overriding exposure is done with the exposure compensation dial, which brightens or darkens the image by using slower or faster shutter speeds. In contrast, when using [ISO AUTO], exposure compensation is accomplished by changing the sensitivity of the sensor. The gain, as indicated by the ISO used when taking the picture, is raised or lowered as you rotate the exposure compensation dial. In this case, the shutter speed stays at a fixed value.

The disadvantage of using these legacy lenses is that you lose Sony's SteadyShot feature—this is the stabilization mechanism that removes minute camera movement. For handheld shooting, remember not to select a shutter speed with a duration long enough that hand tremors move the sensor and induce

blurring. For long telephoto work, we recommend that you either use a tripod or, if handholding the lens, set your shutter speed faster than 1/focal length. For example, for sharp results, a 400mm lens can be handheld at 1/400 second or faster.

The results from our experiments were so gratifying that we do not hesitate to recommend utilizing a legacy lens for your a7/a7R. We have an excellent Tokina 400mm f/5.6 lens that provides crystal-sharp images. Considering that there is no E-mount lens with this long of a focal length, this legacy lens can provide unique images. The optical quality of these lenses can be superb. They are compact and light and have precision focusing helicoids, making them a premium addition to your lens collection.

Adapters for Legacy Lenses

Table 9-2 contains a list of the lens adapters available for the a7/a7R whose prices range from $40 to $350. The most expensive is the one made by Sony for converting the a7/a7R camera to an SLT-type camera. It has a motor for autofocusing and the electrical connections to ensure automatic exposure. There is an adapter, manufactured by Metabone ($400) that will accept Canon EF lenses and provide AF, automatic exposure, and image stabilization. We have not tested this adapter.

Most adapters are much simpler in design and are little more than extension tubes. For many users, the $40 Fotodiox adapters are perfectly serviceable for most lenses. The more expensive Novoflex, Rayqual, and Voigtländer adapters (each approximately $200) have a better fit and finish. Their dimensions are precisely controlled so that when attached to the camera, the flange to sensor distance matches the requirements specified by the legacy lens's manufacturer. Setting this distance precisely enables the lens to reach infinity focus when it reaches the infinity mark on the lens barrel. In some of the older designs, there is a "hard" stop that is placed at this point. This is handy because it allows the photographer to quickly turn the focusing ring to its end point and be assured of having the most distant objects in focus. Its advantage is most evident in astronomical work where there is not enough light to focus manually. This feature can be indispensible when photographing the Milky Way.

If the distance from flange to sensor is shorter than factory specifications, the lens can still reach infinity focus before it hits the stop. Operationally, if you are using manual focus, you won't notice this since the lens will still focus to infinity. The stop will only be noticed if you rely on focusing scales. Since most photographers seldom do this, it can be regarded as a minor deficiency, especially since many modern lenses are equipped with a hard stop that is past the infinity mark.

9

Mount	Fotodiox	Novoflex	Rayqual	Sony	Voigtländer
C-mount			X		
Canon EOS	X	X			
Canon FD	X		X		
Contax/Yashica	X		X		
Leica M	X	X			X
Leica M39	X				
Leica R	X	X	X		
Sony Alpha				X	
Minolta MD	X	X			
Nikon F	X	X	X		X
Olympus OM	X	X	X		
Pentax K	X	X	X		X
Pentax M42	X	X	X		

Table 9-2: Lens mount categories and Sony a7/a7R adapter manufacturers

So how much should you pay for an adapter? This is a matter of personal preference and need. If you want to use the SLT series of lenses (A-mount) and use automatic focus and automatic exposure, it will cost you around $350. For our microscope work, our adapters have to hold the camera's sensor perpendicular to the optical axis of the microscope at a precise distance from the projection eyepiece, so we buy the expensive adapters by Rayqual, Novoflex, or Voigtländer. These do not have focusing mechanisms or electrical contacts and cost about $200. Considering the high cost of the camera and lens and the need for high quality in our work, it is unreasonable to risk degrading our results by using a cheap adapter. We have tested some of the low-cost adapters ($20) from eBay; some were adequate even though the machining was poor. Having said that, we also had units that fell apart or would not fit the camera body.

A Checklist for Using Legacy Lenses
If you want to try legacy lenses, here is a list of camera settings and lens requirements:
- A legacy lens must have a smooth-focusing helicoid ring.
- A legacy lens must have a diaphragm ring that closes down the aperture. Otherwise, make sure the adapter has a way to manipulate the diaphragm.
- Turn the Peaking Level to [Mid]. The default for this is [Off].
- Set the Peaking Color to red or yellow.
- Be sure MF Assist is readily accessible by customizing a button to activate it. This is accomplished easily by NOT altering the assignment for the C1 button. The camera's default settings uses the C1 button for this purpose.

- Use the A mode.
- The default setting for this camera allows it to fire with a legacy lens. If you find the camera is not firing, make sure the following command is set:

MENU>Custom Settings (3)>Release w/o lens>[Enable]

Telescopes

Long-distance photography fascinates many photographers. The thought of obtaining a close-up of the moon makes some photographers long for a super telephoto lens. The longest a7/a7R lens is 200mm (figure 9-5a), and the longest A-mount lens is 500mm (figures 9-5b).

To get a "long view," you may consider using an apochromatic spotting scope or a tele-scope (figure 9-5c). These can be expensive, but they are more economical than the long tele-photo lenses sold by camera manufactures. In most cases, telescopes can be adapted to fit an a7/a7R.

Sony sells a 500mm f/4.0 long telephoto for $13,000. This lens is for their SLT series of cameras, but you can buy the LA-EA4 Sony adapter for attaching it to the a7/a7R camera for $349. Or you can attach the camera to a scope like the TeleVue apochromatic refrac-tor telescope. A new 85mm Tele Vue costs about $2,500 and has a 480mm focal length. Though this is still expensive, it serves a dual function. Not only are such

Figure 9-5a: View from the longest full frame E-mount telephoto lens (200mm)

Figure 9-5b: View from the longest telephoto lens (500mm) in the Sony A-mount lineup

Figure 9-5c: View from a telescope with a camera adapter (1600mm)

9

refractors good photographic accessories, they can also be used in their intended role as visual instruments for long-distance viewing (figure 9-6). The Tele Vue is a favorite among telescope aficionados for its clarity and its ability to provide high-contrast images of the night sky. With this telescope, the moon can be recorded in amazing detail (figure 9-7).

Figure 9-6: With the aid of a telescope, the a7/a7R can record the entirety of the moon

Figure 9-7: A close-up of a lunar mountain range recorded with a Sony camera and a TeleVue 8,5 with the aid of a 2X eyepiece

Another option is to purchase a catadioptric system, made popular by Meade and Celestron. These units tend to be less expensive and use a combination of lenses and mirrors to fold the optical path length into a relatively short tube. The popular eight-inch diameter telescopes can fold a 2,000mm (79-inch) focal length into a tube only 432mm (17-inch) long. Purchased new, these telescopes range in cost from $600 to $2,500. If you have friends who are astronomy buffs, they can guide you on the selection of a telescope, and in most cases these telescopes can be fitted to an a7/a7R with simple adapters. Optically, the main weakness of catadioptric telescopes is that they have less contrast than a telephoto. Also, many photographers do not like these lenses because of their bokeh. Most of these telescopes are equipped with a focusing tube that takes either 1.25-inch or 2-inch diameter eyepieces. The 1.25-inch diameter eyepiece holder is commonly found on those telescopes that are designed primarily for visual observation. There are simple adapters that fit within these

eyepiece tubes (figure 9-8). When you equip these adapters with a bayonet mount for the a7/a7R, you are ready to mount your camera to the telescope and take pictures. We recommend you use a telescope that has a 2-inch diameter eyepiece holder: these telescopes have wider diameter camera adapters that are less prone to vignetting.

You may have heard of digiscoping, where a point-and-shoot camera is held over a telescope eyepiece. Results from this simple technique are quite impressive, but you can obtain better pictures by removing the camera lens and the telescope eyepiece, and attaching it directly to the telescope. The object lens will project an image directly onto the camera's sensor, and you will not have any image degradation resulting from an extraneous camera lens (which was not designed for this use) in the optical path.

The first step is to find a telescope that can be used with your camera. Today there are a tremendous number of telescopes in a variety of sizes to choose from, so we will restrict our discussion to smaller telescopes that can double for terrestrial fieldwork. These telescopes typically have lenses with a front element ranging in diameter from 50 to 100mm (2 to 4 inches). Telescopes smaller than this can be matched by the performance of a telephoto lens. Although they are usable, telescopes with an objective larger than 100mm are too cumbersome to carry and difficult to handle for fieldwork. You will need a sturdy tripod to support your telescope; you will be working at high enough magnification that it is difficult to handhold the telescope and camera while taking pictures.

We have used TeleVue's 60mm, 76mm, and 85mm telescopes for photography, and they have all provided exceptionally high resolving power. The 60mm telescope (360mm f/6) sells for less than $1,000; the 76mm telescope (480mm f/6.3) sells for $2,000; and the 85mm telescope (600 mm f/7) sells for $2,495. Their optical performance rivals, and perhaps exceeds, that of the finest Nikon or Canon telephoto lenses, whose 500mm optics cost $6,000 to $8,000. We have used teleconverters (in this case, Nikon and Tokina) in the optical path to further increase the magnification from the telescope.

9

Figure 9-8: This adapter fits in a 1.25-inch eyepiece holder, and can carry an a7/a7R body

This is not to say that these telescopes can replace a professional telephoto lens. They cannot. For one thing, they lack an iris diaphragm, so you need to shoot wide open. In terms of sharpness, this is not a disadvantage; these telescopes are designed to give their best performance when used at full aperture. Unfortunately, you cannot increase your depth of field by stopping down the lens. Also, they are not compact. Most professional telephoto lenses are physically shorter than their focal length, enabling them to be used in the field for handheld photography without a tripod. Finally, the telescopes do not have autofocusing, but considering their relatively low cost, they provide a good introduction to long-distance photography.

We have tested the Sony a7/a7R extensively on a Tele Vue 85 and a Tele Vue 60. The Tele Vue 85 has a 2-inch eyepiece holder, and the Tele Vue 60 has a 1.25-inch eyepiece holder. Both telescopes can accept camera adapters that fit in the eyepiece tube, and they have T-mounts for attaching a Sony E-mount. We have also experimented with the Borg 400mm f/8.0 telephoto. This telescope is remarkably lightweight, and it is unique in that it can be equipped with an iris diaphragm for stopping the lens down. Using these telescopes with the Sony a7/a7R requires only that the eyepiece holder be removed and replaced with the adapter. The camera should be set to A mode and manual focusing.

We typically use the viewfinder when aiming the telescope at terrestrial objects because ambient daylight can obscure the LCD screen. Make sure the Peaking function is active to allow for rapid identification of when the camera is in focus.

Long distance photography requires that nothing move during the point of exposure. In this respect, the a7 is a superior choice for this application, since its electronic first-curtain shutter does not jar the camera body. In contrast, there is a noticeable vibration imparted by the mechanical first-curtain shutter of the a7R.

Microscopes

For more than 50 years, SLRs have been used on microscopes to take high magnification pictures of single-cell plants and animals, as well as slides of human tissue. Nikon, Leitz, Zeiss, and Olympus used to sell elaborate and expensive accessories for mounting film cameras onto microscopes. However, their SLRs (film and digital) were ill suited for the task, and it was necessary to add expensive accessories to overcome their limitations. For example, special viewfinders and viewing screens replaced the camera's optical viewfinder. In addition, to avoid the movement

of the mirror and the camera's shutter, which generates vibration and blurs the image during exposure, the adapters were equipped with their own swing-out mirror and vibration-free shutter mechanism. Essentially, the camera body had its mirror locked up and the focal plane shutter held open: functionally, it was a simple but expensive film carrier.

These deficiencies are remedied in total or in part with the a7/a7R. The camera's Live View finders allow you to ensure accurate focusing. The lack of a moving mirror means it cannot cause vibration. The a7 has an additional advantage of having an electronic first-curtain shutter. This eliminates vibration when the shutter is actuated. The a7R is not as well suited for this task because vibration is imparted to the microscope by the movement of its mechanical first-curtain shutter. Using long exposures of 1 second or more can mitigate this problem. Figure 9-9 is an example of what can be recorded with a microscope. This is a diatom slide prepared by

Figure 9-9: An arrangement of 100 individual diatoms; the whole array is 1/32 inches across

Klaus Kemp, who arranged more than 100 diatoms in this star pattern. The whole pattern has a diameter of only 1/32 of an inch.

To aid focusing, the Live View screen can work at an increased magnification, thanks to the MF Assist command. The Peaking function provides an additional focusing aid. The small size of the image on the Live View monitor or viewfinder is a deficiency that can be remedied by using the camera's HDMI output and connecting the camera to an HDTV or other large monitor. Also, if you have downloaded the Sony App (Smart Remote Control), you can view your specimen with a tablet computer whose larger screen facilitates focusing and composing the image.

Microscopes designed for photography are equipped with a trinocular head: two of its eyepieces are used for viewing the specimen and the third is used to mount the camera. Due to the multitude of microscope designs, it is difficult to provide an accurate, universal description of how to mount a camera to a microscope. Most modern research microscopes can be equipped with a photographic port. Generally this is a vertical 30-50mm-diameter tube with a bayonet mount for a digital SLR. One can mount the Sony a7/a7R to this tube. Older microscopes require an adapter, which is fitted to a smaller diameter (25mm) photographic port that includes an eyepiece. This adapter carries a bayonet mount to which you can attach a Sony a7/a7R. Martin Microscope Company (www.martinmicroscope.com/MMSLR.htm) makes adapters to fit microscopes. This company has an adapter for about $500 that can make it easy to mount the Sony a7/a7R onto your microscope.

If you are interested in obtaining a home microscope, you can find affordable used microscopes on eBay; however, we recommend finding a seller who specializes in microscopes. Unless you are very experienced, avoid buying from online auction houses. If at all possible, try to buy from a reputable establishment that sells directly and has a record of selling good products. The cost will probably be higher, but you will have more assurance that the microscope has been checked and adjusted for proper operation. We have purchased used microscopes and cameras from Bunton Instrument Company (www.buntgrp.com/used_microscopes.htm). The instruments sold by this company were excellent. Many professional microscopists use older microscopes (30 years old or older). When equipped correctly, these older models can provide excellent performance. We use both modern research microscopes and a set of older microscopes (made in the 1960s); for most of our photographic work, the older instruments do as well as the modern research microscopes that cost twenty times as much.

For older microscopes, there are simple and inexpensive accessories for mounting the camera. You can find simple adapters that clamp onto the vertical tube.

At the opposite end of the adapter is a male screw threaded to take a variety of bayonet mounts. This is usually a T-mount, and you can easily find adapters for this.
 Follow these steps when you use the Sony a7/a7R on a microscope:
- Adjust the microscope to get a sharp image of the slide through the eyepiece.
- Adjust the microscope's light source intensity so the view through the eyepiece is comfortable. If the light is controlled with a voltmeter, run it at the voltage recommended by the manufacturer. If it is too bright, reduce the light intensity with neutral density filters.
- Set the camera's ISO to 100.
- Set the camera's Peaking Level at the medium setting.
- Set the Peaking Color to red or yellow.
- Set the camera to A mode.
- Set the camera to fire without a lens:

 MENU>Custom Settings (3)>Release w/o Lens>[Enable]

- Set the WB to [Incandescent], or set the color temperature scale to [3200 K]. If this does not work, use Custom WB as described in Chapter 6. To do this, find a clear area on the microscope slide and set the WB to on this area. This will calibrate WB directly to the light source.
- Focus the image using the microscope control while viewing it on the LCD screen.
- Fire the camera with a remote release or set the camera's self-timer to a 2-second delay. This keeps any vibration caused by manually pressing the shutter button from disturbing the picture.
- If you are using the a7R, adjust the light intensity so that the camera uses an exposure of 1 second or longer. Its mechanical first-curtain shutter generates brief camera body movement at the onset of exposure. By using a long exposure of at least 1 second, the majority of the exposure will be taken at a time when the vibration has died out and the camera is steady. You do not need to do this if you are using the a7, because it has an electronic first-curtain shutter that does not cause this brief movement.

9

For more information on taking pictures with a microscope, we recommend our book, *Practical Digital Photomicrography*, which can be found on Amazon.

Macro Photography

The a7/a7R cameras are beautifully suited for macro photography. The Nikon, Canon, Olympus, Pentax, and Minolta legacy macro lenses are perfect for this application. In fact, they are more convenient to use than the modern autofocus lenses. When working at high magnification, we found autofocus to be unreliable; it tends to "hunt" and take too much time to find focus. It is more convenient and reliable to use manual focus. In this respect, the a7 and a7R are ideally suited for this type of work. Their live display is essential for precise and accurate composition, especially when using MF Assist. The cameras are particularly convenient for this type of work when linked to a tablet computer.

When used in this manner, we found that depth of field is extremely limited at 1X magnification. The a7/a7R's Live View preview coupled with A mode provides a real-time depth-of-field preview that allows us to determine what is sharp and what is blurred. At 1X, the sharp area is a perpendicular plane to the optical axis of the lens and can be described as an optical section. It is impossible to record the entire three-dimensional structure with one photograph.

To record the subject in its entirety, a combined mechanical and software approach is needed. Record several pictures at different focus points. If enough optical sections are captured, it is possible to use software to merge them to reconstruct the entire three-dimensional subject that your eye sees. Basically, you create an image with an extended depth of field. To accomplish this, you'll need 40 or more sections.

Figure 9-10: Motorized focusing rail StackShot made by Cognysis

This can be done manually, but it is tedious. It is more efficient to use StackShot, (figure 9-10) which is made by Cognysis. StackShot is a tool that automates firing the camera and changing its focus. The camera and lens are mounted on a motorized rail that is connected to a controller box. This allows the photographer to set the point of focus and program how many focus points will be taken. Photographers who need

to make award-winning macro photographs have accepted this process enthusiastically. By using the Sony a7 with a good macro lens, it is easy to collect 40 optical sections that can then be merged to provide an image whose depth of field is an order of magnitude greater than what can be attained by a single photograph. Figure 9-11 shows a single section of a close-up subject taken with the Sony a7 and a Vivitar Series 1 90-180mm macro zoom lens at f/16. The limited depth of field throws the foreground and background out of focus. Figure 9-12 shows the results of using StackShot for generating a focus series and using the program Helicon Focus to combine the individual shots to render an image where the depth of field is expanded tenfold. Compare this to figure 9-11, which shows only a single section from that focus series and the limited depth of field of a macro shot. In figure 9-12, both the foreground and background foliage is clearly seen.

Figure 9-11: A single shot illustrating limited depth of field

Figure 9-12: Multiple shots combined for extended depth of field

Remote Release

As mentioned in Chapter 6, Sony sells a cable release (the RM-VPR1) for the a7/a7R. This is easily attached via the Multi terminal (USB port). We strongly recommend getting this accessory because it allows you to lock the shutter release when you use the Bulb shutter setting. Without a cable release, you would have to hold down the shutter button to keep the shutter open. This can be difficult when you want to use an exposure of a minute or longer. The cable release has a lock mechanism, which keeps the shutter depressed, making it easy to take exposures of over a minute. This accessory also has a separate movie button so you can start recording a movie remotely.

Figure 9-13: Screenshot showing the controls of Sony's Remote Camera software

In addition, you can purchase the RMT-DSLR1 infrared Remote Commander. This small accessory resembles a television remote and emits infrared light that is detected by a sensor located on the front of the camera. If you owned a Sony NEX camera you may already have this accessory. To use it on the a7/a7R, set the following command:

MENU>Setup (3)>Remote Ctrl>[On]

Use the remote to fire the camera. At first, you might think that you have to aim the remote directly at the camera's sensor. This is not the case when you're indoors. The beam is sufficiently intense, and the sensor is sufficiently sensitive, so the infrared beam can be detected after it is reflected off the walls of the room. When you use the camera outdoors, you can employ this strategy by placing your hand in front of the camera (outside the view of the lens) and aiming the remote at your hand.

With software you can download from the Sony website, you can also use your computer to fire the camera. This software is available for computers operating Windows OS and Mac OS. Once downloaded, you will find it as an application (in the case of Mac it is RemoteCameraControl.app). You can then fire and make some adjustments to the camera from your computer. It will require turning on the program, connecting your camera to the computer via a USB cable, and setting this command sequence:

MENU>Setup (4)>USB Connection>[PC Remote]

While you can set several camera settings as well as trigger the camera with this software, it has one omission: it does not provide a preview of the image on the computer screen (figure 9-13). We prefer to use the simpler IR or cable remote commanders described previously.

Our favorite and most-used remote firing strategy is the Smart Remote Control app. This takes advantage of the Wi-Fi capability of the camera and its ability to communicate to a smartphone or a tablet computer. This application provides a preview screen for viewing the subject and the controls for firing the camera. When used with our iPad, this application aids our macro photography work by providing an enlarged live view of the subject. We describe this, and other apps, in Chapter 8.

If you forget to pack your remote release, remember that you can eliminate vibration from pressing the shutter button by setting the Drive Mode command to [Self-timer], and set it for a 2-second delay. This works well with the a7; however, it is not so useful when using the a7R. The former camera has a first curtain electronic shutter, which is vibration free. The latter camera has a mechanical first curtain, and its movement may cause shutter vibration. This is not so much of a problem with a moderate telephoto of 100mm, or with normal and wide-angle lenses. However, it can be a problem when used with a long telephoto, especially one that has a collar for attachment to a tripod. The longer 200mm lenses with this configuration can show vibration-induced blurring even when using the 2-second delay.

Tripod

You may already own a tripod, but if you don't, this section is for you. To fully take advantage of the 24 or higher pixel count Sony sensor, you need to get a tripod and a good head. This accessory is often overlooked when you first start taking pictures and movies. For a light, small camera like the a7/a7R, using a tripod seems cumbersome since it is bulky, reduces mobility, and hinders spontaneous photography. However, a steady support for the camera is necessary when taking pictures requiring long exposures and for extreme telephoto work—in short, for any type of work that demands recording maximally sharp images. In fact, the inconvenience of using a tripod may be its strongest benefit because it forces you to work at a deliberate pace—carefully framing the subject, evaluating depth of field, and ensuring that the horizon is not tilted. This methodical procedure trains you to study the image critically before taking the picture.

Professional tripods are usually sold in two parts: the legs and the head. The legs provide the support, but they do not have a mechanism for aiming the camera. The head, which is attached to the legs, is the actual aiming mechanism. Although you can buy a complete tripod with legs and head, many, if not most, serious photographers buy the two components separately. This way, you have a custom unit that suits your personal photographic style.

A good tripod can easily cost $300, with more expensive units running over $1,000. Although it is initially expensive, a good tripod will outlast a camera and lens. One of our tripods is more than 40 years old and is still in use. Our tripod collection grows with our experience in photography. We have a heavy studio tripod for the laboratory; although its weight discourages us from taking it into the field, we appreciate its stability when we work with high-magnification close-up shots. Such a tripod will be rock solid, and its adjustments are smooth and precise. For fieldwork, we take a lightweight tripod wherever we go. Its legs are made of carbon fiber, so it weighs only a few pounds, but it can aim and hold steady a 400mm telephoto with precision. However, the light weight of these tripods does sacrifice some ability to dampen vibration. We carry a canvas shopping bag and attach it to the center column of the tripod by the handles. By adding rocks to the canvas bag, we can increase the tripod's stability.

Do not skimp on expense. Low-cost tripods are not only flimsy, but they take longer to set up and are sometimes subject to drift, which is when the camera slowly shifts out of position after you aim and compose your picture in the viewfinder. If your equipment is awkward and irritating to handle, it guarantees that you won't use it. A good tripod allows you to aim your camera smoothly. When you lock the controls, there is no observable shift in the viewfinder. Your camera will remain steady and you will take tack-sharp pictures.

Plan to spend a minimum of $300 for the tripod's two components: the legs for support and the head for aiming the camera. The head can be surprisingly expensive, especially if you tend to use long telephoto lenses.

There are two major categories of tripod heads: pan and tilt heads, and ball heads. Pan and tilt heads are heavier and less expensive (about $65 for the Manfrotto 804RC2). They allow you to pan across the scene (horizontal movement) and tilt the camera (vertical movement). To lock the head, you must tighten two knobs: one for the pan and the other for the tilt. Operating two separate controls slows you down when taking pictures, but these systems have the advantage of increased stability when working with heavier lenses. Ball heads (figure 9-14) are lighter and more expensive (about $350). They allow you to move the camera smoothly in any direction. They are locked with a single knob; you loosen it to aim the camera and tighten it to lock it into position. We started out more than 40 years ago with a Bogen 3047 pan and tilt head, but we have since replaced it— we prefer the speed of working with an Acratech ball head.

We use an older Acratech GV2 ball head for our photography. It has a nifty design feature: a gimbal mechanism that is engaged by rotating the ball 90 degrees to the side. This limits the head movement along a vertical plane while the base rotates independently along a horizontal plane. In essence, it

Figure 9-14: Acratech GP-SS ball head

works as a pan and tilt head. This provides increased stability when working with heavy lenses whose tripod mount is on the lens body. When a long telephoto lens is attached to the camera, Acratech's gimbal feature places the center of balance closer to the swivel point for much better balance and control.

This wonderful feature is carried over into newer Acratech models. If you attempt to use a regular ball head without this feature, the center of balance of a heavy telephoto lens is over the ball head. This weight generates sufficient torque that the lens flops over, making it difficult to aim. By using the gimbal, the telephoto's center of balance is lowered and displaced to the side. Since the tripod collar is at the

telephoto lens's center of gravity, the lens is balanced along the axis of the gimbal and can be easily tilted up or down along this axis. This feature is advantageous when using a heavy telephoto lens whose focal length is greater than 200mm.

When we use lenses with a focal length ranging from 18 to 105mm, we do not need to use the gimbal feature. Instead, we use it as a ball head that has two tightening knobs. One is applied to smoothly dampen the movement of the ball for aiming the camera. When we release the camera from our hold, the first tightened knob is sufficient to maintain its position so that it does not flop to its side. This allows us to quickly aim the camera. It can then be locked into position by tightening a second knob. After taking the shot, this second knob can be loosened to frame a new scene, and then tightened again to lock the camera down. You only need to work one knob to aim and lock the camera's position.

We recommend that you get a quick-release clamp for your tripod head. Typically, a basic head allows you to attach the camera to the tripod head with a quarter-inch threaded screw. Attaching and detaching the camera can be time consuming and awkward. To speed up the operation, use a tripod head with a quick-release clamp (figure 9-15). This clamp engages a plate that is attached to the bottom of your camera so attaching and detaching the camera from the tripod becomes fast and simple. To attach the camera, simply place the plate into the head's quick-release clamp and lock it in with a press of the lever. Acratech makes plates specifically for the a7/a7R camera body, which allow free movement of the tilting LCD screen. The plates are equipped with a lip that engages the front surface of the camera body and prevents it from rotating on the plate.

Figure 9-15: Quick-release clamp for attaching the tripod head to the camera

The next thing to consider is the tripod legs. Fortunately, their connection to the tripod head is standard; a screw secures the head of your choice. The price of tripod legs ranges from $200 to more than $1000. Premium models are made of light, durable carbon fiber. Typically, the legs collapse for convenient transport. Gitzo makes some of the best legs—rigid and light. However, they are very expensive and may cost over $500.

We use the less expensive legs by Manfrotto (about $300) and combine them with an Acratech ball head. Several of our colleagues have been satisfied with Velbon, Slik, and Hakuba carbon fiber tripod legs that cost about $200 to $300.

9

Vibration and the a7R

In comparison to the a7, movement of the a7R's mechanical shutter can generate significant vibration, which can blur the image. We have noted this in our work with telescopes, telephotos, and microscopes. Nonetheless, we have been able to capture high resolution images with this camera by taking some additional steps in our photographic techniques.

When using the camera with lenses whose focal length is less than 100mm, we attach the camera directly onto the tripod. Some legacy lens adapters come with a tripod collar for mounting the camera lens combination on the adapter. We have had increased vibration when using this type of mounting system.

When we use a tripod, we do everything we can to increase its stability. In our laboratory work, we use a Manfrotto, which is a heavy aluminum tripod. It weighs over 13 pounds, and is frequently used with medium format or four-by-five cameras. It is capable of supporting 26 pounds of weight. When we use this tripod, we have no problem with shutter bounce for the kit lens and short telephotos. We have used this tripod effectively with a 300mm f/2.8 Nikon telephoto with the gimbal mounting system. This tripod's weight makes it unsuitable for fieldwork. Under these conditions, we use a lightweight carbon fiber tripod and increase stability by adding weight to a canvas bag that we hang from the tripod's handles. We lower the center column to its lowest point to keep camera and lens close to the tripod legs.

When working with lenses longer than 100mm, we use additional strategies to dampen shutter bounce. We have used lenses as long as the 300mm f/2.8 Nikon AIS lens with the Sony a7R on our carbon fiber tripod. We do not use a conventional ball head for this lens. A heavy lens such as this comes with a collar for attaching it to the head. However, this type of attachment does not dampen vibration-inducing blur, so we use a gimbal-type head to counter this; it can be tilted 90 degrees to the side and its gimbal engages a slot. This converts the Acratech to a pan and tilt head that easily handles a 300mm lens. We have found this set-up to be very resistant to vibration.

When using the camera at shutter speeds as slow as 1/30 second, we dampen the shutter vibration by holding onto the lens and camera body, and using the viewfinder. We do this even when the camera and lens are mounted on the tripod. By applying pressure with our hands, we can effectively take pictures at these slow shutter speeds. Presumably, by maintaining contact with the camera body and lens, we help dampen the vibration arising from the mechanical first-curtain shutter. This is not effective when the shutter speed is longer than 1/30 second. For this, we raise the ISO of the camera to ensure we use a shutter speed 1/30 second or faster.

With microscopes, we avoid the detrimental effects of vibration on image sharpness by using shutter speeds of 1 second or longer. This works on stained histological slides, which do not move. If we have to use a faster shutter speed, we will use the a7 over the a7R. For our work with telescopes, we also prefer the a7 to the a7R. For all the above work we turn off Sony's SteadyShot.

9

Recommendations

Thanks to Sony's mirrorless design technology, the a7/a7R is a remarkably versatile working tool. It can be used effectively on specialized optical instruments such as telescopes and microscopes. In the case of the a7, the absence of vibration due to the electronic first-curtain shutter and the ability to precisely focus on the subject lends itself to photomicrography and telescope work. As your expertise increases along with your desire to explore new types of photography, you may spend more on accessories than the camera; however, these accessories allow you to exploit the camera's full potential.

The Sony a7/a7R kit lens is an excellent photographic tool. We recommend that you get to know the strengths and limitations of this lens before you acquire any additional lenses. If you decide to buy more lenses, consider Sony's (including Zeiss lenses sold by Sony) first. Optically, these lenses are high quality, and you can be confident that they are fully functional with your camera. Also, you can use the A-mount Sony lenses with the LA-EA4 adapter. This provides a rapid-focusing accessory that enables you to use lenses ranging from a 16mm wide angle to a 500mm telephoto.

One very important advantage of the E-mount is that you can use legacy lenses made for Canon, Nikon, Olympus, Pentax, and Minolta. If it has a good mechanical helicoid and an external aperture ring, you can take excellent pictures with it. You do lose autofocus capability and image stabilization; however, by using a tripod and cable release you can still take pictures that reveal the finest details within a scene.

9

Chapter 10: Flash Photography

10

Introduction

As sensitive as the Sony a7/a7R is to light, there are times when additional lighting is required. This situation frequently arises when photographing indoors. Supplemental lighting can be easily and conveniently obtained by adding a shoe-mounted flash. If you anticipate doing much interior work, you should consider getting an external flash unit that fits on the camera's hot shoe (figure 10-1). External flash units are easy to use and provide automatic exposure.

Sony has several attachable external flash units; however, choosing which flash to buy can be confusing. First, Sony has only recently started using a typical hot shoe attachment. Previously, their flash units had a proprietary mounting system that fitted such cameras as the NEX-7 and a77. This was a fast and convenient mechanism that allowed the photographer to slide the flash onto the camera and have it locked securely. A simple press of the button unlocked the flash from its attachment and it would slide off easily. With the advent of the SLT-a99 camera, Sony started to use a hot shoe

Figure 10-1: Top of the camera showing the hot shoe

type attachment mechanism. This unit has a series of electrical contacts for attaching accessories other than a flash unit. Sony describes their design as the "Multi-Function Accessory Shoe." While this unit can accept other manufacturer's flash units, its purpose is to provide a secure mounting system that can serve as an electrical connector for video accessories.

If you own the older Sony flash units, you need not run out and purchase a new external flash unit. Instead, you can attach it to the a7/a7R hot shoe with the aid of a simple, inexpensive adapter (described later in the New and Old Sony Flashes side bar).

10

Principles of Electronic Flash

An electronic flash uses a small tube filled with xenon gas. There are two things to consider when using this light source. First, when the flash fires, it generates a short burst of intense light (1/1000 second or less). It controls exposure not by varying the light intensity, but by varying how long the light lasts. The light's color approximates daylight; however, its color temperature is a bit cooler. So, if you use the preset WB Daylight value, you will record an image with a slight bluish tinge. Using AWB or presetting WB to an electronic flash value will impart a warmer tone to the picture and produce skin tones of a more pleasing color.

The second thing to consider is that maximum light output is at 1/1000 second and diminished light output is achieved by reducing the duration of the flash. This is important to realize because it is only at relatively slow camera shutter speeds that the entire surface of the sensor is able to receive light. For the a7R this is at 1/160 second and for the a7 this is at 1/250 second. When the shutter speed is shorter than these values, only a fraction of the sensor's surface is available to receive light. Using the a7 as an example, if you use a 1/500 second shutter speed, only 50% of the sensor can receive light. If you use 1/1000 second, only 25% of the sensor can receive light. Essentially, the shutter can be viewed as a rapidly moving slit passing over the surface of the sensor and the width of the open slit becomes progressively narrow at faster shutter speeds. This works well when light is continuously available during the course of exposure, but this is not the case for an electronic flash where the light duration is, at its longest, 1/1000 second. Using the a7 with a shutter speed of 1/1000 second as an example, only 25% of the sensor can receive the light from the flash—making this the best-case scenario when the flash output is at its (longest) maximum. To record a picture that is wholly lighted, you must use a shutter speed that dispenses with the slit. Again, this occurs at shutter speeds of longer duration than 1/160 second (a7R) or 1/250 second (a7).

Sony engineers are rather conservative in their design, and when you attach a Sony flash to the camera's shoe, the default shutter speed is set to 1/60 second. If you use the S or M mode, you can use a shutter speed of a shorter duration, but you cannot use a shutter speed faster than 1/160 second for the a7R, or 1/250 second for the a7, because the flash will only illuminate a fraction of the sensor's surface.

Flash exposure is calculated by having the flash first fire a constant, low-intensity light (pre-flash). When this light is reflected from the subject, the camera sensor reads it to calculate how much light is needed for a correct exposure. From this, the camera calculates the duration of the main flash. This technique is called Pre-flash TTL (Through The Lens). It assures accurate exposure since the exposure is based on measurements taken at the level of the sensor. This takes into account what lens is used, what f-stop is set, and what filter is placed over the lens.

New and Old Sony Flashes

At the time of the release of the SLT-a99, Sony changed the flash mounting shoe of their cameras and revamped their line of attachable flashes. For the a7/a7R, the new units are: HVL-F20M, HVL-F43M, and the HVL-60M. They replaced the HVL-F20AM, the HVL-F43AM, and the HVL-58AM. Note that the presence of the letter "A" distinguishes the older model numbers from the newer. This can be a source of confusion and frustration since you cannot mount these "A" flash units on the a7/a7R's hot shoe. A solution to this problem is to buy the ADP-MAA adapter that slips on the "A" unit, allowing you to attach it to the a7/a7R. Owners of the older Sony flash units can save themselves the expense of a new flash by getting this $25 accessory. If you don't already have an older flash unit, they may be found at a nice discount as discontinued items. Just make sure you have the ADP-MAA adapter.

As an additional note, there is practically no difference in the performance or functionality of the newer flash models compared to the older models. We have the HVL-F20AM unit and use it with the adapter and have not found any reason to buy its replacement model.

Estimating Exposure Using GN

Because of the popularity of automated electronic flashes, many of today's photographers are unfamiliar with the term *guide number* (GN). This describes the power of a flash and can be used to calculate what lens opening should be set when you know the distance between the flash and the subject. For example, take the flash's GN (provided by the flash manufacturer) and divide it by the distance between the subject and the flash. This gives you the f-stop to use to obtain the correct exposure.

Two factors should be noted. The first is ISO. If unstated, it is assumed to be 100; a higher ISO will raise the GN. The second is the units used to measure the distance from the camera to the subject. Sony assumes that the distance between flash and camera is measured in meters.

Figure 10-2a: External flash that can be attached to the hot shoe

10

Figure 10-2b: Large external flash that can be attached to the hot shoe

For example, the Sony flash rated at GN 60 is based on using an ISO of 100 and a distance expressed in meters.

The GN numbers provide important information on performance abilities of the different flash units. Sony sells a small compact unit, the HVL-F20M with a GN of 20 (figure 10-2a). Sony has two other units that are larger and more expensive, the HVL-F43M with a GN of 43 and the HVL-F60M (figure 10-2b) with a GN of 60.

Flash Artifact: Red Eye

Sometimes when you use a flash attached to the camera to illuminate a face, you may record an unflattering portrait. The person may appear to be demonically possessed because their pupils are glowing bright red. To reduce this red-eye artifact, use the following command:

MENU>Camera Settings (2)>Red Eye Reduction>[On], [Off]

This command needs a bit of background explanation. The camera's flash sends out light, and if a person—or an animal—is looking directly at the lens, the light will enter the eye, pass through the retina, and be reflected back to the camera's lens, and finally onto the sensor. Since the human retina has a dense vascular network, the blood absorbs green light and the light reflecting from the back of the eye is red. If the camera lens captures this light, the photograph displays the pupils as glowing red orbs. As an aside, cats and dogs have a reflective layer behind their retinas, causing their eyes to glow yellow or green rather than red. This is significant for pet photographers because some post-processing software may fail to take the glow out of pets' eyes.

When the Red Eye Reduction command is set to [On], the camera's flash sends out several bursts of light prior to the main flash. Theoretically, this is to make the subject's pupils constrict, reducing the chance that light from the flash will enter the eyes and be reflected directly back to the camera. This command has three

10

flaws. First, it is not foolproof, and you can still have pictures with glowing red eyes. Second, the bursts of light can annoy subjects so that they blink or squint, ruining the shot. Third, the delay imposed by using these flashes can cause you to miss the image you really wanted to capture. For this reason, we recommend that you keep this command [Off]. Fortunately, this is the default setting for the camera.

Alternate Ways of Reducing Red Eye

If you want to avoid red eye, here are three useful strategies. The first is to position the flash away from the camera's lens, reducing the chance that light entering the subject's eye will be reflected back into the lens. You are limited on how far away you can position the flash when using a shoe-mounted flash. The second strategy is to constrict the subject's pupils by increasing the ambient lighting. If you are indoors, turn up the lights. The third strategy is to have the subject look at a point to the right or left of the camera, thus reducing the chance that reflected light from the eyes will enter the camera lens.

Flash Command

You control the flash through the Flash Mode command, the Quick Navi screen, or the Fn screen. This command has a total of six options and not all of them are available in each of the shooting or drive modes.

MENU>Camera Settings (2)>Flash Mode

 Flash Off

This option is disabled in P, A, S, or M mode. An attached flash that is turned on and fully charged will always fire in those modes. If you do not want the flash active, simply remove it from the hot shoe or turn it off. This option to turn an active flash unit off is only available in Intelligent Auto, Superior Auto, and the following SCN predefined modes: Portrait, Landscape, Macro, Sports Action, and Sunset.

Autoflash

This option allows the camera to decide when the flash is needed, and is enabled only in Intelligent Auto, Superior Auto, and the following SCN predefined modes: Portrait, Macro, and Sports Action.

Fill-flash

When this option is selected, the flash always fires, providing light to the subject. The option is used in P, A, S, and M when the flash unit is switched to on. It is also available in Intelligent Auto, Superior Auto, and the following SCN predefined modes: Portrait, Landscape, Macro, Sports Action, and Sunset.

10

⚡ Slow Sync.

This sets the shutter speed to be longer (slower) than 1/60 second. The flash goes off and the camera's shutter is kept open so that the sensor can capture the background that is illuminated by ambient lighting while the flash illuminates subjects close to the camera. This option is only available in P, A, S, and M modes.

⚡ Rear Sync.

Use this option with a slow shutter speed. The flash fires at the end of the camera's shutter cycle. If the subject moves during the exposure, the flash records the subject in its latest position. If there is enough ambient light, the subject's displacement is also captured as a blur while the shutter is open but before the flash is fired. This option is only available in P, A, S, and M modes.

⚡ Wireless

This option requires two Sony external flash units. One serves as the slave and is the primary light source when it receives a wireless signal for firing. The second flash unit, called the master, attaches to the camera's hot shoe and generates the signal that fires the slave. This option is only available in P, A, S, and M modes.

Using Flash in Intelligent Auto and Superior Auto

Only the first three Flash Mode options, [Flash Off], [Autoflash], and [Fill-flash], are available in Intelligent Auto and Superior Auto. These commands are pretty straightforward. The [Flash Off] option ensures that the flash will not fire, and [Autoflash] lets the camera decide whether it should use flash. This option introduces a degree of uncertainty in your shooting since you do not know whether or not the flash will fire. The camera makes that decision for you. [Fill-flash] makes the flash fire all the time. All three commands assume that an external flash has been attached to the camera.

What You Can Do With Flash in Intelligent Auto and Superior Auto

The [Autoflash] option is for people who are interested in using the camera as a point-and-shoot recorder. You might expect the camera to fire the flash only if the light is too dim, but this is not the case. The flash can fire during daylight if the camera determines that there is too much variation in the lighting between the subject and the background. For example, it may fire when you are trying to take a picture of a person sitting in front of a window with outdoor light coming through; in other words, it will fire under backlighting conditions where the subject is rendered as a silhouette (figure 10-3a) to illuminate the subject with enough light to balance

10

the light coming through the window. Thus, you can record both the subject and the scene outside the window (figure 10-3b).

The [Flash Off] command is a safety command; it ensures the flash won't fire even if the flash unit is attached. [Fill-flash] will always fire an attached external flash—even in daylight. It serves to reduce the shadows when shooting at objects that are relatively close to the photographer. We have noticed many outdoor portraits in which the faces are hidden by the shadows cast by the brim of the subjects' hats. Photographers often pose the face against a bright blue sky, but this causes the camera to underexpose the face. This can be remedied easily by attaching the flash and using [Fill-flash] to illuminate the subject's face, which balances the sky's bright illumination.

Figure 10-3a: An imbalance between foreground and background lighting renders the lamp as a silhouette

Figure 10-3b: The [Fill-flash] option illuminates the lamp so it does not appear as a silhouette

What You Can't Do With Flash in Intelligent Auto and Superior Auto

As you take more pictures, you will realize that you are constrained by your lack of exposure control. First, when the flash is used for dim interior shots, the lens will be at its largest aperture. Under these conditions, the camera first tries to brighten the recorded image by opening the lens aperture, raising the ISO, and setting the shutter speed to 1/60 second. This is a disadvantage if you want to capture a detailed view of people scattered throughout a room. Since the lens is wide open, the depth of field is narrow, causing many of the people to be recorded indistinctly. To record all the people sharply, you need to close down the lens aperture; however, this can't be done in either Intelligent or Superior Auto.

Second, you may notice that when the flash fires in response to high-contrast lighting conditions (such as a subject in front of a window, described earlier), the foreground may not be exposed the way you like. The flash may cause the subject

10

to appear too light; you may decide that reduced flash illumination would be more flattering. Unfortunately, you can't control the flash intensity in either Intelligent or Superior Auto.

Under these situations, you will have to take greater control by moving away from Intelligent Auto or Superior Auto and use the camera in the P, A, S, or M modes.

Flash Options in P, A, S, or M Modes

When you switch over to P, A, S, or M mode, your flash is under your control. The Flash Mode's [Autoflash] and [Flash Off] options are grayed out. Operationally, the [Flash Off] option is still available by the simple expedient of turning off the external flash. When you turn on the flash, it will always fire and you will see the icon for [Fill-flash]. In daylight, the flash operates as a fill light and supplements ambient illumination, ensuring that shadows receive additional lighting from the camera. Thus, shadows are recorded not as impenetrable black areas, but as regions that are illuminated to reveal their details. When in dark conditions, the flash serves as the primary light source.

The benefit of using P, A, S, or M modes is that you can adjust the amount of light the flash discharges with the Quick Navi or the Fn screen. You can also adjust it via the menu command below, although it is more inconvenient:

MENU>Camera Settings (2)>Flash Comp.>[n]

The above command allows you to control how dark or how light you want the shadows to appear when using the camera as a fill light. You can use the rim of the control wheel to dial in a flash exposure in a range of −3.0 to +3.0 EV, where the increments are graded in 0.3 EV units (one-third f-stops). No flash compensation is applied when setting the command to 0.0 EV.

This command differs from exposure compensation in that it adjusts the exposure for just the flash. In other words, the Flash Comp. command alters the ratio of light between the flash and the ambient light. This option helps you control how dark you want your shadows to appear in the overall scene. In contrast, exposure compensation keeps the ratio between the light from the flash output and the ambient light constant, so varying this will make the overall picture lighter or darker.

We prefer adjusting the flash compensation using the Fn button. It is a simple matter to dial in your compensation for the flash command using this method. If you need to adjust the overall exposure, you can do so with the exposure compensation dial.

10

Rear Sync., Slow Sync., and Wireless

There are three additional Flash Mode options available in P, A, S, or M modes: [Rear Sync.], [Slow Sync.], and [Wireless]. The menu command for accessing these options is listed below.

MENU>Camera Settings (2)>Flash Mode>[Rear Sync.], [Slow Sync.], [Wireless]

The [Rear Sync.] option is used for special effects. It coordinates the firing of the flash to the movement of the camera's internal shutter. Normally the flash is timed to fire at the beginning of the camera's shutter, but you can synchronize the flash to fire at the end of the shutter movement. You use this feature to enhance the impression of motion. When Flash Mode is set to [Rear Sync.], it is generally used with a slow shutter speed, so a forward-moving car is recorded as an elongated blur. When the flash fires at the end of the exposure, the flash freezes the image of the car. Because the shutter was open while the car was moving forward, the car has a blurred trail behind it. The viewer interprets the car as having moved at such a high velocity that it left a blurred streak behind it. You'll have the opposite effect if you try a long exposure with the flash firing at the beginning of the exposure. In this case, the car would appear with the streak in front of it, creating the impression it is moving rapidly in reverse.

[Slow Sync.] is used when you want the flash to illuminate a foreground subject, but you also wish to record a background object that is far enough away that the flash cannot illuminate it. Normally, when the camera is set to 1/60 second and you are shooting a subject positioned in front of you, the camera will record the subject and not consider the background. This is why many flash shots have the subject brightly illuminated against a black background. But suppose there is something in the distant background that you also want to record. If you set [Slow Sync.], the camera will try to use a long shutter speed (slow sync.) to capture the dim background scene. The camera may use a shutter speed as long as a couple of seconds. When the camera is fired under these conditions, the flash will illuminate the subject and the available ambient light will illuminate the background object.

The [Wireless] option allows you to fire an external flash unit that is not physically attached to the camera. It gives you access to all kinds of different lighting scenarios that would not be available to you if the flash unit had to be physically tethered to the camera. This option is grayed out unless you have a Sony external flash attached with wireless capability. We will discuss this in more detail later in the chapter.

A very useful trick to adjust your flash quickly without having to dive into the menus is to set the data display format to [For viewfinder]. From here, press the Fn button to enter into the Quick Navi screen and find the Flash Mode icon.

10

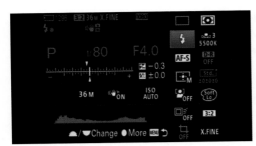

Figure 10-4a: Highlighted Flash Mode command in the [For viewfinder] data display format

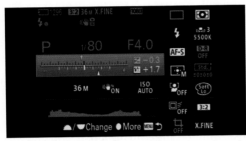

Figure 10-4b: Flash exposure compensation selected

Figure 10-4c: Altering flash exposure for +1.7 EV

Figure 10-4a shows it with the Fill-flash option selected. The orange dot indicates whether the flash is fully or partially charged. Fully charged is indicated by a steadily glowing dot, partially charged is indicated by a blinking orange dot (this means the flash is still charging). Press the center button to display the Flash Mode options.

The Quick Navi screen has two exposure bars in the middle-left side of the screen. The top is the exposure compensation bar. The bottom is the flash compensation bar. To alter flash exposure, highlight the bottom bar. This allows you to vary the flash output (figure 10-4b). In the camera's default configuration, you can also adjust the flash exposure compensation by using the FN button. Figure 10-4c shows the adjustment screen with a +1.7 EV compensation being applied.

Setting up Sony Wireless Flash

To take advantage of the flash mode's wireless option, you will need a Sony accessory flash capable of generating a wireless signal and another unit to receive the signal. You will then have to use the following command:

MENU>Camera Settings (2)>Flash Mode>[Wireless]

This option enables you to fire a flash remotely. It requires that you attach a flash with wireless capability (master) to signal and fire your external accessory flash (slave). A flash that serves well as a master is the small, lightweight HVL-F20M or the older model, HVL-F20AM. The first step involves pairing the the master and

slave flash units so they can communicate with each other. You can do this with the following sequence of steps:

1. Take the flash to be used as a slave and mount it on the camera's accessory shoe.
2. Turn both the external flash unit and the camera on.
3. Set the mode dial to P, A, S, or M.
4. Use the menu to get to the Flash Mode command and select [Wireless]. Press the center button. Note: You can also use the Quick Navi or Fn screen. This tells the slave flash that it will be used as a Wireless unit.
5. Remove the slave flash unit. You should see a red light slowly blinking on the unit, indicating that the flash is ready to be used as a slave.
6. Attach the master flash to the hot shoe. Turn it on. This gives the a7/a7R wireless capability.
7. Press the AEL button. The master flash will emit a small burst of light. In response, the slave flash will fire a burst of light to confirm that the two flash units are communicating.

After you complete this operation, you can reposition your accessory flash (slave) for better flash lighting. Just make sure it can see the light from the master flash. This light can be reflected from a surface, so the slave unit need not be pointed at the camera. It takes surprisingly little light to activate the signal, and it can operate from light reflected off the subject. Once you have placed the slave flash unit, check again to see if the communication link is still active by pressing the AEL button.

Note: if after Step 5 the red light on the slave unit is not slowly blinking, then there was a failure to communicate information from the camera body to the flash unit. Execute a quick check to see if this is due to an incorrect setting on the flash unit by doing a flash reset and restore it to its default values. For example, in the case of the HVL-F43M, this requires removing the flash from the camera and pressing two buttons (Mode and the TTL/M buttons) simultaneously on the back of the flash unit for four seconds. This will reset the flash to its default values. You will then try to reinitiate the settings by returning to step 1.

The advantage of the [Wireless] option is that the external flash does not need to be connected to the camera body so you can position it in a variety of places. For example, you may notice that some photographers have brackets for holding the flash unit away from the camera body. You can use such devices to ensure that the light is flattering and reduce the chances of red eye. Or you can put your Sony external flash unit on a supplied pedestal and position it well away from the camera body.

One trick we use at family gatherings is to mount the slave flash on its pedestal, place it on a strategically located table, and aim it at the ceiling. We then use the wireless option to fire the flash for our group shots. The lighting can be very

10

flattering, and you can move about as you fire the camera. The most convenient flash setup is to use the small, lightweight HVL-F20M as the master flash positioned on your hot shoe. You can then use the heavier HVL-F43M or HVL-F60M as the slave flash, so you can use the power of these units without having to carry their weight on your camera.

Controlling Lens Aperture While Working with Flash

There are two shooting modes for closing down the aperture when using flash: A and M. Table 10-1 lists the active shutter speed and aperture controls when you take the camera out of either the Intelligent or Superior Auto mode.

Mode	Shutter Speed	Aperture
P	1/60 second	Maximum aperture
A	1/60 second	User-defined aperture
S	User defined from 1/160 (a7R) or 1/250 second (a7) or longer	Maximum aperture
M	User defined from 1/160 second or longer	User-defined aperture

Table 10-1: Shutter speed and aperture in P, A, S, and M modes

When using the different shooting modes, you should be aware that the camera was designed to keep the lens aperture to its maximum opening and attempt to use a shutter speed of 1/60 second. This is most obvious in P mode, where Program Shift does not work and you cannot change the shutter speed. To exert full control over shutter speed and aperture, you should select M mode. M mode allows you to use a camera shutter speed faster than 1/60 second, and you can use smaller lens apertures. This is critical because it increases your ability to use the flash outdoors as a fill light.

Recall that the camera's normal ISO is 100. For a sunny day, the base exposure is 1/60 second at f/22. But suppose you want less depth of field and an aperture of f/16. You cannot do this in Intelligent Auto, Superior Auto, or P modes because the shutter speed is locked at 1/60 second. Nor can you accomplish this in S mode because while you can get a minimum of 1/160 (a7R) or 1/250 second (a7) shutter speed, you cannot change the aperture. The A mode allows you to vary the aperture but it keeps the shutter speed locked at 1/60 second. The solution is to use M mode and switch the lens aperture to f/16 and the shutter speed to 1/160 second. Remember, this does not prevent you from using slower shutter speeds. Indeed, not only can you still take flash exposures at 1/60 second, but you can also use longer shutter speeds, such as a full second!

10

This higher flash synchronization speed gives you greater flexibility when you use your flash in daylight as a fill flash; it increases the potential range of your flash unit. As mentioned in the section on GN, the primary determinants for flash exposure are the distance from the camera to the subject and the lens opening for a given ISO. With a higher synchronization speed, you can open your lens aperture by 1 1/3 f-stops for ambient lighting. Using a larger aperture increases the range of your flash.

HSS—High Speed Synchronization

One of the features of the Sony HVL-F43M and HVL-60M flash units is that you can use camera shutter speeds faster than 1/160 second (a7R) or 1/250 second (a7). This is accomplished by setting the flash to HSS mode, which allows it to send a pulse of light that lasts as long as the shutter slit is moving across the sensor's surface. Instead of having a short, brief flash, you have a longer flash of lesser intensity. Since the instructions for performing this operation differ between the two flash models, we will not detail how to set them here. Please refer to your flash manual.

HSS is a useful feature for the [Fill-flash] option. It you are outdoors and you wish to use a larger aperture on your lens to provide a narrower depth of field, you can open your lens aperture and shorten the shutter speed duration so ambient lighting properly exposes your subject. The flash can be fired to lighten the harsh shadows that may result from outdoor lighting.

Viewfinder Brightness: A Note for Studio Photographers

While using the flash, when you close the aperture from its maximum opening, you might notice that the display screen becomes darker. This usually occurs when adjusting the aperture and shutter speed in M mode and working in a dark interior where the flash provides the majority of the light for exposure. This is due to the design of the electronic display, which shows you how the image will be recorded when using ambient light. The camera is not designed to show how the scene will appear when using an electronic flash, whose intensity is much greater than the surrounding light. Under these conditions, the darkening of the display screen can make it difficult to use for composition. This disadvantage is present in all the Sony electronic viewfinder cameras. The remedy is to keep the viewfinder and LCD screen at a constant brightness so that their intensity does not reflect over or underexposure. To accomplish this, use the following menu command:

MENU>Custom Settings (2)>Live View Display>[Setting Effect ON], [Setting Effect OFF]

10

The default for this command is [Setting Effect ON], which allows you to see the effects of exposure compensation and the colorization imposed by selecting either a Picture Effect or Creative Style option. Conversely, when you turn this to [Setting Effect OFF], the screen will not show the exposure or colorization changes. Instead, the screen will have a constant brightness no matter what exposure compensation is applied; or in the case of M mode, it keeps the screen at a constant brightness no matter what you set your shutter speed or aperture to. This means that in low lighting settings you will still be able to clearly see your subject even though the camera won't be able to record it unless more light is added. The disadvantage in using this setting is that the altered color recording modes and special enhancement effects of Creative Style and Picture Effect will not be shown. However, if you are using your camera only for flash photography, this is an incredibly useful command—one that studio photographers should have in their repertoire.

Sony Accessory Flash Units

Sony sells accessory (external) flash units for their cameras. The largest and most powerful unit, the HVL-F60M, is a fantastic unit and well matched to Sony's larger SLT-a99 or SLT-a77 camera; however, its size, weight, and cost are, in our opinion, too much for direct mounting on the a7/a7R camera. A more economical and ergonomic solution is to use the smaller flashes: HVL-F43M and HVL-F20M. The older equivalent units, the HVL-F43AM and HVL-F20AM, are also good; however, they are not sold new and will not fit directly on your a7/a7R. They will require a simple accessory, the ADP-MAA adapter. This accessory is secured to the a7/a7R hot shoe and will accept the discontinued flashes. Table 10-2 summarizes the current models and their pricing.

Flash Model	GN	Zoom Head	Max Wide Angle with Diffuser	Weight in Ozs.	Bounce Capable	Power	Price (Sony Store)
HVL-F20M	20	No zoom	27mm	3.2	Yes	2 AAA	$148
HVL-F43M	43	Yes: 24–105mm	15mm	12	Yes	4 AA	$348
HVL-F60M	60	Yes: 24–105mm	15mm	15.6	Yes	4 AA	$548

Table 10-2: Sony a7 and a7R external flash units

As you can see, there is a flash for most everyone, ranging from the family photographer who needs a bit more power for interior shots to the professional who needs to work with a unit that provides considerably more light. All of the flash units have their own internal power source—either AA or AAA batteries.

Focal Length and Variations in Flash Head Focal Length

Sony's HVL-F43M and HVL-F60M flash units have a zoom lens system for focusing their light onto a smaller area when you use a moderate telephoto setting. This elegant system tells the flash head what zoom is set on your lens. As you zoom in or out with your lens, you can hear a motor within the flash unit drive its lens system. This is all done automatically. Essentially, when you use a telephoto setting, it provides a more efficient use of the flash, matching its light distribution to the coverage of the lens.

A nice feature of the Sony accessory flash units is that they use inexpensive batteries that can be purchased at the corner drugstore. However, we would be remiss if we didn't talk about the charge cycle time of these units. Typically, when the flash is used in an automatic mode for relatively short distances, it fires a very brief burst of light that is much shorter than the maximum duration. Such a short burst doesn't use much battery power, and the capacitor recharges very rapidly. Rather than fire the flash at full power every time, the flash conserves the unused energy and uses it for the next flash. Instead of having to fully recharge, it only needs to partially recharge to reach full capacity.

When you use the flash in a large room and it fires at maximum duration, you will note that the charge cycle time increases. You can check this on the camera's display screen, where you will see an orange circle. If it is flashing, it means the flash is recharging and it cannot be fired. As you drain the batteries, the recharge time becomes progressively longer. This is especially noticeable if you use disposable alkaline batteries.

However, there are situations when you need the flash to recycle quickly at all times so that you can fire the next shot as quickly as possible. For this, you might consider using rechargeable nickel metal hydride batteries. These batteries have a lower internal resistance and reduce the recharge time between flashes. Since the batteries can be recharged, they can be an economical choice if you do a lot of flash photography. If they have any disadvantage, it is that they do not hold as much energy as alkaline batteries.

We always carry the HVL-F20AM flash when we use the a7/a7R. It was Sony's smallest and least expensive external flash. It has been discontinued, but the HVL-F20M model is equivalent. Both are compact and lightweight, balance nicely on the a7/a7R body, and are easy to store in your camera bag. If you get the HVL-F20M, you will not need the flash shoe adaptor because the unit is designed to fit directly

10

on the a7/a7R's hot shoe. With both the older and newer models, you can aim the flash at the subject or adjust the head so it fires a beam at a 75-degree angle toward the ceiling. This provides bounce lighting, which tends to produce a more flattering portrait because the diffuse lighting hides wrinkles. Both models have the benefit of making your a7/a7R capable of wireless operation. The disadvantage of these units is their low-intensity flash—about one-third to half the power of Sony's more expensive units.

Although they are huge and look oversized when mounted on the a7/a7R, we also use the two more expensive units—the HVL-F43M and the HVL-F60M. Their larger size is justified by their greater power: they give us more range and are especially appropriate for bounce lighting. If we use the GN as a rough approximation of maximum distance, the HVL-F43M provides a 2.5x range increase, and the HVL-F60M provides a 3x range increase above that provided by the HVL-F20M. By swiveling and turning the head, HVL-F43M and HVL-F60M can aim their light toward the ceiling, whether the camera is held vertically for a portrait or horizontally for a landscape composition. In either case, light reflected down from the ceiling onto the subject creates soft light without deep shadows. Sony's clever design ensures that their flash units provide the most efficient coverage for bounce lighting if you hold your camera vertically for portrait orientation. Just be aware that depending on how you position the camera and the flash unit, some configurations may create an uncomfortably tight fit for your fingers when you press the shutter button.

Both the HVL-F43M and the HVL-F60M have a motorized lens system to distribute their light so it matches the focal length of your lens. This system works with Sony lenses, however it will not work with most legacy lenses. In this situation, you can set the lens system of the flash manually. The commands for doing so depend on the model of your flash unit, and you will need to check its instruction manual to match its settings to that of the focal length of your lens. This ensures that when you aim the flash directly at your subject, it provides efficient coverage and increases the maximum range of the flash beyond what is expected when using the GN number.

Of the bigger flash units, we found that the HVL-F43M is best suited for our needs. It provides sufficient power for our applications and is not as heavy as the HVL-F60M, nor does it cost as much. If you own the older flash, which has the "A" in its model number, you may wish to upgrade if you do a lot of movie work. The two current models have LED lights to illuminate the subject for movie recording.

10

Bounce or Indirect Lighting: Flash Accessories

One of the benefits of an accessory flash with a tilting and rotating head is the ability to use bounce flash. When the flash is aimed directly at your subject, the light can be unflattering, displaying facial wrinkles and misplaced strands of hair with distressing clarity (figure 10-5a).

Figure 10-5a: Dog photographed with direct flash

One simple strategy for reducing this effect is to swivel the flash head and aim it at a ceiling or an adjacent wall. The light will bounce from these areas and it will become more diffused by the time it reaches the subject. As a result, the light is softer, and masks wrinkles and deemphasizes individual strands of hair to produce a more pleasing image. In figure 10-5b, the diffused light softens the dog's appearance.

Figure 10-5b: Dog photographed with bounce flash

One reason to use the HVL-F43M instead of the inexpensive Sony HVL-F20M flash unit is that sometimes you need more power output for bounced light. Although the light from the Sony HVL-F20M flash unit can be tilted up at a fixed 75-degree angle, the light will be insufficient when we need to stop down the lens. The higher output of the HVL-F43M flash unit allows considerable flexibility in closing down the aperture if we so desire.

One caveat to using a bounce flash is that if you have the camera set for Red Eye Reduction, the flash will emit small bursts of light prior to the main flash for exposure. This is not needed, so make sure you turn the Red Eye Reduction command to [Off] to make your camera fire quickly so you can record the picture without delay.

If you use external flashes for much of your photography, you will want additional ways of diffusing the light. Although we like to bounce the light, it is not always possible. For example, if the ceiling or walls are heavily colored, they will impart their color to the reflected light and destroy the WB. One helpful accessory is a little plastic diffuser. Sto-Fen makes the Omni-Bounce that attaches directly to the front of the Sony flash head. It is fitted by friction, which is advantageous

10

since you don't need to tape it onto the flash head. The device is small enough that you can keep it in your camera bag.

There is no substitute for using large reflectors or diffusers, but they can be cumbersome and expensive accessories. If you wish to experiment, you can assemble your own for pennies. The following website has several tutorials for assembling your own flash accessories:

www.digital-photography-school.com/ diy-flash-and-lighting-hacks-for-digital-photographers

There are also several books that cover this topic. Check out *Low Budget Shooting: Do It Yourself Solutions to Professional Photo Gear* by Cyrill Harnischmacher.

On occasion, we tilt our flash head vertically and attach a heavy sheet of white paper to it with tape. By folding the top of the sheet over the top of the flash head and arranging it so it directs the light forward onto the subject, it serves as an inexpensive reflector and diffuser that can be discarded as soon as the session is over.

Recommendations

Although the attached flash can be used in Intelligent Auto, Superior Auto, or SCN mode, we urge you to use it in P, A, S, or M mode. It is especially important to learn how to use the flash with the camera set to M mode. This allows you to adjust both the shutter speed and the aperture. Plus, you can dramatically increase the depth of field if you adopt this strategy. We like using our HVL-F20AM because it is small and light and balances well on the a7/a7R. If you do a lot of flash photography, you may consider getting a larger external flash unit. In our opinion, the HVL-F43M has an excellent set of features for its cost. If you use wireless flashes, a good combination is to use is the HVL-F20AM or the current HVL-F20M for the master flash and the HVL-F43M or HVL-F60M for a slave.

10

Chapter 11: Making Movies

Introduction

The Sony a7/a7R is a hybrid recorder capable of taking excellent still pictures and movies. As such, you do not have to carry both a camera and a camcorder on those assignments when you need to take movies as well as still photographs. To switch from taking still shots to shooting movies, press the movie button (figure 11-1). The movies are of excellent quality and can be played on HDTVs or recorded to DVD discs.

In this chapter, we introduce the movie operation of the Sony a7/a7R, and approach the topic at the level of a still photographer who occasionally needs to take a movie rather than a professional videographer who needs a dedicated camcorder. We will provide an explanation of file formats and the commands that are used to record movies.

The general rule to remember when taking movies is that the camera uses the settings that you last used for still photography. If you have set the shooting mode to Intelligent Auto, Superior Auto, P, A, S, or M, those setting modes are used for shooting the movie. When you set the camera to Intelligent or Superior Auto, your camera is a completely automatic camcorder and

Figure 11-1: Movie button

sets the ISO value, shutter speed, and WB for you. Fortunately, the automatic mode is so reliable that you will get great-looking movies. This may be all you need for recording family vacations.

Eventually, you will decide to take more control. By using the P, A, S, or M modes, you gain control of the shutter speed, aperture, ISO, and WB. In addition, you can modify the exposure—increasing it to brighten or dimming it to darken the image. This will create the desired mood for your movie. You can also tame extremes in brightness by using DRO, or you can introduce unique coloration by using the Creative Style or Picture Effect options.

One thing that may surprise you is the amount of preparation that is needed to take a high-quality movie. It is necessary to preplan the scene and spend time to ensure camera stability and correct lighting. Just like with still pictures, recording a good movie benefits from using a tripod and some careful planning. The placement of lights (and the shadows they produce) influences the quality of your

11

movie. If your framed image has areas that are extremely bright or dark, you may need to sacrifice details in either the highlights or the shadows. This is when you could use the DRO command to bring out shadow detail. Consider the mood you intend to create. For example, dark shadows can add an ominous feeling to a clip. You may wish to underexpose this sequence and use the Creative Style's [Black & White] option to make a film noir.

As popularized in some professionally made movies, there is a technique of shooting handheld movies where the videographer rapidly shifts position to provide diverse vantage points. The subject appears to bounce and jitter about within the frame, providing a powerful effect of tension-filled action. However, this technique is unsuitable for most tasks. It would not be used for recording a documentary movie and it would detract from recording a family birthday party. Such recordings benefit from having a stable camera platform which keeps the subject centered within the frame. If the subject moves, say walking outdoors, you should aim your camera and follow the subject so it stays centered within the frame of the picture. You will be disappointed in your results if you do not mount your camera on a tripod, because hand tremors will make your subject appear to jitter about within the borders of the screen, which can be distracting to your audience.

Preplanning is important because there is little opportunity for correcting errors in the final movie. Unlike still photography, where you have some latitude in adjusting your pictures with post-processing, you do not have such luxury when shooting movies.

Frame Rate versus Shutter Speed

To introduce still photographers to movies, we compiled table 11-1 to define many of the terms we use. You can refer to this table while reading the chapter.

Term	Description
Aspect ratio	Describes the dimension of the image, expressed as a ratio of width to height. For example, 16:9 represents a 1.78:1 width to height ratio.
AVCHD	Advanced Video Coding High Definition. This is a file format for recording and saving high-definition videos. It provides a high degree of data compression and is typically not edited in its native format. Instead, the file is translated, or transcoded, before it is edited.
Bit rate	The rate that data is being processed per unit of time.
Frame rate	Defines the number of still pictures (frames) recorded per unit of time. It is generally expressed as frames/second or fps.

11

Term	Description
Interlaced scanning	A method for capturing or projecting images by creating two fields per frame. Together, the two fields contain the full number of lines for the frame; individually, each field captures only half the number of lines. To view the complete image, the two fields are integrated. At a rate of 30 frames per second (fps), interlaced scanning actually captures 60 fields per second.
Mbps	The rate of information being processed expressed as megabits per second. This is a measure of data content. Higher-quality videos will be recorded at higher Mbps values.
MP4	A multimedia format based on the QuickTime file format for storing digital video files.
NTSC	National Television System Committee. This television and video standard is used in the United States and contains 525 vertical lines. For video, it is associated with collecting the images at approximately 30 fps.
PAL	Phase Alternating Line. This television standard is used in Europe and Asia. It delivers 625 vertical lines of resolution. For video, it is associated with collecting the images at 25 fps.
Progressive scanning	A frame that is captured in its entirety with a single scan.

Table 11-1: Movie-related terms

Recording movies requires a new perspective. You must always be conscious that you are taking a sequence of images (frames) that, when played back, give the viewer a prolonged interval to study the subject. Distractions that are of little importance in still images can be disturbing and annoying in a movie. We mentioned that the subject moving about the frame could be disconcerting; also annoying are sudden changes in the scene's brightness when the exposure compensation dial is rotated. Even the task of focusing the image can be disruptive.

NTSC and PAL

The number of frames per second depends on the camera's country of origin. The standard in the United States, NTSC, is 30 fps; the standard in Europe, Asia, and other countries, PAL, is 25 fps. As a matter of convenience, we use the NTSC standard. You don't have to be concerned with setting your camera to use either standard. The manufacturer does that for you.

Because you are capturing at a certain number of frames per second (fps), you must be cognizant of your shutter speed. You will be limited on how long it can be can set. If you are recording a sequence of shots at 30 fps, you cannot use long shutter speeds (such as 1 second). This limits your ability to work in low-light

11

situations. Occasionally, new videographers think that using a short shutter speed means that their frame rate goes up. This is not the case. You can set a shutter speed of 1/8000 second on your Sony, but the limit in frame rate cannot be higher than 60 frames per second.

The shutter speed you use for each frame can create different effects. When you shoot at 24 or 30 fps in modes where the camera sets the shutter speed, you will see that the camera attempts to keep the shutter speed at 1/30 second or 1/60 second (depending on the shooting mode), and it avoids shutter speeds shorter than 1/125 second. In part, this is done to provide the smoothest perception of motion. When you take control of the shutter speed in M or S mode, you may be surprised that you can set the shutter speed to as long as 1/4 second. This not only gives you better low-light capability with very slow moving subjects, but it also provides a special effect. A rapidly moving subject will be seen as a blur with a ghostly tail extending behind it. This longer shutter speed is a feature of digital sensors. In the days of film cinematography, the longest shutter speed you could use was 1/30 of a second.

There is a bit of image processing invoked when using longer shutter speeds. If there is no moving subject in the video frame, the slow shutter speed reduces the appearance of sensor noise so that smooth tones don't take on a punctate appearance. At the opposite extreme is using a fast shutter speed of 1/8000 second. When you play a movie recorded at this shutter speed at 30 fps, instead of smooth motion, the action appears to move in jumps, and has a strobe-like appearance. This effect is derived from having sharply defined edges recorded within each individual frame; because of this, the change in position of the edges in adjacent frames can be perceived. Since the movie is being displayed at 30 fps, a crisp edge exaggerates the fact that you are seeing a series of individual frames. This is one reason videographers recommend setting the shutter speed duration to twice the frame rate. The slight blurring that can occur during rapid motion helps the impression of smooth movement in the finished movie.

While this crisp rendering is disconcerting during playback of movement, it is desirable if you need to see all the details within a frame. For example, in surveillance work, it is advantageous for reading the numbers and letters off the license plate of a speeding car. For home movies where you want the movement of your subject to appear smooth and seamless between frames, the slower shutter speeds are preferred. For most videographers, a good starting place for setting your shutter speed is about 1/60 second if you are shooting at 30 fps, or 1/125 second if

you are shooting at 60 fps. This is a good compromise for providing both a sense of sharpness and smooth movement.

Choosing a File Format

Because the frame rate is important for what you will record, you have to decide whether you want to record at 24, 30, or 60 fps. Then, decide the file format you would like to use. There are two file formats available: AVCHD and MP4 (table 11-2).

File Format	Description
AVCHD	Provides the highest-quality movies. Can be viewed directly when the camera is coupled to a suitable HDTV. The PlayMemories Home program can translate the file so it can be burned to a disc and played and viewed on an HDTV. Needs to be transcoded to be edited.
MP4	A computer file type that works well on older, slower machines. This file type can easily be attached to emails or uploaded to websites. PlayMemories Home software cannot burn this file type to disc.

Table 11-2: Sony a7/a7R movie file formats

When you use AVCHD, you can record at either 24 or 60 fps. If you are using MP4, you will record at 30 fps. If you are new to recording movies, we recommend choosing AVCHD if you wish to view the movie at its highest resolution on your HDTV. You can, with the aid of your Sony PlayMemories Home software, create DVDs or Blu-ray Discs for playback on a suitable player. If you think you would like to use the movie for computer-related activities, such as attaching it to an email, record and save the file in MP4 format.

As you gain more experience, you may decide to use your computer to edit and work with AVCHD files. To get a feel for this, download your movies and work with them in the PlayMemories Home software. The Windows version of this program provides some limited movie-editing capabilities. You can shorten the movie by removing extraneous material and then merge the clips to make a coherent, succinct story. If you have an Apple computer, we recommend buying the iMovie program for working with your AVCHD files.

To select the movie's file format, use the following command:

MENU>Camera Settings (1)>File Format>[AVCHD], [MP4]

11

Keep in mind that the movie commands cannot be set via the Quick Navi screen or the Fn button. They must be changed using the menu.

At least two camera manufacturers recommend using AVCHD for directly viewing your movies on a TV or making playable DVDs for an HDTV. They do not recommend using this file format for editing. This suggestion is very conservative, so you may wish to ignore it if you want to edit your movie files. After all, Sony does provide PlayMemories Home, which can serve this purpose. However, for most computers, it is easier to work with the MP4 format . Essentially, this is a simple file type and is a sequential series of still images. Such a file can be simply copied to the hard disk of your computer and worked on with QuickTime Pro, which costs $29.95 and is available for both Apple and Windows operating systems. Like PlayMemories Home, QuickTime Pro provides an inexpensive way to edit movies. It includes options to cut, copy, and delete sections of a movie, and to merge the best sections of the movie to make a longer production with a coherent theme. Unlike PlayMemories Home, you have additional controls with QuickTime Pro, such as audio-video controls for adjusting the volume, balance, bass, and treble of the audio track, as well as the capability to adjust the brightness, color, contrast, and tint of the video stream. When the movie is edited to your satisfaction, you can resize the file to be emailed directly to your recipient for easy viewing.

AVCHD

AVCHD files provide the highest fidelity and smoothest perception of movement for your movie. However, they make greater demands on your computer and software. Although you can work with these files on older computers, newer computers with plenty of RAM and large, fast hard drives make working with these files a more enjoyable experience. If you decide to work with AVCHD files, you will eventually want to buy a more capable software package. We use Final Cut Pro X, which can read Sony's 60p 28 Mbps (megabits per second) files directly. At the time of writing this book, our more affordable software, iMovie '11, could also import this file type. We can edit our AVCHD files with either iMovie or PlayMemories Home (Windows). Both of these software packages are basic editors; PlayMemories Home comes free with your camera, and Apple users can download iMovie '11 for $15. If you decide to work with a higher-end movie editor, such as Final Cut Pro X or Adobe After Effects for Windows, you will have to pay considerably more: $300 and $240 (for a 1-year subscription), respectively.

11

MP4

The MP4 movie file format is the easiest one to work with, since it can generate data files that are easily read by other software programs. There are free programs available for opening and viewing MP4 files, such as Apple QuickTime. If you decide you want more power to edit your movies, you can buy QuickTime Pro from Apple for only $30 from the following website:

http://store.apple.com/us/product/D3381Z/A

The vertical number of pixels is the same for both MP4 and AVCHD, so if you choose MP4 format, you do not give up much in regards to resolution. What you do lose is some width in the image, which becomes a concern if you want to display the movie in a widescreen 16:9 format. Also, you have the option of saving MP4 files in a 640x480 pixel display, the smallest pixel array for saving your movies. This is an advantage if you intend to attach the movie file to an email. MP4 files are recorded at 30 fps.

Record Settings AVCHD (PS, FX, FH)

Several things determine the clarity of the movie playback: fps, bit rate, and format type. We have talked about the format type already (AVCHD or MP4). The Record Setting command determines the quality retained in these file types. Selecting the option for this is more complex because of the bewildering number of choices available, especially with AVCHD file format, where you have five possible Record Setting command options to choose from:

> MENU>Camera Settings (2)>Record Setting>[Command Option (see table 11-3 for the command's options)]

Here are some general guidelines to simplify the selection task:

- For editing AVCHD files on your computer, use the highest movie quality your software can read. Most likely this will either be 60p 28M or 60i 24M. If you are new to taking movies, make sure that your software can handle 60p before using this option.
- When burning a movie to a DVD, choose the lowest quality settings (24p 17M, 60i 17M). Use any Record Setting option that has the letters FH.
- For burning a movie to a Blu-ray Disc, choose the medium (60i 24M) to high (60p 28M or 24p 24M) quality settings. PlayMemories Home will allow you to burn these discs. Use any Record Setting option that has the letters PS or FS.
- For playing a movie back on an HDTV, find out what standard your TV uses and select the Record Setting option based on what the HDTV can accept.

11

AVCHD Record Settings		
Record Setting Value	Average Bit Rate	Movie Recording Size and fps
60i 24M(FX) / 50i 24M(FX)	24 Mbps	Records high-quality videos at 1920x1080 pixels and 60i/50i fps
60i 17M(FH) / 50i 17M(FH)	17 Mbps	Records standard-quality videos at 1920x1080 pixels and 60i/50i fps
60p 28M(PS) / 50p 28M(PS)	28 Mbps	Records highest-quality videos at 1920x1080 pixels and 60p/50p fps
24p 24M(FX) / 25p 24M(FX)	24 Mbps	Records high-quality videos at 1920x1080 pixels and 24p/25p fps
24p 17M(FH) / 25p 17M(FH)	17 Mbps	Records standard-quality videos at 1920x1080 pixels and 24p/25p fps

Table 11-3: AVCHD file recording settings

The number of bits being processed determines how finely the details are rendered. If there are too few, the movie will have unsatisfactory definition and detail.

MP4 Record Setting Command

When you select MP4 for your file format, you will have two Record Setting command options to choose from. The one you select depends on the number of pixels you wish to display (table 11-4).

MENU>Camera Settings (2)>Record Setting>[1440x1080 12M], [VGA 3M]

MP4 Record Settings		
Record Setting Value	Average Bit Rate	Movie Recording Size and fps
1440x1080 12M	12 Mbps	Records high-quality videos at 1440x1080 pixels and 30 fps
VGA 3M	3 Mbps	Records standard-quality videos at 640x480 pixels and 30 fps

Table 11-4: MP4 Record Setting options

The first option, [1440x1080 12M], is easy to understand; your pixel array will be 1440x1080 pixels. The second option, [VGA 3M], is a bit cryptic. The letters VGA refer to an old monitor resolution standard, Video Graphics Array, which had a 640x480 pixel array. VGA provides a much smaller movie frame and generates a small movie file that can be emailed.

11

Interlaced Scanning (i)

Due to technological limitations, older analog cameras and displays for broadcast television relied on forming an image by interlaced scanning. To display enough images sequentially for a smooth perception of movement, a television camera would use two fields to make a single frame. This strategy would allow the viewer to see an object moving smoothly across the screen. The interlaced scanning method is an option on many cameras, including the Sony a7/a7R.

With interlaced scanning, a recording device with a spatial resolution of 600 horizontal lines actually collects only 300 lines, which is considered a Field. Two fields are collected to make a frame. The first field starts with the top line and then collects every other line to create an image with 300 horizontal lines (figure 11-2). Then the sensor collects the remaining 300 lines

Field 1 Field 2 Frame

Figure 11-2: How an interlaced scan combines two fields to make one frame (from left to right: Field 1, Field 2, Frame)

for the second field. The two fields are combined to yield a single frame of 600 lines. In essence, to display a movie at 30 frames per second, a camera or television has to collect 60 fields per second—meaning two sets of 30 fields per second to be interlaced to form 30 frames per second.

If you see the letter "i" with an fps number in your viewfinder or on the LCD screen, it means interlaced scanning, indicating that two sets of fields were combined (interlaced) to form a single frame. If one of the two fields has a moving object, its edges will display an offset. This blurs the edges of the moving object, but due to how the human eye works, the motion will be perceived as smoother.

Progressive Scanning (p)

If you see the letter "p" with an fps number in your viewfinder or on the LCD screen, it stands for progressive scanning. Progressive scanning is the modern way of recording and playing back movies. All computers use this method to display images on their monitors. The newest video cameras, such as the Sony a7/a7R, also have the progressive scanning option.

11

This method is pretty straightforward. Basically, the movie camera and the display projector collect all the vertical lines of a frame in sequence and then display them all at once (figure 11-3). For a moving object, this provides a sharper display of its edges. If you had to deal with a single frame, that frame would provide the highest definition for regions that move from frame to frame. If you plan to image process your movies, this is the preferred movie type.

Frame 1　　Frame 2　　Frame 3

Figure 11-3: Progressive scanning format (from left to right: Frame 1, Frame 2, Frame 3)

Progressive scanning is considered the ultimate in image quality. However, it has one peculiarity. Because of the sharpness of the individual images, movement during playback may not be perceived to flow as smoothly as with interlaced scanning. This is most apparent when you record at 24 fps with a fast shutter speed. If you look at the shutter speeds used when you take movies in Intelligent Auto, you will see that the camera tries to keep the shutter speed duration longer than 1/125 second when shooting at 60 fps. This is to ensure smooth movement from frame to frame during playback. If you select a shutter speed of 1/1000 second, the motion appears strobe-like. However, a single frame of a movie captured with progressive scanning will show a subject with high definition in those parts that are moving.

So, should you use interlaced or progressive scanning? For video editing, it is tempting to simply use the highest quality mode. However, the slight blurring of moving edges with interlaced scanning helps hide the transition from frame to frame. The overall perception of movement looks better. In contrast, at the level of an individual frame, an image obtained with progressive scanning is sharper. For video editing, we suggest you opt for progressive scanning. If you are just viewing the movies and are not interested in using the freeze frame to study fine details, most people will be satisfied with interlaced scanning. Experiment with each and decide which you prefer.

Bit Rate and Frame Rate

AVCHD and MP4 files are highly compressed. The amount of data that is preserved is determined by the amount of data being processed—the more data being processed, the more fine detail is being preserved. In computing, the measure of data being processed is called bit rate (bits/second). In the case of a movie, so much information is processed that you need to express the data in terms of millions of bits per second, or Mbps (megabits per second). The Sony a7/a7R processes movies from 28 Mbps (highest quality) to 3 Mbps (lowest quality).

11

These data rates reflect the fact that movies are a sequential series of images recorded at different frame rates. AVCHD files recorded at the highest frame rate, 60 fps, generate the greatest amount of data and have the highest Mbps value.

So, which file format should you chose? There is no clear answer to this question, simply because it depends on what you plan to do with your movies. If you intend to view the files directly on your TV or make them into playable DVDs, then select AVCHD and use the highest recording quality your playback device will support. If you like to use the freeze frame and carefully study the details in the individual frame, then you should use the highest Mbps data. Also, the highest values are useful for video editing.

Remember, if you decide to use PlayMemories Home and burn your movies to a DVD, you must record at 24p 17 Mbps or 60i 17 Mbps. For recording to a Blu-ray Disc, you can take advantage of your camera's capabilities and record using the higher-quality record settings.

Putting It All Together

The File Format and Record Setting are two of the more complicated commands of the a7/a7R. Most of these options appear cryptic to a still photographer, but the selections can be summarized by their bit rates (table 11-3). The maximum quality is 28 Mbps, which is described as [60p 28M]. Refer to table 11-1: this translates into a format that is recording at 60 frames per second in progressive mode, with 28 megabits of data per second being recorded. You may wish to contrast [60p 28M] with the next highest resolution mode, [60i 24M]. The difference between these file formats can be subtle if your goal is to observe the movie stream on your television. The individual frames will have sharper edges on moving objects when they are taken in 60p. An interlaced scan blurs the edges of a moving object, as can be seen in this case of the shadow of a tree that was recorded while panning the scene (figure 11-4). Remember, "i" stands for interlaced scanning, where two fields are interlaced to form a single frame.

Figure 11-4: An artifact of interlaced scanning. The edges are blurred when the camera pans across a stationary object.

11

The 24p frame rate is referred to as cinematic because it is used in theatrical motion pictures. If your subjects were rapidly moving about—for example, at a sports event—we would not recommend this frame rate. You would get better results if you used 60p fps, which renders rapid motion more realistically by gathering more images. At 24p fps, you may find that the playback looks jittery. This may be even more apparent if you select a very short shutter speed, which freezes the subject's motion in the individual frame. However, for an artistic rendition of a scene, and to present a movie that looks like a Hollywood director created it, try 24p.

Additional Movie Controls

There are some additional controls available when you record movies. The first deals with recording sound with your movie. The default configuration for the microphones is [On]; you can turn them off with the command below. Since audio tracks can be removed later through editing, you can always capture the audio and then decide later whether or not to keep it.

MENU>Camera Settings (7)>Audio Recording>[On], [Off]

If you are recording on a windy day, the camera microphone can pick up the distracting sound of the wind. To reduce this annoyance, you can use a wind noise reduction feature with the following command:

MENU>Camera Settings (7)>Wind Noise Reduct.>[On], [Off]

We recommend selecting [Off] for the Wind Noise Reduct. command when you are recording indoors. Set it to [On] only when you shoot outdoors and there is noticeable wind noise. Otherwise you may cut down on the quality of your audio recording.

11

Finally, you have the ability to adjust the sound level of your movie. Depending on your data display format settings during still photography, you may have noticed two audio bars (figure 11-5). These reflect the input from two stereo microphones located within the camera body whose recording level can be adjusted with the Audio Rec Level command.

Figure 11-5: Audio levels in display screen

MENU>Camera Settings (7)>Audio Rec Level>[n]
(Where n is a value from 0 – 31)

Normally this command is only available under two conditions. The first is when you press the movie button. You can set the audio level while recording the movie. The second is when you turn the mode dial to Movie. When in this mode, the audio level can be adjusted prior to pressing the movie button. This is our preferred method of adjust-

Figure 11-6: Adjusting microphone audio.

ing the microphone. It is convenient and efficient to set your sound levels prior to recording the scene. When setting the sound level, watch the signal bars and try to set it so that the loudest sound extends the green bars to the 0 db (decibels) mark (figure11-6). We find it advantageous to dedicate a custom button to access this command.

11

> ### Improving Sound Recording of your Movie
>
> You can record sound directly with the a7 and a7R: both cameras have built in microphones. They will record voices and music in stereo and you may wonder how you can get the best audio quality. Our first advice is to buy either a pair of earphones or ear buds. These can be plugged into the headphone jack at the left side of the camera. With their aid, you can hear how the camera is recording sound while you are taking the movie. This will help you to set the microphone's sensitivity. It will enable you to judge the extent that wind noise interferes with your recording and it will help you to decide whether the wind noise reduction command improves your sound recording. In addition, you can monitor the noise generated by your lens focusing motor or the clicks resulting from turning your control dials. If accurate and clear sound is paramount, you may decide that you will need an external microphone. These will do a better job in recording sound and some of the units, such as the Sony stereo microphones (model ECM-XYS1M) are so compact that they will mount on the a7/a7R Multi Interface Shoe.

Framing and Starting the Movie

The Sony a7/a7R Live View is set at a 3:2 aspect ratio for still photography. When you press the movie button, the appearance of your display screen will change. The field of view becomes smaller, and your frame drops to a 16:9 aspect ratio. This can be disconcerting. In our earlier books on the Sony NEX-6 and NEX-7, we recommended using the small "tic" marks on the screen for framing the movie. We no longer recommend this since these marks are too small to assure accurate framing. Instead, we set the camera's mode dial to Movie. This provides an accurate preview screen with borders that delineate the edges of your movie frame clearly.

After you frame your scene, you can start recording with a single press of the movie button. The maximum length of a single recording session is 30 minutes. At first, the 30-minute clip may be viewed as a handicap. It really isn't. It is easy to get around this time limit by taking multiple clips, all lasting less than 30 minutes. The only limit for repeating this process is the capacity of your memory card. During post processing, you can link the separate clips together to make a movie that lasts for hours.

P, A, S, or M for Controlling Your Recording

When you shift from Intelligent Auto or Superior Auto to P, A, S, or M mode, you gain control of your aperture, shutter speed, ISO, WB, and exposure compensation settings. You can also give your movie a unique appearance by using the Creative Style or Picture Effect options.

11

There are two ways to select these modes. If you simply press the movie button, the movie will be taken in whichever shooting mode the mode dial is set to. Another way is to turn the mode dial to Movie. Then you can select the shooting mode icon by using the Fn button and dial in P, A, S, or M with the control wheel. We prefer doing it this way because it provides an accurate framing of our scene for taking a movie.

Basically, P (Program Priority) mode is fully automated, and the camera selects both the aperture and the shutter speed. If the camera is set on [ISO AUTO], you will see the same settings that you would expect had you set the camera to Intelligent or Superior Auto and then pressed the movie button. The primary difference is the greater control you will have over your camera. The A (Aperture Priority) mode is used for selecting the lens aperture and controlling the depth of field. The S (Shutter Priority) mode is used for selecting the shutter speed, which will determine how much you wish to freeze the motion in the movie frame. The M mode (Manual) is used to adjust both the aperture and the shutter speed.

Controlling the shutter speed can be useful to avoid the flickering caused by recording under fluorescent lights. Fluorescent bulbs have a cyclic output with a frequency that can, at certain shutter speeds, cause a distracting brightening or fading in the movie. If this occurs, try selecting a shorter or longer shutter speed to remove this effect. You might find that adjusting the shutter speed to 1/100 or 1/125 second will record more uniform lighting. Also, by using M or S mode, you can select a very long shutter speed (up to 1/4 second). This can create an artistic effect where motion is recorded as a blur and moving objects have ghostly images trailing behind them.

Zebra

Zebra is a command familiar to the videographer, but not to the still photographer. This command is set via the menu using the following:

MENU>Custom Settings (1)>Zebra>[Off] [n] [100+]
(Where n = 70 to 100 at +5 increments)

This command puts a series of black and white stripes over areas of the scene. The trigger for their appearance is the attainment of a certain light value. Typically, the numbers refer to the saturation percentage of the pixel's well capacity. In other words, the number refers to pixels that have reached that percentage of their maximum intensity. If you set the option to 100, the pattern appears for those pixels that are at 100% saturation. Typically, you do not set this option that high.

11

We found a setting of 70 to be more useful. When the exposure is adjusted so that zebra stripes appear over a person's face, this indicates an attractive recording of skin tones.

To illustrate this point, we will describe how to use a setting of 70 to record facial features. First, frame your scene and start at an exposure level where there are no stripes. The image will appear dark in the viewfinder. Then, increase your exposure, watching the scene brighten. Eventually zebra strips will appear; stop increasing exposure when the stripes overlie the facial features of your subject. If you continue to increase the exposure, the pattern will disappear from the face and move to another part of the scene—and the recorded skin tones will be too light and unflattering. To effectively use this command, you need to study the scene while changing the exposure. Stop changing the exposure when the bands appear over the subject you wish to record.

The setting of [n] requires some experience, and you may prefer a value other than 70. To record a portrait of someone standing before a white background, you may wish to render that background a brilliant white. To do so, you would set [n] to 100 and adjust the exposure so that the background has the zebra stripes.

Adding Creative Style, Picture Effect, or DRO

Since PlayMemories Home does not allow you to digitally enhance your recorded movies, using the Creative Style, Picture Effect, and DRO commands will be helpful. By using these commands, you can create movies with modern, supersaturated color, or with warm sunset-type colors. If you wish to create a film noir effect, you can record in black and white. In order to use Picture Effect, make sure that you set Quality to a JPEG value before starting to record a movie. Creative Style is more forgiving because it can be used in either RAW or JPEG.

Under extremely harsh lighting conditions that produce deep shadows, DRO can lighten the shadows and reveal details within them. Setting this command requires some practice, and there are no rules to guide you.

11

Recommendations

We enjoy taking movies with the Sony a7/a7R. In some cases, we planned carefully prior to recording, and meticulously executed the movie shooting with the camera mounted on a tripod. In other cases, we acted on an impromptu desire to record an event by handholding the camera. In both cases, the Sony a7/a7R has performed well. For the most professional-looking movies, you should mount the camera on a tripod. Although you can certainly create a pleasing movie without this accessory, failing to use a tripod may result in a movie where the subject appears to bounce around within the frame.

Do not be afraid to work with AVCHD. If you take short movie recordings, you should be able to easily edit these files on your computer. In the case of Mac computers, you will have to buy additional software; however, the cost is nominal. You can download iMovie '11 for $15; at the time of this writing, the program will read the highest-quality (60p 28 Mbps) recording from the Sony a7/a7R. If you own a PC, be sure to load Sony's supplied program, PlayMemories Home, and use it to work with AVCHD files and to create DVDs.

If you simply want to dive in and play and edit your movies on your computer, then use the MP4 file format. Using this format is straightforward and requires minimal software and hardware upgrades, in comparison to the AVCHD format.

11

Appendix A: Menu Commands

This appendix lists all of the Sony a7/a7R menu commands in order of the camera's six main menu groups, moving from top-left to right: Camera Settings, Custom Settings, Wireless, Applications, Playback, and Setup. Each main menu section is further broken into pages and within each page is a list of commands. A few of the commands have pages within them.

The following list of commands has each main section broken into pages with the Menu name and page number labeled in a black bar. Below that we have relisted the title description row for easy reminder. Many of the commands are simple [On] and [Off], but there are also commands with long lists of options, and commands with subcommands within them.

Each main command and its description are highlighted in gray. The commands' available options and their descriptions are listed below the command. Note that the commands' default options are denoted by the addition of "(Default)."

Example 1 shows a command with two options, where Option 1 is the default.

Example 1	
Menu Name - Page Number	
Command	**Description**
Command Name	Command description
	Option 1 (Default) — Option 1 description
	Option 2 — Option 2 description

For a downloadable PDF version of the Appendices please visit
www.rockynook.com/a7a7R

Example 2 **293**

A few of the main commands have subcommands. The subcommand options are listed within the main command and then further broken out with their individual options. Example 2 shows a command with two subcommands, along with their options, where Subcommand 2 and Suboption 2 are the defaults.

Example 2

Menu Name - Page Number (Submenu Name)			
Command	**Description**		
Command Name	Command description		
	Subcommand 1	Option 1 description	
		Suboption 1	Suboption 1 description
		Suboption 2	Suboption 2 description
	Subcommand 2 (Default)	Option 2 description	
		Suboption 1	Suboption 1 description
		Suboption 2 (Default)	Suboption 2 description

Use this list as a dictionary and quick reference for camera commands' functions and locations.

Sony a7/a7R Menu Commands

Camera Settings - Page 1	
Command	**Description**
Image Size	Defines the image size in pixels by camera. Different values are presented based on the selected Aspect Ratio and APS-C Size Capture command values. Works only on JPEG files. RAW file sizes are constant at 6000x4000 pixels for the a7 and 7360x4912 pixels for the a7R. Note that the image size decreases when an APS-C lens is attached to the camera.

Sony a7	
When Aspect Ratio = [3:2] and APS-C Size Capture = [Off]	
24m L: 24M (Default)	6000x4000 equivalent pixels
10m M: 10M	3936x2624 equivalent pixels
6.0m S: 6.0M	3008x2000 equivalent pixels
When Aspect Ratio = [16:9] and APS-C Size Capture = [Off]	
20m L: 20M (Default)	6000x3376 equivalent pixels
8.7m M: 8.7M	3936x2216 equivalent pixels
5.1m S: 5.1M	3008x1688 equivalent pixels
When Aspect Ratio = [3:2] and APS-C Size Capture = [On]	
10m L: 10M (Default)	3936x2624 equivalent pixels
6.0m M: 6.0M	3008x2000 equivalent pixels
2.6m S: 2.6M	1968x1312 equivalent pixels
When Aspect Ratio = [16:9] and APS-C Size Capture = [On]	
8.7 L: 8.7M (Default)	3936x2216 equivalent pixels
5.1m M: 5.1M	3008x1688 equivalent pixels
2.2m S: 3.2M	1968x1112 equivalent pixels

A

Camera Settings - Page 1 - (con't)	
Command	**Description**
Image Size	**Sony a7R**

	Sony a7R
When Aspect Ratio = [3:2] and APS-C Size Capture = [Off]	
36m L: 36M (Default)	7360x4912 equivalent pixels
15m M: 15M	4800x3200 equivalent pixels
9.0m S: 9.0M	3680x2456 equivalent pixels
When Aspect Ratio = [16:9] and APS-C Size Capture = [Off]	
30m L: 30M (Default)	7360x4144 equivalent pixels
13m M: 13M	4800x2704 equivalent pixels
7.6m S: 7.6M	3680x2072 equivalent pixels
When Aspect Ratio = [3:2] and APS-C Size Capture = [On]	
15m L: 15M (Default)	4800x3200 equivalent pixels
9.0m M: 9.0M	3680x2456 equivalent pixels
3.8m S: 3.8M	2400x1600 equivalent pixels
When Aspect Ratio = [16:9] and APS-C Size Capture = [On]	
13 L: 13M (Default)	4800x2704 equivalent pixels
7.6m M: 7.6 M	3680x2072 equivalent pixels
3.2m S: 3.2M	2400x1352 equivalent pixels

Aspect Ratio	Specifies the image's width to height ratio.	
	3:2	Represents a width of 3 units to a height of 2 units. This is the default still picture ratio.
	16:9	Represents a width of 16 units to a height of 9 units. This is the default movie frame ratio and is best when viewing your images on wide screen high-definition TV.

Camera Settings - Page 1 - (con't)	
Command	**Description**
Quality	Sets the still image's file format. RAW files are minimally processed image files containing more data than JPEG files. JPEG files are compressed, modified, and/or changed.

	RAW	The data is stored with minimal digital processing. Contains more data than JPEG file types. This is the best file type to use if you wish to digitally process the image on a computer. File extension is ARW.
	RAW & JPEG	Two files are created: RAW and JPEG Fine. The RAW file is stored with minimal digital processing. The JPEG file is more compressed than RAW, and its image reflects the results of the camera's digital processing. File extensions are ARW and JPG, respectively.
	Extra Fine	This is the least compressed JPEG file with the highest retention of image detail. File extension is JPG.
	Fine (Default)	The JPEG default compression rate, with an intermediate degree of compression and retention of image detail. File extension is JPG.
	Standard	The highest compression rate of the three JPEG file types. Can lose fine detail. File extension is JPG.
Panorama Size		Determines the size of a panoramic picture. Command is enabled only when the mode dial is set to Sweep Panorama.
	Standard (Default)	When Panorama Direction = [Right] or [Left]: panorama picture size is 8192x1856 pixels.
		When Panorama Direction = [Up] or [Down]: panorama picture size is 3872x2160 pixels.
	Wide	When Panorama Direction = [Right] or [Left]: panorama picture size is 12416x1856 pixels.
		When Panorama Direction = [Up] or [Down]: panorama picture size is 5536x2160 pixels.
Panorama Direction		Defines the direction to pan the camera when executing a panorama sweep. Command is enabled only when mode dial is set to Sweep Panorama.
	Right (Default)	Pan camera from left to right.
	Left	Pan camera from right to left.
	Up	Pan camera upward from the bottom.
	Down	Pan camera downward from the top.

Camera Settings - Page 1 - (con't)		
Command	Description	

File Format	AVCHD (Default) 60i/60p or AVCHD 50i/50p	Defines the file format for storing movie files.
		NTSC: Records movies in AVCHD using either interlaced or progressive scanning at either 60 fps or 24 fps. PAL: Records movies in AVCHD at either 50 fps using interlaced or 25 fps using progressive scanning.
		NTSC and PAL are not user selectable but are determined by the manufacturer based on the location the camera is sold.
	MP4	Records movies in MPEG-4 format at 30 fps. These MP4 movies are suitable for attaching to emails and uploading to websites.

Camera Settings - Page 2		
Command	Description	

Record Setting		Data rate of movie compression
	When File Format = [AVCHD 60i/60p]/[AVCHD 50i/50p]	
	60i 24(FX) or 50i 24M(FX)	Average bit rate = 24 Mbps. Records high-quality movies, 1920x1080 pixels at 60i/50i fps.
	60i 17M(FH) or 50i 17M(FH) (Default)	Average bit rate = 17 Mbps. Records standard-quality movies, 1920x1080 pixels at 60i/50i fps.
	60p 28M(PS) or 50p 28M(PS)	Average bit rate = 28 Mbps. Records highest-quality movies, 1920x1080 pixels at 60p/50p fps.
	24p 24M(FX) or 25p 24M(FX)	Average bit rate = 24 Mbps. Records high-quality movies, 1920x1080 pixels at 24p/25p fps (cinema-like movies).
	24p 17M(FH) or 25p 17M(FH)	Average bit rate = 17 Mbps. Records standard-quality movies, 1920x1080 pixels at 24p/25p fps (cinema-like movies).
	When File Format = [MP4]	
	1440x1080 12M (Default)	Average bit rate = 12 Mbps. Records 1440x1080 pixel movies.
	VGA 3M	Average bit rate = 3 Mbps. Records 640x480 pixel movies.

Camera Settings - Page 2 - (con't)	
Command	**Description**
Drive Mode	Determines how the camera will fire to capture the picture(s).

☐ Single Shooting (Default)	Camera fires one shot per press of the shutter button. Camera will establish focus and exposure with each press of the shutter button.
⧉ Cont. Shooting	Camera shoots continuously at two shots/second for the a7 and 1.5 shots/second for the a7R as long as the shutter button is held down. Camera maintains this firing rate until the buffer is filled, which depends on some camera settings. Exposure can vary between the first shot and subsequent shots when AEL w/shutter is set to [Off]. When it is set to [On] or [Auto], exposure is set just prior to the first shot and locked so it does not change in subsequent shots. Continuous auto focusing is available in this drive mode when Focus Mode command is set to [Continuous AF]. If Focus Mode is set to [Single-shot AF], focus is locked just prior to the first shot. This option is disabled in the following functions: Sweep Panorama, Smile Shutter, Auto HDR, all SCN modes except Sports Action, and when Picture Effect is set to [Soft Focus], [HDR Painting], [Rich-tone Mono.], [Miniature], [Watercolor], or [Illustration]. Many other camera commands are disabled when Drive Mode's [Cont. Shooting] is selected, such as Face Detection and Auto Obj. Framing.

A

Camera Settings - Page 2 - (con't)	
Command	**Description**
Drive Mode (con't)	Records continuously at five shots/second for the a7 and four shots/second for the a7R as long as the shutter button is held down. The camera maintains the selected firing rate until the buffer is filled. Speed can be slowed by the image size, ISO setting, High ISO NR, or setting the Lens Comp. command to [Distortion Comp.]. Focus is fixed and determined just prior to the first shot.
[S] Spd Priority Cont.	Exposure can vary between the first shot and subsequent shots when AEL w/shutter is set to [Off]. When it is set to [On] or [Auto], exposure is set just prior to the first shot and locked so it does not change in subsequent shots.
	This option is disabled in the following functions: Sweep Panorama, Smile Shutter, Auto HDR, all SCN modes except Sports Action, and when Picture Effect is set to [Soft Focus], [HDR Painting], [Rich-tone Mono.], or [Miniature].
	When [Spd Priority Cont.] drive mode is selected, many camera commands are disabled, such as Face Detection and Auto Port. Framing.
Self-timer	Delays the firing of the camera after the shutter button is pressed. The camera's audio beep sounds and the self-timer light in the front of the camera flashes until the allotted time has passed and the camera takes the shot. To cancel, press either the control wheel's left rim (Drive Mode icon) or the shutter button.
	This option is disabled in the following functions: Sweep Panorama, Smile Shutter, Auto HDR, [Hand-held Twilight] and [Anti Motion Blur] SCN modes, and when Picture Effect is set to [Soft Focus], [HDR Painting], [Rich-tone Mono.], or [Miniature].
	⟳10 (Default) — Uses a 10-second delay. Use this option when you need to get into a group shot.
	⟳2 — Uses a 2-second delay. Ensures the camera is motionless when the picture is taken. Works best with the Sony a7; less well with the a7R, where the mechanical shutter vibration can move the camera.

Camera Settings - Page 2 - (con't)		
Command	**Description**	
Drive Mode (con't)	Delays firing the camera until after the shutter button is pressed. The camera's audio beep sounds and the self-timer light in the front of the camera flashes until the allotted time has passed. The camera then fires a set of three or five shots. To cancel, press either the control wheel's left rim (Drive Mode icon) or the shutter button.	
	⏱C Self-timer (Cont.)	This option is disabled in the following functions: Sweep Panorama, Smile Shutter, Auto HDR, [Hand-held Twilight] and [Anti Motion Blur] SCN modes, and when Picture Effect is set to [Soft Focus], [HDR Painting], [Rich-tone Mono.], or [Miniature].
	⏱C3 (Default)	Delays firing for ten seconds and then fires three shots.
	⏱C5	Delays firing for ten seconds and then fires five shots.
	BRK C Cont. Bracket	To activate, press and hold down the shutter button. This option takes a series of three or five shots with the EV varied ± by the selected amount.
		When using a Sony flash, bracketing is done by adjusting the flash output. It requires that you press the shutter button for each image. This allows the flash to recharge for the shot.
		This option is available only in P, A, S, and M modes; it is not available with Smile Shutter, Auto HDR, and Picture Effect's [Soft Focus], [HDR Painting], [Rich-tone Mono.], or [Miniature] options.
	0.3EV 3 Image (Default)	Takes three shots in the following sequence: base exposure, –0.3EV, +0.3EV.
	0.3EV 5 Image	Takes five shots in the following sequence: base exposure, –0.6EV, –0.3EV, +0.3EV. +0.6EV.
	0.5EV 3 Image	Takes three shots in the following sequence: base exposure, –0.5EV, +0.5EV.
	0.5EV 5 Image	Takes five shots in the following sequence: base exposure, –1.0EV, –0.5EV, +0.5EV, +1.0EV.
	0.7EV 3 Image	Takes three shots in the following sequence: base exposure, –0.7EV, +0.7EV.
	0.7EV 5 Image	Takes five shots in the following sequence: base exposure, –1.4EV –0.7EV, +0.7EV, +1.4EV.

A

Camera Settings - Page 2 - (con't)			
Command	**Description**		
Drive Mode (con't)	**BRK** C Cont. Bracket	1.0EV 3 Image	Takes three shots in the following sequence: base exposure, –1EV, +1EV.
		2.0EV 3 Image	Takes three shots in the following sequence: base exposure, –2EV, +2EV.
		3.0EV 3 Image	Takes three shots in the following sequence: base exposure, –3EV, +3EV.
	BRK S Single Bracket	This option allows you to take a series of three or five shots with the EV varied ± by the selected amount. Note that you must press the shutter button for each image. This option is available only in P, A, S, and M modes; it is not available with Flash Mode, Smile Shutter, Auto HDR, and Picture Effect's [Soft Focus], [HDR Painting], [Rich-tone Mono.], or [Miniature] options.	
		0.3EV 3 Image (Default)	The camera cycles through three shots in the following sequence: base exposure, –0.3EV, +0.3EV.
		0.3EV 5 Image	The camera cycles through five shots in the following sequence: base exposure, –0.6EV, –0.3EV, +0.3EV, +0.6EV.
		0.5EV 3 Image	The camera cycles through three shots in the following sequence: base exposure, –0.5EV, +0.5EV.
		0.5EV 5 Image	The camera cycles through five shots in the following sequence: base exposure, –1.0EV, –0.5EV, +0.5EV, +1.0EV.
		0.7EV 3 Image	The camera cycles through three shots in the following sequence: base exposure, –0.7EV, +0.7EV.
		0.7EV 5 Image	The camera cycles through five shots in the following sequence: base exposure, –1.4 EV, –0.7EV, +0.7EV, +1.4EV.
		1.0EV 3 Image	The camera cycles through three shots in the following sequence: base exposure, –1EV, +1EV.
		2.0EV 3 Image	The camera cycles through three shots in the following sequence: base exposure, –2EV, +2EV.
		3.0EV 3 Image	The camera cycles through three shots in the following sequence: base exposure, –3EV, +3EV.

Camera Settings - Page 2 - (con't)			
Command	**Description**		
	BRKWB White Balance Bracket	With one press of the shutter button, the camera records three images, each with a variation (small or large) in the white balance, color temperature, and color filter settings.	
		LO (Default)	Variation of the white balance, color temperature, and color filter settings is small.
		HI	Variation of the white balance, color temperature, and color filter settings is large.
	BRK DRO DRO Bracket	With one press of the shutter button, the camera records three images, each with a variation (small or large) in the D-Range Optimize value.	
		LO (Default)	Variation of the D-Range Optimize value is small.
		HI	Variation of the D-Range Optimize value is large.
Flash Mode	Determines how and when the flash unit will fire when capturing a picture. You must attach an external flash to the camera. The command's default and available values depend on the selected shooting mode.		
	⊕ Flash Off	Prevents the attached flash unit from firing. This option is available only in Intelligent Auto, Superior Auto, and the following SCN predefined modes: Portrait, Landscape, Macro, Sports Action, and Sunset.	
	⚡ AUTO Autoflash	The camera decides when the level of light is low enough to fire the attached flash. Flash may also fire if subject is backlit. This option is enabled only in Intelligent Auto, Superior Auto, and the following SCN predefined modes: Portrait, Macro, and Night Portrait.	
	⚡ Fill-flash	When this option is selected, the attached flash always fires, providing light to the subject. This option is available only in P, A, S, M, Intelligent Auto, Superior Auto, and the following SCN predefined modes: Portrait, Landscape, Macro, Sports Action, and Sunset.	
	⚡ SLOW Slow Sync.	This option uses a shutter speed longer than 1/60 of a second. The attached flash goes off and the camera's shutter is kept open so that the sensor can capture the background illuminated by ambient lighting, while the flash illuminates subjects close to the camera. This option is only available in P, A, S, and M modes.	

Camera Settings - Page 2 - (con't)		
Command	**Description**	
Flash Mode (con't)	**⚡ REAR** Rear Sync.	The attached flash fires at the end of the camera's shutter cycle. If there is movement during the exposure, the flash records the subject in its latest position. If there is enough ambient light, the subject's displacement is captured as a blur while the shutter is open, but before the flash is fired. This option is only available in P, A, S, and M modes.
	⚡ WL Wireless	This option requires two Sony external flash units. One serves as slave and is the primary light source when it receives a wireless signal for firing. The second attached flash unit generates the signal that fires the slave. This option is only available in P, A, S, and M modes.
Flash Comp.	Allows you to adjust the amount of light from the flash unit.	
	-3 to +3 in 0.3 or 0.5 increments with +/- 0.0 default. The increment value is determined by the Exposure step command.	
Red Eye Reduction	The camera's flash sends out several small flashes prior to the main flash to prevent or reduce red, glowing eyes. This command is not available when using Sweep Panorama or SCN's [Handheld Twilight] and [Anti Motion Blur] shooting modes, when shooting with [Flash Off] or [Auto] Flash Modes, or when Smile Shutter is [On].	
	On	Red Eye reduction process is in effect.
	Off (Default)	Red Eye reduction process is not in effect.
Focus Mode	Used to select the autofocusing method that the camera will use.	
	AF-S (Default) Single-shot Autofocus	Camera focuses and locks when shutter button is partially depressed.
	AF-C Continuous Autofocus	Camera continually focuses when shutter button is partially depressed.
	DMF Direct Manual Focus	Direct Manual Focus provides a quick transition from autofocus to manual focus. Once camera finds and locks focus in AF, turning the lens's focusing ring changes focus. Only works when finger is pressing the shutter button halfway.
	MF Manual Focus	Sets the camera to use manual focus only.

Camera Settings - Page 3

Command	Description		
Focus Area	Used to set the area where autofocusing will occur within the framed image.		
	Wide (default)	Entire area of the screen is available for focusing. Focusing areas are distributed among 25 areas distributed in the framed image.	
	Zone	Only 9 of the 25 focusing areas used for focusing. Each set of 9 focusing areas resides within a zone whose position can be adjusted to different regions of the screen.	
	Center	Only the center area is available for focus.	
	Flexible Spot	Flexible Spot S	Positions the spot and sets it to its minimum size.
		Flexible Spot M	Positions the spot and sets it to its medium size.
		Flexible Spot L	Positions the spot and sets it to its maximum size.
Focus Settings	Selects the type of focusing to be used with the control wheel. Also enables the front and rear dial to position where the focusing point will be on the viewing screens.		
	Wide (default)	Entire area of the screen is available for focusing. Focusing areas are distributed in 25 regions.	
	Zone	Only 9 of the 25 focusing areas are used for focusing. Use the front and rear dial to position the specific focus zone.	
	Center	Only the center focusing area is available for focus.	
	Flexible Spot S	Allows you to set the position of the smallest sized focus spot using the front and rear dials.	
	Flexible Spot M	Allows you to set the position of the medium sized focus spot using the front and rear dials.	
	Flexible Spot L	Allows you to set the position of the largest sized focus spot using the front and rear dials.	

Camera Settings - Page 3 - (con't)	
Command	**Description**
AF Illuminator	Determines whether the AF illuminator turns on in dimly lit areas. The AF Illuminator command is disabled when the Focus Mode is set to [Continuous AF]; when recording movies; or when in Sweep Panorama or SCN's [Landscape], [Night Scene], or [Sports Action] shooting modes. The AF illuminator aids autofocusing under low-light conditions. Curiously, the AF illuminator will not work with an A-mount lens when that lens is mounted to the a7/a7R with the LA-EA4 adapter.

	Auto (Default)	Turns on the light in low light conditions and turns it off in bright light conditions.
	Off	The AF illuminator never turns on.

Exposure Comp.	Allows you to adjust the exposure in exposure step's EV increments to a range of ±5EV for stills and ±2EV for movies.
	When the command is selected, a horizontal scale appears in the display screen with tic marks at 0.3EV intervals. The indicator can go in between these intervals depending on the Exposure step command's value. An orange triangle moves along the scale to indicate the degree of over- or underexposure. The EV value of over- or underexposure is also shown as a numerical readout above the scale.
	The command is disabled in the Intelligent Auto, Superior Auto, and SCN modes. In M mode it is enabled when ISO command's [ISO AUTO] is used.

Exposure step	Determines the EV increments used when overriding the recommended exposure.

	0.5EV	Sets the EV increment unit for changing the Exposure Comp. and the Flash Comp. to 0.5EV.
	0.3EV (Default)	Sets the EV increment unit for changing the Exposure Comp. and the Flash Comp. to 0.3EV.

Camera Settings - Page 3 - (con't)			
Command	**Description**		
ISO	Sets the sensor's sensitivity to light. The higher the ISO, the more gain is applied to the sensor's output. A lower ISO provides higher image quality with less noise.		
	ISO AUTO	Multi Frame NR: "NR" stands for Noise Reduction. Four shots are fired and the images are averaged to remove noise.	
		ISO Auto	The ISO value used is determined automatically.
		n	The Multi Frame NR ISO value is set by the user. N can be set from a minimum of 100 to a maximum of 51,200.
	AUTO (Default)	ISO AUTO: Camera automatically sets its sensitivity to the light. This option is used when shooting in Intelligent Auto, Superior Auto, Sweep Panorama, and SCN modes.	
		Minimum	This is the minimum value camera can automatically set the ISO. Default range is a minimum of 100.
		Maximum	This is the maximum value camera can automatically set the ISO. Default is 6400.
	n	Allows the user to specify the sensor's level of sensitivity to one value. N can be set from a minimum of 50 to a maximum of 25,600.	

Camera Settings - Page 4		
Command	**Description**	
Metering Mode	Defines the area to be used for metering the exposure.	
	Multi (default)	Exposure is measured in multiple areas of the scene to determine an overall exposure. Intelligent Auto, Superior Auto, SCN, Movies, Face Detection, Smile Shutter, and Zoom use only [Multi].
	Center	The camera biases its exposure on the central area and provides less emphasis on the periphery.
	Spot	The camera uses the center of the framed image to determine exposure. A faint circle indicates the area the camera will use for measuring the light.

A

Camera Settings - Page 4 - (con't)	
Command	**Description**
White Balance	Adjusts the sensor's color output to provide neutral colors for different sources of light. Note that white balance is often abbreviated to WB. Each option, except [Custom Set], has a submenu for adjusting the blue, amber, green, and magenta tints.

AWB Auto (default)	WB is set automatically by the camera.
☀ Daylight	WB is set for a subject in direct sunlight.
🏠 Shade	WB is set for a subject in the shade. Assumes a clear day with blue skies.
☁ Cloudy	WB is set for subject on an overcast day when the sun is hidden by cloud cover.
💡 Incandescent	WB is set for a subject illuminated by indoor light (assumes the light is tungsten filament).
⚡-1 Fluor.: Warm White	WB is set for a subject illuminated by warm fluorescent light (3000 K).
⚡0 Fluor.: Cool White	WB is set for a subject illuminated by cool fluorescent light (4100 K).
⚡+1 Fluor.: Day White	WB is set for a subject illuminated by day white fluorescent light (5000 K).

Camera Settings - Page 4 - (con't)	
Command	**Description**
☀+2 Fluor.: Daylight	WB is set for a subject illuminated by daylight fluorescent light (6500 K).
WB ⚡ Flash	WB is set for light from an electronic flash unit.
AWB 🐟 Underwater Auto	Equivalent to AWB, but it is used for photographs taken by scuba divers or snorkelers using the camera with the aid of an underwater housing. This corrects for the blue coloration imparted by photographing underwater.
K⊘ C.Temp./Filter	You can set the WB based on the illuminant's color temperature value when expressed as kelvin units (K). Light bulb manufacturers specify a kelvin rating on the package. While in Live View: 1. Press the White Balance (right) button. 2. Scroll through the option list by rotating the control wheel. Select [C. Temp./Filter]. 3. Press the right button. 4. Scroll through the color temperature values by rotating the control wheel. 5. Select the value that matches the kelvin rating of the bulb. Press the center button to select the value. Press the shutter button halfway to select the value and return to Live View.
◣1 Custom 1	This option stores a custom color temperature WB preset setting created using the Custom Setup WB option.
◣2 Custom 2	This option stores a custom color temperature WB preset setting created using the Custom Setup WB option.
◣3 Custom 3	This option stores a custom color temperature WB preset setting created using the Custom Setup WB option.
◣SET	Use this option to set up a custom WB preset to be stored and used by one of the [Custom] options.

A

Camera Settings - Page 4 - (con't)

Command	Description
DRO/ Auto HDR	Dynamic Range Optimization (DRO) is used under harsh lighting conditions to lighten the shadows and darken the highlights. It is available only in P, A, S, and M shooting modes. The degree of lightening and darkening can be either set manually or determined automatically. It is most useful when taking movies.
	Auto HDR (High Dynamic Range) takes multiple exposures in rapid succession to record details in the highlights, midtones, and shadows. Like DRO, it is used for harsh lighting conditions and functions to record a wider range of lighting. It cannot be used for taking movies or for recording RAW-quality images.

D-R OFF (Default)	This option disables both DRO and HDR functions.		
DRO On	The DRO On icon (left) acts as a marker in the table and does not exist in the camera menu.		
		AUTO (Default)	Executes DRO automatically when the image has deep shadows and bright highlights. The camera chooses what level to use to lighten the shadows and darken the highlights. Auto DRO is the default mode in Intelligent Auto, Superior Auto, and the SCN's [Portrait], [Landscape], [Macro], and [Sports Action] options.
		Lv1	Level 1: The least lightening of shadows in the image.
		Lv2	Level 2: The second least lightening of shadows in the image.
		Lv3	Level 3: The middle amount of lightening of shadows in the image.
		Lv4	Level 4: The second most lightening of shadows in the image.
		Lv5	Level 5: The most lightening of the shadows in the image.

Camera Settings - Page 4 - (con't)

Command	Description		
HDR On	The HDR On icon (left) acts as a marker in the table and does not exist in the camera menu. The camera shoots multiple images and saves two on the memory card: one with the recommended exposure and one that's a combined image to bring out details in the highlights and shadows. The process closely retains the subject's coloring. Quality must be set to a JPEG only value.		
		AUTO (Default)	The camera determines the best (EV) range and sets each of the three images' EV based on the subject's contrast.
		1.0EV	The camera brackets the EV within a range of ±1.0EV from the recommended exposure.
		2.0EV	The camera brackets the EV within a range of ±2.0EV.
		3.0EV	The camera brackets the EV within a range of ±3.0EV.
		4.0EV	The camera brackets the EV within a range of ±4.0EV.
		5.0EV	The camera brackets the EV within a range of ±5.0EV.
		6.0EV	The camera brackets the EV within a range of ±6.0EV.
Creative Style	Applies different styles involving color to both RAW and JPEG images. Each of the creative style options, except [Black & White] and [Sepia], have three suboptions: Contrast, Saturation, and Sharpness. [Black & White] and [Sepia] have only Contrast and Sharpness. Each of the suboptions can be adjusted within a ±3 range. Creative Style defaults to [Standard] when shooting in Intelligent Auto, Superior Auto, SCN, and when the Picture Effect command is set to [Off].		
		Std. Standard (Default)	Starting point for setting colors. Must be set if you use Picture Effect.
		Vivid Vivid	Accentuates color saturation and contrast to make images appear vibrant.

Camera Settings - Page 4 - (con't)	
Command	**Description**

Command	Description
Ntrl Neutral	Lowers saturation and sharpness of colors.
Clear Clear	Color saturation is reduced in highlights.
Deep Deep	For recording deep colors.
Light Light	For recording lighter colors.
Port. Portrait	Reduced color saturation for recording natural skin tones.
Land. Landscape	Heightens saturation, contrast, and sharpness to produce distant landscapes that are more vivid and crisp.
Sunset Sunset	Accentuates the warm tones in sunset and sunrise photographs.
Night Night Scene	Contrast is reduced for shooting night scenes containing deep shadows.
Autm	Reds and yellows are enhanced for foliage shots.

Camera Settings - Page 4 - (con't)

Command	Description
B/W ✦ Black & White	Records scene in monochrome with gradations of gray.
Sepia ✦ Sepia	Transforms the image into brown tones, reminiscent of old-fashion photographs.
1 Std. ✦ Standard Style Box	Allows you to apply a modified Standard Creative Style setting.
2 Vivid ✦ Vivid Style Box	Allows you to apply a modified Vivid Creative Style setting.
3 Ntrl ✦ Neutral Style Box	Allows you to apply a modified Neutral Creative Style setting.
4 Port. ✦ Portrait Style Box	Allows you to apply a modified Portrait Creative Style setting.
5 Land. ✦ Landscape Style Box	Allows you to apply a modified Landscape Creative Style setting.
6 B/W ✦ Black & White Style Box	Allows you to apply a modified Black & White Creative Style setting.
 Contrast	Controls the intensity of highlights and shadows. A plus value brightens highlights and darkens shadows and gives the image a bolder, stronger look. A minus value darkens highlights and lightens shadows and gives the image a smoother overall look.

Camera Settings - Page 4 - (con't)	
Command	**Description**
Saturation	Controls the richness of the colors. A plus value makes the colors bolder and accentuates them. A minus value mutes and softens the colors, giving the image a more homogenous look. This adjustment option is unavailable for the [Black & White] and [Sepia] options.
Sharpness	Controls edge definition. A plus value heightens the edges, accentuating fine details and noise. A minus value softens the edges, creating a more blended look that helps hide noise.
Picture Effect	Applies different effects involving color, intensity, and detail to JPEG images only. Several of the options have suboptions to control the extent of the picture effect. The displayed icons for those Picture Effect options with suboptions will have the selected value displayed in the lower half of the icon.
Off (Default)	Turns off Picture Effect.
Toy Camera	Creates an image as if it was taken with a toy camera. Colors and shadowing are more pronounced with less smoothness and gradation.
	Suboptions: [Normal] (Default), [Cool], [Warm], [Green], [Magenta]
Pop Color	Emphasizes color tones and makes them more vivid.
Posterization	Emphasizes primary colors; or, in the case of the black-and-white suboption, makes the image black and white. Creates a more contrasting, abstract look with pronounced tones.
	Suboptions: [Color] (Default), [B&W]
Retro Photo	Creates the image in an old-fashioned photo style using sepia and reduced contrast.
Soft High-key	Creates a softer and more ethereal image.

A

Camera Settings - Page 4 - (con't)	
Command	**Description**
(Part) Partial Color	Creates an image that retains one color and turns the rest to black-and-white. Suboptions determine the retained color.
	Suboptions: [Red] (Default), [Green], [Blue], [Yellow]
(HC BW) High Contrast Mono.	Creates a high-contrast black-and-white image.
(Soft) Soft Focus	Creates a soft lighting effect. Suboptions set the effect intensity.
	Suboptions: [Low], [Mid] (Default), [High]
(Pntg) HDR Painting	Takes three images and merges them to create one HDR image. The image colors and details are heightened. This is unlike Auto HDR where two images are created. Suboptions set the effect intensity.
	Suboptions: [Low], [Mid] (Default), [High]
(Rich BW) Rich-tone Mono.	Takes three images and merges them to create an HDR image in black-and-white.
(Mini) Miniature	Creates an image with the main subject in focus and the background out of focus. Often used for miniature model images where the model is in focus and the background is not. Suboptions set the focus area.
	Suboptions: [Auto] (Default), [Top], [Middle(Horizontal)], [Bottom], [Right], [Middle(Vertical)], [Left]
(WtrC) Watercolor	Creates images with blurring effects, as if the watercolor paint is spreading across the paper and bleeding into each adjoining color.
(Ilus) Illustration	Creates an illustration-like image with crisp color demarcations.
	Suboptions: [Low], [Mid] (Default), [High]

A

Camera Settings - Page 4 - (con't)	
Command	**Description**
Zoom	Enlarges the central part of the sensor to create a larger view of that area. This command is disabled for modes in which multiple images are merged into one image.
	Rotate the control wheel or use the left and right buttons to increase or decrease zoom.

Camera Settings - Page 5		
Command	**Description**	
Focus Magnifier	Disabled until you use manual focus (MF). Press the center button to increase magnification once. Press it a second time to increase magnification again. A third press returns you to regular view.	
Long Exposure NR	Implements noise reduction for pictures taken with exposures of one second or longer. The process requires taking a second, dark exposure equal to the original exposure time. The camera will be inoperative for at least double the exposure time.	
	This command is automatically turned [Off] when the camera needs to acquire multiple shots, such as in Sweep Panorama and SCN's [Sport Action], [Hand-held Twilight], and [Anti Motion Blur] shooting modes.	
	The command is automatically set to [On] in Intelligent Auto, Superior Auto, and SCN's modes, excluding [Sports Action], [Hand-held Twilight], and [Anti Motion Blur].	
	On (Default)	Enacts the noise reduction process when a picture is taken with an exposure of at least one second or longer.
	Off	Disables the process.
High ISO NR	Adjusts the degree of noise reduction to be applied to JPEG files when shooting at ISOs of 1600 or higher. This software process occurs after taking the picture, and needs to be completed before taking the next shot. Because of this, it may slow down the rate of taking several shots.	
	This command is not used on RAW images.	
	Normal (Default)	Default setting for reducing noise. Can also reduce image sharpness.
	Low	Reduces the least amount of noise and takes the shortest time to complete. Helps preserve image sharpness.
	Off	No noise reduction.

Camera Settings - Page 5 - (con't)	
Command	**Description**
Lock-on AF	The camera locks onto a subject and tracks it as it moves within the framed image, while continuously refocusing on it.
	Note: this command is much improved when the a7/a7R's firmware is upgraded from version 1.01 to 1.02.
	This command is unavailable in Sweep Panorama and in SCN's [Hand-held Twilight] and [Anti Motion Blur] shooting modes, or when in Zoom or manual Focus Modes.

▣⛛**OFF** (Default)	Turns the command off.
▣⛛**ON**	Lock-on AF tracking is ready to be used. Will work in AF-S. You will be asked to frame the subject and press the center button to establish lock-on. This will initiate tracking.
▣⛛ 🔽 On (Start w/ shutter)	Only available with Continuous AF. When this option is selected, the camera automatically initiates lock-on and tracking when the shutter button is pressed part way.

Smile/ Face Detect. Shutter	Face Detection is typically turned [Off]. When turned on, it is set to either recognize faces stored in the memory (Registered Faces) or to recognize generic faces [On]. It can be set to recognize faces and fire the camera when at least one face smiles to a certain degree (Big Smile, Normal Smile, Slight Smile). Autofocus Area must be set to [Multi].
	This command is disabled when AF/MF command is set to [Manual Focus], in shooting modes requiring continuous shooting (Sweep Panoramic), and in modes where multiple images are taken and merged into one image (Auto HDR). Drive Mode command will automatically be set to [Single Shooting].

[●] 👤**OFF** Face Detection Off (Default)	Turns off Face Detection.
[●] 👤👑 Face Detection On (Regist. Faces)	Activates Face Detection and prioritizes focus for registered faces. Face Detection is automatically set to this value when Smile Shutter is on.

Camera Settings - Page 5 - (con't)	
Command	**Description**
[◉] ON Face Detection On	Activates Face Detection but uses any face to establish focus prioritization.
☻ ON: Big Smile	Triggers the shutter when a big, full smile is detected.
☺ ON: Slight Smile	Triggers the shutter when a slight smile is detected.
☺ ON: Normal Smile (On's Default)	Triggers the shutter when a normal smile is detected.
⟨♀⟩ Soft Skin Effect	Softens details in areas of low contrast while retaining detail in the high-contrast area. Will hide small skin blemishes and conceal fine wrinkles. This command is disabled in movie recording, or when Quality is set to [RAW], and in Sweep Panorama and SCN's [Sports Action] shooting modes. It is only available in Drive Mode command options: [Single Shooting] and [Self-timer].
⟨♀⟩OFF (Default)	Deactivates the Soft Skin Effect command.
⟨♀⟩LO On: Low	Sets the intensity to Low.
⟨♀⟩MID On: Mid (On's Default)	Sets the intensity to Medium.
⟨♀⟩HI On: High	Sets the intensity to High.

Camera Settings - Page 6

Command	Description
Auto Obj. Framing	Camera will attempt to frame the subject for the best composition. Does not work on RAW files.
	OFF — Disables Auto Obj. Framing functionality.
	AUTO — Enables Auto Obj. Framing functionality.
Auto Mode	This determines whether the camera is set to either Intelligent Auto or Superior Auto shooting modes when the camera mode dial is set to AUTO.
	Auto — Sets the camera's shooting mode to Intelligent Auto.
	Auto + — Sets the camera's shooting mode to Superior Auto. This mode has an additional capability of applying shooting functions to enhance the still picture's results.
Scene Selection	These pre-defined scene modes set the camera controls to provide the best results for the selected subject.
	Portrait — Focuses on the person's face using a narrow depth of field, therefore causing the background to be less in focus. Turns on Smile/Face Detection. Softened skin tones are emphasized.
	Sports Action — Uses a fast shutter speed to capture a moving subject. Sets Focus Mode to [AF-C] and Drive Mode to [Cont. Shooting].

Camera Settings - Page 6 - (con't)	
Command	**Description**
♣ Macro	Shoots close-ups of objects. Sets Focus Mode to [AF-S] and Drive Mode to [Single Shooting].
▲ Landscape	Shoots scenes with vivid colors and a wide depth of field, so more of the fore- and background of the picture are in focus. Sets Focus Mode to [AF-S] and Drive Mode to [Single Shooting].
⊜ Sunset	Enhances the image's red, orange, yellow, and pink hues. Note that you can use this Scene mode regardless of the image. Sets Focus Mode to [AF-S] and Drive Mode to [Single Shooting].
☾ Night Scene	Used to shoot night scenes. Note that if you don't use a flash, the camera will compensate.
☾✋ Hand-held Twilight	Use this mode for shooting under low light conditions. The camera takes four shots and combines them into one image to conceal sensor noise, thus removing the effects of slight movement due to unsteady handheld shooting during a long exposure. Note that if Quality is set to [RAW] or [RAW & JPEG] when this SCN mode is selected, Quality will be changed to JPEG [Fine] and will return to [RAW] or [RAW & JPEG] once the mode is changed to one that allows [RAW] files to be recorded. You can record Hand-held Twilight images in either of the other JPEG formats: [Extra Fine] and [Standard].
👤☾ Night Portrait	Use this mode to shoot night portraits. Note that if you don't use a flash, the camera will compensate.
((👤)) Anti Motion Blur	Use this mode for shooting indoors without a flash where noise and blur may affect the recorded image. The camera takes four shots and combines them into one image, removing the effects of slight movement. If Quality is set to [RAW] or [RAW & JPEG] when this SCN mode is selected, Quality will be changed to JPEG [Fine] and will return to [RAW] or [RAW & JPEG] once the mode is changed to one that allows [RAW] files to be recorded. You can record Anti Motion Blur images in either of the other JPEG formats: [Extra Fine] and [Standard].

Camera Settings - Page 6 - (con't)	
Command	**Description**
Movie	Allows you to shoot movies in P, A, S, and M shooting modes.

	P Program Priority	In Movie mode, the camera will set its aperture and shutter speed for taking the movie.
	A Aperture Priority	In Movie mode, the user sets the aperture and the camera will select the shutter speed and ISO for adjusting exposure.
	S Shutter Priority	In Movie mode, the user sets the shutter speed and the camera will select the Aperture and ISO for adjusting exposure.
	M Manual Exposure	In Movie mode, the user sets the aperture and the shutter speed for exposure. If camera is set to ISO Auto, it will adjust exposure automatically.

Command	Description	
Steady- Shot	Enables lens stabilization for eliminating unsteady handheld shots. Its default is [On]; however, if the camera is mounted on a tripod, it should be turned [Off]. If [Off], the command will automatically be set to [On] when using SCN's [Hand-held Twilight] or [Anti Motion Blur] shooting modes. Note that the 70-200mm FE zoom has a switch on the lens for turning SteadyShot off or on.	
	On (Default)	Enables SteadyShot.
	Off	Disables SteadyShot.
Color Space	Allows you to select one of two preset color spaces for recording colors. Check your printer for supported color space.	
	sRGB (Default)	Common standard for most electronic display and recording units.
	Adobe RGB	Common standard for CMYK four-color professional printing.

Camera Settings - Page 7

Command	Description

Auto Slow Shutter

Allows the camera to automatically use a longer shutter speed while recording a movie in low light. The slower shutter speed will reduce the apparent noise in the video.

This command is available when ISO is set to [ISO AUTO] and the camera is in one of the following shooting modes: Intelligent Auto, Superior Auto, P, or A.

On (Default)	When shooting at 60 fps, the slowest shutter speed will be 1/30 second. When using 30 fps, the longest shutter speed will be 1/15 second. At 24 fps, the shutter can go no slower than 1/25 second.
Off	The slowest shutter speed in automatic exposure shutter speed settings will be 1/60 second for 60 fps, 1/30 second for MP4, and 1/30 second for 24 fps.

Audio Recording

Determines whether audio is included when recording a movie.

On (Default)	Audio records with the movie.
Off	No audio records with the movie.

Audio Rec Level

Adjusts the sensitivity of the microphone when recording audio with a movie.

Adjustment ranges from 0 – 31 where 0 represents no sound recorded and 31 represents the loudest sounds that can be recorded.

Audio Out Timing

Controls the timing of audio and movie outputs when monitoring audio via headphones.

Live (Default)	Audio is outputted without delay when recording movie.
Lip Sync	Delays the output of audio. The delay is needed when the camera delays movie output and produces perceptible mismatch between movie and sound (failure of lip synch). The audio delay ensures proper synchronization between audio and movie.

Wind Noise Reduct.

Reduces the sound of wind noise on movie audio.

On	Reduces wind noise on captured audio. Note: once wind noise has been reduced, additional sound may be picked up by the microphone.
Off (Default)	Does not reduce wind noise on captured audio.

Memory

A memory site for storing camera settings. Two groups of settings can be saved.

1	Memory register for one group of camera settings.
2	Memory register for a second group of camera settings

Custom Settings - Page 1	
Command	**Description**
Zebra	The appearance of stripes when a portion of the scene reaches a certain brightness level. Strips are absent if the light level is below or above the selected brightness level.

Off (default)	No zebra bars are shown.
70	
75	
80	Different levels of brightness when zebra stripes appear. Typically a setting of 70 will record appealing skin tones. These settings are used most often in monitoring movies. The stripes are not recorded in the movie.
85	
90	
95	
100	
100+	Stripes at this level will be brilliant white with no recorded detail.

MF Assist	MF Assist magnifies the screen to facilitate focusing the lens manually. Sony autofocus lenses require the Focus Mode command to be set to [MF] or [DMF].

On (Default)	Provides two levels of magnification for manually focusing the camera. Only the central part of the Live View scene can be seen when it is magnified, limiting the field of view. It drops down to 1X magnification when the shutter button is pressed halfway.
Off	Magnification cannot be increased.

Focus Magnif. Time	Sets the length of time the Live View image will be shown in its magnification form in MF Assist. Timer starts when the focus ring stops being rotated. Timer resets when focusing ring is turned.

No Limit	Magnification will be retained until the shutter button is pressed lightly.
5 Sec	Magnification will be retained for 5 seconds.
2 Sec (Default)	Magnification will be retained for 2 seconds.

A

Custom Settings - Page 1 - (con't)	
Command	**Description**
Grid Line	Superimposes a line pattern on the display screen in Live View to aid composition.
Rule of 3rds Grid	Pattern consists of a 3x3 array of rectangles.
Square Grid	Pattern consists of a 6x4 array of squares.
Diag. + Square Grid	Pattern consists of a 4x4 array of rectangles with diagonal lines radiating from the center to each corner.
Off (Default)	No grid patterns are overlaid over the live preview screen.
Audio Level Display	Displays the audio levels being recorded from the camera's built-in microphone during movie recording.
On (Default)	This is used with Audio Rec Level to adjust the microphone's sensitivity to sound.
Off	Channels are not displayed on the screen.
Auto Review	Displays the recorded picture just after it is taken. Pressing the shutter button returns you to Live View. Movies are not displayed after being recorded.
10 Sec	Displays captured image for 10 seconds.
5 Sec	Displays captured image for 5 seconds.
2 Sec (Default)	Displays captured image for 2 seconds.
Off	Does not display captured image.

Custom Settings - Page 2			
Command	**Description**		
DISP Button	Used to select the display formats to be used on both the LCD screen and in the viewfinder.		
	Monitor	Allows you to select from a list of six data display formats for the LCD screen when in Live View.	
		Graphic Display	Displays the full-size image with major shooting settings and two horizontal scales, one for shutter speed and the other for aperture.
		Display All Info.	Displays full-size image with the camera shooting settings around the image's borders.
		No Disp. Info.	Displays full-size image with the exposure settings along the bottom of the display screen. The shooting mode is displayed momentarily in the upper-left corner. No icons are layered over the Live View of the subject.
		Histogram	Displays full-size image and the exposure settings. In addition, a live histogram is displayed in the lower right of the display screen for evaluating exposure.
		Level	Displays full-size image with the exposure settings along the bottom of the display screen. A live digital level gauge is displayed for horizontally aligning the frame to the horizon and ensuring the sensor's surface is perpendicular to the ground.
		For viewfinder	No Live View. Displays a histogram, level, camera shooting, and exposure settings. Used for checking and adjusting camera settings.
	Finder	Allows you to select data display formats that can be applied to the viewfinder when previewing an image.	
		Graphic Display	Displays the full-size image with major shooting settings and two horizontal scales, one for shutter speed and the other for aperture.
		Display All Info.	Displays full-size image with the camera shooting settings around the image's borders.
		No Disp. Info.	Displays full-size image with the major shooting settings along the top of the display screen and the exposure settings along the bottom of the display screen.

Custom Settings - Page 2 - (con't)		
Command	**Description**	
	Histo-gram	Displays full-size image with the major shooting settings along the top of the dis-play screen and the exposure settings along the bottom of the display screen, plus the live white histogram in the lower-right of the display screen.
	Level	Displays full-size image with the major shooting settings along the top of the dis-play screen and the exposure settings along the bottom of the display screen, plus the digital level gauge in the center of the screen for horizontally aligning the frame to the horizon and ensuring the sensor's surface is perpendicular to the ground.
Peaking Level	A manual focusing aid. It generates a fringe of color on borders that exhibit a sharp change in contrast (in focus). The extent of color fringing is adjust-able. It complements MF Assist and it has the advantage of showing the whole field of view. This command requires that MENU>Camera Settings (2)>Focus Mode com-mand be set to [MF].	
	High	Adds maximum-sized fringe to in-focus areas.
	Mid	Adds mid-sized fringe to in-focus areas.
	Low	Adds small-sized fringe to in-focus areas.
	Off (Default)	Turns off the Peaking function.
Peaking Color	Determines the color used to identify high-contrast areas. This command is only enabled when the Peaking Level command is turned on.	
	White (Default)	Color fringe for high-contrast areas is displayed white.
	Red	Color fringe for high-contrast areas is displayed red.
	Yellow	Color fringe for high-contrast areas is displayed yellow.
Exposure Set. Guide	Provides an enlarged numerical value when you change aperture, shutter speed, or ISO.	
	On	Enlarged exposure guide numbers are displayed except in [Graphic Display] and [For viewfinder] data display formats.
	Off	Enlarged exposure guide numbers are not displayed.

Custom Settings - Page 2 - (con't)		
Command	**Description**	
Live View Display	Determines how the camera displays Live View under ambient lighting conditions.	
	Setting Effect ON (Default)	Live View reflects exposure compensation: darker when underexposed, brighter when overexposed. The color effects of Creative Style and Picture Effect options are shown.
	Setting Effect OFF	Live View is in color and at a constant intensity. It is used by studio photographers who work with flash units with intensities that are much greater than ambient light. This option is available in P, A, S, and M modes only.
Phase Detect. Area	This is valid only for the Sony a7. Shows position of phase detectors.	
	On	Shows position of phase detectors.
	Off (Default)	Does not show position of phase detector.

Custom Settings - Page 3		
Command	**Description**	
Pre-AF	This allows the camera to automatically start focusing prior to the shutter button being pressed. The function is only available for still photography and when an FE or E-mount lens is attached to the camera.	
	On (Default)	Camera starts automatic focusing before the shutter button is pressed. This option will use up the camera's battery faster due to constant re-focusing while the camera or the subject within the frame moves.
	Off	Automatic focusing starts after the shutter button is pressed.

Custom Settings - Page 3 - (con't)	
Command	**Description**
Zoom Setting	Provides magnification to the image.
	Optical zoom only (Default) — Magnification of the image is provided by the focal length of the zoom lens.
	On: ClearImage Zoom — Increases magnification beyond that of the zoom lens. A special algorithm is applied to provide improved image quality, but no increase in resolving fine detail, unlike Optical zoom only.
	On: Digital Zoom — Increased magnification is applied beyond On: ClearImage Zoom. Image will seem degraded in comparison to ClearImage Zoom.
Eye-Start AF	Initiates focusing before the shutter button is pressed when an object, presumably one's eye, is against the viewfinder. This is available only when using A-mount lenses with the LA-EA3 or LA-EA4 adapter.
	On — Automatic focusing starts when you look through the Electronic Viewfinder.
	Off (Default) — Automatic focusing starts when pressing the shutter button halfway.
FINDER/ MONITOR	Determines how the LCD screen and the viewfinder interact.
	Auto (Default) — Camera switches automatically between turning on or off the LCD monitor and the viewfinder depending on which is being used. Controlled by proximity sensor near the viewfinder's eyepiece. Only one, either the LCD monitor or the viewfinder, will be on at a time.
	Viewfinder — Only the viewfinder is on.
	Monitor — Only the LCD is on.
Release w/o Lens	Determines whether the camera fires when a non-FE or non-E-mount lens is attached to the camera.
	Enable (Default) — Enables the camera to shoot without a lens attached. Should also be set when using legacy lenses or with telescopes or microscopes.
	Disable — Prevents the camera from shooting without an FE or E-mount lens attached.

Custom Settings - Page 3 - (con't)

Command	Description	
⌲ **AF w/ shutter**	Determines how autofocus starts in relation to shutter button.	
	On (Default)	Pressing shutter button starts or accelerates autofocus.
	Off	Pressing shutter button does not start or accelerate autofocus.

Custom Settings - Page 4

Command	Description	
⌲ **AEL w/ shutter**	Determines how exposure is locked when pressing the shutter button.	
	Auto (Default)	Camera will lock exposure in [AF-S] Focus Mode after it focuses when the shutter button is pressed halfway. If in continuous autofocus ([AF-C]), exposure will change instead of locking.
	On	Camera locks exposure during partial press on the shutter button.
	Off	Exposure continually adjusts after the shutter button is pressed. If you need to lock exposure, you must use the AEL button.
e-Front Curtain Shut.	Controls how the shutter operates. This only applies to the a7 camera body.	
	On (Default)	First-curtain electronic shutter initiates exposure. Provides vibration-free exposure.
	Off	Mechanical shutter initiates exposure. Slight vibration will occur when shutter activates.
S. Auto Img. Extract.	When multiple images are fired in Superior Auto mode, this command determines whether to save all of them on the memory card or just the one that is judged to be the best.	
	Auto (Default)	Saves one picture on the memory card.
	Off	Saves all the pictures on the memory card.

Custom Settings - Page 4 - (con't)		
Command	**Description**	
Exp.comp. set.	Provides more or less exposure to the exposure recommended by the camera in its auto or semi-auto shooting modes	
	Ambient& flash (Default)	If external flash is used, this will adjust the overall exposure, keeping the ratio of flash illumination to ambient illumination constant.
	Ambient only	If external flash is used, this will not change the flash output—only adjust the ambient light compensation. The ratio of flash illumination to ambient will be changed.
Reset EV Comp.	Determines whether the EV compensation applied by the menu (Fn button, Quick Navi Screen) is retained when the camera is turned off.	
	Maintain (Default)	The EV compensation is retained when the camera is turned off and reapplied when it is turned back on.
	Reset	The EV value is reset to 0 when the camera is turned off.
Bracket Order	Determines the ordering (numbering) of images when bracket is used in exposure and white balance.	
	0➔-➔+ (Default)	Shoots an image at the recommended, then under, and then over the specified EV or determined white balance.
	-➔0➔+	Shoots an image under, at the recommended, and then over the specified EV or determined white balance.

Custom Settings - Page 5		
Command	**Description**	
Face Registration	Allows you to register and maintain up to eight faces in the camera's memory for autofocus preferences. Registered faces are retained when the Setting Reset command's [Camera Settings Reset] option is executed, but are deleted when [Initialize] is executed.	
	New Registration	Registers new faces one at a time (up to eight total).
	Order Exchanging	Prioritizes the registered faces for selection in autofocusing.
	Delete	Deletes a single registered face.
	Delete All	Deletes all registered faces at one time.

Custom Settings - Page 5 - (con't)	
Command	**Description**
APS-C Size Capture Order	Determines the size of the area on the sensor to be used for image capture.

	On	Captures the central 24x16mm area of the sensor.
	Auto (Default)	Detects if the Sony APS-C designated lens is mounted and captures the central 24x16mm area of the sensor.
	Off	Captures the entire 36x24mm area of the sensor.

AF Micro Adj.	Only active with Sony A-mount lenses mounted on the a7/a7R camera body via either the LA-EA3 or LA-EA4 adapter.
	Allows you to compensate focus setting if the lens is either back or front focusing. The camera registers up to 30 lenses. Lens classification is based on its aperture and focal length so only one lens of that type can be registered. The camera identifies the lens being mounted and sets the correction if AF Adjustment Setting is [On].

AF Adjust- ment Set.	Controls the adjustment process activation.	
	On	Enables the adjustment process.
	Off	Disables the adjustment process.
amount (this is grayed out when a FE lens is attached)	This option is enabled only when an A-mount lens is attached to the camera using Sony's LA-EA series Mount Adaptor and AF Adjustment Setting is [On]. Adjusts focus setting from −20 to +20 in increments of one. 0 requires no correction.	
Clear	This will clear the adjustment for all the registered lenses.	
	Enter	Clears all of the saved adjustments with the lens name.
	Cancel	Exits the process without clearing anything.

Custom Settings - Page 5 - (con't)		
Command	**Description**	
Lens Comp.	This provides compensation for optical aberration in Sony lenses. For non-Sony lenses, you must download the Lens Comp. app.	
	Shading Comp (Default)	Enables automatic adjustment to reduce the appearance of vignetting in JPEG files. It is not applied to RAW files.
		Auto (Default) — Corrects vignetting for FE-mount lenses.
		Off — Does not correct vignetting so image may show light fall-off at the periphery.
	Chro. Aber. Comp.	Enables automatic adjustment to reduce the appearance of chromatic aberration in JPEG files. It is not applied to RAW files.
		Auto (Default) — Reduces appearance of chromatic aberration in FE-series lenses.
		Off — Displays the chromatic aberration.
	Distortion Comp.	Enables automatic reduction to reduce the appearance of geometric distortion in JPEG files. It is not applied to RAW files. This command is not enabled on the Sony FE 28-70 or the Zeiss FE 24-70mm zoom lenses.
		Auto (Default) — Reduces appearance of geometric distortion for FE-series lenses.
		Off — Disables function. Lens distortion is displayed in saved JPEG images.

Custom Settings - Page 6

Command	Description
Function Menu Set.	Sets the functions (commands) that will be displayed when the Fn button is pressed. The assigned options are displayed in two rows along the bottom of the screen with Function Upper1 through 6, from left to right in the top line, and Function Lower1 through 6 in the bottom line. Use the control wheel to navigate through them. When selected, the command's options are automatically displayed vertically along the right side of the display screen.

Function Menu Set. Page 1

Options are always enabled. Each of the Function options can be assigned one of the following values:

Function Upper1		
Function Upper2	Drive Mode	Soft Skin Effect
	Flash Mode	Auto Obj. Framing
	Flash Comp.	
	Focus Mode	Image Size
Function Upper3	Focus	
	Exposure Comp.	Aspect Ratio
	ISO	
	Metering Mode	Quality
	White Balance	
Function Upper4	DRO/Auto HDR	SteadyShot
	Creative Style	Audio Rec Level
	Shoot Mode	Zebra
	Picture Effect	Grid Line
	Lock-on AF	Audio Level Display
Function Upper5	Smile/Face Detect.	Peaking Level
		Peaking Color
		Not Set
Function Upper6		

Custom Settings - Page 6 - (con't)	
Command	**Description**

Function Menu Set . Page 2

Options are always enabled. Each of the Function options can be assigned one of the following values:

Function Lower1		
Function Lower2	Drive Mode	Soft Skin Effect
	Flash Mode	Auto Obj. Framing
	Flash Comp.	
	Focus Mode	
Function Lower3	Focus Area	Image Size
	Exposure Comp.	Aspect Ratio
	ISO	
	Metering Mode	Quality
Function Lower4	White Balance	
	DRO/Auto HDR	SteadyShot
	Creative Style	Audio Rec Level
	Shoot Mode	Zebra
	Picture Effect	Grid Line
Function Lower5	Lock-on AF	Audio Level Display
	Smile/Face Detect.	Peaking Level
		Peaking Color
		Not Set
Function Lower6		

Custom Settings - Page 6 - (con't)

Command	Description
Custom Key Settings	Allows the user to further customize the camera to have direct access to several camera functions in Live View without having to go through the camera menu structure. The Custom Key Settings command is available in P, A, S, and M modes only. When in another shooting mode, the buttons default to the Custom Key Settings command's default. Custom Key Settings are not active in Movie mode. For those countries that do not have application downloading capabilities, [Download Appli.] and [Application List] options are not available.

Custom Key Settings - Page 1

Control Wheel	ISO
	White Balance
	Creative Style
	Picture Effect
	Not set

Each of the following Custom Key Settings options can be assigned with one of the following values:

Custom Settings - Page 6 - (con't)		
Command	**Description**	
AEL Button	Drive Mode Flash Mode Flash Comp.	AEL hold AEL toggle
AF/MF Button	Focus Mode Focus Area Focus Settings Exposure Comp. ISO	AEL hold AEL toggle AF/MF Control Hold AF/MF Ctrl Toggle
Custom Button1	Metering Mode White Balance DRO/Auto HDR Creative Style Picture Effect	Lock-on AF Eye AF AF On Aperture Preview Shot. Result Preview
Custom Button2	Smile/Face Detect. Soft Skin Effect Auto Obj. Framing SteadyShot Audio Rec Level	Zoom Focus Magnifier Deactivate Monitor Zebra Grid Line
Custom Button3	Image size Aspect Ratio Quality In-Camera Guide Memory	Audio Level Display Peaking Level Peaking Color Send to Smartphone Download Appli. Application List Monitor Brightness Not set

Custom Settings - Page 6 - (con't)

Command	Description
	Custom Key Settings - Page 2 - (con't)
	List of Available Options

Standard		
Drive Mode		
Flash Mode		Eye AF
Flash Comp.	SteadyShot	AF On
Focus Mode	Audio Rec Level	Aperture Preview
Focus Area	📷 Image size	Shot. Result Preview
Focus Settings	📷 Aspect Ratio	Zoom
Exposure Comp.	📷 Quality	Focus Magnifier
ISO	In-Camera Guide	Deactivate Monitor
Metering Mode	Memory	Zebra
White Balance	AEL hold	Grid Line
DRO/Auto HDR	AEL toggle	Audio Level Display
Creative Style	🔘 AEL hold	Peaking Level
Picture Effect	🔘 AEL toggle	Peaking Color
Smile/Face Detect.	AF/MF Control Hold	Send to Smartphone
📷 Soft Skin Effect	AF/MF Ctrl Toggle	Download Appli.
📷 Auto Obj. Framing	Lock-on AF	Application List
		Monitor Brightness
		Not set

| | Center Button | All of the above options are available for assignment. |

Custom Settings - Page 6 - (con't)	
Command	**Description**
	All of the above options are available for assignment except the following:
	Left Button — Standard / AEL hold / ◉ AEL hold
	Right Button — AF/MF Control Hold / Eye AF / AF On
	Down Button — Aperture Preview / Shot. Result Preview
Dial Setup	Controls the role of front and rear dials.
	🔆SS🔆F/no. — Front dial controls shutter speed, rear dials controls f-stop.
	🔆F/no.🔆SS — Front dial controls f-stop, rear dial controls shutter speed.
Dial Ev Comp	Determines front and rear dials' role in adjusting EV compensation.
	Off (Default) — Neither front or rear dials adjust EV compensation.
	Front dial — Front dial adjusts EV compensation.
	Rear dial — Rear dial adjusts EV compensation.
Movie Button	Determines the action of the Movie button.
	Always (Default) — Movie button works in all camera mode settings.
	Movie Mode Only — Movie button only works when mode dial is set to Movie mode.

A

Custom Settings - Page 6 - (con't)		
Command	**Description**	
Dial / Wheel Lock	Locks the front and rear dials and the control wheel.	
	Lock	Pressing the Fn button for several seconds will either lock or unlock the wheel control and the front and rear dials.
	Unlock (Default)	The front and rear dials and wheel control always work.

Wireless Settings - Page 1		
Command	**Description**	
Send to Smartphone	Sends an image from the camera to the smartphone via the camera's Wi-Fi transceiver. Phone must have PlayMemories Mobile installed and linked to camera's Wi-Fi transceiver.	
	Select on This Device	The pictures to be sent to a smartphone are selected on the camera.
	Select on Smartphone	Thumbnails of pictures are first sent to a smartphone. Selected files are loaded onto the smartphone.
Send to Computer	Sends images to a computer via Wi-Fi. Sending files is faster using a USB cable connected from the camera to the computer. Note: For Macs using OS ver. 10.7 and earlier, you will need to download a Wireless Auto Import program.	
View on TV	Requires the television and camera to be connected to a Wi-Fi network. The camera will need to be connected to the same Wi-Fi network as the television.	
One-touch (NFC)	Requires a NFC-enabled Android phone. The NFC function must be activated on the phone. If the camera's Live View screen shows the NFC icon, physically touch the phone to the camera to establish communication. Does not work with iPhone or iPad.	
Airplane Mode	Turns off the camera's Wi-Fi transceiver. Equivalent to a phone's Airplane mode.	
	On	Wi-Fi transceiver is active.
	Off (Default)	Wi-Fi transceiver is turned off, which can help extend battery life.
WPS Push	Requires wireless router with "Push" capability. When this command is used, press the WPS button on the router to transfer its login information to the camera. Simplifies setting the Wi-Fi communication protocol.	

A

Wireless Settings - Page 2	
Command	**Description**
Access Point Settings	Used to manually type in the camera's router name and password. To be used if WPS is unavailable.
Edit Device Name	Changes the Wi-Fi's device name. The default name is either ILCE-7R for a7R or ILCE-7a for the a7.
Disp MAC Address	Displays the camera's Media Access Control (MAC) address. The numbers and letters are the device's unique identifier to the network.
SSID/PW Reset	Changes the SSID and Password of the camera.
Reset Network Settings	Resets all of the network settings to the camera's original default settings.

Applications - Page 1		
Command	**Description**	
Applica-tion List	Allows you to manage your downloaded Sony applications.	
	List of Apps	Displays a list of apps downloaded to the camera and ready to use.
	Application Management	Orders the listing of apps. Also enables the deletion of downloaded app.
	PlayMemories Camera Apps	Provides connection to PlayMemories Camera Apps if there is an available Wi-Fi station. Can directly download apps without the aid of a computer.
Introduc-tion	Displays Sony application information.	
	Service Introduction	Displays Sony's application website URL for applica-tion service information. Announces new and updated applications.
	Service Availability	Displays Sony's service availability. Searches for an access point. If none is found, you will be asked to perform the Network Settings command.

Playback Settings	
Command	**Description**
Delete	Allows you to delete one, many, or all unprotected images within a selected folder or date view. To change the selected view, use the MENU>Playback (1)>View Mode command. The Delete command will be disabled when there are no files within the selected view. You can also use the C3 (delete) button to erase a single image in playback mode.
Multiple Img. (Default)	Displays one image at a time with its associated delete check box. Scroll through individual images using the control wheel. Press the center button to check or uncheck the delete box. When all files have been identified for deletion, press the MENU button (Enter), select OK and press the center button. Press the center button again to exit the function. Press the shutter button halfway to return to Live View.
All with this date	Deletes all images recorded on the selected View Mode's date. The following message is displayed: Delete all images with this date? *date*. Select OK to delete or select Cancel to exit.
All with this folder	Deletes all images recorded in the selected View Mode's folder. The following message is displayed: Delete all images with this folder? *folder name*. Select OK to delete or Cancel to exit.
View Mode	Allows you to select what type of images should be displayed while reviewing them to perform a function.
Date View	Display images you wish to view based on the date recorded, with the first one displayed being the first image recorded on a selected date. Displayed images will cycle through all recorded dates.
Folder View(Still)	Display only recorded still images within a selected folder.
Folder View(MP4)	Display only recorded MP4 images within a selected folder.
AVCHD View	Display recorded AVCHD images based on the date recorded with the first displayed AVCHD image being the first AVCHD movie recorded on the selected date. Displayed movies will cycle through all recorded dates.

A

Playback Settings - Page 1 - (con't)	
Command	**Description**
Image Index	The Image Index screen simplifies the task of reviewing several images by displaying either 9 or 25 thumbnails of the still pictures, or the first frame of movies. Once the option is selected, the selected number of images is displayed according to the View Mode.
	You can select a specific image at this point, and use the directional buttons to navigate through them. Note the highlighted image is enclosed with orange borders. The movies' first frames can be played by pressing the center button. Pressing the MENU button returns you to the Image Index screen. Images and movies are ordered by recorded date.
	The vertical bar on the left allows the user to enter in the View Mode command and select whether to display the images by the day of the month, the file type, Still photos, MP4 movies, or AVCHD movies.

	9 Images (Default)	Displays up to 9 images at a time.
	25 Images	Displays up to 25 images at a time.

Display Rotation	Determines framing of a picture when viewing images in Playback. Its role is evident when shots are oriented in "portrait" framing.

	Auto (Default)	The image's top is displayed pointing up during playback. Even if the camera is rotated by 90 degrees, the object orientates so top remains pointed up.
	Manual	The image's top is displayed pointing up during playback. If the camera is rotated during playback, the image will not rotate with camera.
	Off	If the object is recorded in portrait mode, the image is displayed sideways in landscape mode. To view the played back image in portrait mode, rotate the camera. by 90 degrees.

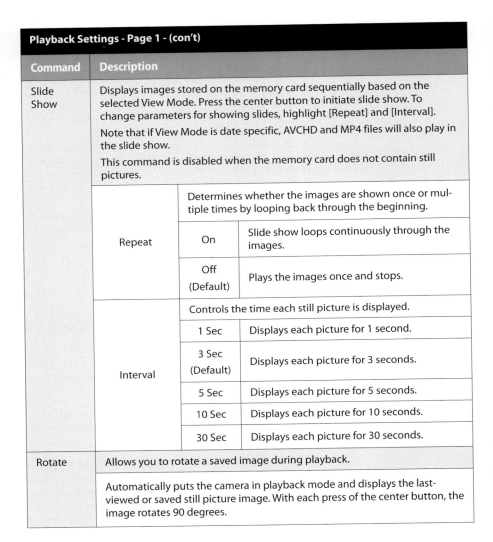

Playback Settings - Page 1 - (con't)		
Command	**Description**	
Slide Show	Displays images stored on the memory card sequentially based on the selected View Mode. Press the center button to initiate slide show. To change parameters for showing slides, highlight [Repeat] and [Interval]. Note that if View Mode is date specific, AVCHD and MP4 files will also play in the slide show. This command is disabled when the memory card does not contain still pictures.	
	Repeat	Determines whether the images are shown once or multiple times by looping back through the beginning.
		On — Slide show loops continuously through the images.
		Off (Default) — Plays the images once and stops.
	Interval	Controls the time each still picture is displayed.
		1 Sec — Displays each picture for 1 second.
		3 Sec (Default) — Displays each picture for 3 seconds.
		5 Sec — Displays each picture for 5 seconds.
		10 Sec — Displays each picture for 10 seconds.
		30 Sec — Displays each picture for 30 seconds.
Rotate	Allows you to rotate a saved image during playback.	
	Automatically puts the camera in playback mode and displays the last-viewed or saved still picture image. With each press of the center button, the image rotates 90 degrees.	

Playback Settings - Page 2	
Command	**Description**
Enlarge Image	Magnifies a saved still picture to check fine details within the image. Automatically puts the camera in playback mode and enlarges the last viewed or saved still picture image.
	To further enlarge the image, press the C2 button; to reduce image magnification, press the AF/MF or AEL button. To move the magnified region being viewed, press the right, left, up, and down buttons.
4K Still Image PB	Requires a 4K-resolution television and an HDMI cable. Camera must be connected to television.
	On — Activates the 4K-resolution process being sent to the television.
	Off — Deactivates the 4K-resolution process being sent to the television.

Playback Settings - Page 2 - (con't)	
Command	**Description**
Protect	Allows you to prevent images on the memory card from being erased with the camera's Delete command or button. Command can be reversed. Image files can still be removed by using the Format command. This command displays only images within the selected MENU>Playback (1)>View Mode value. You can protect up to 100 images at a time per memory card. The Protect command is disabled when the current folder is empty.

	Multiple Img. (Default)	When the Protect command is enabled, this option is displayed regardless of the current MENU>Playback (1)>View Mode value. Displays one image at a time with its associated protect check box. Use the control wheel to scroll through the individual images. Press the center button to check or uncheck the protect box. When all files have been identified for protection, press the MENU button, select (OK), and then press the center button to protect.
	All in this Folder	Displays a confirmation screen with the following message: Protect all images in this folder? *folder name*. Folder is specified via the View Mode command's value. Select [Enter] to protect all the images recorded on the specific date; select [Cancel] to exit the process.
	Cancel All in this Folder	Displays a confirmation screen with the following message: Cancel protect all images in this folder? *folder name*. Folder is specified via the View Mode command's value. Select [Enter] to unprotect all the images in the folder; select [Cancel] to exit the process.
	All with this date	Displays a confirmation screen with the following message: Protect all images with this date? *date*. Date is specified via the View Mode command's value. Select [Enter] to protect all the images recorded on the specific date; select [Cancel] to exit the process.
	Cancel All with this date	Displays a confirmation screen with the following message: Cancel protect of all images with this date? *date*. Date is specified via the View Mode command's value. Select [Enter] to unprotect all the images in the folder; select [Cancel] to exit the process.

A

Playback Settings - Page 2 - (con't)	
Command	**Description**
Specify Printing	Allows you to identify an image on the camera's memory card to print. You can also specify whether you want the image's recorded date imprinted on the picture.
	To print a specific image, connect the memory card directly or through a computer to a Digital Print Order Format (DPOF) printer or send the memory card to a photo printing service.
	Command is enabled only when MENU>Playback (1)>View Mode>[Folder View(Still)]. You cannot print RAW images or movies. You can identify a maximum of 999 images per memory card.

Multiple Img. (Default)	Controls the selection and deletion of images for printing.		
	Displays one image at a time with its associated print check box. Use the control wheel to scroll through the individual images. Press the center button to check or uncheck each print box. When all files have been identified for printing, press the MENU button. Select [OK] to accept print indicators and [Cancel] to exit the process.		
	DPOF print indicators are retained with the images even after the pictures have been printed.		
Cancel All	Deletes all DPOF print indicators. When option is selected, select [OK] to cancel all print indicators and [OK] again to confirm; select [Cancel] to exit the process.		
Print Setting	Allows you to specify if you want the still picture's recorded date to be included on the print.		
	Select [Enter] to process your Date Imprint value; select [Cancel] to exit and return to the Specify Printing menu.		
	Date Imprint	Allows you to specify if you want the still picture's recorded date to be included on the print.	
		On	Include the date on the print.
		Off (Default)	Don't include the date on the print.

Setup			
Command	**Description**		
Monitor Brightness	Controls the LCD screen's brightness either automatically or manually. The LCD screen must be active when setting this command.		
	Brightness Setup	Manual (Default)	Allows you to set the LCD monitor's brightness between –2 and +2 at ±1 increments, where –2 is less bright and +2 is the brightest setting.
		Sunny Weather	Camera maximizes the LCD monitor's brightness for use in bright sun.
View-finder Bright.	Controls the viewfinder's brightness automatically or allows you to set it manually. The viewfinder must be active when setting this command.		
	Brightness Setup	Auto (Default)	Relies on the camera to determine the viewfinder's brightness.
		Manual	Allows you to set the viewfinder monitor's brightness between –2 and +2 at ±1 increments, where –2 is less bright and +2 is the brightest setting.
Finder Color Temp.	Provides warmth or coolness to the color temperature of the viewfinder. Can be set to one of 4 values.		
	Scale		Allows you to set the viewfinder color temperature between –2 and +2 at ±1 increments, where –2 is cooler and +2 is warmer.
Volume	Adjusts the loudness of the audio playback when playing back movies		
	Scale		Allows you to set the audio from 0 to 17 where 0 is no sound and 17 is the loudest during playback. This is also controllable during playing back movie in the Control Panel.
Audio signals	Confirmation sounds, i.e., when focus is established in Single-shot AF and self-timer countdown.		
	On (Default)		Confirmation beeps occur.
	Off		No confirmation beeps occur.

Setup - Page 2

Command	Description	
Tile Menu	Determines the display format of the main 6 menu options: Camera Settings, Custom Settings, Wireless, Applications, Playback, and Setup.	
	On	Large icons for the six main menu items are arranged in a matrix.
	Off (Default)	Small icons for the six main menu items are arranged linearly at the top of the screen.
Mode Dial Guide	Determines the information content displayed on the screen when selecting a mode dial option.	
	On	Brief description of mode function with displayed mode's icon.
	Off (Default)	Small icons for the six main menu items are arranged linearly at the top of the screen.
Delete confirm.	Determines the order of confirmation when the delete button is pressed.	
	"Delete" first	Delete option is highlighted, so pressing the center button deletes the image.
	"Cancel" first (Default)	Cancel option is highlighted, so pressing the center button keeps the image. Use this setting when you desire a validation step prior to deleting a recorded image.
Display Quality	Improves the quality of the display.	
	High	Slightly improved display quality, increased battery depletion.
	Standard (Default)	Standard display quality.
Pwr Save Start Time	Determines the amount of time before an inactive camera is placed into sleep mode. Maximizes operational time when using the camera's rechargeable battery. Note that the camera does not go into sleep mode if Smile Shutter function is active.	
	30 Min	Camera enters sleep mode after 30 minutes of inactivity.
	5 Min	Camera enters sleep mode after 5 minutes of inactivity.
	2 Min	Camera enters sleep mode after 2 minutes of inactivity.
	1 Min (Default)	Camera enters sleep mode after 1 minute of inactivity.
	10 Sec	Camera enters sleep mode after 10 seconds of inactivity.

Setup - Page 3		
Command	**Description**	
Cleaning Mode	Executes the sensor cleaning process by applying ultrasonic vibration to the sensor to loosen dirt and dust particles. At the end of cleaning, you must turn off the camera.	
	Enter	Initiates cleaning process.
	Cancel	Exits the process and returns you to the menu.
Demo Mode	Enables the camera to play a recorded movie from the memory card after a period of inactivity, such as in a retail store. Only available to retailers. The Demo Mode command becomes enabled when an AC-PW20 AC Adaptor powers the camera.	
	On	Enables the demo mode to begin playing protected AVCHD movies from the memory card automatically when the camera has been inactive for one minute.
	Off (Default)	Disables the demo mode.
Remote Ctrl	Allows the IR based Remote Commander to trigger the camera's shutter.	
	On	Camera will respond to an IR signal, and fire.
	Off	Camera does not respond to an IR signal.
HDMI Resolution	Requires the camera to be connected to an HDMI television with an HDMI cable. Provides a suitable output to generate an image to the television.	
	Auto (Default)	Camera communicates with the television and decides whether to output as select 1080p (progressive) or 1080i (Interlaced). If the television does not show the image, the camera's output can be controlled by setting a specific option.
	1080p	Sets camera's output to 1080p resolution.
	1080i	Sets camera's output to 1080i resolution.
CTRL FOR HDMI	Requires a television that supports "Bravia" Synch. Camera must be connected to television with an HDMI cable. You can play slide shows, display images one at a time, and delete images through your TV.	
	On (Default)	Control camera's operation with television remote.
	Off	Do not control camera's operation with television remote.

Setup - Page 3 - (con't)	
Command	**Description**
HDMI Info. Display	Requires the television to be connected to the camera with an HDMI cable.
On	Live View from the camera shows its shooting information.
Off	Live View from the camera does not display shooting information.

Setup - Page 4	
Command	**Description**
USB Connection	Determines the type of connection your camera establishes with your computer or with a USB device when using a USB cable. Requires a USB cable to connect camera to computer.
Auto (Default)	Camera selects either Mass Storage or Media Transfer Protocol (MTP).
Mass Storage	Camera selects USB Mass Storage Class, which is useful for drag-and-drop file transfers. Supported by Apple operating systems and utilized by Windows. Use this option if the computer does not recognize the camera.
MTP	Camera selects MTP, used by Windows and PICT Bridge-compatible printers. Use this to download apps from your Apple computer, which is connected to the camera with a USB cable.
PC Remote	The camera shooting controls can be set by the computer when the camera is connected to the computer.
USB LUN Setting	Specifies how the camera appears to the computer when they are connected with a USB cable.
Multi (Default)	LUN: Logic Unit Number: Camera can appear as multiple devices to the computer.
Single	Use this setting if you cannot connect the camera to a MAC computer. Camera appears as a single unit to computer.
Language	Selects the language to be used in menu items, warnings, and messages.

Setup - Page 4 - (con't)				
Command	**Description**			
Date/Time Setup	Sets the camera's clocks and date information, including display format.			
		Determines whether daylight savings or regular time is in effect.		
	Daylight Savings	On	Current location is in Daylight Savings mode.	
		Off (Default)	Current location is not in Daylight Savings mode.	
	Date/ Time	Sets the date and time.		
		Time	Sets the time in hours and minutes.	
		Date Format	[Y-M-D]	Year-Month-Date
			[M (English)-D-Y]	Month (spelled out) Day Year
			[D-M-Y]	Day-Month-Year
			[M-D-Y]	Month-Day-Year
Area Setting	Sets the time zone where you are taking pictures.			
	World map is broken into time zones.	Selects your local time based on a world map. Time zone is in white and can be moved east or west by pressing the right or left button respectively. Rapid positioning can be attained by rotating the control wheel.		

Setup - Page 5	
Command	**Description**
Format	Quickly erases all images from the card, including protected images, by reformatting the memory card. A confirmation screen is displayed. Note that the camera's internal memory is not affected.
	Ensure you have enough battery power to complete the format. The access lamp lights up while the memory card is being formatted. Do not turn off the camera or remove the memory card while reformatting. Do not reformat the memory by using a card reader connected to a computer.
	Enter — Reformats the memory card.
	Cancel — Exits the process.

Setup - Page 5 - (con't)	
Command	**Description**
File Number	Determines how file numbers are assigned to images and maintained.

Series (Default)		Assigns file numbers in sequence from 0001 to 9999. Does not reset file numbers even if the folder is changed, images are deleted, the memory card is reformatted, or a new memory card is inserted.
Reset		Assigns file numbers in sequence from 0001 to 9999 within each folder. Does not reuse file numbers when an individual file within a folder is deleted until all of the files are deleted, at which time the numbering starts over at 0001.

Select REC Folder	Enabled only when you create an additional folder with the New Folder command. Initial still folder is 100MSDCF. Name command is set to [Standard Form]. Allows you to choose from a displayed list containing both Standard Form and Date Form folders used to hold still images on the memory card. Use the control wheel to scroll through the list and press the center button to select one. Note: folders with AVCHD and MP4 files cannot be selected.
New Folder	Creates a new folder. Folder name's format is determined with the Folder Name command. Folders are created in a new memory card when the card is formatted.

OK (Default)		Creates a new still picture folder based on the Folder Name command's option and a new MP4 folder—both folder names start with the same number incremented by one on the memory card.

Folder Name	Allows you to choose between two folder name structures for storing your still picture images.

Standard Form (Default)		Folder number + MSDCF (example: 100MSDCF). MSDCF is a file naming convention created by JEITIA (Japan Electronics and Information Technology Industries Association).
Date Form		Folder number + last digit of the year + two-digit month + two-digit day (example: 10040210, where folder number = 100, last digit of the year = 4, month = 02, and day = 10).

Setup - Page 5 - (con't)	
Command	**Description**
Recover Image DB	Attempts to recover a corrupted image database on the memory card. Processing the stored images on the memory card outside of the camera usually causes this problem. Make sure your camera is fully charged when executing this command.

	Enter (Default)	Initiates recovery.
	Cancel	Exits the process.

Setup - Page 6	
Command	**Description**
Display Media Info.	Displays an estimate of the remaining available space for still images and movie time on the memory card. The calculations are based on the current still and movie Image Size and Quality command values.

	OK (Default)	Exits and returns you back one level to the menu with Display Media Info. Command highlighted.

Version	Displays the camera body name and current version of firmware. Initial version of the camera was 1.01. At the time of writing this book, it is 1.02 for both the a7 and a7R.

Setting Reset	Allows you to reset the camera's command values back to the manufacturer's defaults.

	Camera Settings Reset (Default)	Resets all the values in the commands listed under Camera Settings back to the manufacturer's defaults.
	Initialize	Initializes all camera settings to the manufacturer's defaults.

Appendix B: Error Messages/Warning Messages and Resolutions

The Sony a7/a7R displays error or warning messages and icons as you utilize the camera's functions. The following tables contain common messages and icons whose meaning may not be obvious. Note that many error or warning messages are displayed when you try to select a command or function that is not available in the current mode. Such messages are very explicit and are not included in this appendix.

Message	Description	...
Camera Error. Turn power off then on.	This is a nonspecific error message.	
Cannot recognize lens. Attach it properly.	The camera does not recognize that a standard lens is attached.	
Could not shoot panorama. Move straight in the direction of the arrow.	The camera was panned too slowly or not all the way, or the camera was not level either horizontally or vertically.	
Could not shoot panorama. Move the camera slowly.	The camera was panned too fast or in the wrong direction.	
--E-	Memory card error	
Image Database File error.	An error has been encountered in the Image Database File, usually due to an inconsistency created between what the camera needs to read on the memory card and what was saved when the memory card was used outside of the camera, such as when files were downloaded to a computer.	
Image protected.	You tried to delete an image that is protected.	
Internal temp. high. Allow it to cool.	The camera sensor has become heated from prolonged shooting.	
Memory Card Error	The inserted memory card is incompatible with the camera, or the Format command failed.	

B

	Resolution

Turn the camera off. Remove the battery pack and reinsert it. Turn the camera back on. If the message persists or appears more frequently over time, contact a Sony dealer or authorized Sony service facility.

If a lens is currently attached, rotate it to make sure it is locked in the mount. If this does not solve the problem, remove the lens and clean contacts on both the lens and the camera body. Reattach the lens.

If the lens is attached properly and it is not a standard Sony lens, or if the camera is attached to a microscope or telescope, set MENU>Custom Settings (3)>Release w/o Lens>[Enable].

If SteadyShot command is set to [On] but you are not seeing the SteadyShot [On] icon and the attached lens is an E-mount with SteadyShot within the lens, turn the camera off and back on. If function is still not initiated, contact Sony Tech Support.

Reboot the camera by turning it off and back on to see if the camera can then recognize the lens or if the error message disappears. If a power zoom lens is retracted and will not extend, turn off the camera, remove and reinsert the battery. If the power zoom lens still does not operate, contact Sony Tech Support.

Reshoot the picture and pan a bit faster, making sure the camera is level horizontally and vertically. Make sure the pan is not stopped before reaching the completion mark.

Reshoot the picture and pan a bit slower in the direction of the arrow on the display screen.

Remove memory card, clean contacts, and reinsert. If problem persists, reformat memory card. If problem continues, use different memory card.

Execute the database recovery command: MENU>Setup (5)>Recover Image DB command. Ensure that the camera's battery is sufficiently charged prior to executing the command. If the error message persists, use a different memory card.

Unprotect the image by executing MENU>Playback (2)>Protect, then select the image and unprotect it. Execute the Delete function again.

Stop recording and turn off the camera so that it can cool down prior to using it again. Tilt the LCD monitor so that there is an air space between the LCD and camera body.

Download the memory card's files to your computer, and reformat the memory card. If the problem persists, use another memory card and make sure it is formatted using the Sony a7/a7R.

Message	Description	···
Memory card locked.	The memory card's write-protect switch is set to LOCK.	
NO CARD	This message is displayed when the camera is turned on and no memory card is in the camera.	
No images in this view.	The memory card does not contain any stored images for the currently selected file type.	
No images selected.	You have executed a multiple-image delete function but did not select any images for deletion.	
No memory card. Cannot play.	Playback mode was initiated and memory card is not inserted in the camera.	
Processing...	This message appears when the camera is processing a long exposure or High ISO noise reduction image.	
Recording is unavailable in this movie format.	The camera cannot record an AVCHD movie.	
Set Area/Date/Time.	The camera's area, date, and time are not set. There are two explanations: 1. The camera's area, date, and time information have never been set. 2. The camera's internal battery is drained and can no longer maintain the information.	
This memory card may not be capable of recording and playing normally.	The memory card is incompatible with the a7/a7R camera.	
Unable to display.	The Sony a7/a7R can only display images recorded and maintained by the camera and other selected Sony camera models. This message indicates that the inserted memory card has images recorded and/or modified from another camera that is not compatible with the Sony a7/a7R.	
Unable to magnify.	The currently displayed image was recorded by another camera and therefore cannot be magnified.	
Unable to print.	The selected image's RAW format is not compatible with a DPOF Mark.	
Unable to read memory card. Reinsert memory card.	The camera cannot recognize the memory card due to incorrect insertion, damage, or dirty terminal connectors.	
Unable to rotate image.	The currently displayed image was recorded by another camera and therefore cannot be rotated.	
Unable to use memory card. Format?	The memory card was not formatted with the Sony a7/a7R or selected other Sony camera models, or the memory card's file format was modified outside the camera.	

...	Resolution
	Set the write-protect switch to UNLOCK. Insert card taking care that the write-protect switch does not rub against the side of the slot and set it to LOCK.
	Insert memory card.
	Change the View Mode command value to a file type matching the images stored on the inserted memory card.
	Execute the command again and select at least one image to be deleted. Exit out of the error message and the process if you did not intend to delete any images.
	Insert memory card and continue with playback mode.
	Wait until the process is completed.
	Switch the File Format command to [MP4].
	Set the camera's area, date, and time information using MENU>Setup (4)>[Date/Time Setup] and MENU>Setup (4)>[Area Setting]. Make sure a fully charged battery pack is inserted to recharge the camera's internal battery.
	Replace the memory card with a compatible model.
	If there are images on the card you wish to save, download them to a computer via a card reader. Then reformat the memory card.
	There is no resolution within the a7/a7R camera. To magnify the image, download the specific file to your computer and use third-party software.
	Ensure that only JPEG images are marked for printing within the camera. If you wish to print a RAW file, download the image to third-party software, save it to a printable format, and print it from outside the camera's memory card.
	Resolutions: 1. Remove and reinsert the memory card. If this does not work, clean the memory card's contacts and reinsert. 2. If the above does not work, replace the memory card (the memory card is damaged).
	There is no resolution within the a7/a7R camera. To rotate the image, download the specific file to your computer and use third-party software.
	Select [Enter] to reformat the memory card with the Sony a7/a7R. Any images on the card will be lost. If you wish to save them, remove the card and download the images via a card reader to your computer. Once download is complete, reinsert the memory card into the a7/a7R and execute the Format command.

B

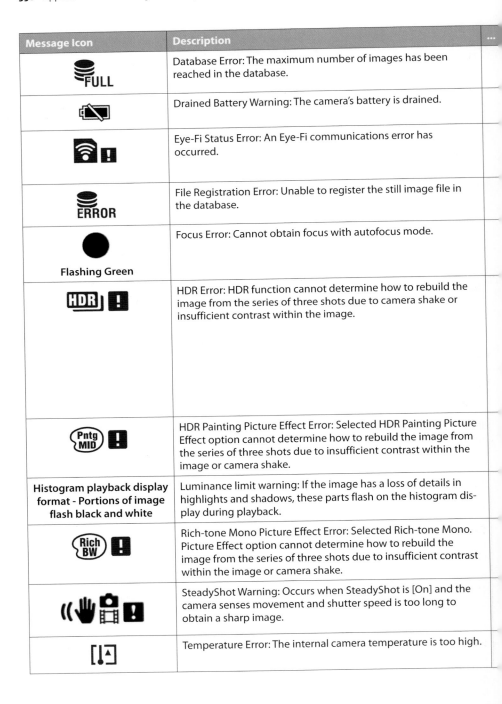

Message Icon	Description	...
FULL	Database Error: The maximum number of images has been reached in the database.	
	Drained Battery Warning: The camera's battery is drained.	
	Eye-Fi Status Error: An Eye-Fi communications error has occurred.	
ERROR	File Registration Error: Unable to register the still image file in the database.	
Flashing Green	Focus Error: Cannot obtain focus with autofocus mode.	
HDR	HDR Error: HDR function cannot determine how to rebuild the image from the series of three shots due to camera shake or insufficient contrast within the image.	
Pntg MID	HDR Painting Picture Effect Error: Selected HDR Painting Picture Effect option cannot determine how to rebuild the image from the series of three shots due to insufficient contrast within the image or camera shake.	
Histogram playback display format - Portions of image flash black and white	Luminance limit warning: If the image has a loss of details in highlights and shadows, these parts flash on the histogram display during playback.	
Rich BW	Rich-tone Mono Picture Effect Error: Selected Rich-tone Mono. Picture Effect option cannot determine how to rebuild the image from the series of three shots due to insufficient contrast within the image or camera shake.	
	SteadyShot Warning: Occurs when SteadyShot is [On] and the camera senses movement and shutter speed is too long to obtain a sharp image.	
	Temperature Error: The internal camera temperature is too high.	

Resolution

Download all of the images to a computer and reformat the memory card within the camera.

Recharge the battery.

1. Remove and reinsert the Eye-Fi card.
2. Turn the camera's power off and back on.
If the error persists, the Eye-Fi card may be damaged

Download all of the images to a computer using "PlayMemories Home" or third-party software and reformat the memory card within the camera.

Increase ambient light on the subject. Make sure the selected subject has sufficient contrast so the camera can identify it and obtain focus. If this does not work, use manual focus.

Multiple resolutions for this problem.
In regards to insufficient contrast within the image:
1) Reframe the image to one that has more contrast.
2) If in a low light situation, add additional light on the subject.
3) If in a bright light, reduce the lighting or reduce the ISO.
In regards to camera shake:
1) Mount the camera on a tripod.
2) Brace yourself so you can hold the camera steady.

Refer to HDR Error's Resolution.

Retake image after changing the image's exposure (ISO, exposure compensation, aperture, shutter speed). You may have to provide light to fill in shadows.

Refer to HDR Error's Resolution.

Mount the camera on a tripod and turn SteadyShot off or leave SteadyShot on and brace the camera to reduce shaking.

Stop recording and turn off the camera. Allow the camera to cool down prior to using it again.

Index

Get in the Picture!

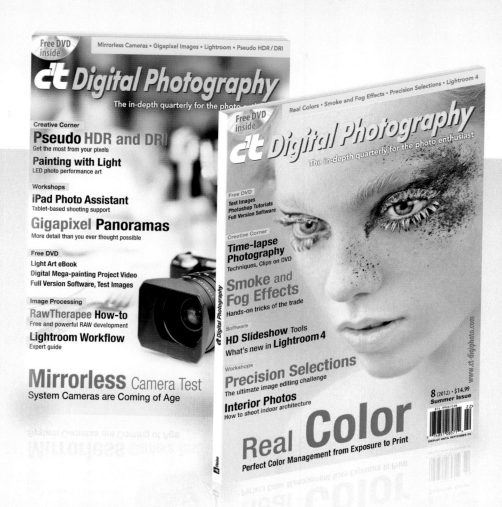

c't Digital Photography gives you exclusive access to the techniques of the pros.

Keep on top of the latest trends and get your own regular dose of inside knowledge from our specialist authors. Every issue includes tips and tricks from experienced pro photographers as well as independent hardware and software tests. There are also regular high-end image processing and image management workshops to help you create your own perfect portfolio.

Each issue includes a free DVD with full and c't special version software, practical photo tools, eBooks, and comprehensive video tutorials.

Don't miss out – place your order now!

Get your copy:
ct-digiphoto.com

Learning to Photograph:
Volumes 1 and 2

You have a great camera and have learned to operate it. Now what?

Learning to Photograph is a two-part series that will guide you along the path toward creative expression and technical expertise.

Volume 1 teaches the basics of camera technology, including how cameras and lenses work and how they influence one another. Building on this foundation, you'll learn to apply this knowledge to create successful images.

Volume 2 addresses design and composition. Topics include managing light, color and its effects, sharpness and blur, shapes and lines, and much more. You will learn how to design strong images, train your photographic eye, strengthen your artistic message, and hone your personal style.

Sold separately, these two volumes combined offer a firm foundation in the hard skills and the soft skills of photography, making them essential resources for photographers to develop their craft.

Cora Banek and Georg Banek
Learning to Photograph: Volume 1
Camera, Equipment, and Basic Photographic Techniques

978-1-937538-20-0, 8x10 Softcover
August 2013, 256 pages
$39.95 US, $41.95 CA

Cora Banek and Georg Banek
Learning to Photograph: Volume 2
Visual Concepts and Composition

978-1-937538-21-7, 8x10 Softcover
August 2013, 256 pages
$39.95 US, $41.95 CA